Wicked Problems for Archaeologists

Wicked Problems for Archaeologists

Heritage as Transformative Practice

JOHN SCHOFIELD

Great Clarendon Street, Oxford, OX2 6DP,
United Kingdom

Oxford University Press is a department of the University of Oxford.
It furthers the University's objective of excellence in research, scholarship,
and education by publishing worldwide. Oxford is a registered trade mark of
Oxford University Press in the UK and in certain other countries

© John Schofield 2024

The moral rights of the author have been asserted

All rights reserved. No part of this publication may be reproduced, stored in
a retrieval system, or transmitted, in any form or by any means, without the
prior permission in writing of Oxford University Press, or as expressly permitted
by law, by licence or under terms agreed with the appropriate reprographics
rights organization. Enquiries concerning reproduction outside the scope of the
above should be sent to the Rights Department, Oxford University Press, at the
address above

You must not circulate this work in any other form
and you must impose this same condition on any acquirer

Published in the United States of America by Oxford University Press
198 Madison Avenue, New York, NY 10016, United States of America

British Library Cataloguing in Publication Data
Data available

Library of Congress Control Number: 2023923193

ISBN 978–0–19–284488–0

DOI: 10.1093/oso/9780192844880.001.0001

Printed and bound in the UK by
Clays Ltd, Elcograf S.p.A.

Links to third party websites are provided by Oxford in good faith and
for information only. Oxford disclaims any responsibility for the materials
contained in any third party website referenced in this work.

The manufacturer's authorised representative in the EU for product safety is
Oxford University Press España S.A. of El Parque Empresarial San Fernando de Henares,
Avenida de Castilla, 2 – 28830 Madrid (www.oup.es/en or product.safety@oup.com).
OUP España S.A. also acts as importer into Spain of products made by the manufacturer.

(Not a) Dedication

This book is dedicated to the history teacher who once wrote in my school report: 'This boy has no interest in the past whatsoever'. In a way he was right. I don't. I am far more interested in the present and the future, in why understandings of the past matter and what they can do to help make our future world a better place. This school report has long been my motivation, to explore the contemporary relevance of the past and not just study it for its own sake. So perhaps it is more of an 'up yours' than a dedication! Either way, I am grateful.

With reference to John Steinbeck's inspirational (1939) *The Grapes of Wrath*, the book is also dedicated to Joad families everywhere: resilient, generous, open- and positive-minded people who, in spite of their difficulties, look out for one another and care for the world in which they live.

Preface

What is archaeology and why do we do it? Alongside my history teacher telling my parents and me that I had 'no interest in the past whatsoever',[1] another comment that rankles was from an economics student during my first year as an archaeology undergraduate. He didn't particularly like me (nor me him for that matter) but he nonetheless came with some of his friends to sit with me over a canteen meal. He was looking for mischief and, with his friends egging him on, opened what became a very one-sided conversation with the question: 'So, what is the point of archaeology?' I struggled to answer his question and this failure to articulate under pressure what it was about my chosen subject that made it so appealing and so necessary, has troubled me for a long time. Perhaps this book is my attempt to finally provide an answer.[2]

However, and importantly, this book is not intended as a manifesto,[3] or even necessarily a justification for archaeology's existence and for public support. Rather it is an argument, illustrated with a set of examples of methods and applications, to promote the view that archaeology can enhance understanding of and provide new perspectives on familiar problems and, ultimately therefore, help to make the world a safer and healthier place. Wicked problems provide significant challenges to human and planetary health and yet such problems cannot be simply resolved. That is the nature of them, as I will explain. But through using what has been referred to as a 'small wins' framework, archaeologists and those of us who apply an archaeological lens across the wider field of cultural heritage studies, can make a difference. I also argue that, as archaeologists, we can be more creative in our approaches than we have been in the past, using our imagination to design projects that align with these wicked problems, and not always necessarily in obvious ways. To address wicked problems, we also need to work more collaboratively,[4] using these collaborations to experiment more within our discipline, whether in the field, at our desks, or in the lab. We also need to find new ways to involve more people from the local communities where we undertake our work, and in particular those people who have the most to gain from participation, being those who are also often the hardest to reach. Participation will often also mean co-creation and sometimes even handing expertise over to

[1] It is the 'whatsoever' that still really gets me!
[2] And it is ironic that some of the book's core principles (not least in its final chapter) originate with economics. I will discuss this in much more detail in the book's closing chapter.
[3] Although some reviewers have read it as such!
[4] Disagreeing here with artist David Hockney who said that collaboration always means compromise.

others. And we need to align our work with policymakers and with industry, promoting those amongst us with the appropriate skills to serve as our 'policy entrepreneurs' or 'influencers'. To achieve all of these aspirations, we also need to start incorporating what, for most, will be a new terminology to help communicate the significance of what we do amongst funders, community and other leaders, and those in policy settings. We need to be part of a much wider conversation in other words. Currently we are typically not involved in that wider conversation, partly because we don't speak the language used in other relevant disciplines. I will talk about the Doughnut, the Rainbow, and the Three Horizons, for example, in the book's final chapter. In short, the book argues that we may need to think about the role and purpose of archaeology in a completely new way, without necessarily changing much about the way we do it.

This is therefore a book about archaeology and the heritage sector within which it sits. It concerns what we do and how we do it but also addresses why we do it and who we do it for? It questions whether we are doing enough to address wicked problems, or whether we can simply reframe what we are doing already to make it more relevant to these global challenges that are universally faced. The archaeological evidence we recover often demonstrates how people have dealt with significant challenges in the past, embracing all of the themes covered in this book, and more.

But I also ask the question you may now be asking yourself: 'Why should this fall on us, as archaeologists? Solving the World's problems isn't what we signed up for!' I disagree. I think that this is our business as archaeologists, and that our perspective is not only relevant but vital to getting us out of the mess we are in ... besides the fact that this is a responsibility of every person on the Planet. But Greta Thunberg has already written that book!

Simply, therefore, this book argues that archaeology (and the related field of heritage studies) can make significant contributions to wicked problems, not least when viewed as a creative and transformative practice.

In Chapter 1, I refer to archaeologists having superpowers, in terms of the capacity to travel across time, to see more than others might see (the subtle traces of human behaviours and to interpret what these traces might mean), and to consider contemporary phenomena in the context of a *longue durée*, the long, deep history of human existence. All archaeologists have these superpowers, even those who train as archaeologists but then follow careers in very different fields. Once an archaeologist, always an archaeologist!

Also as individuals, we have distinct superpowers and these can also be effective if we learn to channel them effectively. It took me half a century to realize it, but my neurodivergence is my superpower and this is the first book I have written that uses it. In the past, I found myself agonizing over the very things I have now learnt to embrace and to take confidence from. With my particular neurodivergence, for example, I struggle to concentrate on anything for very long, always jumping to

another email, another project, another paper, managing many things at the same time. This suits me. I like to be on the move, flitting between different places and disciplines, but always looking for ways to connect them, somehow.[5,6] Yet I also like to dig deeper, and follow certain threads to see where they lead. Both of these characteristics have helped me to write this book. And I like time alone, which is ideal for writing! Finally, I have never developed what some might describe as a mature academic writing style, much preferring to keep things simple. Once I would have apologized for this and tried to correct it. I no longer feel the need to do so. I hope that anyone who attempts to read this book will follow my line of argument, whatever their age or level of educational attainment.

It was by using all of these qualities (as I will describe them), that this book came to be written, using my superpower and by keeping my head down, thus avoiding a lot of the social contact that I find challenging and stressful. Overall, I have come to recognize neurodiversity not as a disability but rather an *a*bility, in spite of the challenges that it can and does present.

Having said all of that, I do enjoy working with people, and I have worked with many wonderful friends and colleagues who are willing to accommodate these distinct and at times challenging characteristics. Some of the people I have worked with share some elements of these characteristics, in fact. So I want to acknowledge that many of the ideas presented in this book owe much to the many creative and interesting people I have worked with over the past forty years. Some of these people, but only some of them, are archaeologists. Given that length of time, and the many different things I have done in that time, I could write pages of acknowledgements, recognising those who have supported, encouraged, and enhanced my work through partnership and collaboration, alongside those who have constructively criticized it, often specifically on topics that feature in this book. I am deeply indebted to all of these people, but I won't be naming names for these professional colleagues. The danger of doing so is that people can be forgotten where they shouldn't have been and I wouldn't want that to happen.

However, I will make special mention of one group of people who may not realize the vital contributions they have made (and continue to make) in helping shape ideas, or fine-tuning those that already exist. Those people are the many students I have taught since I began teaching in 2001. First of all, I taught an undergraduate heritage programme at Southampton University for ten years, and contributed teaching to some Masters programmes at the University of Bristol from 2005 to 2010. I then took up an academic position at the University of York

[5] I do the same thing as a DJ, putting music together that has no right to be together in the same playlist.

[6] A few years back, as part of a performance review, I was advised to focus more on one thing rather than dabbling in many. I then went to Australia and met wicked problems and policy scholar Brian Head, of the University of Queensland. I explained the many dimensions to my research and he recognized them as having a shared context: wicked problems. This was a turning point.

where I have taught mostly Masters but also undergraduate classes, as well as having a steady stream of outstanding PhD students, some of whose work is described and acknowledged in this book. I have also taught regularly in Turku (Finland), Cottbus (Germany), and in Australia. Wherever in the world my teaching occurs, and at whatever level, I find it stimulating, rewarding, and always iterative. What the students may not realize is that I learn as much from them as they (hopefully) learn from me. Over that twenty-two-year period that I have been teaching, I have only rarely taught beyond the topics that feature in this book. That means that the ideas presented here are as much my students' ideas as they are my own and I am therefore grateful to all of those students for their inspiration and for the wisdom that they have shared with me and with each other. I address this acknowledgement also to my future students for the contributions they will undoubtedly continue to make to my own learning process and my ongoing creative development.

I would like to acknowledge my wonderful children, all now adults: Armorel, James and Benedict. Their journeys have not been straightforward, mainly because mine has made it more difficult for them. But they have all become amazing adults, all achieving success in different ways, in part through their good nature and positive outlooks on life. I am proud of them all for so many reasons, but the main reason is simply that they are good, kind and intelligent people, who care for and support others. I acknowledge them here because, over the years, their spirit and good nature have been a constant source of both joy and inspiration.

I would like to single out three people who have contributed to making me a better, happier and more fulfilled person, helping to create the space that allowed me to attempt this book. Rob Tissera is a world-class DJ. He was amongst the first to promote rave culture in UK warehouses, and the first DJ ever jailed for fighting for the right to party. His autobiography was recently published, and I recommend it. At a time when I was struggling with self confidence, I decided it might be a good idea to learn to DJ, and Rob was the person who taught me. We have remained friends ever since. In teaching me to DJ, Rob helped me develop a much stronger sense of self confidence, always encouraging me to be brave with my track selections and mixes, and to think about the audience. And it means I can now enjoy parties without the stress of having to talk to people! Music has always been important to me, and Rob helped me learn how to channel this enthusiasm and how to make sense of it.

And Golnar Bayat, a counsellor, therapist and psychoanalyst. About ten years ago I badly needed support and Golnar provided it. With Golnar, I discovered and came to terms with my neurodivergence. Golnar helped me through a very difficult period. I also learnt, through Golnar, to think about heritage in a more intimate way than I had managed previously, in terms of its relationship to one's own identity, through such things as place attachment, object attachment and

phenomenology. It may be an exaggeration to say that she saved me, although I have used this phrase on occasion so it must be partly true.

Finally, my wife, Caroline. Over the past ten years, since we met at a gig at the National Railway Museum in York.[7] Caroline has helped me to view life as a series of opportunities and not something to be feared. My neurodivergence means that I still find experiences that involve any form of social interaction to be either stressful or exhausting and often both. I'd always rather stay in than go out and be required to socialize! But Caroline makes these situations much easier for me. She makes possible that which would otherwise be difficult if not impossible. And being calmer in myself has made this book easier to write than would otherwise have been the case. As already stated, neurodivergence is my superpower and Caroline has taught me how to harness it; to treat it as an ability, a gift. Simply, this book would not exist without her. She is wonderful and I am very lucky that she chose me.

I would like to thank the reviewers whose kind and perceptive comments led to a few late changes in the book's tone and content, those who gave generously of their time to write testimonials, and the team at Oxford University Press (notably Jamie Mortimer, Charlotte Loveridge and Srividya Raamadhurai) who supported the writing and production of this book, helping to ensure that its preparation and production ran smoothly and to time.

Finally, all permissions for illustrations are included in the List of Figures. However I would like to specifically acknowledge Nele Azevedo for giving consent to use the evocative 'Millennial Monument' artwork for the book's cover. This image encapsulates so much of the book's content, and I was delighted to have the permission to use it.

John Schofield

York,
23 January 2024

[7] Trains, grassroots live music, and everyday heritage shape our time together.

Contents

List of Figures and Tables xv
1. Wicked Problems 1
2. Climate Change 43
3. Environmental Pollution 89
4. Health and Well-being 125
5. Entanglement 164
6. Social Injustice 182
7. Conflict 221
8. Transformations 259

Some Questions for Book-group Discussions, Essays, and Examinations 301
Bibliography 305
Index 335

List of Figures and Tables

Figures

Cover Image. Wicked problems in microcosm. Brazilian artist Nele Azevedo's display of over 5,000 figures made out of ice at Chamberlain Square, Birmingham (UK). Image source: Néle Azevedo, Minimum Monument, Berlin, 2009 (detail). © DACS 2024. Photo: Andreas Rentz/Getty Images.

1.1	Number of papers and citations per year identified through a Scopus search on 'wicked problem' in January 2020	15
1.2	The Sustainable Development Goals, adopted on 25 September 2015 as a part of the 2030 Agenda	21
1.3	Alternative types of complex problems	23
1.4	Knowledge map of the concepts, ontologies, and obstacles that define engagement in Grand Challenges	24
1.5	The Prescriptive or 'Waterfall' Model (solid line) and the more jagged line of the 'Seismograph' Model	25
1.6	Just Stop Oil protests at the Kelvingrove Art Gallery and Museum, Glasgow (Scotland), in June 2022	37
2.1	Aldabra Atoll	51
2.2	Future projections of a changing climate	60
2.3	Observed changes in (a) global average surface temperature, (b) global average sea level from tide gauge and satellite data, and (c) Northern Hemisphere snow cover for March–April	61
2.4	The CITiZAN team working with volunteers on a shipwreck, found off the East Kent Coast (England), 2021	75
2.5	Coast erosion bringing properties closer to the cliff edge in 2012, at Ulrome in Lincolnshire (England)	76
2.6	A workflow for the archaeology of climate change	77
3.1	Ocean plastic mass concentrations at the Great Pacific Garbage Patch, for August 2015	99
3.2	Surface survey for marine plastics at Bahia Rosa Blanca on San Cristobal island, Galápagos	107
3.3	The many and varied stories of a detergent-powder container recovered from Bahia Rosa Blanca on San Cristobal island, Galápagos	108
3.4	The industrial remains of atomic tests, left in the desert at Nevada Test Site (USA)	118

xvi LIST OF FIGURES AND TABLES

4.1 Archaeologist Janine Peck teaches one of the Operation Nightingale veterans, Jesse Swanson, how to draw features at Dunch Hill on Salisbury Plain (England) — 144
4.2 A participant examines a Roman lamp, part of the Romans at Home project — 151
4.3 Don Rubelio Masaquiza Jimenez performing a healing ceremony at Taita Punta Rumi, near Huasalata, Salasaka, Ecuador — 153
4.4 Some of the ways in which heritage practice can relate directly to aspects of well-being — 159
5.1 An example of entanglements, in this case a preliminary causal loop diagram demonstrating the complexity of the COVID-19 pandemic environmental–health–socio–economic system, where any intervention triggers responses in those various fields — 171
6.1 Rachael Kiddey interviewing a homeless man at a historic site in Bristol (England) where homeless people choose to sleep, often citing historical factors to justify their selection — 209
6.2 In reflection: Sitting on Turbo Island, Bristol, learning valuable lessons about landscape archaeology and personal security from our homeless colleagues — 210
6.3 A tour guide with lived experience of homelessness, giving a tour of York's heritage as part of the Good Organisation's Invisible Cities initiative — 213
6.4 Strait Street, Valletta (Malta), as it was in *circa* 2009, with most of the premises locked up and abandoned — 217
7.1 Maiden Castle hillfort (Dorset, England) — 236
7.2 Robben Island, South Africa, now a heritage attraction and World Heritage Site — 241
7.3 The reconstructed Mostar Bridge, in 2020 — 247
7.4 Rachael Kiddey running a drawing workshop with migrant children living in temporary accommodation, Athens, Greece, 2019 — 252
8.1 How wicked problems align with concrete projects, through missions — 265
8.2 The Doughnut of social and planetary boundaries — 273
8.3 The Rainbow Model showing, in this case, the main determinants of health — 276
8.4 Four different relationships between research and policy — 282
8.5 A typology of problems, power, and authority — 288

Tables

3.1 Characteristics of wicked problems and their applicability to the plastic pollution issue — 97
7.1 Angestrom's (2001) framework for investigating non-international armed conflicts — 228

1
Wicked Problems

This is the first human generation in which the majority will live in crowded cities, whose actions will flood low-lying islands and whose rate of resource use exceeds 2.5 times the production capacity of the planet. Well-founded projections suggest that future supplies of the air we need to breathe, the water to drink, and the food to eat are in doubt. Global issues such as these generate local issues. And it is the sum of the local issues that has generated the global issues in the first place. Thus, we can appear to be locked in an endless spiral from which there is no escape.

(Brown et al. 2010, 3)

'If we can land a man on the moon, why can't we solve the problems of the ghetto?' The question stands as a metaphor for a variety of complaints about the uneven performance of the American political economy. In an economy with such vast resources and powerful technologies, why can't we provide medical care at a reasonable cost to all who need it, keep the streets, air, and water clean, keep down crime, educate ghetto kids, provide decent and low-cost mass transport, halt the rise in housing and services costs, have reliable television and automobile repair service?...In part the moon-ghetto metaphor is about income distribution but there is much more to it than that.

(Richard Nelson 1977, 13)

Archaeologists Assemble!

Archaeologists can be superheroes, with some very special superpowers. Most archaeologists in the past never realized this, and only now are they...are *we*, coming to terms both with the fact we have them, and with the implications of responsibility that these entail.[1] In a recent book, for example, and to highlight one of the superpowers that archaeologists hold, Alfredo Gonzalez-Ruibal (2019, 79) described how archaeologists have the ability to 'see more', even though they

[1] In this book I will often refer to 'we'. When I do so I am referring to my community of archaeologists some of whom work in heritage practice.

sometimes see it too late. Archaeologists have the skills, for example, to identify and interpret traces, marks, and signs and to use these to follow lines of inquiry that others might not think to follow. Archaeologists can build stories or narrative and then connect those stories through time or across landscapes, sometimes locally but also globally. As archaeologists we have the ability to connect things.

In December 2021 in the United Kingdom, membership and charitable advocacy organization the Council for British Archaeology launched a series of 'letters to a young archaeologist', in which practising archaeologists and heritage professionals wrote to the next generation, giving words of advice and encouragement, not least to inspire them to become archaeologists. The first letter, of January 2022, was sent by Hannah Fluck, then head of environmental policy at Historic England (one of the UK's leading heritage agencies). In a persuasive letter, addressing 'young archaeologists, fellow time travellers, future guardians of planet earth', Hannah began by describing how:

> When I was at school in the 1980s and '90s I learned about global warming, what we were doing to the planet, and how bad it was. My parents were told 'don't leave a mess for your children'. But no one listened. Now those children are grown up and we have also failed. We are leaving a mess for your generation to clear up, and for that I am truly sorry. But I want to give you some hope. As an archaeologist you won't be rich, you are unlikely to be famous, but you *can* help to save the planet. (emphasis in original)

The letter goes on to describe how archaeologists are well placed to help achieve this. They have, Hannah Fluck says, 'superpowers that the world really needs right now: story telling; time travel; evidence of how people change the environment; and evidence of how people can live without fossil fuels.' Quoting Hoesung Lee, a South Korean economist who chairs the Intergovernmental Panel on Climate Change[2] and who has described culture and heritage as 'windows into millennia of human experience from which we can draw and use . . . to make our communities more resilient to climate change risks and challenges', Hannah concludes by encouraging her readers to 'go forth, study archaeology and help to save the world!'

It's a strong letter and an important message for a professional archaeologist to be sending out, not least at a time when the humanities[3] are under increased threat of cuts and redundancies, and the value of archaeology continues to be questioned by some of those in authority (often those budget holders who have significant

[2] Of which much more later.
[3] If archaeology *is* a humanities subject. It also sits comfortably with the sciences and social sciences. Examples in this book have been deliberately selected to cover this range of possibilities.

influence as key decision-makers within government). Within the UK planning system, for example, the position of archaeology as a material consideration, whose mitigation the developer (the 'polluter') must currently pay for, is under threat. Some university departments, with responsibility for producing the next generation of archaeologists, are being closed, with some government ministers having branded archaeology (alongside some other arts and humanities subjects) as a 'low value' degree which does not increase earning potential. With an understandable focus on climate change (the subject of this book's second chapter), Hannah's letter makes plain to the next generation of archaeologists that, contrary to this viewpoint, the subject is vitally important because, quite simply, the information it generates can 'help save the world'. However, that isn't the full story. Archaeologists' superpowers extend even further. It isn't just the information (the data and their interpretation) that archaeologists produce that can help us to better understand and engage with the world, but also the *process* of archaeological research and how participation in that process has the capacity to help improve people's lives.

For the (presumably, largely) adult readership that this book will attract, we can put this another way using as my source not an open letter to young archaeologists, but a popular website. To give a flavour[4] (and do please read this footnote before proceeding), the website beanunfucker.com opens with the following statement, also concerning climate change, by way of introduction:

> We've made a mess of this planet and we need to stop thinking it's not our problem, that it's up for debate or it's just too hard to fix. Dive bombing our heads in the sand or thinking it's up to the tree huggers just isn't an option anymore. Before you start running for the hills, stick with us for a little longer because this isn't all doom and gloom.
>
> What you'll find here is a list of head-slappingly easy things everyone can do to start unfucking things. The power of people can be pretty amazing. But before we get into that, let's take a moment to refresh our memories. We know fossil fuels, global warming and greenhouse gases are bad, but to care about something, is to properly understand it. . . . etc.

So here, talk is of 'unfuckers', not just activists but all of us who take practical steps to resolve those problems facing a 'fucked-up' planet and society, and of the need to first understand the problems that we are facing. The invitation being issued here isn't to go out and achieve anything substantive necessarily, but simply to do

[4] And with a *language warning*, both here and occasionally also for later in the book. I have used this language on occasion because these are subjects that should make us angry and require us to be blunt, sometimes.

one small thing that can help—a 'head-slappingly easy' 'small win' (being a term I will return to later in this chapter). To return to the website:

> Remember, what's the norm now doesn't have to be the same in the future. But that takes people-powered change. So give a bit more of a shit, feel that wave of guilt when you take that plastic bag at the supermarket, buy that pristine white toilet paper or don't recycle properly.
> *Let's start unfucking things.* (emphasis in original)

What both the open letter to young archaeologists and the beanunfucker website refer to, in very different ways, are often referred to as wicked problems, those problems facing the planet and its inhabitants, present and future, which are hard (if not impossible) to resolve and for which bold, creative, and messy solutions are typically required. These have also been referred to as 'clumsy' solutions, being those 'that include many different viewpoints when making a decision or establishing policy' (Dugmore et al. 2013, 435, citing Shapiro 1988). Such 'clumsy approaches can provide enduring solutions for complex problems' (Dugmore et al. 2013, 435, citing Verveij et al. 2006). Later in the chapter I will define these problems and some of the language surrounding them in much more depth. But before doing that, I dig deeper (as it were) into the character of archaeology and what I think it represents. This means elaborating on and extending some of the observations made in Hannah's letter or, put more directly, questioning precisely how archaeology can help to unfuck those things that are fucked up and how and why archaeology's contributions are any different to those that people working in other specialist disciplines might wish to make.

So, what is archaeology? In using the term, I am referring to it both as a subject invested in understanding past human behaviours and therefore also ourselves, as people, as humanity, often through the material traces which humans have left behind; but also the associated field of heritage studies whereby researchers and practitioners focus on the recognition, documentation, protection and presentation of, amongst other things, archaeological sites as part of a wider and holistic historic environment. Archaeology is about being human in other words, and understanding humanity through its traces. In both aspects,[5] archaeology benefits from having a no stopping rule:[6] that it begins with the earliest humans, currently thought to be around 2.5 million years ago, and ends with the most recent time, being that moment that has literally just passed. This means that archaeologists

[5] To be clear: archaeology as evidence and as practice, and heritage as a way of managing the evidence (sites, artefacts, etc.) that archaeology produces (while recognising that the scope of heritage extends far beyond just the archaeological evidence for past human activities).

[6] A term I shall be using again later in the chapter, but in a different context.

will have a legitimate interest not only in buried archaeological sites but also in standing buildings and the wider contemporary landscape which exists and continues to evolve as a palimpsest, with traces of human activity constantly being added over time, the most recent traces being the most visible because they exist as 'surface assemblages', as Rodney Harrison (2011) has described them. In short, archaeologists are interested in the world around them in its entirety, and how it came to be the way it is. As I will explain later, archaeologists are now using their inclusive and holistic perspectives on the past to also think about the future. This book contains many examples of this future-oriented approach and of how this approach, alongside more conventional archaeological work, relates directly to wicked problems.[7]

With these definitions in mind, and to help to unravel some of the different ways archaeology can act as a superpower, as Hannah Fluck suggests in her letter, I will begin by following the theme both of Hannah's letter and the statement from the beanunfucker website, by focusing on archaeological *evidence*, outlining how information from archaeological investigations (often but not only excavation) can help achieve a better understanding of such things as the impacts of climate change, by documenting adaptation strategies in the past, for example. This is not to say that knowledge of the past must always have a specific focus on a particular current global challenge, although there is usually a connection with one or more of them, as I will explain.[8] Second, I will focus on archaeology as a practice or an activity, emphasizing the fact that information and understanding obtained from archaeological investigations is not the only benefit to be gained from the endeavour. The *practice* of archaeology, of being in the field, getting one's hands dirty, and thinking through an interpretation of what one finds, is also beneficial, notably to one's physical and mental health. One can gain similar benefits from lab-based analysis or, for non-specialists, from engaging in citizen science projects. At this stage, I will present all of these arguments in the abstract, given that the remainder of the book will describe and critique the examples that illustrate them. Having used the following sections to outline how I define and think about archaeology, the remainder of this chapter will then focus on the nature of wicked problems, being some of the world's most serious and complex challenges which I believe archaeology is uniquely placed to help resolve. It is in that sense, using their superpowers to help resolve some of the world's most pressing wicked problems, that archaeologists can be superheroes. It is also why the subject is so important for humanity and for the future.

[7] And see Tutton (2017) for a discussion of how sociologists have found the future itself to be a wicked problem that is difficult and tricky, conceptually and empirically.

[8] Simply knowing or discovering something in order to better understand it, or to bring joy and entertainment, is important too. My argument here is that this type of benefit also relates to wicked problems, in this case health and well-being which might include happiness through developing a stronger sense of belonging or identity.

Learning from the Past

Let us begin with evidence in the form of data that derive from archaeological investigations and projects, and their interpretation. Beyond simply understanding more about what happened in the past, to what extent does our understanding of past human adaptation and behaviours help shape strategies for managing the challenges faced by people now and in the future? As humans, do we learn from experience? Framing this as a proposition, we might say that by ignoring lessons from the past places us at a distinct *dis*advantage in securing an easier, safer, and more sustainable future.

As already described, archaeology involves the investigation of human behaviours through the material remains which they have generated and which have persisted through time, surviving today as archaeological traces, available for investigation. Those remains can be truly ancient (from the deep past, of the earliest humans) to the very recent past, by which I mean up to and including that moment just...now.[9] In Europe, especially in the later eighteenth and nineteenth centuries, antiquarians excavated ancient sites to retrieve their contents primarily in order to build private or national collections but also, increasingly, to generate and enhance knowledge of past worlds through studying those collections. From antiquarianism, therefore, came archaeology, and—into and through the earlier twentieth century—a focus on material culture as evidence, the artefacts and the contexts in which they are found being subject to ever closer scrutiny not least through rigorous scientific analyses. Initially, such analyses were often themselves driven by a thirst simply to better understand the past, but slowly that understanding began to reveal information that had wider implications, not just about the past for its own sake but also what it tells us about the current state of the planet and the future. It is no surprise therefore that both the present (e.g. Harrison and Schofield 2010) and the future (e.g. various contributions to Holtorf and Högberg 2021a) are now legitimate areas of archaeological investigation. In fact (one might argue), archaeology is all about the future, using what we have learnt about the past to strengthen our prospects of survival. And I don't just mean the next generation or two. I mean longer term—the deep future (to return to Holtorf and Högberg 2021a), a way of thinking that aligns in some ways with Indigenous perspectives. Seven Generation Sustainability, for example, is believed to originate with the Iroquois, and the need to think seven generations ahead.

'Archaeology need not involve excavation...but performs the sustained disclosure of unspoken material coordinates and dimensions of social life. In this

[9] It is well known that archaeology is the study of past human behaviours, and that early humans have long been the subject of archaeological investigations. Archaeology is definitely *not* the study of dinosaurs. Except (and perhaps ironically) modern archaeological traces are often made of plastic and plastic is often made from crude oil, which comes from sedimented deposits from that same pre-human period in which the dinosaurs existed, the Jurassic. So archaeology is a bit about dinosaurs after all.

view, Contemporary Archaeology begins with the commitment that the more carefully we attend to objects, buildings and landscapes, the more human our account of the world may become' (Hicks and Mallet 2019, 19). Those last few words hold particular relevance for archaeologists. As the first celebrity archaeologist Mortimer Wheeler (1954, v) famously declared, archaeology is not so much about things as about people. He said many other things and conducted some iconic excavations but it is for this statement that he is perhaps best known. It is in this phrase, in particular, that we can see how archaeology has evolved to provide the capacity to focus on the present and the future, rather than only on understanding the past for its own sake. By placing emphasis both on the individual (e.g. the person buried in a Bronze Age burial mound) and on the community (through investigating complete settlements or their populations represented within communal burial mounds or in cemeteries), we come to appreciate how people interacted with their world, by shaping it but also by responding to the pressures that it brought to bear; and the ways in which it influenced them and their lives—whether a plague that wiped out large parts of a community and how that community eventually recovered, or through adapting traditional farming or subsistence strategies to survive times of drought or shortage. It can also help in addressing urgent social issues through explorations of cultural diversity (e.g. Barrett 2021). From archaeological investigations that focus on people and their lives, we can therefore better understand the contemporary relevance of social, environmental, economic, or health-related pressures. And we can take comfort in knowing that, in spite of personal tragedy or cultural tensions, communities in the past often came back stronger. If they did not, we can usually establish why that was the case. In other words, by personalizing (or 'peopling') the past, we make it relevant to contemporary issues and peoples even if the events we describe happened millennia ago.

I can illustrate what I mean by that final statement. Recently, I have started using a particular example in lectures to illustrate this observation about people and about time. I often find myself lecturing on the archaeological evidence for recent conflict, as a form of dark or dissonant heritage. Because much of what I describe in those lectures is both recent and traumatic, the subject can be challenging. I am always aware that people in the audience may have close experiences of the kinds of traumas that I am describing, having lost parents or grandparents in wars or in accidents, or having themselves been displaced as a result of conflict (the subject of this book's Chapter 6). I have also taught former military personnel who may still suffer from post-traumatic stress disorders. The subject of conflict therefore requires careful handling and sensitivity. To address this point, and alongside my careful presentation of recent examples, I now often describe the example of a massacre that occurred in Africa some nine thousand years ago (Lahr et al. 2016). The massacre is the subject of a paper whose abstract describes

inter-group violence towards a group of hunter-gatherers from Nataruk, west of Lake Turkana, which during the late Pleistocene/early Holocene period extended about 30 km beyond its present-day shore. Ten of the twelve articulated skeletons found at Nataruk show evidence of having died violently at the edge of a lagoon, into which some of the bodies fell. The remains from Nataruk are unique, preserved by the particular conditions of the lagoon with no evidence of deliberate burial. They offer a rare glimpse into the life and death of past foraging people, and evidence that warfare was part of the repertoire of inter-group relations among prehistoric hunter-gatherers.

The images that accompany this paper reflect the quality of the preservation and the degree to which details of the fatal injuries can be both described in detail and graphically illustrated.[10] I have had audience members tell me how difficult they found this part of the lecture and how this surprised them, given that the events occurred (typically) a long way from home and nine millennia ago. There is usually nothing directly relevant about this topic, nothing to align this community in Africa directly, for example geographically or culturally, with those attending my lecture, except of course the obvious point: that we are all people and that similar things (inter-group violence) still happen today, possibly even for similar reasons. Such archaeological evidence therefore carries weight, especially where the story is one we can relate to, for example around the precise details of injuries or speculations as to the cause. There are many young victims of knife crime in the United Kingdom. Every death is a personal tragedy for the victim and the victim's friends and family. But every death also has wider implications for the community of which that person was a part. This would have been true nine thousand years ago, on the edge of Lake Turkana, just as it is today, in south London, New York or Paris, for example.

This brings me to the question of narrative, and also to the question of scale. As this example illustrates, and as Hannah Fluck said in her letter to young archaeologists, one part of archaeology's appeal lies in its capacity to tell stories. Humans have existed on this planet for over two million years, and archaeologists studying human history have generated tens of thousands of detailed and captivating stories about an infinite number of lives throughout that intervening period. Many of these stories are unfortunately lost in journal articles that only a few specialists will ever read. But increasingly, archaeologists are presenting these stories to wider audiences through a variety of media. A novel example is of a comic, recently published in a mainstream journal, which describes lives and stories around Hollis Croft, a geographical area and its residential community

[10] I have chosen not to reproduce that image here. If readers wish to see it they can do so through the citation for the original source, which is available through Open Access.

in nineteenth-century Sheffield, in England (Rajic and Howarth 2021).[11] It is stories like these that bring us together as people. And the stories can become increasingly close if we decide to research our own stories to see how we align with these broader cultural narratives. I am reminded of the diversity and breadth of humanity almost every day when I receive yet another email from MyHeritage about new DNA matches. These messages are all the same and I have become immune, but the first ones I received caused excitement, telling me that [full name redacted, but let us call him Timur] has 0.4 per cent shared DNA suggesting that he is a third—fifth cousin. Every time I wonder: how many stories connect (in this case) Timur and me?[12] Knowing these stories will not change the world, or improve the planet in any significant way, except that it makes me feel good to know Timur is out there and that we (may) have a connection. The thought brings me joy and it makes me think about connections and about history. This relates to well-being which forms part of the subject matter in Chapter 4.

The impact of storytelling can hold even greater potential at a communal level, with stories from the past having the capacity to inspire, educate, enliven, and entertain via screen or print media. It can transport people from their perhaps troubled, stressful, or difficult lives to another place and time, much like a good novel or a movie, except of course this is real—archaeology presents stories of events that really happened (or are interpreted to have happened), to real people at some point in the past. This is partly why millions of people tune into television programmes about archaeology and read popular accounts of the subject, enthralled at the forensic forms of investigation and the facts and interpretations they can reveal. Once again, it makes people think, and that often helps to make them happy.

So there are clear benefits to be gained from reading and learning about the past as it is revealed through archaeological investigations. This process of investigation has been taking place for several centuries, yet the combination of scientific developments, presenting ever more complex and detailed stories, with broadcast and social media with their capacity to disseminate those stories to both global as well as diverse local audiences, has widened archaeology's reach immeasurably.[13]

But what about the *practice* of archaeology? For those given the opportunity to actively take part, whether in an excavation or some aspect of citizen science or even local history or genealogy—what are the benefits people can expect to gain from such forms of cultural participation?

[11] A previous example of this original approach to publication described the archaeology of homelessness in contemporary Bristol (Brate and Kiddey 2015).
[12] And I do recognize, of course, the problems and the challenges associated with online ancestry.
[13] Much archaeological work in the United Kingdom is undertaken through developer funding, in advance of infrastructure projects for example. Recent research has been conducted into the public benefit of this developer-led archaeology, notably Fredheim and Watson 2023 and Watson 2021.

The Benefits of Participation

I am always struck by those research projects that demonstrate through rigorous and large-scale surveys whose results are subject to detailed statistical analyses, that people gain physical and mental health benefits from various forms of cultural engagement. A study undertaken in Norway, for example, demonstrated a positive correlation between cultural participation and longevity (Løkken et al. 2020, 624), one aspect of the results being summarized as follows: 'Frequently attending at least one cultural activity influenced longevity. Creative activities lowered mortality in both genders, while receptive activity benefits were mostly found for men. Thus, promoting and facilitating engaged cultural lifestyles are vital for longevity.'

This is one of many such studies to reach similar conclusions. It seems obvious to say that archaeology should perform well in the list of beneficial cultural activities, and we will examine this question in some depth in Chapter 4. But here, to pre-empt that deeper discussion, I offer a short overview of some examples that demonstrate such positive benefits and which therefore emphasize ways that archaeology (incorporating heritage participation) can support people's health and well-being, beyond the cognitive benefits of simply knowing about the past or enjoying the colourful stories that archaeology has the capacity to generate.

I begin with the many and diverse objects that exist within museum collections. Handling such objects combines the joy and privilege[14] of tactile engagement with often rare and ancient objects and the comfort of encountering what are often also very familiar items (cooking pots, cups, tools), with the cognitive benefits to be gained from thinking about them: what makes these ancient objects similar to, or different from, modern equivalents; what memories does the handling of such familiar objects evoke; and what images of their past lives does our imagination conjure up? Such creative thinking can only be a good thing. That certainly seems to be the consensus. As Camic and Chatterjee (2013, 68) describe:

> It is argued that when people interact with museums and their collections, the objects' material, physical and intrinsic properties trigger a variety of emotional and sensory responses, cognitive associations, memories and projections. Such encounters can lead to a process of symbolisation, and elicit ideas and meaning-making opportunities. Meaning making has emerged from other studies of museum interventions while other researchers have drawn upon the psychoanalytic conception of transitional objects to explore how museum objects can offer an 'intermediate area of experience' between the self and [the] object, where the [museum] object becomes an externalised representation of unconscious wishes and desires.

[14] As people often describe it.

Museum objects can therefore carry people beyond their routine everyday experience, which might entail loneliness or depression. Camic and Chatterjee (ibid.) also cite others in making similar claims to those supported by their own research, noting as an example that:

> Mack (2003) has described objects as 'containers of memory' and several [other] authors have noted that museum objects trigger memories in ways that other information bearing materials do not. For this reason many museums offer reminiscence and memory activities, and evidence suggests that these activities can affect mood, ideas of self-worth and general sense of well-being.

Therefore, long after their original use, the objects retrieved by excavation retain the capacity to inspire, to enliven, and to enhance people's lives.

But what about the processes involved in recovering such objects: what does participation in the archaeological fieldwork required to retrieve these objects do for our physical and mental health? Considering just one element of the retrieval processes, excavation, as an example of what archaeology can achieve, I will focus on some universal aspects of the experience of that process, whether it is situated in an urban or a rural setting. Those aspects of excavation are: physical exertion, cognitive function, and the connection with soil.

The first two of these aspects (physical exertion and cognitive function) can be closely aligned as you will know if you are either a gardener or an archaeologist, or perhaps both. In the context of a garden or an archaeological excavation, people will expect to exert themselves physically, while thinking deeply about what they are doing (as discussed below, and in Chapter 4). Equally, the argument around physical health and exercise is well documented and long standing. Over 2,500 years ago, for example, Hippocrates outlined the health benefits of daily exercise in the form of a simple walk. More recently (and since the earliest research undertaken and described for example by Morris et al. 1953), Kokkinos (2012, 1) described how 'the plethora of epidemiologic evidence accumulated supports unequivocally an inverse, independent, and graded association between physical activity, health, and cardiovascular and overall mortality in apparently healthy individuals and in patients with documented cardiovascular disease'.

So, being physically active is good for us. To give a specific and comparative example of how this principle might apply to field archaeology, analysis of the benefits of gardening (as a closely comparable activity to field archaeology) for people's health was published by Soga, Gaston and Yamaura (2017), based on twenty-two separate research studies published since 2001 from across a variety of countries and involving variable gender and age groups. From examining these various studies, the authors concluded, unequivocally, that 'a regular dose of gardening can improve public health' (2017, 92).

Soga, Gaston and Yamaura go on to summarize their argument by highlighting some specific conclusions, again from previous studies, including the facts that

> daily contact with nature has a long-lasting and deep impact on health, including on depression and anxiety symptoms (Beyer et al. 2014), birth weight (Dadvand et al. 2012), diabetes, and obesity (Lachowycz and Jones 2011), circulatory and heart disease (Maas et al. 2009), and longevity (Takano et al. 2002). It is therefore increasingly recognized that a regular contact with nature can promote human health and be used as a form of preventive medicine (Groenewegen et al. 2006).

Much archaeological excavation happens within cities. But nature also exists within these urban settings, meaning that these urban excavations can also provide the same health benefits for participants. Urban parks are often referred to as 'green lungs' for related reasons.[15]

The health outcomes reported by the authors of the twenty-two individual studies into gardening summarized and examined together by Soga, Cox and Yamaura et al. (2017) included positive impacts on depression, anxiety, stress, vigour, sociability, self-esteem, anger, and body mass index, to name a few. As we will see in Chapter 4, some of the same benefits are gained from studies undertaken of people involved in excavation, as one might expect for two activities that are closely comparable in terms of those two key elements: physical exertion and cognitive function, not to mention (at least in the case of allotment gardening) sociability.

As a related aside, I have heard it said by many prospective archaeology students contemplating degrees in history or archaeology, that they favoured the former because 'they don't like to get their hands dirty'. But what is dirt, precisely? I follow the arguments of Mary Douglas, best articulated in her seminal *Purity and Danger* (2002 [1966]). She gives the example of shoes which in themselves are not dirty but become so when placed on a dining table (an example I return to in Chapter 3). She puts it like this: 'Our pollution behaviour is the reaction which condemns any object or idea likely to confuse or contradict cherished classifications' (2002, 45). By Mary Douglas's argument, soil on an excavation site isn't dirt—it is supposed to be there; in the ground, comprising the ground.[16] And as archaeologists we are also meant to be there, working with and through that soil. The soil in fact is evidence—think of any drawn stratigraphic sequence, with the strata distinguished by subtle changes in colour, determined by reference to the Munsell Soil Colour Chart, with each colour determined through variables

[15] However, a decrease in contact with nature can cause what Soga, Gaston and Yamaura. (2017, 93) refer to as a nature-deficit disorder.

[16] In fact, archaeologists are often excavating sediments not soils, the distinction being that one is deposited and the other is in its natural or original place.

including hue, value, and chroma. And those soil-covered objects that we retrieve from the excavation trenches are also meant to be there, although sometimes their occurrence can be surprising. Soil isn't just soil therefore, and it certainly isn't dirt. It is evidence.

So all is well with dirt.[17]

But I will go further.[18] Evidence suggests that, for the benefit of our health, we should in fact spend *more* time playing or digging in the soil. Lowry et al. (2007) have conducted research which stemmed from reports that cancer patients treated with the soil-derived bacterium *Mycobacterium vaccae* had reported increases in their quality of life. Paddock (2007) summarizes this research:

> *Mycobacterium vaccae* is a friendly bacterium which, when tested on mice, did activate a particular group of the brain neurons that produce serotonin, which is found in the gut, brain, nerves and blood of humans and other animals. Serotonin constricts blood vessels, sends messages between cells in the brain and within the central nervous system, regulates secretion of digestive juices, and helps to control the passage of food through the gut.... Different parts of the brain and the body need different levels of serotonin. In the brain for example, the hypothalamus (involved in mood regulation) needs a lot of serotonin while the cortex (involved in many complex processes like thinking, memory, attention, awareness and consciousness) only needs a little. The brain keeps serotonin levels in balance using at least three mechanisms. One way is by releasing it, a second way is by inactivating it once it is released into the synaptic space between the nerve endings, and the third way is by absorbing it, a process known as 'reuptake'. Low levels of serotonin are linked with a number of disorders including aggression, anxiety, depression, obsessive compulsive disorder, bipolar disorder, irritable bowel and fibromyalgia. The friendly bacteria in this study appear to be having an antidepressant effect by increasing the release of serotonin.

To summarize all of this, archaeology can be a bit like gardening. It is a sociable activity and one that involves both physical exertion and cognitive function. Furthermore, it typically involves being outdoors with direct and regular physical contact with soil. It is also a subject that explores and reflects upon humanity. It addresses big questions by focusing on people and how communities have responded to and shaped the world over the past two million or so years. This combination of scope and benefits is unrivalled for our physical and mental health, and for planetary health, topics I return to later in the book.

[17] I will remember to use this argument next time a student tells me they like to keep their hands clean as an argument for not studying archaeology!
[18] If the student is still listening.

Archaeology therefore has impact, which I will turn to in the book's conclusion.[19] For now, I present this brief summary of the benefits of archaeology and the contributions it can make, by way of a contextual framework for the next section of this Introduction, a section in which I will define what is meant by wicked problems, the main subject of this book. This brief contextual introduction will hopefully provide some grounds for starting to think through ways that archaeology might contribute to creating the solutions needed to help resolve wicked problems.

The Moon and the Ghetto (or: Wicked Problems for Archaeologists)

In 1977, Richard Nelson, an economics professor at Yale University, wrote a book called *The Moon and the Ghetto* (a concept he revisited in Nelson 2011).[20] The opening few sentences of the book appeared at the top of this chapter, but I will repeat them here:

> 'If we can land a man on the moon, why can't we solve the problems of the ghetto?' The question stands as a metaphor for a variety of complaints about the uneven performance of the American political economy. In an economy with such vast resources and powerful technologies, why can't we provide medical care at a reasonable cost to all who need it, keep the streets, air, and water clean, keep down crime, educate ghetto kids, provide decent and low-cost mass transport, halt the rise in housing and services costs, have reliable television and automobile repair service?
>
> In part the moon-ghetto metaphor is about income distribution but there is much more to it than that. (Nelson 1977, 13)

Perhaps surprisingly, Nelson's arguments built around the moon-ghetto metaphor do not refer explicitly to wicked problems, even though what he described in his opening paragraphs are precisely that, and given that the language of wicked problems had emerged four years previously, in Rittel and Webber's (1973) seminal 'Dilemmas in a General Theory of Planning'.[21] This is a publication

[19] But for now, for many examples of impact evident in research across archaeology departments at British universities, see https://results2021.ref.ac.uk/impact and search on 'Sub-panel 15 Archaeology'.

[20] The 'ghetto' concept and label are now deeply problematic as a racialized term that is widely avoided. But I use it here as it does feature regularly within wicked problems literature in the context of this same specific metaphor that Richard Nelson first adopted. There is also an obvious gender issue with the other part of this metaphor, relating to a man on the moon!

[21] Ironically, in a research programme funded by NASA. I will say more about this later.

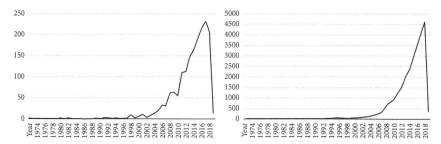

Figure 1.1 Number of papers (left) and citations (right) per year identified through a Scopus search on 'wicked problem' in January 2020
Note: Graphs show the period 1974 to 2018. (After Lönngren and Poeck 2021, 481)

Nelson would certainly have been aware of, yet he didn't cite it in the book or in the earlier essays from which it derived.

Even though Nelson didn't use the term 'wicked problems', it is one that has lasted, and in fact has grown exponentially in popularity, albeit with some refinement and subdivision. In one of a number of review papers (see also Danken et al. 2016; Head 2019; Turnbull and Hoppe 2019), Lönngren and Poeck (2021, 481) describe how, 'for the years 1973–2001, a Scopus search (conducted in January 2020) on "wicked problem" returns less than 10 papers per year; by 2017, this number has increased to over 200 papers yearly. The number of citations for papers mentioning "wicked problem" has also grown approximately exponentially' (see Figure 1.1).

In this section, and given what we now understand of the benefits of archaeology, in terms of both knowledge gain and the health improvements to be achieved in obtaining that knowledge, I will use the moon-ghetto metaphor as the basis for summarizing some key references from an extensive wicked problems literature, citing some of the more significant sources and identifying leading arguments. Where this literature refers to specific examples, their discussion will follow in the thematic chapters. This discussion of the concept of wicked problems therefore provides the foundation for the chapters that follow, being mostly case-study oriented thematic chapters that examine ways that archaeology (alongside the related area of heritage practice, whereby those traces of a human past are either managed in some way or presented for public engagement or enjoyment) might contribute to the mitigation of these challenging and vital problems. We begin by exploring how the concept of wicked problems, and the term, came about.

Origin Story

Let us begin then with the 'origin story'. When and how did the concept of wicked problems first emerge, and why? There is no doubt that the origination of this

influential idea stems from a collaboration in the later 1960s involving Horst Rittel, a mathematician and professor of the science of design, and Mel Webber, a professor of city planning, both of the University of California, Berkeley. And here we return to the moon and the ghetto. With the prospect of a moon landing alongside urban revolt in cities across the United States, West Churchman, a scholar at the same university at that same time, received a research grant from NASA to explore ways in which technologies being adopted for the US space programme could be translated to the very different context of urban problems (this situation is described by Skaburskis 2008, 277; and see for example Churchman 1968). To help him explore this possibility, Churchman established a weekly seminar series which Rittel attended. At one such seminar Rittel presented his list of differences between social and scientific or technical problems, outlining the 'ten attributes' that later appeared (adjusted and summarized) in Rittel and Webber's seminal (1973) paper.[22] Skaburskis describes what happened at the end of the seminar: Churchman responded to Rittel's presentation by stating: 'Hmm, those sound like "wicked problems".' From which statement a new field of study emerged. Churchman himself wrote a short editorial outlining the event, soon after its occurrence. In his short report Churchman described how Rittel had

> suggested... that the term 'wicked problem' refers to that class of social system problems which are ill-formulated, where the information is confusing, where there are many clients and decision makers with conflicting values, and where the ramifications in the whole system are thoroughly confusing. The adjective 'wicked' is supposed to describe the mischievous and even evil quality of these problems, where proposed 'solutions' often turn out to be worse than the symptoms'. (1967, B-141)

In presenting their 'ten distinguishing properties' of wicked problems (specifically in this case what they refer to as 'planning-type problems'), Rittel and Webber (1973, 160–161) explained in their own words how they used the term 'wicked': 'not because these properties are themselves ethically deplorable. We use the term "wicked" in a meaning akin to that of "malignant" (in contrast to "benign") or "vicious" (like a circle) or "tricky" (like a leprechaun) or "aggressive" (like a lion, in contrast to the docility of a lamb).'

They go on:

> We do not mean to personify these properties of social systems by implying malicious intent. But then, you may agree that it becomes morally objectionable

[22] Noting that the concept's initial publication was a year earlier (Rittel 1972).

for the planner to treat a wicked problem as though it were a tame one, or to tame a wicked problem prematurely, or to refuse to recognize the inherent wickedness of social problems.

These observations are then followed by the ten distinguishing properties, listed and summarized here:

1. There is no definite formulation of wicked problems.
2. Wicked problems have no stopping rule.
3. Solutions to wicked problems are not true or false, but good or bad.
4. There is no immediate or ultimate test for solutions.
5. All attempts to solutions have effects that may not be reversible.
6. Wicked problems have no clear solution, and perhaps not even a set of possible solutions.
7. Every wicked problem is essentially unique.
8. Every wicked problem may be a symptom of another problem.
9. There are multiple explanations for the wicked problem.
10. The planner (or policymaker) has no right to be wrong.

And while these properties are not definitive (Peters [2017, 388] for example, suggested that we should add to this list that they involve multiple actors and are socially and politically complex), they do at least provide a helpful framework for understanding wicked problems and positioning them, not least within an ever-shifting social context (Rittel and Webber 1973, 168). It is also important to recognize that not every situation will be the same, and not every place or community will experience the same degree of wickedness. There will also be changes to the nature of the problem and to the possible range of solutions over time. Although obvious, the first of these is worth highlighting, on how different communities will vary in their experience of wickedness, recognizing that, 'diverse values are held by different groups of individuals—that what satisfies one may be abhorrent to another, that what comprises problem-solution for one is problem-generation for another...and there is no gainsaying which group is right and which should have its ends served' (1973, 169).

This brings Rittel and Webber briefly to the role of the 'wise and knowledgeable professional expert' (1973, 169), something I have written about previously (Schofield 2014). As they say, whether one finds this concept ethically tolerable or not, wicked problems present such experts with a very particular set of challenges. Their argument is that, resorting to experts

> only begs the question, for there are no value-free, true-false answers to any of the wicked problems governments must deal with. To substitute expert professional judgement for those of contending political groups may make the rationales and

the repercussions more explicit, but it would not necessarily make the outcomes better. (Rittel and Weber 1973, 169)

In attending another seminar by Horst Rittel in 1969, Skaburskis (2008, 279) wrote in his lecture notes: 'While people dream, there will be problems. Having complex and "wicked" problems is a sign of progress.' Equally inevitable, it would seem, are the significant challenges of managing and mitigating those problems, and who holds the responsibility for doing so.

Defining Wicked Problems

But we should pause at this point to review more precisely what we mean by wicked problems. Perhaps unsurprisingly, there are several albeit subtle variations on how the term has been used. There are also many alternatives to be aware of.

Returning to the original source, Rittel and Webber (1973) present their 'ten distinguishing properties' (listed above) which remain helpful but are perhaps partly now overtaken both by events (e.g. the massive increase in marine pollution since 1973) and by the way sciences and the humanities (or scientific and 'planning problems', as they put it) now relate to one another, overlapping and integrated and no longer clearly separate. We have also seen massive information technological developments since 1973 (notably the Internet) and the ending of the Cold War with its binary politics, creating a whole new set of political challenges in Eastern Europe and the Middle East, for example. Perhaps more helpful now (and more contemporary, I would suggest) are some of those more recently published summaries of the concept and its application. Alford and Head (2017, 397) open their 'typology and contingency framework' paper, for example, by defining wicked problems simply as 'those that are complex, intractable, open-ended, unpredictable', providing a helpful, tight summary definition. Equally, Conklin's (2006, 14–16) descriptive (and shorter) list of characteristics provides a clear overview of what is now meant by wicked problems. These characteristics are repeated here, further summarized from the original:

1. You don't understand the problem until you have developed a solution. Every solution offered exposes new aspects of the problem, requiring further adjustments of the potential solutions. Indeed, there is no definitive statement of 'the problem'. The problem is ill structured, an evolving set of interlocking issues and constraints.
2. Wicked problems have no stopping rule. Since there is no definitive 'the problem', there is also no definitive 'the solution'. The problem-solving process ends when you run out of resources such as time, money, or energy, not when some optimal solution emerges. As Conklin further stated on this

characteristic: 'Herb Simon (1973), Nobel Laureate in economics, called this "satisficing"—stopping when you have a solution that is good enough.' Thus,

3. solutions to wicked problems are not right or wrong—they are simply 'better', 'worse', 'good enough', or 'not good enough'. With wicked problems, the determination of solution quality is not objective and cannot be derived from following a formula. Solutions are assessed in a social context in which many parties are equally equipped, interested, and/or entitled to judge them, and these judgements are likely to vary wildly and depend on the stakeholder's independent values and goals.
4. Every wicked problem is essentially unique and novel. There are so many factors and conditions, all embedded in a dynamic social context, that no two wicked problems are alike, and the solutions to them will always be custom designed and fitted. Over time, one acquires wisdom and experience about the approach to wicked problems, but one is always a beginner in the specifics of a new wicked problem.
5. Every solution to a wicked problem is a one-shot operation. Every attempt has consequences. This is the 'Catch 22' about wicked problems. You cannot learn about the problem without trying solutions, yet every solution you try is expensive and has lasting unintended consequences which may spawn new wicked problems.
6. Wicked problems have no given alternative solutions. There may be no solutions, or there may be a host of potential solutions, or there may be a host of problems that have never been thought of. Thus, it is a matter of creativity to devise potential solutions and a matter of judgement to determine which are valid, and which should be pursued and implemented.

While all of these six characteristics defined by Conklin (2006) are themselves a summary and reworking of the original ten defined by Rittel and Webber (1973), the last, with its emphasis on creativity, was the most prominent in my realizing that archaeology might have a role in this arena. While the first five characteristics have helped to determine which topics (or wicked problems) this book should address, the last would determine how, within the realms of the related fields of both archaeology and heritage studies, we might be more creative in using our specialism to help find potential solutions and then to judge which merit support and funding.

But let us conclude unravelling the definition of wicked problems. Danken et al. (2016), in tightening the definition still further, with a focus on just three core characteristics or 'attributes' (non-resolvability, multi-actor involvement, and the challenge of problem definition) emphasize the importance of cross-boundary collaboration and leadership if there is to be any chance of success in resolving these problems. Leadership related to wicked problems has been subject to

investigations by leadership scholar Keith Grint (2008, 2010a), whose work I shall return to in the book's Conclusion.

For comparison at this point, I will provide a definition of the corollary of wicked problems: the more straightforward and thus more easily resolved 'tame problems'. These are helpfully defined by Conklin (2006, 18–19) as those which

1. Have a well-defined and stable problem statement.
2. Have a definite stopping point, i.e. when the solution is reached.
3. Have a solution that can be objectively evaluated as right or wrong.
4. Belong to a class of similar problems that are solved in a similar way.
5. Have solutions that can be easily tried and abandoned.
6. Come with a limited set of alternative solutions.

A tame problem is not necessarily simple and can be highly complex, not least in terms of the technical skills required to solve it. But it is not in any sense 'wicked'. Thus repairing a computer or IT system is a tame problem. Ensuring that trains run on time to a timetable is another example. Creating a teaching timetable for a university might be yet another. By contrast, resolving marine plastic pollution is a wicked problem. As is global warming. Returning to our example of the moon landing and the ghetto (after Conklin 2006, 19), putting somebody on the moon and getting them back safely to earth was a highly technical and complex task. But, although it had some wicked elements, it was largely a tame problem to resolve. The problem statement was clear. There was a point at which it could be said the mission had been successful. And the solution too could be clearly evaluated as having been a success. Resolving poverty and unrest within urban neighbourhoods, however, was then, and remains, a wicked problem.

We should not let this discussion pass without referring to some critical engagement with the concept, beyond the simple suggestion made earlier that the initial definition was now, in some ways, outdated. As Lønngren and van Poeck (2021, 482) have suggested, wicked problems have also been criticized for being used as a rhetorical (as opposed to an analytical) concept to support certain political agendas, either drawing attention and resources to a specific problem, or excusing failure to adequately address the problem (e.g. Peters 2017; Turnbull and Hoppe 2019). Lønngren and van Poeck (2021, 482) also highlight another criticism levelled at the concept: 'that describing problems as "wicked" may lead to paralysis and discourage stakeholders from attempting to address these problems'.

In a more recent analysis, Guy Peters (2017) reviews the use (or abuse) of the concept of wicked problems. In this analysis he first recognizes how the concept has evolved, noting the usefulness of a conceptual stretching of the definition which he describes as characterizing much of the recent wicked problems

literature, taking it beyond the original definition which restricted the concept to complex policy problems facing governments. Second, and on a related point, he describes how many ordinary policy problems can have attributes often used to characterize wicked problems. Typically it is the lack of a clearly defined solution that renders the problem 'wicked', requiring experimental as opposed to planned solutions. Equally, he notes that some more obvious examples of wicked problems do not meet all of the usual criteria. Third and finally, Peters questions the normative element that has crept into wicked problems literature and thinking: that wicked problems can and must be solved through forceful action and the developing of suitable policies. The reality of course, given the nature of wicked problems, is that they cannot be solved in any final or definitive manner (2017, 386).

Examples of such irresolvable wicked problems form the subjects of subsequent thematic chapters, noting close alignment between these and the 17 Sustainable Development Goals (Figure 1.2) listed in the United Nations Agenda for Sustainable Development (United Nations Assembly 2016), this Agenda being a 'blueprint for global development, which represents a fundamental shift in thinking, explicitly acknowledging the interconnectedness of prosperous business, a thriving society and a healthy environment' (Stibbe et al. 2019, 6). These Sustainable Development Goals are themselves an evolution of the earlier Millennium Development Goals. Crucially, the former promoted 'treating

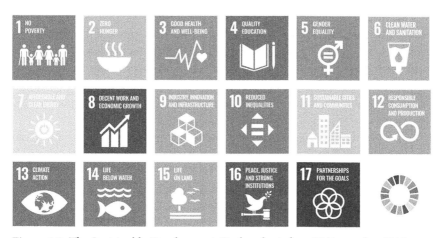

Figure 1.2 The Sustainable Development Goals, adopted on 25 September 2015 as a part of the 2030 Agenda

Source: Available via https://commons.wikimedia.org/wiki/File:Sustainable_Development_Goals.svg

symptoms over addressing underlying issues' while the latter favoured underlying and systemic issues over symptoms (Stibbe et al. 2019, 6). Further, the Millennium Development Goals relied on a top-down, government-delivered, and siloed approach while the Sustainable Development Goals emphasized bottom-up ideas (2019, 6)

But hold those thoughts! It may be that some of the wicked problems that have been referred to already as examples and which feature as chapters in this book, are not wicked at all, but come under the heading of 'super wicked problems' (after Lazarus 2009; Levin et al. 2012), where additionally

1. time is running out;
2. there is no central authority, or only a weak authority, to manage the problem;
3. the same actors causing the problem are required to help solve it; and
4. the future is discounted radically so that contemporary solutions become less valuable.

As Peters states, of these characteristics, the time element is critical at least for some of the more serious (or super) wicked problems such as climate change or pollution (which are related, as we shall see in Chapter 5,) where irreversible harm will be the outcome if significant policy interventions are not made, and quickly. Time is also relevant in the sense that many wicked (and all super wicked) problems are long-term and large-scale. As Peters (ibid., 389) points out, however, public-sector decision-making is not good at dealing with long-term challenges, especially in democratic regimes where changes in government often also mean changes in emphasis related to policy.

This suggestion of a greater complexity within the definition of wicked problems is discussed further by Alford and Head (2017), who present them as existing within a typology of problems. Recognizing the difficulties involved with creating such a typology, theirs is an approach which focuses on what they refer to as 'the two irreducible elements of wicked problems: the problem itself and the actors involved', an approach that results in a 'two-dimensional matrix of possibilities' (Figure 1.3).

In explaining the usefulness of this particular framework, Alford and Head (2017, 405) state that

> it enables recognition of differing kinds of underlying causes, and therefore assists selection of more tailored ways of both comprehending and tackling them. For instance, it may emerge from an investigation of the various contributory factors that a particular problem's 'wickedness' is more attributable to the problem structure than to the qualities of the stakeholders. In short, it opens up the possibility of varying our responses to wicked problems.

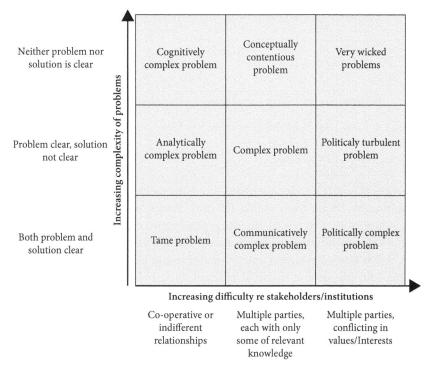

Figure 1.3 Alternative types of complex problems, from Alford and Head (2017)
Note: One axis refers to the nature of the problem, and the other to the people involved.

Finally here, Dorado et al. (2022) refer to wicked problems as one of several concepts that exist within a temporal framework of concept development culminating in what they refer to as 'grand challenges'. Through this approach the authors define the problems framework in terms of concepts, the ontologies that underpin those concepts, and the obstacles to success (Figure 1.4). Adopting George et al.'s (2016, 1881) definition, which associates grand challenges with the 'specific critical barrier(s) that, if removed, would help solve an important societal problem with a high likelihood of global impact through widespread implementation', they construct a knowledge map of the kind used by scholars often in emergent areas of research to build theoretical scaffolding (e.g. Jabareen 2004). Wicked problems are included here as one of the four concepts investigated (the others being tragedy of the commons, social problems, and metaproblems), with its ontology built around critical theory and for which the obstacle is largely related to sensemaking, whereby the framing of both problems and solutions 'affects actors' approaches' to tackling the problem (Dorado et al. 2022, 1261).

Referring to Figures 1.2 and 1.3 and the associated discussion, one gets an immediate sense of the complexity in this area of research, with myriad terms and concepts, each with their own literature and research context. There is more to be

Concepts	Tragedy of the Commons	Social Problems	Wicked Problems	Metaproblems
Ontologies	Technical Rationality	Pragmatism	Critical Theory	Complex Adaptive Systems
Obstacles	Governance	Curation	Sensemaking	Adaptation

Figure 1.4 Knowledge map of the concepts, ontologies, and obstacles that define engagement in Grand Challenges

Note: After Dorado et al. (2022, Figure 1).

said about this, and a wider discussion of related terms will follow after offering some thoughts on how one should (or can) manage wicked problems. But for now, suffice to say that among the many possibilities available, I have chosen to use the term wicked problems for two main reasons. One is the simplicity of the term; that it says and conveys exactly what it means and it is a term that draws attention for precisely its sense of inherent wickedness. The second reason is because it is a term that has a long history, and is widely used and widely known, not in archaeology necessarily but in other diverse fields of research. As we saw in Figure 1.1, its use is also growing exponentially.

These various contextual frameworks (which are simply outlined here) all raise questions of context, time, and typology that will be familiar to archaeologists. In fact, as we shall see in the thematic chapters, many of the wicked problems this book considers have a conventionally archaeological dimension to them, where archaeological evidence has shown that the problems have existed and people have attempted to resolve them in various ways in the past. And with that thought in mind, I conclude this section with another relevant concept that will be familiar to archaeologists: that of the palimpsest.[23] Turnbull and Hoppe (2019, 328) refer to this in their own critique of wicked problems, noting that not all processes introduced to help resolve wicked problems will be linear or evolutionary, or even necessarily about learning from experience. Instead they describe the picture as comprising an 'endless series of palimpsests, where newer questions and answers obscure, blur or relegate older ones to lesser importance though never completely replacing them'.

Managing Wicked Problems

I want to move from the origins and definitions of wicked problems to the ways in which we might try to manage them. We can think of this in terms of the

[23] Albeit mentioned briefly earlier in the chapter in the context of a changing landscape.

types of projects that might seek to help resolve such wicked problems, many examples of which appear in the chapters that follow. Again here we can refer to Jeff Conklin's (2006) helpful and practical *Dialogue Mapping: Building Shared Understanding of Wicked Problems*. In this, the author refers to 'opportunity-driven problem solving'. Logically and typically (for tame problems), one begins by understanding the problem one seeks to address, which will likely include gathering and analysing data. Once the problem is specified and the requirements are clear, a project that seeks to find a solution to that problem can be formulated and eventually (and hopefully successfully) implemented. This approach is referred to as the 'Waterfall Model', with the problem flowing down the steps to completion. It is a model and a process to problem solving that is widely understood. Conklin (2006, 9) states that, 'the more complex the problem is, the more important it is to follow this orderly flow' (see Figure 1.5).

However, wicked problems will rarely if ever follow such a smooth course to a successful resolution. Those seeking a solution may begin by focusing on trying to understand the problem, before jumping straight back into formulating potential solutions. Then they'd go back to refining the understanding of the problem and so forth, many and multiple times. Therefore, as Conklin (2006, 9) puts it, 'rather than being orderly and linear, the line plotting the course of thinking looks more like a seismograph for a major earthquake' (Figure 1.5). This Conklin refers to as the 'jagged-line pattern' and is opportunity driven, because 'in each moment the designers are seeking the best opportunity for progress towards a solution' (2006, 10). This pattern does not reflect inefficiency or indecision. Rather, those problem-solvers working with such complex problems are being creative and learning quickly, ensuring that their 'thinking pattern is full of unpredictable

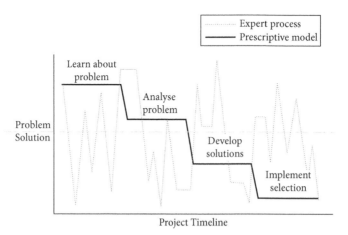

Figure 1.5 The Prescriptive or 'Waterfall' Model (solid line) and the more jagged line of the 'Seismograph' Model
Note: After Moraes et al. (2021, derived from Conklin 2006).

leaps' (Conklin 2006, 11). Vitally, '"wandering all over" is not a mark of stupidity or lack of training. This nonlinear process is not a defect, but rather a mark of an intelligent and creative learning process' (Conklin 2006, 12).

This jagged line of opportunity-driven problem-solving thus characterizes a realm of learning in which the more novel (and wicked) the problem, the more learning is required. As Conklin explains (2006, 12): the waterfall is a picture of 'already knowing'. With wicked problems we are in the realm of *learning*. This point is also highlighted by Lønngren and van Poeck (2021, 492) who refer to the multi-faceted and evocative nature of the concept as being particularly valuable for exploratory research, as it 'provides a starting point for reflection rather than a definitive terminology', recognizing the benefits of a 'conflictual, decentralized, and multi-perspectival approach to addressing wicked problems'. Moreover, they go on to state (2021, 493): 'The wicked problems concept may be particularly valuable as a sensitising/creative or critical/emancipatory tool.' This principle is also adopted by Moraes et al. (2021, 139) in which they propose the W-model, in which, 'co-evolution of the problem and solution are mandated through rapid iterations of five design phases: define, ideate, synthesize, assess and reflect. The W-model was tested on pre-college novice designers who used this framework [successfully] to solve a wicked problem.'

Looking at this from a more theoretical perspective, one suggestion made recently is through sociology, which as a discipline has been surprisingly slow to address wicked problems (as noted by Selg et al. 2022, 3). In their paper, Selg et al. present the notion of a 'missing bridge' through relational thinking and specifically through the application of processual relationalism. This way of thinking is defined by Selg et al. (2022, 1) as presuming that the relations between and among elements that define the problem are not static but rather unfolding, dynamic processes. They are also unowned processes, in the sense that no single person or group of people can have responsibility for them. One might also refer to the problems as being co-owned. As we shall see in the chapters that follow, this is true of all the wicked problems that this book explores. Selg et al. go further in viewing these relations, not as 'something external to pre-given elements but as constitutive of the very identity of those elements' (2022, 1). They present this approach in the context of the COVID-19 pandemic and health concerns more generally. But to summarize their approach:

> [Wicked problems literature] has always highlighted that wicked problems are processual and in constant flux, making analysing them in a traditional piecemeal or variable-centred manner ever more problematic and calls for analytical strategies that see them as emerging from unfolding dynamic relations. This is exactly what processual-relational sociology has proposed as a general perspective on social reality. Hence, it might seem natural to turn to relational sociology when trying to study wicked problems. (Selg et al. 2022, 21)

Having now outlined some of the ways to think about managing wicked problems, and the frameworks for doing so, for the remainder of this chapter I will first return briefly to basics and introduce a few more of the concepts central to the discussions that follow, including various other ways that wicked problems have been defined and described. I will then introduce and critically examine a term and concept that will be widely used in the chapters that follow: 'small wins'. I will then talk about the potential role of archaeologists as 'policy entrepreneurs', acting as influencers, champions, or advocates, to use a more conventional terminology. Together, these final two sections provide further essential foundations for the thematic chapters that follow.

Complexity, Turbulence, and Mess

Complexity, turbulence, and mess are just some of the terms used to describe concepts and issues not dissimilar to the idea of wicked problems. As was described earlier, there are other terms too. Guy Peters (2017, 389), for example, describes how Herbert Simon (1973) defined 'ill-structured problems' at around the same time Rittel and Webber were publishing what was to become their highly influential (1973) 'wicked problems' paper. In comparison to Rittel and Webber, Simon's focus was in defining the problem, highlighting its independence from other problems, and the need for knowledge to help address that problem. As Simon argued, understanding will not necessarily solve the problem; but solving the problem will be impossible without it. And this then relates to policy and design. As Peters (2017) states in summary, 'ill-structured policy problems, like wicked problems, are difficult for policy makers to manage effectively and perhaps in particular defy the development of simple designs for policy'.

This 'mess' (or whatever we choose to call it) aligns closely with the idea that we live in postnormal times (PNT) in which postnormal science (PNS) provides a response to challenges of policy issues of risk and the environment during the epoch through which we are living. Where system uncertainties and decision stakes are high, traditional methodologies are generally ineffective. That is always true with wicked problems. In such cases, Funtowicz and Ravetz support the notion of a PNS, being a, 'model for scientific argument...not (as) a formalised deduction, but an interactive dialogue...involv[ing] broader societal and cultural institutions [including] persons directly affected by a [policy] problem' (Funtowicz and Ravetz, cited in Weber et al. 2017, 5).

Further, Ziauddin Sardar refers to 'postnormal times' (PNT) (2010; 2015)[24] as an era in which, 'complexity, chaos and contradictions will become the dominant

[24] And here Sardar uses the word 'postnormal' unhyphenated, as I have chosen to do except when citing others who take a different view.

themes; and uncertainty and ignorance will increase drastically' (2015, 26). As Sardar points out, PNT offers a universally relevant theoretical framework to help describe and explain our epoch. Such a framework would seem a good fit for helping to frame the problems that we face, yet it is not without criticism. Rakesh Kapoor (2011) for example argues that PNT is a Western theory. Sardar disagrees (2015, 27, citing Sardar 2013), stating that:

> To talk about a neat division between East and West in a globalised, diverse, interdependent world of common problems and shared human destiny is dangerous and absurd. The boundaries and dividing lines of East and West have not only changed but have become blurred and indistinguishable. There is as much East in the West as there is West in the East. The West cannot continue to perceive the East as inalienably different; the classic tirade against the West that promotes the innocence and vaunts the superiority of the East is meaningless. The potency of the ideas that impelled Western imperialism is alive and well and operated by the East within itself, by itself.

But of course, as Sardar goes on to acknowledge, citing Kapoor (2015, 27):

> The world looks very different from the vantage point of a person sitting in New Delhi, or other parts of Asia, such as China and Vietnam. The countries of 'emerging markets' have not enjoyed the level of development enjoyed by the Western industrialised countries. But 'the world' is also a deeply interconnected, globalised system. The subsystems of such a planetary system cannot escape the effects of what happens elsewhere in the system.

To reinforce the alignment between PNT and wicked problems, Sardar lists and discusses in some depth examples that I cover in this book, notably: climate change (or 'climate chaos' in Sardar's terms), health and medical systems, and the social landscape. In summarizing the argument and his examples, Sardar (2015, 37) also highlights two other points of obvious synergy. One is the observation that 'we cannot manage and control postnormal times, but we can navigate through them'. And second, 'the fact that the multitude of problems we face simultaneously cannot be solved in isolation.' He goes on:

> When you look at a problem you also have to look at all the other problems it is connected with and to. As Jordi Serra notes, the linear cause and affect relationships do not hold anymore: 'action on just one element is not only futile but often also quite dangerous. Action on A triggers myriads of reactions in B, C, D all the way to Z; and many of these reactions can acquire chaotic proportions at lightning speed' (Serra 2014). Moreover, given that these problems are complex and are embedded in a complex environment, their solutions cannot be simple.

A major principle of survival in a complex environment is that the mechanism that deals with it must itself be complex—what is known as Ashby's Law of Requisite Variety (Ashby 1956). The larger the variety of actions available to a system, the larger the variety of perturbations it is able to compensate: or to put it in other words, *only variety can cope with variety*. Thus, plurality, diversity and multiple perspectives are essential for understanding and steering through postnormal conditions. (My emphasis; citations in original)

Thinking about Sardar's (e.g. 2010, 2015) repeated use of the term 'chaos' and recalling also the notion of clumsy solutions (e.g. Dugmore et al. 2013), Emery Roe (2013) spoke similarly about 'mess', emphasizing that policy messes cannot be cleaned up or avoided; rather they need to be managed. Equally, Christopher Ansell writes about turbulence (e.g. Ansell et al. 2021), a scenario characterized by uncertainty and the fast pace of change and development, requiring robust solutions. All three are helpful frames of reference. Also helpful in providing overview of the use of alternative concepts and terminology, are the outcomes of various literature reviews, including some I referred to previously, and the degree to which they describe wicked problems as being associated with these alternative concepts. The review undertaken most recently, by Lønngren and van Poeck (2021), for example, highlights some clear trends and a direction of travel. The trends are for wicked problems as a concept, to be mostly associated with the terms 'intractable problems', 'complex problems', 'wicked issues', 'ill-defined problems', 'messy problems', and 'messes'. The direction of travel appears to show a growing association with the term 'complex'. We have already seen the move towards the notion of grand challenges (after Dorado et al. 2022).

The complexity and persistence of wicked problems provide a justification for using networks and specifically policy network theory to help address them. As van Bueren et al. (2003) pointed out, this area of theory had already received attention over the preceding decade. They define policy network theory as a

framework for analysing the strategic and institutional complexity of problem solving and decision making. Wicked problems are dealt with in policy games: processes in which actors try to get a grip on the uncertainties that characterise these issues. In doing so, the actors involved are dependent upon each other. The resources necessary to tackle the problem are scattered across different parties. As long as there is no shared perception of the content of the problem, it is difficult to be sure about the strategies other parties will develop, and it will also be difficult to decide upon one's own course of action. From this perspective, dealing with wicked problems is—to a large extent—a problem of interaction. On this point, the traditional approaches to wicked problems fall short. More research cannot solve differences in perceptions of the problem and its possible solutions, and it cannot prevent research and its results from being ambiguous

and contested. Decisions based on limited and contested information will provoke strong reactions from stakeholders and will polarise decision making. The strategy of risk avoidance and learning by doing is often unacceptable in the face of the nature of the risks that urge governments to take more than small steps.

That is a long quotation, but I have included it here as it is important to recognize the tension between what governments might see as easy fixes and the true complexity of the problem, and how networks provide the opportunity to bridge this gap. The authors provide an example, being the (then) ongoing Zinc Debate in the Netherlands, a dispute between policy makers, water managers, architects, industrialists, researchers, and consultants about the environmental impact of emissions from zinc products, and how best to address this problem, reminiscent—as the participants see it—of many of the characteristics of wicked problems. We can skip over the details (for which, see van Bueren et al. 2003) and cut to the summary which identifies the three networks of the Zinc Debate (housing, water, and environment), each with its own agenda, organizations, etc., and five policy 'arenas' in which the industry's interests were at stake. One reason for highlighting this example is to help emphasize the complexity in a relatively straightforward (by which I mean clearly demarcated) situation. The other reason is to illustrate the opportunities present within the policy landscape through networking and collaboration.[25] The network perspective allows for some dilution of the complexity of wicked problems, clarifying their nature and character, for example, and highlighting the issue of dependency. As van Bueren et al. state (2003, 211):

Actors are dependent in the sense that their actions influence other actors' interests, and solving the problem usually requires the joint action of various actors. But these interdependencies are often very complex and not easily visible... Even if the actors do acknowledge their interdependency, they find it difficult to engage in joint action. Institutional barriers, cognitive differences, and the dynamics of the interactions themselves can block joint action and the undertaking of necessary network management strategies. In this sense, using a network perspective not only highlights the characteristics of the decision situation in which actors perform but also makes the blockage and problems of joint action visible for them. It shows that doing more research will not solve the perception differences about the starting points and value of that research. In addition, it shows that in most cases, unilateral action will not result in satisfactory outcomes. The case demonstrates that breakthroughs in the joint action problem are possible but require much effort and a clear understanding of actor positions and institutional constraints.

[25] I will return to this subject in the book's final chapter.

The Zinc Debate therefore highlights in microcosm both the challenges that characterize any attempts to resolve wicked problems, but also the opportunities that networks provide to maximize the chances of success.[26] Networks definitely help, and increasingly archaeologists are abandoning the lone-scholar model of working to operate collaboratively and collectively towards higher and more ambitious goals, as we will see in the chapters that follow. They are also working increasingly outside of their traditional disciplinary comfort zone including with those who can exert influence, in the policy arena, for example. This is defined as a transdisciplinary approach.

Weber and Khademian (2008) summarize some of the more obvious benefits of using networks over the alternative: hierarchies. For one, there is 'transfer of information across a network through the channels or relationships that connect participants'. Generating these networks helps provide an intellectual foundation from which solutions can start to emerge. Of course one has to create the network in the first place, and shape and perfect the technical systems by which information can be shared with ease and efficiency across it. Another element is facilitation across boundaries, and here the appointment of suitably qualified managers and leaders, with the relevant social and administrative skills is vital. This is Weber and Khademian's (2008, 344) main argument: that the mind-set of the managers of these networks provides the context for actions (and see also Grint 2010a, 2010b).[27]

To summarize these sections on wicked problems and related terms and concepts, I will highlight two particular considerations as headlines. First, that efficient networks are advantageous if not vital to helping find some resolution to wicked problems. And second, that while the terminology for wicked problems is diverse, the many terms that have been used do tend to congregate around the idea of complexity and wickedness. Furthermore, as Lønngren and van Poeck (2021, 493) have said (and as stated repeatedly above, in one way or another), the term 'wicked problems' has value as a 'sensitising/creative or critical/emancipatory tool'. And what are archaeologists if not creative and critical thinkers?

Small Wins

In their overview of 'strategies for decolonizing, transforming and creating meaningful spaces for Indigenous Peoples' within academic structures and practice, Smith and Smith (2019, 1098–1099) recognized the need for what I refer to as a small wins approach; they talk instead of 'small and incremental gains': 'there is a need for all of us to appreciate that what may seem a utopian vision is worth

[26] Recognizing also that 'success' is itself a problematic concept when it comes to wicked problems!
[27] And I will return to the question of leadership relative to wicked problems in the book's conclusion.

striving for and maybe won through a series of small and incremental gains rather than singular and spectacular actions'.

They do not describe the position of Indigenous Peoples within academic practice specifically as presenting a wicked problem, but the implication seems obvious. In fact, the whole discussion of wicked problems raises what we might refer to as a wicked problem of its own:[28] how can anybody, let alone archaeologists or heritage professionals, ever hope to resolve a wicked problem? The answer should be obvious by now: they can't! The complex nature of the problem alone renders this an impossibility. However, progress and significant contributions can be made, and here we come to the important notion of 'small wins', whereby, 'a series of concrete, complete outcomes of moderate importance builds a pattern that attracts allies and deters opponents. The strategy of small wins incorporates sound psychology and is sensitive to the pragmatics of policymaking' (Weick 1984, 40).

Defined in this way, small wins are possible within this challenging environment and they can make a difference (and see Bours et al. 2022 for a discussion of ways that small wins can be aligned with a missions approach in the context of plastic pollution removal in the Netherlands, part of the wicked problem of environmental pollution discussed in Chapter 3). Small wins have also been referred to as 'nudges' towards a bigger solution, deriving from nudge theory (after, e.g. Dolan et al. 2012 and Thaler and Sunstein 2008). As Taylor (2023, 201) has stated, this area of theory originates in the field of cognitive psychology and refers to the idea of making choices that are not necessarily optimal, but are good enough for any given situation (Simon 1956). This approach has also been referred to using the concept: 'divide and conquer' (after Xiang 2013, 1), or to return to Churchman (1967, B-141), 'carving off a piece of the [wicked] problem and finding a rational and feasible solution to this piece'. The disadvantage of course is that the remainder of the wicked problem is left behind, unresolved. Or, to use Churchman's colourful metaphor: 'the beast [the wicked problem] is still as wicked as ever' (1967, B-142). This then in turn raises a moral and an ethical question, highlighted by Churchman, that 'whoever attempts to tame a part of a wicked problem, but not the whole, is morally wrong' (1967, B-141). Churchman does, however, recognize the dilemma here, and notes the second-best option to complete resolution is being honest about not addressing the entire problem. Yet we are left with the reality: that partial solutions to wicked problems may be the only feasible way forward (Termeer and Dewulf 2019; Turnbull and Hoppe 2019).

Termeer and Dewulf (2019) are amongst those who argue for a small wins framework for dealing with wicked problems. Mirroring and adding nuance to Weick's earlier definition, Termeer and Dewulf (2019) regard small wins as

[28] And a tautology.

'concrete, small-scale, in-depth and positive changes which can lead to transformative change[29] as they accumulate' (Termeer et al. 2019, 173). They recognize five mechanisms which can propel transformative change while affecting how small wins can impact one another, thus accelerating their accumulation and the chances of success. These five mechanisms are:

- energizing,
- learning by doing,
- the logic of attraction,
- bandwagon effect, and
- coupling and robustness.

These are concepts not unfamiliar to archaeologists, albeit perhaps through a different terminology. Termeer et al. (2019, 173) refer then to a final step, being to ensure that

> results feed back into the policy process, through telling the involved actors and the world how important the emerging small wins are, making them more salient through inspiring stories and encouraging actors to seriously reflect on their achievements and the use of insights to overcome barriers to initiating or upscaling new small wins.

This policy arena is one in which archaeologists perhaps perform less well and where more learning and experience are required—archaeologists are amongst the best storytellers however, so making an improvement in translating those stories across into policy should not be difficult to achieve.

Let us return to Weick's (1984) paper on small wins which was published, it should be noted, in the journal *American Psychologist*. And I return to it here for two reasons. One to present a couple of examples of small wins that he uses and which pave the way for the many more archaeological examples that follow in subsequent chapters. The second reason is to provide a short outline of some of those psychological issues that render small wins such an attractive prospect within this highly complex and challenging wicked problems policy arena.

I will begin with the examples. The first example Weick provides concerns American Football.[30] In early February 1980, the Pittsburgh Steelers had won eighty-eight games and lost twenty-seven under their then coach, Chuck Noll. But as Weick (1984, 41) notes, these statistics become more interesting if they are partitioned on the basis of whether the Steelers were playing against teams with

[29] Hence this book's subtitle.
[30] Although I can easily translate this example across to my own team, recently relegated from the English Premier League.

winning or with losing records. Against opponents who won more than half their games, the Steelers won twenty-nine and lost twenty-six. However, against teams who lost more than half their games, the record was 59–1, meaning they won 98 per cent of these games. In other words, the Steelers did not become great by winning the big ones. Rather, they distinguished themselves by being consistent in those games where their skill advantage should make a difference, a condition one might describe as characteristic for a small win.

While this first example doesn't refer to a small win relative to a wicked problem (unless, perhaps, you are a Steelers fan), the next one does. It is worth citing in full (after Weick 1984, 42):

> When William Ruckelshaus became the first administrator of the U.S. Environmental Protection Agency [EPA] in the early 1970s, he laid aside his mandate to clean up all aspects of the environment and went instead for a small win.
>
> He discovered some obscure 80-year-old legislation that permitted him to go after some cities on water pollution. He took advantage of the legislation, effectively narrowing his practical agenda for the first year or two to 'getting started on water pollution'. On day one of the agency's formal existence, Ruckelshaus announced five major lawsuits against major American cities. The impact was electrifying. The homework had been meticulously done. Noticeable progress was made quickly. It formed the beachhead for a long series of successes and distinguished EPA from most of its sister agencies. (Peters 1979, 5)
>
> Ruckelshaus did not tackle everything nor did he even tackle the most visible source of pollution, which is air pollution. [Instead] Ruckelshaus identified quick, opportunistic, tangible first steps only modestly related to a final outcome. The first steps were driven less by logical decision trees, grand strategy, or noble rhetoric than by action that could be built upon, action that signaled intent as well as competence.

This seems like a sensible strategy in the face of wicked problems which appear irresolvable due to their scale and complexity: understand the problem, start small, and build momentum. We will see this trajectory again, many times, in the chapters that follow.

The real value in Weick's (1984) paper, however, rests with the psychological perspectives that it presents on small wins and their relationship to wicked problems. The original source provides the details. Here a short summary of the salient points will suffice, framed around his opening statement that 'from a psychological perspective, small wins make good sense' (1984, 44).

The first of Weick's four key points concerns what he refers to as 'cognitive limitations'. To gain control, people (the actors involved) can disconnect the parts so they don't affect each other; they can disconnect incomprehensible systems to

render things more straightforward, more manageable. The problem is seen more clearly in the form of a result which improves the chances of a solution being found. Weick goes on (1984, 45): 'The resulting small win becomes a visible change in a highly inertial world. The change was made possible because the bounds of rationality were not exceeded. The change also becomes more visible to other people because its size is compatible with their own bounded rationality.'

Thus small wins can be as effective because they are 'small', as because they are 'wins' (1984, 44).

Second, there are 'affective limitations', and here Weick (1984, 45) reports that psychologists have repeatedly demonstrated that small changes are preferred to large ones, and that the small scale of small wins is as important affectively as it is cognitively. Specifically, Wieck notes that:

> Small wins are not only easier to comprehend but more pleasurable to experience. While no one would deny that winning big is a thrill, big wins can also be disorienting and can lead to unexpected negative consequences.... Big wins evoke big countermeasures and altered expectations, both of which make it more difficult to gain the next win (e.g. attention paid to Nobel prize winners often makes it impossible for them to do any further significant work).

Third is stress. Weick (1984) cites research by McGrath (1976) who argues for the potential for stress 'when people perceive that demands exceed capabilities'. Thus reducing stress would involve creating a situation where capabilities match or exceed demand. The former will likely apply for larger (or wicked) problems; the latter is more likely for small wins. Citing Weick (1984, 46) again on this: a small win: (1) reduces the importance of the task, meaning that the cost of failure is small and the rewards considerable; (2) reduces demands (e.g. all we need to do is persuade one city or island authority to discipline local polluters); and (3) raises the skills levels, with existing skills deemed sufficient to deal with the more modest demands being faced. Thus: 'Continued pursuit of small wins could bring increasing resistance to stress in people not originally predisposed towards hardiness' (Weick 1984, 46).

Fourth and finally is the 'enactment of environments' whereby small wins build order into unpredictable environments or situations. It is a presumption of logic that people expect a situation to make sense. Typically with wicked problems, the situation does not make sense, either because it is so technically complex or organizationally confusing. Small wins can introduce order to this chaos, rendering it comprehensible and thus (one hopes) more manageable. Or, in other words: 'The confidence that flows from a pursuit of small wins frequently enacts environments in which the original problem becomes less severe and the next improvement more clear' (Weick 1984, 47).

In concluding his paper, Weick said this:

> Social problems seldom get solved, because people define these problems in ways that overwhelm their ability to do anything about them. Changing the scale of a problem can change the quality of resources that are directed at it. Calling a situation a mere problem that necessitates a small win moderates arousal, improves diagnosis, preserves gains, and encourages innovation. Calling a situation a serious problem that necessitates a larger win may be when the problem starts. (Weick 1984, 48)

He refers specifically to social problems, but the wider relevance and implications are hopefully obvious. Keep it small and the chances of success are improved. In time these small wins move us closer to mitigating or even partly resolving the greater and more wicked problem.

That, at least, is the theory. As an eternal optimist, it is one that I subscribe to. It is not, however, a view that is universally held. Some people feel that, as a society, and as individuals within that society, we do need to fight the injustice and aim higher than locally relevant small wins. The activist and journalist George Monbiot (2021) presents a robust critique of this approach under the heading 'Capitalism Is Killing the Planet'. Other non-human animals put survival first, he says. Humans on the other hand seem to confront impending disaster, 'going out of our way to compromise our survival'. What I refer to here as small wins is part of the problem, Monbiot suggests. He argues, for example, that:

> Surface tension dominates even when we claim to be addressing the destruction of our life-support systems. We focus on what I call micro-consumerist bollocks (MCB): tiny issues such as plastic straws and coffee cups, rather than the huge structural forces driving us towards catastrophe. We are obsessed with plastic bags. We believe we're doing the world a favour by buying tote bags instead, though, on one estimate, the environmental impact of producing an organic cotton tote bag is equivalent to that of 20,000 plastic ones.
>
> I'm not saying the small things don't matter. I'm saying they should not matter to the exclusion of things that matter more. Every little counts. But not for very much.

He concludes by stating that:

> Acting alone, seeing ourselves as consumers, fixating on MCB and mind-numbing trivia, even as systemic environmental collapse looms: these are forms of obedience. We would rather face civilisational death than the social embarrassment caused by raising awkward subjects, and the political trouble involved in resisting powerful forces. The obedience reflex is our greatest flaw, the kink in the human brain that threatens our lives.

These issues came to head in 2022 with Just Stop Oil climate protests at art galleries across the world, causing Monbiot (2022) to reflect on the values society places on planetary health, versus depictions of landscape, in a past and theoretically pristine and healthy state:

> Whenever I visit the National Gallery, I can't help but wonder how many of the places in its treasured landscape paintings have been destroyed by development or agriculture. Such destruction, which... the government now plan to accelerate, even in our national parks, is commonly justified as 'the price of progress'. But if someone were to burn or slash the paintings themselves, it would be an abhorrent act of brutality. How do we explain these double standards? Why is life less valuable than the depiction of life?

Does the kind of damage seen in Figure 1.6 and at London's National Gallery constitute a small win through direct action, and is this activist approach any more

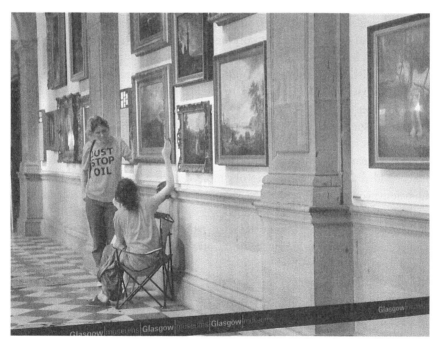

Figure 1.6 Just Stop Oil protests at the Kelvingrove Art Gallery and Museum, Glasgow (Scotland), in June 2022

Note: The protesters glued themselves to a nineteenth-century landscape painting by Horatio McCulloch called 'My Heart's in the Highlands'.

Source: This file is licensed under the Creative Commons Attribution-Share Alike 4.0 International licence.

effective than less damaging and direct forms of action? Is it the publicity that such direct and controversial acts generate that make a difference?

Archaeologists as Policy Entrepreneurs (or: Archaeology Needs Influencers)

In her speech about the schools' climate change strikes in 2019, environmental campaigner Greta Thunberg said: 'We know that most politicians don't want to talk to us. Good, we don't want to talk to them either. We want them to talk to the scientists instead. Listen to them because we are just repeating what they are saying and have been saying for decades' (Thunberg 2019, 33).

But for that to happen, scientists need a voice, and spokespeople who are good at communicating and have access to data that deserve to be talked about.

The chapter began by exploring the idea of archaeologists as superheroes with a specific and distinctive range of superpowers at their disposal. There is nothing new in this. The book cites many examples that date back over many years. Such examples demonstrate what we are capable of and how we can help inspire others to follow (and do better). A key word here is probably activism—the ability and the desire to be an activist in taking steps to change things for the better. The anthropologist Larry Zimmerman (2014) has written on this and provided a helpful overview of what being an activist entails. We will return to examples of his work later in the book (and see also Stottman 2010 for a further overview of this same issue).

Within archaeology, we are getting used to the idea of being activists, not least given the expansion of archaeological interest into the contemporary world which has provided the opportunity to work more directly with marine pollution and homeless people, to name just two examples as teasers for what is to come. But within the context of policy, archaeologists probably need to up their game somewhat, and to change the language they use, not least for their non-archaeological partners, audiences, and collaborators.[31]

A term that is used to describe the role I anticipate for archaeologists within the wicked problems arena is 'policy entrepreneurs'. It is a term I like for its clarity, its resonance with policymakers and for the professional status that it implies.[32]

[31] We know we can be superheroes and change the world, but for now at least we need to keep the language (mostly) professional and build the case—and we know from the funding threats facing archaeology that we cannot assume anything in this regard. Recall that the Avengers lost political support at one point in the story, with dire consequences!

[32] Unlike 'influencers' for example, which in any case aligns most closely with social media.

It is a role that is helpfully explained and defined by John Kingdon (2013, 181) within the context of his study of health-care provision. He summarizes this as follows:

> When researching case studies, one can nearly always pinpoint a particular person, or at most a few persons, who were central in moving a subject up on the agenda and into position for enactment. Indeed in our 23 case studies, we coded entrepreneurs as very or somewhat important in 15, and found them unimportant in only 3.... In none of these cases was the single individual solely responsible for the high agenda status of the subject, as our reasoning about multiple sources would indicate. But most observers would also identify these policy entrepreneurs as central figures in the drama.

So policy entrepreneurs can be important, and they can make a difference. But what makes for a successful policy entrepreneur? Kingdon (2013, 180) lists three qualities:

First, the person must have some claim to a hearing. This claim can have one of three sources: expertise; an ability to speak for others, for example as the leader of an interest group; or an authoritative decision-making position, such as presidency or chairpersonship of a committee.

Second, the person will be known for their connections and/or their negotiating skills. Kingdon refers to a person from his area of work (health care) who combined technical expertise with political savvy, 'the combination creating much more influence than either of the two qualities taken separately'.

Third, and according to Kingdon, probably the most important, successful entrepreneurs must be persistent: 'sheer tenacity pays off'. As Kingdon states (2013, 181):

> Most of these people spend a great deal of time giving talks, writing position papers, sending letters to important people, drafting bills, testifying before committees and commissions, and having lunch, all with the aim of pushing their ideas in whatever way and forum might further the cause.

But, as Kingdon goes on to say, tactics are also key: entrepreneurs do more than push, push, and push. They also lie in wait for a window to open. The surfer provides a helpful parallel here. Like the surfer, 'entrepreneurs are ready to paddle, and their readiness combined with their sense for riding the wave and using the forces beyond their control contributes to success' (Kingdon 2013, 181).

Sarah Anderson et al. (2020, 590) also highlight the critical role of policy entrepreneurs in policy formulation and agenda-forming, increasing the likelihood that

legislation on a key issue will be introduced. They go so far as to say that 'policy-makers who report contact with a policy entrepreneur are more likely to introduce legislation' (2020, 591). Like Langdon, they recognize that such policy entrepreneurs can come from a diversity of professional backgrounds including academia, and that they need not be individuals, but also organizations including think-tanks and NGOs. Anderson et al. (2020, 591) present data on the tactics employed by policy entrepreneurs, noting for example meetings and discussions, coalition-building, and grassroots advocacy as examples. But most helpful here, and in summary, they present three key findings that have relevance to us in exploring ways that archaeologists might become successful policy entrepreneurs, on the assumption that the ultimate goal is some form of policy or legislation to address the wicked problem at hand: first, that 'information gathering and dissemination is a critical strategy for policy entrepreneurs in promoting the introduction of legislation' (2020, 604). Second, that 'when a legislator has had contact with a policy entrepreneur, agenda change is more likely to occur' (2020, 605). And third, that 'legislators who work with policy entrepreneurs from lobbying and advocacy organizations are significantly more likely to introduce legislation' (2020, 605). These are helpful headlines in understanding the task ahead, especially at that point where the understanding generated through archaeological endeavours has reached the stage of warranting further attention and action at the level of policymaking or legislation. We will return to this in the concluding chapter, having looked at a diverse range of examples where policy entrepreneurs might perform a useful role.

Conclusion

In summarizing this first chapter I will simply emphasize its two central messages. First, archaeology is well positioned to address many of the challenges facing the contemporary and future world. Archaeology can help in two ways. It can contribute new knowledge and understanding through archaeological fieldwork and the interpretation of its results. These results might illustrate, for example (and to pre-empt the next chapter) how communities dealt with climate change in the past, responding to global warming and rising sea levels. But archaeology can also help through the opportunities it provides for all people to participate, whether physically on an excavation, or virtually through citizen science, for instance. Participation brings well-being benefits that address the wicked problem of poor physical and mental health. This is the subject of Chapter 4. The second central message of this Introduction is the definition and rendering of the concept of wicked problems, through an overview of relevant literature and a description of relevant terms. Part of that review also included an

introduction to the idea and to the benefits of a small wins framework, and to the role of policy entrepreneurs.

Within archaeology, and across the broader cultural and humanities sectors, the social relevance of archaeology is being realized, along with its economic potential, relating to tourism for example. Archaeology matters. It can tell us things about the past, present, and future that no other subject can tell us. It does this by storytelling, creating compelling and colourful narratives through the medium of material culture, the things that archaeologists find and then interpret through a complex and ever-changing matrix of theories, methodologies, and perspectives.[33] Many of these stories, and the processes by which archaeologists create them, relate to what this book refers to as wicked problems. If we put these two things together—the evidence from the past and the retrieval process, and the significant challenges society faces now and will continue to face in the future—we can make a convincing argument to position archaeology at the centre of a complex and transdisciplinary scholarly network (not to mention of course a profession) through which solutions and resolutions to these wicked problems can begin to be found, at least within a small wins framework.

The language and the terminology presented in this opening chapter provide one example of how the future might look, with some or much of our endeavour as archaeologists linked to aspects of this wicked problems agenda. For my part, I struggle to think of any archaeological project or initiative which fails to meet this aspiration.[34] Most of the following chapters are thematic and will elaborate on this argument, focusing on its central point: that archaeology is directly relevant to addressing the world's most pressing of wicked problems and that it can therefore make valid and valuable contributions to shaping a better world while also improving our own lives in the process. As archaeologists, we just need to have confidence in our ability to recognize this higher goal, by seeing the connections to wicked problems and mapping our work onto them. Many archaeologists are doing this already. They just often don't see or describe their work in these terms. Yet, as I will argue, archaeologists have the superpower, the ability to help unfuck things. They just need to learn to channel it, and then join forces for their work to have the greatest impact. As I said at the start of this chapter: It is time for archaeologists to assemble!

[33] Many archaeologists and students of archaeology say that they do not like theory, or that they do not understand the point of it. This must come down to the way it is taught. Theory is as fascinating as it is essential. Archaeology is nothing without theory. Discuss?! If you disagree, then read Gavin Lucas's (2022) *Archaeological Situations*.

[34] I have often heard it said, in coffee-room and corridor conversations, that 'this is all very well but I do not see how my archaeological interests can address these kinds of global issues'. In my view, all archaeological work aligns with one of these wicked problems. Read the book and tell me if you disagree.

Chapter Headlines

- Wicked problems are complex and irresolvable. They are the opposite of tame problems, which may be technically complex but are easy to fix. Climate change is one example of a wicked problem; environmental pollution is another.
- Archaeology and heritage practice are concerned with human experience in the past, and what this can tell us about ourselves and our future. Archaeology provides a suite of methods and theories for investigating people's behaviours in the past; heritage concerns the management of those traces, and how we prioritize and value them.
- It may not be immediately obvious, but archaeology and heritage practice can help to address some of the world's wicked problems, but only through tackling parts of these problems or specific aspects of them. This approach is known as a small wins framework.
- Managing wicked problems (even through small wins) is very different to managing tame ones. Managing wicked problems involves risk and requires creativity, striving not for elegant but, rather, clumsy solutions.
- To persuade funders, industry leaders, policymakers, and politicians to support such endeavour, policy entrepreneurs (or influencers) are needed, to act at the interface between these very different worlds.

2
Climate Change

> Since the dangers posed by global warming aren't tangible or visible in the course of everyday life...many [people] will sit on their hands and do nothing of a concrete nature about them.
>
> (Giddens 2009, 2)

> Many people say that we don't have any solutions to the climate crisis. And they are right. Because how could we? How do you 'solve' the greatest crisis that humanity has ever faced? How do you 'solve' a war? How do you 'solve' going to the moon for the first time?...Avoiding climate breakdown will require cathedral thinking. We must lay the foundation while we may not know exactly how to build the ceiling.
>
> (Greta Thunberg, Speech to the British Parliament, 23 April 2019)

> PROFESSOR BERNARD QUATERMASS: If we found that our Earth was doomed, say by climatic changes...What would we do about it?
>
> DR MATHEW RONEY: Nothing. Just go on squabbling as usual.
>
> (From the film adaptation of Nigel Kneale's *Quatermass and the Pit*, 1967)

Introduction

I like to think that we have moved beyond squabbling, hopefully at least given that nearly sixty years have elapsed since Roney's terse observation. Disagreements may persist around the precise nature of climate change, its possible future impacts, and around how certain specialisms (and let us include archaeology in that list) might help shape solutions. But at least (and with only a few notable exceptions) there appears to be consensus on one point: that climate change (also often referred to as global warming) is one of the most difficult and challenging of wicked problems that faces the world and its inhabitants, current and future. As we will see, with the benefit of hindsight (through archaeology), it was sometimes a problem in the past as well.

It is important to emphasize that the climate has always changed. In the past, natural fluctuations (swinging between full glaciation and interglacial) have had an impact on humans, determining where they could live based on the availability of resources and the temperature (and see Mondanaro et al. 2020 for a discussion of how, uniquely within the animal kingdom, humans can culturally construct their

climatic niche as opposed to always biologically inhering it). Simply (within the northern hemisphere) a cooling climate forced people to move south from northern Europe, in advance of ice sheets. A warming climate allowed them to move back again. But these changes happened over millennia. Most people would hardly have noticed any change in their lifetimes. It took archaeological investigations to reveal this slow-motion ebb and flow. I will return to this difference in perspective shortly. However, what I am referring to as climate change in this chapter is not so much these natural planetary rhythms but an unnatural human-induced exaggeration of these processes leading to what has been referred to by American environmentalist Hunter Lovins as 'global weirding', a term later popularized in the *New York Times* by Thomas Friedman in 2010 (see also Bauman 2017). 'Weirding' refers to those erratic weather events which are increasing in frequency related to, but separate from, the natural changes that would have happened anyway. As Bauman (2017, 11) puts it: 'One thing is certain, the climate is weirding and anthropogenic forcings play the dominant role in these changes.'

Essentially, the argument runs, humans do not significantly (if at all) influence this natural ebb and flow, from warm to cool and back again—this would happen without humans occupying the planet. What we are doing as humans, because of the impacts that we continue to have on the planet, is to exaggerate some of these natural changes, speeding them up and making them more extreme than would naturally have been the case. This is what causes the weirding. These exaggerated human-induced changes are especially characteristic of a newly labelled geological era called the Anthropocene, a period whose literal definition refers to the growing impact of human influence on planetary systems including its climate (e.g. Randall 2022). Nonetheless, weirding is an important marker, partly because it is these weird events that people notice, suggesting to them that something is not right. Weirding is essentially the planet telling us it is fucked, in the language of Chapter 1. Finally, after a few early warnings, it seems that we—as citizens in general and archaeologists in particular—have received this message and can at last begin the challenging task of helping to unfuck things. But to do that we need to use some of those superpowers I described in the previous chapter.

In this, the first of five thematic chapters in the book to each address archaeological approaches to a particular wicked problem, I focus my attention on climate change and in particular weirding. I am taking this subject first for two reasons. First, because the political, economic, and social issues that it entails are about as complex (or as messy, to use Emery Roe's [2013] phrase, described briefly in Chapter 1), as one can get. And second, because our changing climate provides a backcloth or context for many of the other wicked problems that I will go on to discuss in subsequent chapters: social injustice for example, health, and environmental pollution. Both of these reasons refer in subtly different ways to what I refer to as entanglement, which forms the subject of a more theoretical focus in Chapter 5. By this I mean the complex interconnections that entangle all of these wicked problems, like a bundle of cables. I will add an additional

consideration here, picking up on a previous point: that, for many people, climate change is also arguably (and ironically, given its significance) the least *visible* of all the wicked problems, certainly when viewed in short-term perspective from a personal or community viewpoint and framed alongside the more overt and immediate everyday problems like health, social inequality, and crime. This was the point Giddens's (2009) made, in one of the chapter's opening quotations. On this more familiar scale of the everyday encounter, most people only ever 'see' climate change when a drought hits, when severe storms force us indoors or when wildfires threaten our homes and livelihoods; when flowers and shrubs bloom earlier than usual, or birds begin nesting earlier because of a warmer start to the year.[1] On these weird occasions we may think more about climate change, but often only as a short-term problem, an inconvenient situation to be endured and to overcome over the next few days, until things 'return to normal'. Unless of course you happen to be an archaeologist.[2] This consideration of climate change as something almost imperceptible for much of the time, is another reason to tackle it first. It is the elephant in the room one might say—we try to ignore it, but it is always there, right before our eyes if only we care to look.[3]

So how can climate change best be summarized?[4] As climate-change archaeologist Robert van der Noort (2013, 1) presents it:

> Climate change is one of the greatest challenges, if not the greatest, facing humanity in the twenty-first century. In the past, climate change was a natural process. But current global warming is, to a large degree, linked to the production of greenhouse gases from the burning of fossil fuels and its impact on radiative forcing, namely, the solar energy received by the earth minus the energy reflected and radiated back into space. The scenarios for the rate of future climate change are dependent on our ability to reduce greenhouse gases in the atmosphere. More heat from the sun will be trapped in the Earth's atmosphere in the twenty-first century than was the case in previous centuries, inevitably leading to higher average global temperatures. A direct consequence of this will be that the Eustatic Sea level will rise because landlocked ice will melt and add water to the seas and a warmer sea takes up more space due to thermal expansion. By the end of the twenty-first century, Eustatic Sea levels could be 0.59 m higher than they are today. An estimated 400 million people live on land less than 10m above current sea levels.

[1] Somebody I follow on X (formerly Twitter) literally just Tweeted to say that they were (and I paraphrase) fed up with the grey damp weather currently enveloping the city where we both live. The point of this may not be immediately obvious, but stay with me: I return to this later.
[2] Recognizing of course that other disciplines also take this longer-term view.
[3] And as artist David Hockney makes plain, we really do need to look, and look closely at the world, for what it is telling us.
[4] And I do only offer a summary here—climate change is only one chapter in this book, one topic of five. Other authors, including the one I am about to cite, provide far more depth and insight than I am able to, or is appropriate here.

Van der Noort's work provides a 'rallying call for the archaeological community', making the point that we, as archaeologists, 'need to think differently about the interrelationship between societies and their environment in the past if we want our research to play a part in climate change debates' (2013, 19; see also 2011). He presents what he refers to as 'climate change archaeology', which he defines as: 'a repository of ideas and concepts that can help build the resilience of communities in a time of rapid climate change' (2013, xii). In this sense, his work is distinct from that of many other scholars approaching the changing climate from an archaeological perspective. Significantly, for example, he describes how:

> Elements of climate change archaeology include long-term perspectives on natural processes and occasionally ecological or technical solutions that are no longer a part of the social memory of communities. However, *the more important elements are social in nature*, and are linked directly to people's sense of place and identity in a world that needs to adapt. (2013, xii, my emphasis)

This final point feels important, and raises a theme that will be discussed further in Chapter 5, about entanglement—the way that wicked problems are all, to some degree, interrelated. But more immediately, van der Noort's suggestion that the wicked problem is, in part, a social problem is a theme I will pursue in this chapter, partly seeking to document the impacts of climate change on people and the places they value, but also in terms of creating solutions, both in terms of small wins and in the roles of archaeologists and local community members as policy entrepreneurs.

I will start the chapter, however, by focusing on how archaeologists currently perceive the impact of climate change and what it means for our specific sector, some ten years on from van der Noort's important book on the subject. I will do this by outlining a recent and very relevant statement on archaeology and climate change, emerging from the European Association of Archaeologists (EAA) conference at Kiel (Germany) in 2021. I present this as one example amongst many of how heritage organizations are beginning to muster around core issues such as climate change, stating their position in the hope of generating momentum, creating research priorities and building consensus around activism. Perhaps this strategy and this Statement represent an important step along the way to forging precisely what this book suggests: a framework that makes it easier to take small steps in shaping policy for tackling wicked problems. Having presented this Kiel 2021 Statement, I will then backtrack a few decades to discuss some of the more traditional archaeological approaches to climate change, focusing on what I was taught on the subject as part of my own undergraduate degree programme in the early to mid-1980s. I use this example to illustrate how things have changed, prior to offering some explanation of why they have changed. I then present some of the policy literature around climate change as a wicked problem before asking the central question: as a wicked problem, why does climate change research need

archaeology? I will then focus on some of the specific problems that archaeology faces in addressing climate change as a wicked problem, and how (and why) archaeology has tried to overcome these problems in order to make a meaningful contribution. Archaeology forms an important part of the wider cultural heritage 'family', so I will also present some insight into contributions to the debate from across the heritage sector, referencing the built environment for example and the threats and perhaps also opportunities that climate change presents. The chapter will conclude by reflecting upon these examples and the issues that they raise, positioning these thoughts within the wicked problems arena, looking, for example, at how archaeology might generate small wins and how we, as archaeologists, can serve more effectively as policy entrepreneurs to influence and shape mitigation.

As with all of the thematic chapters in this book, the purpose here is to emphasize the significance of small wins and the vital role of archaeologists as policy entrepreneurs. The thematic content is therefore more of a signposted overview than in-depth analysis. To achieve my main purpose, I will endeavour to keep things as straightforward as possible, meaning that the examples chosen will generally be summarized with citations for further reading where appropriate. Remember, with regards this chapter, that this is not a book about climate change. For that you can go elsewhere (e.g. and notably van der Noort 2013). For the purposes of this chapter, climate change is but one example of how archaeology and archaeologists can help change the world.

The Science and the Philosophy of Climate Change

Back in fictional 1967, if Mathew Roney and Bernard Quatermass had experienced a small time warp and landed briefly in Kiel fifty-four years later, Roney's answer to Quatermass's question might have been very different. As an archaeologist,[5] he might have provided a much lengthier answer, perhaps even citing van der Noort's work, and the recently drafted European Association of Archaeologists' Kiel Statement on Archaeology and Climate Change (EAA 2021). In fact the Kiel Statement would have made an excellent response to Quatermass's question. To summarize the Statement here, I begin by citing some headlines from the introductory paragraphs. These include, amongst other things, the observation that: 'Archaeology provides a unique perspective to the interpretation of recent climate and cultural change and provides a vast array of data for the better understanding of the development of, and resilience to these global crises.'

[5] More accurately, a palaeontologist.

It goes on:

> We take it as a given that archaeology and the archaeological and cultural heritage of which it is a part, have much to offer efforts to address climate change....The advocacy of archaeologists on local, regional, national and global levels can play a pivotal role not only in protecting archaeological sites and data from the destruction through climate change, but also in learning from the past for the present and the future.

This final statement, it seems to me, is the most important of all: that archaeology has a vital role to play in shaping sustainable strategies for mitigating the impacts of climate change in the future, alongside and incorporating recognition of the importance of archaeological data for highlighting what those impacts might be, and how people have dealt with them in the past. In introducing a themed issue of a major interdisciplinary scientific journal, on this subject, Rick and Sandweiss (2020, 8252) have made this same point, that 'increasingly, archaeologists look to the future, drawing on the unparalleled long-term record of human-environmental interactions to provide context and guidance for future environmental conditions, scenarios and planning.'

And similarly:

> Natural climate archives (e.g. pollen data, sediment records, ice cores) and the paleontological and archaeological records offer unique opportunities for observing, measuring and understanding how humans have responded to a wide range of climate events in the past, *forming a sound basis for predicting how climate change could transform our lives in the future and offering a range of possible solutions.* (Burke et al. 2021, my emphasis)

So Kiel does not sit in isolation. It feels part of a wave.

From its contextual introduction follows the Kiel Statement itself. This comprises six short paragraphs that I paraphrase in the text box that follows (and which include my own highlights, for emphasis):

EAA 2021 Kiel Statement on Archaeology and Climate Change

1. *Archaeologists can help understand climate change on a local to global scale by providing evidence and data from the past.* In particular, it is the data from past societies and environments that archaeologists around the world provide on environmental and societal changes that better help to assess human-made global warming, and to carry out prognoses on the further development.

CLIMATE CHANGE 49

2. *Archaeological research can contribute to increasing modern resilience and adaptation through lessons learned by past societies.* Archaeological research deals with people from a wide range of social and temporal contexts, from Palaeolithic to contemporary societies. The diversity of social and economic conditions under a wide range of environmental conditions makes it possible to evaluate questions of sustainability and resilience. For example, archaeological insights into food security through the study of past agriculture and land-management practices may allow an understanding of what works, or could work in extreme ecological conditions resulting from modern climate change. Additionally, archaeologists may assist situations where 'sustainable' climate change mitigation strategies produce unsustainable local and social effects.
3. *Climate change puts archaeological remains at risk.* Among the climate-driven forces affecting archaeological sites are coastal erosion, sea-level rises leading to inundation, droughts, floods, the drying of soils including peats, soil erosion, increased frequency and intensity of wildfires, changes to the weather leading to extremes of heat, precipitation and storms, changes in vegetation and biodiversity, permafrost thawing, and glaciers melting.
4. *Preserving both rural and urban archaeological sites and landscapes can help mitigate climate change.* For example, preservation of archaeological sites and monuments in pasture, grasslands, and peatlands can help both preserve cultural assets and help meet ecological, biodiversity, and climate change goals.
5. *Archaeologists and cultural resource managers must have a basic understanding of climate change issues* in order to better protect and manage archaeological resources for the future. For example, archaeologists and cultural resource managers should create best practices to monitor and mitigate the effects of climate change on archaeological remains, and to create an appropriate record of those sites and remains which cannot be saved.
6. *Archaeologists should explore ways to translate fundamental archaeological research into actionable science* to inform decision-making, as well as monitor climate change as it relates to archaeology and heritage.

It is a strong statement and one most archaeologists would support. There is little here that is controversial. I would take two issues with it, however. First is the emphasis it appears to place on archaeological data that helps us to understand climate change in the past (paragraphs 1 and 2). Second (and a related point) is the stated need to preserve archaeological sites for the information that they contain, including about climate change to help shape future decision-making (3 and 4). Few would argue that these principles are correct and laudable. But should they be presented seemingly as *the priority* for archaeologists? Is it not more compelling to

present archaeological data (and the archaeological sites that contain those data) in terms of how they can inform new ways in which society as a whole, and individuals and communities, might think about climate change and its risks? Should it be more about philosophy than science, in other words? And can we not make more use of our skills as storytellers and present this, too, as an aspiration archaeology is well suited to delivering? Either way, how we present the message feels important, as it is on this basis that politicians, policymakers, funders, and the wider public will form a view as to the relevance and merits of archaeology in this particular context.

To complete the list, Paragraphs 5 and 6 of the Statement do at least refer specifically to 'the future' and to 'translation... into actionable science' respectively. It is logical that these paragraphs come last in the sequence as they follow on from the other points being made, but these are surely the key points in any argument that promotes the cultural relevance and indeed the value of archaeology as a future-oriented discipline.

It is relevant also here to note how these issues are informing thinking on and policies concerning World Heritage Sites, those places identified globally as having outstanding universal value for all of humanity. A recent extensive study of World Heritage Sites (Woodward and Cooke 2022) includes a chapter on world heritage and climate change, in which the authors define climate change before documenting the impact of increasing temperatures and rising sea levels on World Heritage Sites including Aldabra Atoll (a natural site, see Figure 2.1) in the Indian Ocean and Nan Madol (a cultural site) in the Pacific. Interestingly, however, these and other World Heritage Sites are mentioned alongside risks to their fabric and integrity, but not (at least in this context) in relation to risks facing those communities who often live locally and who presumably value these sites and recognize them as forming a part of their identity.[6] This issue of social values draws together the wicked problem of climate change with those of social injustice and health and well-being, potentially alongside others not covered by this book, such as food security. It highlights the need for archaeologists and heritage managers to think beyond their own specialisms, in an inter- and transdisciplinary way.

To close this short discussion around World Heritage, it is worth highlighting Woodward and Cooke's observation of an aspiration for World Heritage properties (alongside biosphere reserves and global geoparks) to be 'reimagined as climate change observatories, and to be used in climate change communication, where relevant information can be gathered and experimental approaches developed' (2022, 80). This new aspiration for World Heritage Sites also aligns with Holtorf's thinking on new perspectives to respond to planetary crises and uncertainty. As recently expressed, Holtorf (2023, 123) states:

[6] If not also providing an income stream.

CLIMATE CHANGE 51

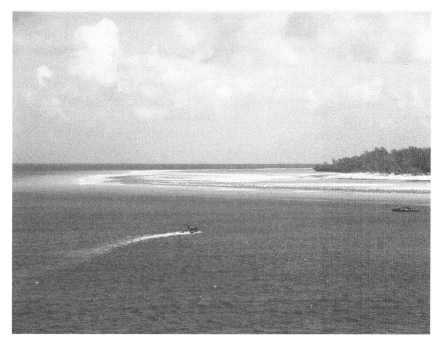

Figure 2.1 Aldabra Atoll

Notes: This World Heritage Site is under existential threat due to rising sea levels caused by climate change. As stated in the UNESCO synthesis: 'Located in the Indian Ocean, the Aldabra Atoll is an outstanding example of a raised coral atoll. Due to its remoteness and inaccessibility, the atoll has remained largely untouched by humans for the majority of its existence. Aldabra is one of the largest atolls in the world, and contains one of the most important natural habitats for studying evolutionary and ecological processes. It is home to the largest giant tortoise population in the world. The richness and diversity of the ocean and landscapes result in an array of colours and formations that contribute to the atoll's scenic and aesthetic appeal.'

Source: This file is licensed under the Creative Commons Attribution 2.0 Generic licence.

> The kind of cultural heritage we need does not preserve important sites of the past but uses heritage to encourage people in the present and future to have the courage to invest trust in other people and collaborate, to take responsibility for humanity and the planet at large, to be creative in imagining future realities, and to be resilient when facing change.

These points also return us to the question of whether the ways in which archaeologists engage with the climate change debate would be better focusing as much (or more) on philosophy as science? The argument carries weight. As Budolfson et al. (2021) state, 'philosophers have much to contribute to the discussion of climate change. This is because philosophers have developed important intellectual tools and ideas that can help everyone think more clearly and carefully about central issues raised by climate change' (ibid., 1). They (and

the authors of other chapters in that same edited volume) proceed to give a diverse range of examples, one set of which relates to ethics, and 'some of the most profound ethical challenges of our time' (ibid., 1). For example, to decide how to respond to climate change collectively, we need to, 'think about *who and what* matter, about *what sorts of effects* on them matter and about what would be a *just* or *equitable* way of arranging those effects.' (ibid., 1; emphasis in original).

They give examples:

> Should our aim in responding to climate change be merely to maximize the total economic output of the world, as many influential economic models assume? Or should we also value the health and well-being of all humans equally regardless of whether those individual people are rich or poor, and thus regardless of their contributions to global economic output? And what about future humans, who do not yet exist, and who may or may not exist at all depending on what policies we choose? Does the health and well-being of the environment and non-human animals matter as well even beyond its value to humans? How should the burdens of adaptation and mitigation be distributed given the nature of the climate change problem and its causes? (Budolfson et al. 2021, 1–2)

Thinking through the issues also ensures we never lose sight of the symmetrical alignment of culture and nature. The philosophical and ethical issues of climate change relative to both culture and nature are the subject of a recent essay by biologist and philosopher Bernard Feltz (2019) significantly, in the context of this heritage-grounded discussion, in the *UNESCO Courier*. He begins by stating that, 'climate change concerns both our daily lives and the world geopolitical order. It is one of the dimensions of a global ecological crisis, a direct consequence of the complex interactions between humans and nature.'

Feltz goes on to describe the four ways in which philosophers and philosophy have interpreted these interactions. First, Descartes considered nature as a set of objects made available to humans. This approach has led to the 'shameless exploitation of nature in all its forms' (2019). Second, British botanist Arthur George Tansley in 1937 proposed the concept of the ecosystem that would go on to revolutionize the scientific relationship between humans and nature. This concept refers to the interactions between all living species and between them and the physical environment. The ecosystem, as Tansley stated, is finite. Third, deep ecologists promote the idea of totality that integrates humans with other living organisms without granting them any particular status: 'Respect for animals is the same as respect for humans' (Feltz 2019). And finally is the idea that 'nature and humans coexist and interpenetrate in a more respectful way of living' (Feltz 2019). By this approach, animals are respected for themselves without being given the same status as humans.

These are different philosophical approaches and there is no linear progression implied to exist between them. However, recognizing some element of totality aligns with emerging views within heritage management on natureculture (an initiative specifically within ICOMOS and the International Union for Conservation of Nature, or IUCN),[7] and with the Chinese concept of the 'unity of heaven and humans' (Zhang et al. 2021; see also Harrison 2015 and Haraway 2008 who also used the term 'naturecultures'). In the ICOMOS/IUCN initiative, some of those philosophical approaches that promote integrated ways of thinking identified by Feltz, are in evidence. For example, their webpages describe how the initiative

> builds on the growing evidence that natural and cultural heritage are closely interconnected in most landscapes and seascapes, and that effective and lasting conservation of such places depends on better integration of philosophies and procedures regarding their identification and management. The [natureculture] journey recognizes an approach to heritage that has emerged based on the understanding that relationships between people and the natural environment have worked to shape both our physical environment and belief systems. It embraces the complexity of our heritage, which includes biological resources, genes, landscapes, geological diversity, cultural places and practices, and traditional knowledge systems.[8]

This all aligns closely with Pétursdóttir and Sørensen's (2023) argument that archaeological data can help frame a new way of thinking; that it is not so much about the data but about how those data help us to frame new approaches to the changing climate, alongside other wicked problems—more philosophy than science, as stated previously. These authors also describe the 'increasingly messy world' that we inhabit, comprising, 'a mesh of infiltrated phenomena and trajectories, some of which have little or no directional course...and where the contemporary "archaeological record" emerges as an "insane collection" (after Stewart 1993, 154)' to reflect that world. In a world of wicked problems, Pétursdóttir and Sørensen (2023) suggest that archaeology can help us define an approach in which we slow down, and pause, to think and reflect. Small wins can exist within this approach, meaning we continue to act. But we can also wonder, look, and think:

> Attempting to respond to this mess we're in makes us hesitate. It quite literally makes us think about object agency and speculate about the continuous

[7] https://www.iucn.org/
[8] https://www.icomos.org/en/focus/culture-nature/93567-icomos-work-on-connections-between-culture-and-nature

presences and aftermath of things. This is not because we see humans as free of responsibility or as a side-lined non-concern, but rather because this mess turns people, places and things into multispecies' assemblages, where, we contend, ethical activism not only can but *must* be aesthetic and speculative, allowing *also* for patience and slowness—a poetic lingering, if you like. (emphasis in original)

The argument I am suggesting therefore is that contributions from archaeology and heritage to help mitigate and manage climate change do, of course, require good data from archaeological research and the heritage investigations of climate change impacts, but they can also be extended to align more with philosophical approaches, encouraging people to think differently about their own part in the narrative. This is an argument I will return to in the following chapter on environmental pollution, where some of the impacts are arguably more tangible than with climate change. In this mode of archaeological thinking around climate change we can emphasize the temporal dimension and the fact that it is both a global and universal crisis and one that both affects us, and that we can affect, in our daily lives and practices, in the form of small wins. The temporal dimension means taking a long-term view (e.g. Schofield and Pocock 2023), both back into the past when people also had to manage the changing climate but also into the deep future, beyond the current emphasis on 2100 to at least 2500 for example (Lyon et al. 2021), recalling the Seven Generation Sustainability, referred to in Chapter 1.

But with that contextual discussion in mind, let us now focus our attention more specifically on climate change from archaeological perspectives.

The Archaeology *of* Climate Change

In a lecture theatre on a university campus in the south of England, in the autumn of 1983, the author was one of around twenty students taking a module in 'The Palaeolithic Archaeology of Europe'. Professor Clive Gamble was the lecturer. This module was an inspiration for my career in contemporary archaeology, through the dramas it presented of life on the move, stories conveyed through and evidenced by the material culture of Arctic Nunamiut, !Kung San bushmen of the African Kalahari and other Indigenous hunter gatherer communities. This was not the Palaeolithic archaeology I was expecting when I signed up for the course, and I loved it! It was a module built around Gamble's then forthcoming book *The Palaeolithic Settlement of Europe* (1986) with a Preface written in December 1983, at the same time I took this module. As a student cohort we are not mentioned, so clearly our insightful comments were not sufficient to shape the book in any way. More likely, its content was 'tested out' on us as this current book was on my own students, in autumn 2022. Amongst that content, and equally engrossing to me as

the ethnographic components, was an in-depth discussion of the changing climate and how this impacted the Palaeolithic settlement of the book's title.

To return to the Tweet I mentioned in a footnote earlier: looking out of my window today, the 'climate' appears just the same as it did yesterday, and the day before, and many similar days earlier this winter and last winter, and the one before that. Nothing, it seems, has changed. Yet this perception of stability, albeit with changes in the weather (it is sunnier today, but slightly cooler than yesterday) is something we, as archaeologists, have learnt to challenge through recognition of the longer-term view that our specialism affords us. There is a contradiction, in other words, between what we experience from day to day (a perception of stability) and the longer-term perspective which reveals the reality of how much things change over time. It is where 'weirding' comes in—it shakes us from this dangerous misconception! Writer Cal Flyn (2021, 288) explained this same contradiction in her recent *Islands of Abandonment*, in stating that

> even the apocalyptic Permian extinction—the extinction event that dwarfs all others, when the future of life itself appeared in doubt—took place over a period of perhaps 100,000 years. Barely an instant in geological terms; but to a human observer in its midst, living through a tiny snapshot of time, it might appear nothing much was going wrong.

Of course, there were no human populations at that time, but the point concerns perspective, and this is one area where archaeologists' superpowers are clearly in evidence. As archaeologists, we have that capacity to transcend the perspective of the everyday, a bit like zooming away from Earth on our desktop computer, courtesy of Google Earth, to view what has quickly become a mere pin-prick location in global context. As archaeologists we can talk about today's weather compared to yesterday's and what we might expect tomorrow.[9] But we also appreciate our position within a deeper temporal perspective, or the *longue durée* as it has been described (by Braudel 1958).[10]

I first learnt about this longer-term perspective and about the idea of a *longue durée* in my Palaeolithic Europe module. Over the period of the past 700,000 years (700 Kyr), we were taught how, 'ice sheets advanced and retreated, oceans rose and fell, animal communities evolved and plant communities suffered progressive simplification. As far as can be judged no single episode of either warm or cold conditions during this period was identical to any other' (Gamble 1986, 70–71).

[9] As an English archaeologist, even I am surprised at how much I seem to be talking about the weather!
[10] The *longue durée* forms part of a tripartite division that includes short-term *événements* (specific short-term events) and medium-term *conjunctures* (usually periods of decades or centuries over which cultural changes such as the Industrial Revolution can take place).

We learnt, therefore, that, 'human adaptations in Europe have to be viewed not only against the repeated fluctuations of climate on a cyclical basis every 90 Kyr but also against the long-term climatic change toward drier and colder conditions' prior to the interglacial in which we now find ourselves (Gamble 1986, 81). We also know from ethnographic accounts that Indigenous communities who still rely heavily on hunting and gathering, are influenced by seasonal fluctuations in weather and by specific weather events. Indigenous people have also developed strategies for their adaptation to just these fluctuations and events, in order to ensure their survival. They have developed strategies for survival in other words.

The point of the detailed climatic overview included in Gamble's (1986) study is to contribute to hypotheses around settlement patterns that represent these strategies for survival across the long period of human history. In short, how were people surviving, and how did their strategies for survival compare to what came before, and what would follow? This approach to investigating human adaptation over the long term is only possible from the archaeological perspective. As Flyn points out, on the ground, how much would people have realized what was happening? With a strong oral history tradition, perhaps there was a sense of better or much harder times in the past, much like our parents tell us about harsher winters even as recently as the 1980s.[11] Gamble (1986, 97) also touches on this, when he says, given the climatic fluctuations across this long period of history, that 'no sooner had they become established than populations would have had to retreat since few of the [climatic] episodes were of sustained duration'.

In a recent study, authors from a range of related disciplines (Mondanaro et al. 2020) have used a variety of data sources (including notably archaeological and palaeoclimatic) to demonstrate how humans are uniquely able to construct— rather than biologically inherit—a climatic niche. This was mentioned briefly at the start of the chapter. Humans, the authors suggest, use their cognitive abilities to successfully inhabit all environments on Earth, something other animals cannot do. Separately, other authors (e.g. Lyon et al. 2022) have argued that this temporal perspective on human adaptations to changing climates in the past is vital for future planning. Currently future planning (notably through the Working Groups of the Intergovernmental Panel for Climate Change, IPCC) takes us only to the year 2100. This was the benchmark first used for climate projects in the 1980s and 1990s. Perhaps then it was a suitably distant horizon. That is no longer the case however, being only one human lifespan away. Instead of 2100, Lyon et al. argue for extending climate projections through to 2500,[12] with scenarios representing strong, moderate, and weak global climate policy. Their projections model climate and vegetation, heat stress and human well-being, and agricultural challenges.

[11] Which I remember. Also, I have now become that parent: 'Back in my day...'!

[12] The seven generations, referred to earlier, gives us 210 years, assuming a generation is thirty years in duration. This approach would therefore take us to the year 2234.

This suite of models also illustrates how climate change is integral to other wicked problems such as human health, as well as economic factors that may impact social injustice and cause conflict.

Therefore, to briefly summarize an immense and complex field of study: from the archaeological perspective, we have learnt to view changes to human behaviours over time through a series of lenses. One of those lenses comprises material culture, being the things people have left behind and which have been recovered by archaeologists and interpreted. Material culture changes over time, relative to and often determined by a diversity of social, economic, technological, environmental (including climatic), and sometimes political factors. Another (related) lens is the climate that people experienced and how changes in the climate caused people either to behave in different ways, by relying on different natural resources for example, or to live in different places or even follow entirely different lifestyles depending, for instance, on the resources that they had come to rely upon. While not necessarily always a determining factor, the climate, and climate change were important to people in the past just as they are to people today. This is why learning how people responded to it in the past can help understand, and perhaps even shape, survival strategies in and for the future. The existence of these lenses highlights the relevance of archaeology and serves to emphasize why the superpower archaeologists hold is such an important one to have. We may not be able to unfuck this situation by ourselves but, by working with other scientists, specialists, and policymakers, by being good policy entrepreneurs seeking some significant small wins, using the knowledge and perspectives we have established from being archaeologists, we can be part of the solution.

Climate Change as a Wicked Problem

In the previous chapter the idea of wicked problems was introduced alongside a discussion of the policy frameworks within which they exist. It also introduced the idea that some of these wicked problems (including climate change) might be better referred to as super wicked problems, given the high degree of complexity and their significance to the future of the planet and to humanity. As stated previously (and after Levin et al. 2012, Lazarus 2009, and specifically Peters 2017, 388), this concept of super wicked problems captures those problems for which:

1. Time is running out.
2. There is no central authority, or only a weak central authority, to manage the problem.
3. The same actors causing the problem are needed to solve it.
4. The future is discounted radically so that contemporary solutions become less valuable.

As Peters (2017) goes on to note, for these super wicked problems, the element of time has particular and direct relevance, proceeding to describe how, in the case of climate change, 'there are a number of clear and compelling predictions of irreversible harm if there are not significant policy interventions.'

In his book *Hyperobjects: Philosophy and Ecology after the End of the World*, Timothy Morton (2013) specifically describes the climate emergency as a wicked problem, one that places intense and transformative pressure on our patterns of reasoning, demanding an overhaul of some of our key ideas and values. In a critical review of that book, Boulton (2016) notes that climate change, 'renders vulnerability as the tangible human experience of environmental degradation and destabilizes our sense of existence to the extent that it challenges human scale understandings of personhood, planetary existence and cognition in general' (cited in Armstrong and Pratt-Boyden 2021, 227).

In published literature reviews, climate change is amongst the most commonly cited of wicked problems. Danken et al. (2016, 20) for example identified forty-three contributions (41 per cent of their sample of 105 research papers) that dealt either with environmental resource management or global climate change. Through this analysis, they refer to climate change as the 'quintessential example of a wicked problem... mentioned as a single policy problem' in 20 per cent of all 105 contributions. Some authors regard this problem as so challenging and so immensely complex that it may ultimately be beyond resolution. Grint (2010b, 4, cited in Danken et al. 2016) for example concludes by stating that 'we can make things better or worse—we can drive our cars slower and less or faster and more—but we may not be able to solve Global Warming, we may just have to learn to live with a different world and make the best of it we can' As Tutton (2017, 490) notes, the philosopher Slavoj Žižek (2011) makes a similar point, that, 'any attempt at resolving global warming and its effects requires significant change to contemporary capitalism', recognising that total catastrophe which ends all life on earth is more likely to occur.[13]

This challenge relates to what has also been referred to as complexity theory (e.g. Cairney 2012, 347), in which we, 'identify (and then explain) systems or processes that lack the order and stability required to produce universal rules about behaviour and outcomes... [being] a "new way of thinking" and "seeing the world"; as a "world of instability and fluctuations" when in the past it was seen as "stable"'.

This complexity in turn raises the question of how small wins align with the wicked problem of climate change, or more precisely, what small wins might look like in this arena and how archaeology (specifically) can be used to achieve them. I shall return to this point later in the chapter.

[13] In this context, we may recall George Monbiot's (2021) observations (cited in Chapter 1) around plastic bags and straws in the context of what he referred to as micro-consumerist bollocks.

Here though we should probably define the problem with some precision. Building on the statement from van der Noort (2013), cited at the beginning of this chapter, I have chosen to do so using some statements from the United Nations website, having been drawn to this overview specifically by the optimistic title: 'The Climate Crisis—A Race We Can Win' (https://www.un.org/en/un75/climate-crisis-race-we-can-win). Defining the climate crisis as 'the defining crisis of our time and [one that is] happening even more quickly than we feared', it goes on to define the problem thus:

> No corner of the globe is immune from the devastating consequences of climate change. Rising temperatures are fuelling environmental degradation, natural disasters, weather extremes, food and water insecurity, economic disruption, conflict, and terrorism. Sea levels are rising, the Arctic is melting, coral reefs are dying, oceans are acidifying, and forests are burning. It is clear that business as usual is not good enough. As the infinite cost of climate change reaches irreversible highs, now is the time for bold collective action.

These problems and challenges and how they are reflected in future climate projections, is summarized here in Figure 2.2.

By stating that '[r]ising temperatures are fuelling...food and water insecurity, economic disruption, conflict, and terrorism', this UN statement also helpfully signposts the subject of this book's Chapter 5, that of entanglement and the complex relations that exist between the many wicked problems facing the planet and its occupants, human and non-human alike.

With a focus particularly on rising global temperatures, the UN statement goes on to describe how:

> Billions of tons of CO2 are released into the atmosphere every year as a result of coal, oil, and gas production. Human activity is producing greenhouse gas emissions at a record high, with no signs of slowing down. According to a ten-year summary of United Nations Environment Programme (UNEP) Emission Gap reports, we are on track to maintain a 'business as usual' trajectory.

> The last four years were the four hottest on record. According to a September 2019 World Meteorological Organization (WMO) report, we are at least one degree Celsius above pre industrial levels and close to what scientists warn would be 'an unacceptable risk'. The 2015 Paris Agreement on climate change calls for holding eventual warming 'well below' two degrees Celsius, and for the pursuit of efforts to limit the increase even further, to 1.5 degrees. But if we don't slow global emissions, temperatures could rise to above three degrees Celsius by 2100, causing further irreversible damage to our ecosystems.

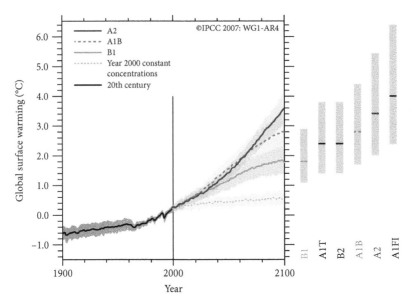

Figure 2.2 Future projections of a changing climate

Notes: The principal different scenario families are described in (IPCC 2000, 4–5), but summarized here:

A1—a future with very rapid economic and population growth which reaches its peak around AD 2050 and falls thereafter, but also one wherein new and efficient technologies are introduced. A1Fi = a fossil-intensive storyline; A1T = non-fossil energy storyline; A1B = balanced use of a range of renewable and non-renewable energy storylines.

A2—a future with economic and population growth but one wherein regional differences and self-reliance are maintained and where the global population continues to grow after AD 2050 and where new and efficient technologies are introduced at a much slower pace than in A1.

B1—a future with an increasingly integrated and cooperative world seeking global sustainability, where population peaks around AD2050 but falls thereafter and where rapidly changing economic structures enable the emergence of clean and resource-efficient technologies.

B2—a future with an emphasis on regional and local sustainability, with a growing population and where new and resource-efficient technologies are developed but introduced at a slower pace on a global scale because of the fragmented nature of this scenario family.

Source: From IPCC (2007b), with permission; see also IPCC (2007c).

Glaciers and ice sheets in polar and mountain regions are already melting faster than ever, causing sea levels to rise. Almost two-thirds of the world's cities with populations of over five million are located in areas at risk of sea level rise and almost 40 per cent of the world's population live within 100 km of a coast. If no action is taken, entire districts of New York, Shanghai, Abu Dhabi, Osaka, Rio de Janeiro, and many other cities could find themselves underwater within our lifetimes, displacing millions of people.

Some of these trends and trajectories are illustrated here in Figure 2.3.

CLIMATE CHANGE 61

As Figure 2.3 highlights, the situation appears bleak, with all of the data (a rising average temperature, rising sea levels, and declining snow cover) suggesting the same overall trajectory. Yet the tone of the statements presented in this part of the UN's website is one of optimism, aligning it with a similar mood at the recently concluded UN Climate Change Conference 2021 (COP26) with its universal recognition both of the need for action and the suggestion that this was a battle that could eventually be won. As an example of the positive mood of

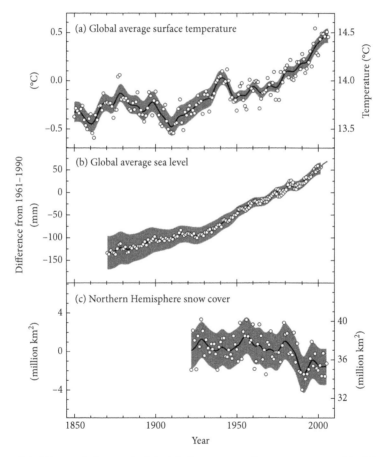

Figure 2.3 Observed changes in (a) global average surface temperature, (b) global average sea level from tide gauge data, and (c) Northern Hemisphere snow cover for March–April.

Notes: All changes are relative to corresponding averages for the period 1961–1990. Smoothed curves represent decadal average values while circles show yearly values. The shaded areas are the uncertainty intervals estimated from a comprehensive analysis of known uncertainties (a and b) and from the time series (c).

Source: From IPCC (2007a), with permission.

COP26, in his Foreword to the 'COP26 Explained' document, Alok Sharma, the COP president-designate, said that: 'At COP26, we will work with partners to take forward action on protecting and restoring forests and critical ecosystems, and we will champion the transition towards sustainable, resilient and nature positive agriculture.'

There is no denying the scale of the challenge. It brings to mind observations made previously (and in the previous chapter) by Conklin (2006, 11) that the 'problem' is often hard to define, not least because what constitutes the problem is fluid; that 'the understanding of the problem, the "real issue", is changing and growing'.

Brian Head (2008, 113), a leading scholar on wicked problems and public policy, outlines the various factors that render climate change as a particular and particularly challenging wicked problem. Amongst these factors is the recognition that climate change is in fact a series of linked problems, none of which can be resolved in isolation.[14] There is an issue with the short- and longer-term calculations of impacts, costs, and benefits of interventions, which are highly variable. The impacts of climate change are local, regional, national, and global simultaneously, thus making the understanding of impacts and mitigation very complicated. As is widely acknowledged, not least amongst the global public, the extent of climate change and the human contribution to it, is contested, with a good deal of scepticism in some quarters, focused in particular on the interpretation of the evidence upon which the crisis has been defined. The allocation of responsibility—amongst government, corporations, individual citizens—for changing their behaviours or making investment is also fraught with difficulty. There are then the local issues. In Australia, for example, there is debate around whether the country's responsibility in tackling climate change requires leadership, by encouraging investment in new green technologies for example, or whether it should hide behind other nations and make only incremental changes ('small wins', relatively speaking) that can require less investment in the short term.

To summarize, climate change is a problem of the highest order, sometimes referred to as a super wicked problem (after Peters 2017) or a 'very wicked problem' (after Alford and Head 2017, 402). It is highly complex, its causes (and indeed—albeit rarely—its very existence as a problem) are sometimes disputed. Yet there is optimism that a seemingly irreversible set of damaging trends can be slowed and perhaps even reversed. More realistically, we can also perhaps render this particular problem more manageable by breaking it down and recognizing some individual aspects of the problem. If we return to the conditions of a

[14] Back to entanglement again, for which fast-forward to Chapter 5.

wicked problem, as defined for example by Alford and Head (2017, 407), we can see how this particular problem of climate change:

1. Has structural complexity.
2. Is unknowable, along with the solution.
3. Suffers from knowledge fragmentation, given the number of specialisms and stakeholders involved,
4. and also knowledge framing, in that 'some of the knowledge receives either too much or too little attention'.
5. Involves stakeholders with interests that are in conflict with one another— in this case that might include representatives of industry on the one hand and scientists on the other. This is referred to as 'interest differentiation'.
6. Highlights the dysfunctional distribution of power amongst stakeholders.

There are different elements to this problem, therefore, some of which require data to help solve them, some are infrastructural, and some require the actions of individuals. That then seems like an appropriate point from which to move on to consider why archaeologists might be helpful in this debate. Should archaeologists be amongst the stakeholders and, if so, why?

Why Climate Change Research Needs Archaeology

Let us begin with van der Noort's (2013, xii) comment that: 'When it comes to understanding the impact of climate change on the environment, and how this will affect communities, the past is mostly ignored by the climate change science community.' This is in spite of the fact that, as we have seen already, archaeology has a long and illustrious history of engagement with climate change research, largely due to its interest in the many and complex ways that people in the past interacted with their environment across time. The example of Palaeolithic Europe exemplifies this as demonstrated by Gamble's (1986) authoritative overview of mobility and adaptation, with people constantly creating strategies for survival in what, over the *longue durée*, was an ever-changing landscape. An archaeological perspective on climate change shows 'the great diversity in human cultural responses to environmental change', even in the deep past (Hudson et al. 2012, 316). I will present some examples of archaeological perspectives later in the chapter, emphasizing some studies that have a public-facing element.

To pre-empt these examples and the following discussion, it is worth recalling Giddens's (2009) comment at the start of this chapter: that 'many people will sit on their hands and do nothing' given that 'the dangers posed by global warming aren't tangible, immediate or visible in the course of everyday life'. For those archaeologists specializing in this particular field, or people living and working in

places where the signs of a changing climate are at their most obvious (for example in the Arctic region), climate change is both visible and obvious. As we shall see, there are many examples of archaeologists taking a proactive view of this particular wicked problem. But this was not always the case.

Let me give an example of this passive approach and how things have improved more recently. In their helpful overview of 'prospects and challenges for an archaeology of global climate change', Hudson et al. (2012) highlighted that a decade ago at time of writing, little attempt had been made by archaeologists to employ their knowledge and expertise within climate change discourse. And to counter this lack of engagement, they went on to propose five areas of archaeological research that might have particular relevance in helping to address it using an archaeological lens. In many of these five areas, there have been significant developments over the course of the past decade.

First: How past society managed decline and recovery in the face of long-term climatic and environmental change. On the face of it, this would seem a rather traditional approach that broadly aligns with the example of settlement change and human adaptation in Palaeolithic Europe, cited earlier. It also aligns with the collaboration that exists between the natural and human historical disciplines to address the interaction between people and landscape over the longer term. This field of study has been referred to variously as environmental history (e.g. McNeill 2003) and human ecodynamics (e.g. Harrison and Maher 2014), as cited in Holm and Winiwarter (2017, 116). But there have been significant recent developments in the way this area of archaeological research has been conducted, and by whom. To focus on one notable example, Burke et al. (2021) describe the significance of recently increased computer capacity and the widespread adoption of machine learning and modelling techniques. As Burke at al. go on to say, following early research which can be best characterized as an 'inductive approach', focused on correlating changes in the archaeological record with climate events,

> modelling approaches are used both inductively and deductively. Models can be designed to test hypotheses generated from anthropological and evolutionary theory about the sensitivity of human systems to environmental change across a range of temporal and spatial scales. They can focus on the mechanisms underlying human–environment interactions and explore their biological, social and ecological ramifications... Complex systems approaches provide a framework for this type of modelling, with established methods for exploring mechanistic linkages across spatial and temporal scales, how human systems react to environmental tipping points, and how patterns emerge at the population level from the collective actions of individuals. This includes methods for evaluating the adaptive capacity of human systems, for example by simulating the effects of changing decision rules about land use, reproduction, or mobility in response to environmental change.

Second, Hudson et al. (2012) consider ways that archaeology can inform and allow a reconfiguration of the nature–culture divide, particularly given the recognition of wicked problems as disturbingly messy and entangled, not neat, distinct, separate, and articulate. As we have already seen, archaeology involves the study of human behaviours primarily through the material culture that they generate, and this includes the processes of production, use, and discard within the context of change, whether social, political, or environmental. These things cannot be separated off and treated in isolation from one another. They are deeply entangled today just as they were in the past. Understanding entanglement and its societal implications is something archaeologists are closely familiar with. As previously stated, entanglement forms the subject of further discussion in a break from the thematic chapters, in Chapter 5.

Third, the authors address public archaeology, which involves the rendering of archaeological research more accessible to the public while encouraging the public's direct involvement with it. Such public archaeology, Hudson et al. (2012) argue, can help promote education about environmental impacts. To return again to Giddens (2009) quotation at the start of this chapter, people can tend to sit on their hands and do nothing, given that the impacts of climate change are not always immediate or obvious. Archaeology makes these impacts visible and draws them into people's everyday experience. As Paul Ehrlich (2011, 6) has said (and cited in Hudson et al. 2012, 322): 'Arguably, no challenge faced by humanity is more critical than generating an environmentally literate public.'

Fourth, archaeology can also contribute to the study of social injustice[15] and how this might affect responses to the environment. Of all the contributions that archaeology can make, this is arguably the most compelling and Hudson et al. (2012, 322) state their position here clearly: 'If archaeology was simply the study of the material remains of the (distant) past, its relevance to current climate change debate would be rather limited. It is, however, the ability of archaeology to use the past to rethink the present that gives it a significant voice in the debate.'[16]

Or at least, it should! Perhaps one of the reasons that its voice has not been heard as loudly or as clearly as archaeologists might have expected, is Hudson et al.'s later observation (2012) where climate change is referred to as a question of justice/power in which '[t]he interests of the unborn and the unseen' (Kjellen 2006) have to be defended. Archaeology does not deal directly with the unborn,[17] but can be said to hold a privileged position with respect to the 'unseen'.

Archaeology is a fast-moving discipline and Hudson et al. made these compelling observations a decade ago, at time of writing. Since that time, significant developments have been made to align archaeological and heritage research (see

[15] The subject of Chapter 6.
[16] Beyond 'the present', it seems obvious here to add 'and the future'.
[17] But it should. See below, and note in particular the views of Holtorf and others, and Harrison et al.'s (2020) Heritage Futures project.

the section on 'heritage', below) as a critical engagement with the future, or the 'unborn', in Kjellen's words. Also since Hudson et al.'s publication in 2012, a comparatively new area of archaeological research has matured—the archaeology of the contemporary past, or simply 'contemporary archaeology' (Harrison and Schofield 2010). We might also refer to this as the archaeology of the Plastic Age, as we will see in Chapter 3. Particularly relevant here is the role of archaeology in interpreting contemporary adaptations to climate change and engagement with the debate, beyond its traditional focus on how people adapted and responded to it in the deeper past. The contemporary past provides a significant and arguably also unique opportunity for archaeologists, using material remains, to confront the 'taken for granteds' of a supposedly familiar world (Graves-Brown 2000, 1; Buchli and Lucas 2001), to address and perhaps also confront those things about our world that we think we understand. This focus on the contemporary world presents archaeology with new opportunities to focus on both the 'unseen' and the unborn, and to be activist in its approach. This goes beyond Hudson et al.'s (2012, 322) observation that archaeology can, 'use the past to rethink the present'. Archaeology can also use the past to envisage many possible futures and devise sustainable and realistic mitigation strategies for the grand challenges we are likely to face whatever course the future might take.

Finally, archaeology can contribute to common 'intercultural' responses to climate change. I should begin by highlighting the very obvious point (to archaeologists at least) that archaeology is already a highly interdisciplinary field of research. It is harder to think of subjects with which archaeology has no obvious connection, than to list all of those with which it does! In this regard, Hudson et al. (2012, 323) cite Cornell et al.'s (2010) observation that to meet the challenges presented by such things as climate change requires us (the scientists) 'to do unfamiliar and even uncomfortable things'. We need to work in new ways, with people from subjects we have not worked with before. For some scientists and policymakers, including representatives of industry, this experience might indeed be uncomfortable. But for archaeologists at least this will not usually be the case.[18] What is needed are networks and the opportunities to make our voices heard within the context of those networks, in a setting where people are more likely to listen. That is not to suggest that archaeology's voice should have primacy in any sense. It is more the case that archaeologists should join the choir, and occasionally have the opportunity to deliver a solo. Sometimes, archaeologists have joined choirs, but more often than not, they have either chosen not to, or been denied

[18] Indeed it is where archaeologists have the advantage of considerable experience. Maybe this is another of archaeologists' superpowers: the ability to work and communicate easily with scientists from other disciplines, as well as the public. In general, archaeologists are good at working with the media, and people will often listen attentively to the stories they tell.

entry. And we are certainly not members of those choirs that attract big audiences. I will give an example of this.

While archaeologists have a particular, distinctive, and informed view on climate change, and many publications describing examples across the globe and from all periods exist to demonstrate this, archaeologists have not yet managed to find a platform to present their viewpoint to larger audiences. But things may be changing, as archaeologists were present at the recent UN Climate Change Conference in Glasgow, COP26. Jane Downes from the United Kingdom's University of the Highlands and Islands, for example, delivered the prestigious Dalrymple Lectures during the conference, on the theme 'Archaeology, Climate Change and Sustainability: Island Perspectives'. But what about the influential IPCC, which I mentioned at the start of this chapter, and which has the brief, 'to assess on a comprehensive, objective, open and transparent basis the scientific, technical and socio-economic information relevant to understanding the scientific basis of human-induced climate change, its potential impacts and options for adaptation and mitigation' (cited in Holm and Winiwarter 2017, 115)?

This Panel was created in 1988 by the United Nations Environment Programme (or UNEP) along with the World Meteorological Association (WMO) as the authoritative assembly of expertise on planetary change. Holm and Winiwarter (2017) have researched the composition of this Panel and did so by identifying the discipline of the 468 authors of the various IPCC reports, using a web search methodology. This was established by self-identification of each author according to their job title, discipline of highest degree and any other obvious professional identifiers. Given all that I have said about archaeology's unique perspective on climate change (citing many other authors), you'd expect a whole bunch of archaeologists on this Panel, wouldn't you, alongside all of the other diverse specialisms? Yet if that is your expectation, then you'd be wrong. Quite reasonably, the results revealed that 46 per cent of authors came from the social sciences and humanities while the remainder were from engineering and natural science backgrounds. So far so good. However, this overview masks some interesting detail. For example, of the thirty-five 'coordinating lead authors', fourteen are economists, one is a lawyer and twenty are engineers or energy specialists. This fairly close disciplinary concentration is diluted slightly for 'secondary lead authors' and further still for 'contributing authors'. But here's the rub. Taking all of these three layers of expertise, comprising 468 authors, at the time of Holm and Winiwarter's (2017) publication, there was not one archaeologist. Not one. There was one historian (a 'secondary lead author') with (apparently) sole responsibility for representing 'the past' in this crucial research arena. It is comforting to read (in Holm and Winiwarter 2017, 119) that, '[a]ll five (IPCC) Assessment Reports published to date have used historical information to varying degrees', just as it is encouraging to read Morel and oud Ammerveld's

(2021, 280–281) review summarizing references to heritage within IPCC documents in a 2017 preliminary report. Yet while Morel and oud Ammerveld's summary (and Morel's summary report in 2018) describes IPCC's recognition of the 'critical contribution heritage studies[19] can have towards climate action', the absence of archaeologists and heritage professions across the IPCC panels still appears short-sighted given the complexity and richness of the data that have accrued since archaeologists first began investigating the changing relationships between humans and their environment.[20] This short-sightedness appears to be reinforced in the observation by Rockman and Hritz (2020, 8297) that what archaeological evidence is available to the Panels is often not being used. In the IPCC Fifth Assessment Working Group II Report, for example, they describe how references are made in the Report to past societies such as the Mayan civilization, early Mesopotamia, and Viking settlements in Greenland:

> That this IPCC case study ends with the statement 'It would be useful to consider how lessons learned from historical experience may relate to the perceived multiple environmental changes characterised by the "Anthropocene"' is strong evidence that use of archaeological information for climate change action is not yet clearly defined or practised. (Rockman and Hritz (2020, 8297)

Holm and Winiwarter's conclusion to their investigation of IPCC WG III is therefore obvious: 'There is a need for a science-policy change that includes changes in recruitment of authors as well as a review of what is considered "useful knowledge" by the IPCC' (2017, 121).

One of the authors of this paper also added the following, in an email (Winiwarter, pers. comm):

> The [Panel] works under extreme pressure and I know many authors personally who try their very best but reaching consensus in the political realm is mind-wrecking. The only social science that seamlessly works with climate models is economics (in fact, integrated assessment models have long included economics), and hence, the dominance of economic scholars. I personally think that it is the dominance of modelling and orientation towards the future that makes them unaware of or unable to integrate historical evidence, be it archaeological or historical. The great works of climate history get scant, if any attention. This is a modelling-driven group of people and not a sum total of all relevant evidence.

[19] Which includes archaeology.
[20] To cite Holm and Winiwarter (2017, 116): 'The idea that human action has a planetary impact may be ascribed to the historian George Perkins Marsh. In *Man and Nature* (1864), revised as *The Earth as Modified by Human Action* (1874), Marsh argued that unmanaged exploitation and cultivation of natural resources has altered and ultimately destroyed land through history.'

This was an observation also made by van der Noort (2013, 2) ten years ago when he described how studies of societies adapting to climate change in the past have made no impression on the debates on the ways humanity will need to adapt to climate change. This, he said, was true of the IPCC reports and of the Stern Report (Stern 2006), and in much of the academic literature on climate change. Crucially, this disregard is not because archaeologists are unwilling to participate in the debate. The main reason is because, according to van der Noort (2013, 2), for many people, the

> past appears to provide few, if any, 'lessons' for the future. There is a broad realisation that the 'present situation is dire precisely because there is no clear precedent for global environmental mismanagement' (Yoffee 2010, 178), and it is undeniably true that we live now with a globalised 'fossil fuel energy system' that has no parallel in the past (McNeill 2010, 364).

The irony here is that archaeology *is* mostly about the future and how we can use what we have learnt from the past to ensure that that future is more secure. But that requires science and philosophy to work alongside and to help inform policy. Jungcurt (2013) helpfully frames this relationship in terms of what Gieryn (1983) previously defined as 'boundary work', being the need for scientists in one field of research, to 'expand authority or expertise into domains claimed by other professions or occupations' (1983, 791). The definition has now been extended to focus, as Jungcurt (2013, 255) puts it,

> on the social processes at the boundary between the production of scientific and other types of knowledge as well as decision-making processes. The concept [therefore] goes against earlier representations of the science-policy interface which are based on science and policy as distinct and separate worlds depicting science as the world of neutral and independent facts and policy making as the world of values.

'Boundary work' is an arena in which archaeologists can work effectively alongside policy makers, and have influence, potentially at least.[21] I will refer to this idea of boundary work in the book's closing chapter.

With all of this in mind, let us then see what archaeologists have done more recently to address and better understand the global challenges of climate change and how such information and insight might be better used to mitigate risk and

[21] We should also recognize here the important point made recently by Gay-Antaki (2021) that women's experiences as IPCC authors show how 'gender, race, nationality etc. increase barriers to participate in the production of climate science, even for the best scientists'. This represents another urgent issue, additional to the representation of archaeologists on the Panel.

help address the wicked problem of climate change, through the small wins framework identified in Chapter 1.

Archaeologists Tackle Climate Change

I have already said that archaeologists have been studying the impact of climate change on human populations for decades. I have also addressed climate change as a wicked problem and examined some of the reasons why climate change research needs archaeology. But what does the archaeology of climate change look like, and what can we learn from it to demonstrate that archaeological data and heritage perspectives are not only relevant but central to climate change discourse? We should also recall the argument that archaeologies of climate change relate not only to what the data tell us about human responses in the past, and strategies for survival, but how they help us to think about the issues in new ways, and not merely as an inevitable and impending disaster. I will address that question with a few select examples.

Recognizing that many authors have published research papers that present good examples of archaeological contributions to climate change (e.g. Burke et al. 2021, and Sandweiss and Kelley 2012, whose overview presents examples from as far afield as Peru, northern Mesopotamia, Maine, the United States, and Shetland, Scotland), I will outline three that together represent geographical range and diversity in methods and perspective: from East Africa, the Arctic region, and the English coastline. These examples will be summarized, and the main sources signposted, given that the main purpose of this chapter is to explore the relevance of archaeological data and the importance of archaeological perspectives to climate change debate, rather than to focus on the details of the archaeological work undertaken.

I will begin in East Africa (and specifically, the countries of Kenya, Uganda, Tanzania, Rwanda, and Burundi). We know from evidence from sedimentary cores from across this region that some areas and their associated ecosystems are more resilient to climate change than others and, equally, that some areas have experienced greater degrees of climate change (Marchant and Lane 2014, 14). As we have already established, this palaeoenvironmental record can provide the foundation (or the benchmark) for exploring change in the present as well as testing (or modelling) future predictions. In other words, the palaeoenvironmental record can be vital for future-proofing the various alternative scenarios suggested by climatic data. The archaeological evidence (by which I mean the material record in this context) is what provides the human story or, more precisely, the narratives around which humans adapted to the changing climate and adjusted their environment accordingly. It should be obvious that we need to consider both categories of evidence together in order to maximize the chances of

using these data to help shape solutions and model resilience.[22] As Marchant and Lane (2014, 15) have described it:

> A range of techniques combine to illustrate how human population composition and distribution has changed, and how the interaction with the environment has evolved. This evidence varies from direct analysis of past occupation layers revealed by diverse sources ranging from archaeological investigations to linguistics, and from molecular markers to documentary evidence. (Citations within the original have been removed)

This example highlights also the complexity of the dynamic relations that exist between people and their landscape, and how an understanding of this complexity is vital to mitigating future climate change impacts. Marchant and Lane (2014) highlight for example how the three factors of climate change, land use, and the human population serve as drivers which interact to determine the composition of an ecosystem. These drivers, they suggest, influence the nature of the resource base and the economic benefits of plant resources to society. Managing this interaction effectively forms the basis of sustainable development, especially where the temporal perspective (in the sense of longer-term viability) is introduced into the equation.

Richer et al. (2019) make similar observations, recognizing how authors (themselves included) have described how an understanding of both people, and how their ecosystems have responded to past climate change, can be 'highly relevant to questions of sustainability'. Their main point, however, concerns communication. The value of archaeological and paleoenvironmental data, they suggest, is not the data themselves, or even their interpretation, but rather how they are communicated and interpreted to the diverse audiences (and notably policymakers) who might make use of them. Perhaps this is why there are no archaeologists on the IPCC working groups: because the data that archaeologists present are not being offered in such a way that they can be easily understood and used; that IPCC find the archaeological data hard to interpret in terms of creating solutions and delivering mitigation. Perhaps also these archaeological data are not being presented by policy entrepreneurs in settings where they might catch the attention of policymakers and politicians. I shall return to this point (and with a particular emphasis on the value of Indigenous knowledge and the benefits of co-designing archaeological projects) in this chapter's conclusion.

We next head north, to the Arctic region but with the same emphasis as the previous example: how can the evidence of past responses to climate change help shape future strategies? Again the example refers to the need for better communication of results if we (as archaeologists and heritage practitioners) are to have the influence we believe that our work deserves within a policy setting.

[22] If indeed they can ever be separated, which I would always question!

In their recent overview of Arctic archaeology and climate change, Desjardins and Jordan (2019) present the Arctic region as 'one of the best suited regions on Earth' to address the issue of climate adaptation, and how our understanding of that adaptation can help shape future planning and mitigation. The authors describe the archaeological and palaeoenvironmental records on which interpretation is based as 'palaeo-societal archives' which, ironically given that the techniques for their investigation are rapidly improving, are fast disappearing due to anthropogenic warming.

The traditional argument around climatic change and human adaptation in the Arctic is a straightforward and seemingly logical one: that warmer conditions led to the retreat of heavy sea ice during cold seasons which then increased the abundance and geographic range of high-utility marine mammals such as whales and walruses. 'Marine-adapted hunter-gatherer cultures simply followed on behind' (2019, 280). But herein lies a problem. Such 'monocausal, environmentally deterministic arguments' that assume direct links between climate change on the one hand and cultural response on the other, oversimplify a complex set of interrelationships. And it is these interrelationships that archaeologists need to both understand themselves and then articulate to non-specialist audiences if the message around significance is to be conveyed effectively and have impact. Desjardins and Jordan (2019, 280) highlight three shortcomings with this oversimplification. First, that it implies a lack of agency among Arctic peoples, whose decisions 'are reduced to automatic reactions to stark environmental pressures'. Second, the relationships that exist between climate and the availability of resources in the Arctic is more complex than was first assumed. Simply, warmer temperatures do not necessarily create increased ecological productivity. In fact, there are arguments to suggest the opposite may be true. And third, that effective responses to new climatic conditions may take generations to gather pace and settle down, while existing traditions may persist long after the new conditions have rendered them inefficient.

These are all shortcomings that most archaeologists would recognize. They may however be counterintuitive amongst non-specialists, making it even more important for archaeologists to engage with the archive in a critical way and to communicate their findings beyond their own discipline. The fact that archaeology is, by its nature, an interdisciplinary field of research, should make this a comparatively simple goal to achieve. (This is a point also raised by Richer et al. in relation to the East Africa example, above.)

Of the examples Desjardins and Jordan (2019) provide, the Norse colonization of Greenland is worth highlighting, as the consequences of climate change played a key role in long-running debates over its failure, at around 965 years before the present (BP). The ultimate disappearance of colonizers from the island at about 475 years BP coincides with a period of intense climatic cooling (2019, 286). The traditional argument here is that the settlements failed because colonists persisted

with unsuitable practices such as farming and animal husbandry, while having a bad attitude towards Indigenous peoples and their practices, from whom they might have learnt to adapt better. However, there is compelling archaeological evidence of the opposite: that

> the Norse made significant adjustments to their subsistence regime over time, including hunting and consuming large amounts of protein from the sea.... An analysis of stable carbon and nitrogen isotopes of 80 Greenlandic Norse burials shows that consumption of marine protein gradually increased from a low of ~15% of the total measurable diet during the early phase of the occupation to between 50% and 80% by the final stages (citing, e.g. Nelson et al. 2012).

Zoological evidence suggests the same conclusions.

Recent research therefore suggests that the explanation here is not environmentally deterministic but may rather revolve around social factors.[23] The Norse colonists had adapted well it seems and in a short time. More significant was likely the economic and perhaps also social isolation from Europe. It is a helpful example, therefore, in illustrating both strategies for survival and the importance of recognizing climatic factors as being amongst a diversity of influences that relate to human behaviours and their archaeological trace.

I will close this brief outline of discussions concerning adaptations in the Arctic region with a further comment on Indigenous knowledge. In a separate study, the same combination of authors (Desjardins et al. 2020) examine the other seventeen case studies included within the same special issue as their own report, to assess the degree to which these studies align with approaches to resilience amongst modern Arctic communities. The conclusions are worth repeating for the fact that they highlight the significance of the dynamic nature of traditional or Indigenous knowledge and its capacity to 'equip Inuit[24] for rapidly changing climates' (2010, 246). Desjardins et al.'s review recognizes the significance of three factors that should be positioned either alongside or in the context of a changing climate and environmental conditions: agency, in terms of how people make their choices and take action; innovation, in the development of new practises and technologies for example; and occasional inefficiency and even unsustainability. To repeat the point, these interrelationships between people and their physical and social worlds are rarely simple and not always painless.

[23] Recalling van der Noort's comment on this point earlier in the chapter.
[24] 'Modern Inuit of Inuit Nunangat (the parts of northern Canada traditionally occupied by Inuit) are the direct cultural and genetic descendants of Thule Inuit populations (ca. 820–350 years BP) that already survived major episodes of climate change in the past.... many modern Inuit are well versed in *Inuit quajimajatuqangit* (Inuktituk for "things long known to Inuit"), which draws from and builds on past experiences, to inform contemporary life and aid in planning for the future' (Desjardins et al. 2020, 241).

Having looked at the various ways archaeological (including palaeoenvironmental) data can contribute to climate change discourse from perspectives that might include traditional knowledge, I move now to an example that explores ways that citizen science can contribute meaningfully both to data generation and to widening awareness. I referred earlier to the fact that, barring seasonal variations and freak weather events ('weirding'), the weather one day is generally the same as it is the next. But that apparent sense of everyday sameness is arguably less evident at the coast. Here, especially on 'softer' and more exposed coastlines, cliff-falls and inundations can be dramatic, and even fatal in some cases. In these places, we can see coastal erosion happening before our eyes. And as archaeologists we can directly align places like Doggerland (a submerged landscape in the North Sea that was once occupied), to crumbling coastlines, and to low-lying islands with resident populations which may very soon need to leave in advance of rapid inundation.

The British coastline, including these vulnerable areas of the softer east coast, is currently subject to a detailed study through a community archaeology project called CITiZAN.[25]

It seems an obvious point to make, but the world's coastlines are vital to understanding and therefore also to developing ways to help manage climate change. Oceans cover 70 per cent of the surface of the Earth. This gives them an important role as a temperature regulator for the planet. As a member of the CITiZAN team has described it: this makes the coast our 'key messenger' (Band et al. 2021, 17). As Band et al. (2021, 17) go on to say, in the magazine *British Archaeology*:

> [The coast] reveals critical data relating to climate change and uncertainty, on matters such as sea level rises, water salinity, erosion and pollution. It shows us the interdependency between nature and people, and how complex this is, and it helps us understand the physical, biological, social and cultural factors of an environment we are entirely dependent on. Indeed our coast is a whistle-blower, speaking through unique ecosystems that house thousands of plants, people, animals and insects, which reveal hundreds of thousands of years of the nature-culture story.

CITiZAN is a community archaeology project in the United Kingdom, one that works with communities through their volunteers in what has been referred to as citizen science (Figure 2.4). The project's aim is to respond to coastal threats while developing a better understanding of them, and of their causes (Milne et al. 2022), at the same time empowering those communities to identify and understand their environment, its heritage, and the threats posed to that heritage by climate change (Morel et al. 2022). Specific projects include work that reframes thinking around nature and culture on England's soft east coast where, as mentioned previously,

[25] Coastal and Intertidal Zone Archaeological Network—www.citizan.org.uk

Figure 2.4 The CITiZAN team working with volunteers on a shipwreck off the East Kent Coast (England), 2021
Source: Museum of London Archaeology.

erosion of the coastline can be a rapid and highly destructive process (Figure 2.5). Doggerland, the submerged landscape occupied until its inundation some ten thousand years ago, lies just off this coastline, a hidden reminder of what the oceans are capable of as sea levels rise (Gaffney et al. 2007). As an example of this, at comparatively nearby Spurn Point, where the River Humber enters the sea, storms have more-or-less islanded the peninsula, and rather than try to protect this and shore it up, the decision was recently taken to allow nature to take its course returning it to an 'original' state, as a shifting sand and shingle island with a low-tide spit. As Band et al. (2021, 19) state, thinking about and managing sites in this way is 'critical for global climate change, and understanding [it] now and in the past, can help build awareness about climate impacts and the need for long-term planning... with archaeology providing that link across time and narrative in shaping drivers for change'.

The results of these CITiZAN surveys stand as a national point-in-time audit of the state of coastal heritage alongside devising strategies to introduce managed change to key sites and locations over the duration of the project (and see DeSilvey 2017 and the notion of curated decay which is relevant here). They also provide examples of the new language we should develop in the sense of a conceptual framework for understanding coastal transformations in terms of how we articulate loss (Venture et al. 2021).

These approaches are important. But two other aspects of CITiZAN are arguably more important still. As noted above, one aspect is the project's use of volunteers, marshalling citizen scientists to undertake the recording and thus

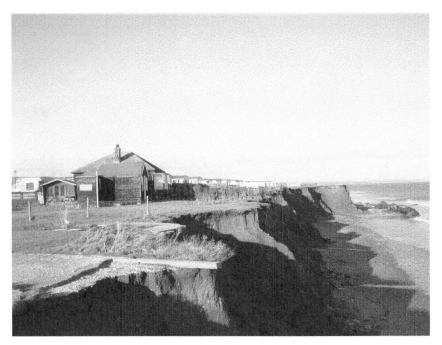

Figure 2.5 Coast erosion bringing properties closer to the cliff edge in 2012, at Ulrome in Lincolnshire (England).

Note: The land visible in the photograph has now been lost to the sea.

Source: Tracey Anne Taylor, licensed for reuse under the Creative Commons Attribution-ShareAlike 2.0 licence.

extend both the message about coastal erosion and the skill set needed to recognize and document it. As Morel et al. (2023) explain, examples include The Humberside Discovery Programme (in England's north-east region) which involves working with a group centred around rehabilitating adults in the community and highlighting the need to adapt programmes according to the audience. Also on England's east coast, at Mersea Island (in the country's south-east), the project has involved developing a communication network across the island to reach the widest cross-section of the community. This point about community agency is important and can lead, for example, to the production of community-centred toolkits, as Buffa, Thompson and Reijerkerk et al. (2023) have demonstrated with Vezo fishing communities in southwestern Madagascar. The second aspect is the wider dissemination of this project's outputs involves reporting at major international events like COP26, where policymakers and politicians, industry stakeholders, and influencers were present. As we have seen already, mega-events such as this present rare opportunities for archaeologists to demonstrate the relevance and the urgency of what they do to a wider audience. The results of CITiZAN are a clear example of what society can learn, of what this knowledge represents in terms of understanding long-term perspectives on a significant and

contemporary global challenge, and of how we might be more proactive in pushing that message with archaeologists in the role of policy entrepreneurs.

To summarize: all three examples, from different environmental settings and different time periods, highlight the many ways that archaeology and its data can contribute to climate change discourse through what Gieryn (1983) and later Jungcurt (2013) have referred to as boundary work, using both real-world examples with an emphasis on resilience and devising strategies for survival. The examples also present a worrying contradiction: that the data that archaeologists need to tell these stories and present their evidence as models for future adaptation and survival are threatened by the very processes that those data are best positioned to document.[26] But notwithstanding the dangers posed to archaeological and palaeo-environmental data and the risk of their being lost without record, we can present clear models or strategies for using these data, coupled with the modelling I referred to earlier, to make meaningful contributions to planning, for example, through policymaking. Burke et al.'s (2021) workflow diagram (Figure 2.6) is one example of how such an approach might look.

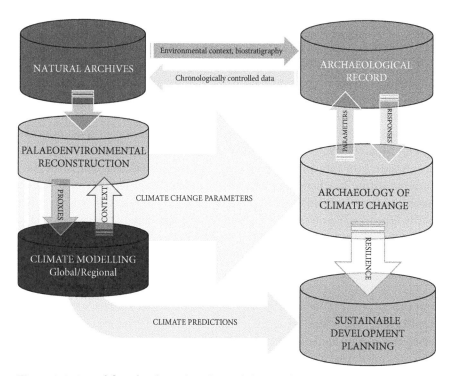

Figure 2.6 A workflow for the archaeology of climate change
Source: After Burke et al. (2021).

[26] Returning us to the Kiel Statement of earlier in the chapter.

Cultural Heritage and Climate Change

To this point, this chapter has focused on the various and diverse ways that archaeology has contributed to the wicked problem of climate change, and the potential to do so further, and better, and in creative and novel ways. I have spoken about boundary work, being the relationship that needs to be developed between the scientists undertaking archaeology and those policymakers responsible for engineering change. With all of these examples and instances, it should be obvious that I am not suggesting that archaeology can solve climate change on its own, but rather to see the advantage of recognizing archaeology's capacity to contribute significant inroads to better understanding the process of climate change and people's resilience towards it. Archaeology also provides the opportunity for people to think about climate change in new ways with the benefit of a deep-time perspective alongside the opportunity to 'place undecidability and speculation as dispositions equally important to urgency and impact' (Pétursdóttir and Sørensen 2023). It also provides opportunities to actively participate in climate change research, through citizen science. These examples and instances amount to what have previously been defined as 'small wins' (Weick 1984), something I discussed in Chapter 1.

Archaeology sits within a wider heritage ecosystem, an ecosystem that includes a diversity of components embracing a variety of disciplines that are focused to varying degrees on nature and culture, on the rural landscape, on urban and peri-urban areas and on historic buildings, to name a few of the more obvious ones. All of the components within this heritage ecosystem are tightly enmeshed. Urban areas include buried archaeological remains for example, whose character and distribution may correlate with and afford shape to the street pattern of the contemporary city and the historic buildings that have survived within it, whether by accident or design. The modern city will often have a historic footprint, which is either clearly legible or harder to decipher partly depending on one's experience and knowledge of the city in question, and partly due to the extent of modern development. The point here is that we cannot easily separate archaeology from the wider heritage landscape of which it is a part.

With that in mind, this section provides an outline of how practitioners and researchers across those other related parts of that wider heritage ecosystem are approaching the wicked problem of climate change. The examples here, as elsewhere in the book, are not claimed as definitive or even necessarily representative in any thematic or geographical sense. The examples I provide are merely *indicative* of an extensive and expanding field of study. It is also worth stating here that, within the heritage sector, practitioners and researchers are often closer to the position where boundary work happens, and are typically only one-step removed from those influential policymakers who I referred to in Chapter 1.

Some within the heritage organizations I am about to mention may even consider themselves to *be* policymakers.

An obvious example for me to give is Historic England, not least given my previous role as an employee of its predecessor, English Heritage. Historic England has a statutory duty to provide advice to the government on heritage matters in England. This brief includes matters related to heritage protection but also contributions to policy. As an example of this, in the text box below, I present Historic England's 2020a position statement on climate change and sustainability, as an example of how national agencies can and do approach this issue from a strategic standpoint.[27]

Historic England's Position on Climate Change and Sustainability (Historic England 2020a)

As an organization we have a duty of care to protect our heritage. We support actions that address the causes of climate change and that reduce greenhouse gas emissions.

These goals are compatible. In fact, looking after and learning from the historic environment contributes positively to overall global sustainability and can help us adapt to and mitigate for climate change. Here's how:

Understanding sustainability over the long term
The UK has the oldest building stock in Europe, thanks to the skills of the conservation sector in 'repair and reuse'. We've studied the materials, operation and design of our historic places, how they've changed through time, how they've been affected by transforming environmental conditions and how previous generations managed both structures and land.

England's historic landscapes, seascapes, built environment and archaeological sites provide environmental benefits, enhance our personal wellbeing and quality of life, and contribute to both national and local economies. Our expertise in looking after, maintaining and adapting heritage sites that have survived for generations uniquely equips us to understand sustainability over the long term. This knowledge can help us to manage historic places and structures for future generations.

Continued

[27] For a UK-wide Joint Heritage Sector Statement on Climate Change, see https://historicengland.org.uk/whats-new/statements/climate-change/

Continued

Sympathetic, informed maintenance, upgrade and reuse of existing buildings and historic places is a sustainable approach

Many of our historic buildings and sites date from a time before the industrial use of carbon and yet are durable and have survived for generations. We can learn a lot from the materials, techniques, design and management of these, including how they have responded to and been affected by changing environmental conditions.

By caring for and reusing heritage assets we can:

- Save energy and carbon dioxide through better maintenance, management and energy efficiency measures
- Avoid the carbon dioxide of constructing new buildings and places

This knowledge can make an important contribution to a low-carbon, sustainable future, not just for those historic sites but also in providing 'green skills'. The skills needed to maintain historic buildings, which make use of low-carbon, sustainable materials and practices, can also be applied to current and future construction.

Taking a 'whole building approach' leads to sustainable decision-making

Modern buildings and historic buildings are different. Not just in their materials, but in their design and the way they function. Understanding how they function and all the factors that affect their energy use is critical for making decisions that improve the sustainability of structures we change, maintain and manage in the future. Factors include: construction, location, environment, historic significance, services and occupant behaviour. We call this the 'whole building approach' and it should be the starting point for any energy-efficiency improvements.

Considering the whole-life carbon of materials leads to more sustainable decisions

Achieving sustainability requires the delivery of environmental, social and economic objectives. Delivering on the environmental objective means protecting and enhancing the historic environment, while also mitigating and adapting to climate change. This encompasses the whole life carbon of building materials—their reparability, durability, reusability and suitability for future conditions. The carbon impact of buildings is not only in their operational carbon (the carbon they require to run on a daily basis) or energy efficiency—it is also in the carbon embodied in their materials and labour. This includes their manufacture, transportation, installation, durability, reparability and reusability. When you take the long view, older buildings and traditional materials are often extremely effective.

There are two aspects to this position statement that I will emphasize, and these coincidentally mirror the more 'archaeological' examples given earlier in the chapter. One is understanding: the fact that we can (put simply) learn from the past, and present evidence that shows how people adapted to changing conditions through the unique archive of the archaeological (and in this case also historic architectural) record. The second is applying that understanding to shaping management decisions for the future through policymaking.

These two principles are so obvious they hardly need stating. Except of course when we recall organizations as vital and as influential as IPCC as a forum within which these aspects are rarely discussed and—to which one assumes—the information is rarely if ever presented, at least not with the important contextual overview of those who produced it and who are best positioned to understand and present their data in ways that appear relevant and meaningful.

To be a policy entrepreneur, to participate in meaningful boundary work and to help create small wins, requires data to help build narratives. And for other non-specialists to take notice requires these narratives or stories to be clear, coherent, and persuasive. Archaeologists are very good at this. They take the long view, and a human view, of places (after Fluck and Dawson 2021, 265), recognizing that people generally feel a strong sense of attachment towards them (and I will say more about place attachment in Chapter 4). Storytelling is what archaeologists do. But elsewhere across the wider heritage sector, often entailing specialists from other academic disciplines, this skill may be less well developed. What we can say is that the data emerging from across this wider field of cultural heritage research is compelling.[28] The potential for good stories is there. Climate change and human adaptation to a changing climate is just one area in which those stories can have transformative influence. Heritage is a 'tool for reflection', as Morel and oud Ammerveld (2021, 275) describe it. But it is also a call to arms, as a research field that is central to the wider climate change debate, and one that people can congregate around, not least for its emphasis on people and the places they feel an attachment towards. This feels important, not least given that there can be problems over expert credibility, including relative to climate change (e.g. Lachapelle et al. 2014). While Downs (1957) noted that rational citizens have little incentive to invest their limited time to learn about the complex issues they face (cited in Lachapelle et al. 2014, 674), those same citizens often enjoy learning about archaeology and are invested in various ways in heritage. When good archaeological stories are told, or heritage is threatened, those citizens do tend to take note. Let me provide a few examples of this potential from across heritage practice.

[28] Some examples of this are included within the recent paper by Riesto et al. (2022), from Denmark and the Netherlands.

In a recent review of risk assessment relative to climate change within urban areas, Quesada-Ganuza et al. (2021) recognized clear gaps in understanding relating to this important point about the vital connections that exist between people and place. They describe for example an imbalance between methodologies focused on flooding compared to other aspects of climate change where further research was (also) urgently needed. Floods are dramatic (and often 'weird') events that can impact people in a direct and very tangible way. There are stories of past floods and the impacts these have caused (people are constantly reminded of these events, by flood gauges on historic buildings for example). But there are few such tangible reminders of heat waves or cold winters which tend not to have the same dramatic and immediate impact. These less-tangible aspects of climate change are vital (and of course they relate directly to flooding events, by association) yet there continues to be a focus on the more dramatic events. A lesson emerging from archaeology is the benefit of treating all indicators of climate change together and within a coherent, holistic, and interdisciplinary perspective.

Orr et al. (2021, 451) conducted a systematic review on climate change and cultural heritage, revealing a 'rich and complex range of research from 2016 to 2020 that has continued to grow in scale since 2015'. One conclusion emerging from this review highlighted another problem in the fact that much of this recent research involved people working in the United States and Europe studying their respective heritage and publishing it across a broad range of media, meaning (amongst other things) that the literature is disparate and therefore difficult to find and synthesize. Furthermore, the majority of the literature concerns the physical impacts of climate change on individual buildings, monuments, or sites and not the implementation of cultural heritage into adaptation and mitigation strategies. As Orr et al. (2021, 452) conclude: '[A] vagueness in approach has been found to limit the translational potential of research in an archaeological context. Further work is needed to understand the impact of this on implementing effective policy practises, especially in the context of climate change policy, driven by time-based agendas and targets.'

It seems, therefore, that in the cultural heritage arena, specialists may be outstanding scholars, practitioners, and researchers. But they don't always know how to become effective policy entrepreneurs and to ensure that their results and conclusions reach the audiences that can facilitate change. Working in the field of wicked problems, that is what is needed. In subsequent chapters I will examine whether the situation is any better with regard to other such problems.[29]

[29] Spoiler alert: I think it is. Because data and issues related to climate change often appear quite distant and beyond resolution (and for some people it isn't even a problem or a crisis), solutions may be harder to find. With other things (being the subjects of later chapters), the problem is more immediately visible and solutions are arguably therefore easier to find.

Small Wins and Policy Entrepreneurship

This all begs the central question: how can archaeologists and heritage professionals make a difference to the climate change debate, beyond simply supplying compelling data and stories, and helping to frame a new way of thinking? The data and stories are vital, as we have seen, but we can and should do more. This is a view widely embedded within the research cultures of higher education where impact beyond academic audiences is strongly encouraged if not a requirement. This closing section builds on the policy frameworks of the first part of the chapter and the examples of the second, to focus on two key areas, asking the questions: first, are small wins important in the context of climate change, or is this more a case of 'all or nothing'; and second, how can archaeologists and heritage professionals extend their reach beyond their own discipline to serve successfully as policy entrepreneurs?

Small wins are, as we saw in Chapter 1, 'a series of concrete, complete outcomes of moderate importance [which build] a pattern that attracts allies and deters opponents. The strategy of small wins incorporates sound psychology and is sensitive to the pragmatics of policymaking' (Weick 1984, 40). Also in Chapter 1 we saw that small wins were possible within this challenging environment and that they can make a difference. It is an approach that has also been referred to as one of 'divide and conquer' (after Xiang 2013, 1), or after Churchman (1967, B-141), 'carving off a piece of the [wicked] problem and finding a rational and feasible solution to this piece.' The disadvantage of course is that the remainder of the wicked problem is left behind, unresolved. With climate change that is particularly concerning.

I would argue that small wins can have an influence here in two ways. First, that a project with a particular outcome (such as the managed retreat described earlier at Spurn Point) can serve as a template or exemplar which other people and places can adapt and embed within planning policies for, in this case, coastal management in areas vulnerable to inundation. We might view this approach at Spurn as employing one of a number of such options available for managing dynamic and vulnerable coastlines, involving four types of loss: invisible, adaptive, inevitable, and radical (after Venture et al. 2021, 397). One might imagine a planning policy map of the coastline with these options mapped onto it as coastal management policies, not a result of public consultation so much as policies derived through co-production. Second, that a small wins framework can generate publicity, and help to both build public understanding for the issue and garner support for any actions that are required to mitigate, in this case, coastal erosion. For another example of a small win we can return to East Africa where Richer et al. (2019) highlight the fact that, in their experience,

communicating research results is insufficient to demonstrate relevance beyond the discipline [arguing that instead] this can be achieved by defining research questions *in partnership with* the people or organisations that might later seek to apply archaeological knowledge or gain insights derived from this knowledge.... [E]nvironmental archaeology projects that seek to have impact beyond the discipline [should] be co-designed and co-produced with end-user audiences. (my emphasis)

Citing Gibbons et al. (1994), Richer et al. (2019) identify two modes of research, in which Mode 1 is driven by intellectual curiosity and undertaken within a 'disciplinary, primarily cognitive, context'; and Mode 2 is where knowledge is created in broader, transdisciplinary social and economic contexts, with the word transdisciplinary meaning work conducted across sectors such as charities, NGOs, and industry. Thus any results arising from Mode 1 research can only be applied retrospectively, as this intention was never part of the original project design. Mode 2, on the other hand, is problem-based and was originally envisioned to engage the humanities (where archaeology traditionally sits) in applied research.

The work described by Richer et al. (2019) provides an example of Mode 2 being applied within the context of climate change research. As they state (2019): 'Within environmental disciplines it has already been recognized that in order to address the global challenges that we are facing today there needs to be a change in how we think about, implement and integrate knowledge and research.' Mode 2 research is one of the ways that this can be achieved and is an approach through which significant small wins can be more easily generated.

Small wins can involve more than the generation of new data and insight, however. Creating new approaches and developing new partnerships can also constitute small wins. The Mode 2 research model outlined above is one example of this. Hambrecht and Rockman (2017, 637) provide another, in the form of four achievable structural and procedural priorities that can drive efforts to deal with climate change threats. These are:

1. Greater knowledge sharing between participants at an international level.
2. More communication to the various publics (local, regional, national and international).
3. The development of tools that local communities and cultural resource managers can use to monitor and prioritize threatened sites.
4. The allocation of more resources by funding agencies, governmental and non-governmental organizations towards projects dealing with the effects of climate change on cultural heritage.

While I would also wish to embed within this framework an additional statement around prioritizing Mode 2 research (after Richer et al. 2019, above),

emphasize the importance of Indigenous knowledge (e.g. Richer et al. 2019) and education (after Lehtonen et al. 2019), prioritize opportunities for citizen science and co-production, and highlight the need for research into the contribution of heritage impacts to creating strategies for managing alternative futures for a landscape impacted by climate change (alongside the impact of climate change on heritage), this kind of wish-list is nonetheless helpful for showing what a realistic small-wins-led approach could look like. Hambrecht and Rockman's (2017) discussion begins from the position that problems on the scale of climate change are too big to tackle, before showing some of the ways that this can be achieved through small wins.

This then brings us back to the role of archaeologists as policy entrepreneurs. In Chapter 1, I cited Sarah Anderson et al. (2020, 604–605) and their three key findings relevant to archaeologists or heritage professionals wishing to exert influence relative to wicked problems. First, they suggested that 'information gathering and dissemination is a critical strategy for policy entrepreneurs in promoting the introduction of legislation' (2020, 604). This was discussed earlier in the chapter through the examples of projects that involved various forms of archaeological investigation and the communication of results to a diversity of audiences. Second, they described that 'when a legislator has had contact with a policy entrepreneur, agenda change is more likely to occur' (2020, 605). Third, they recognized that 'legislators who work with policy entrepreneurs from lobbying and advocacy organisations are significantly more likely to introduce legislation' (2020, 605). In my opinion, it is these two later areas of influence where archaeologists now need to focus their attention.

Conclusion

Harvey and Perry (2015, 8) describe how, 'all human relationships with climate change operate through a lens of heritage'. This is because (they go on), 'all debates, models, experiments and deliberations about climate change have a social context, as do scientific endeavours'. Although this cultural contingency is vital for understanding any aspect of climate change adaptation, these '"cultural dimensions"...are often overlooked in conventional policy discussions' (2015, 8).

With those comments in mind I will present some closing remarks.

There are at least two broad dimensions to presenting archaeology and heritage science as part of the solution to climate change, and as fertile ground for achieving small wins. One involves primary research that generates good data that help society form a better understanding of climate change and human resilience towards it. As Desjardins and Jordan (2019, 280) stated

in their Arctic example earlier, historical disciplines, such as Arctic archaeology, 'have the unique ability to contribute multigenerational human-scale data to the analysis of climate change dynamics. The deep-time perspective promised by archaeology may eventually play a vital role in future climate change mitigation strategies.'

The second dimension involves doing more with these data, by archaeologists acting as policy entrepreneurs and influencing policy- and decision-making. As Rick and Sandweiss (2020, 8252) have put it: 'A key step forward in the coming years is to use...interdisciplinary archaeological examples to engage policy makers, other scientists and the public.' Reminding us of van der Noort's (2013) comment earlier in the chapter about the social element, Rockman and Hritz (2020) refer to the social environment that humans inhabit and which plays host to policymakers and influencers: 'The social environment is created by human interactions, values, expectations, perceptions, and beliefs. The social environment shapes what actions are considered to be possible, acceptable, and desirable' (2020, 8295).

Rockman and Hritz (2020, 8300) recognize a need to change the social environment if the content and process benefits of archaeology and heritage are to be fully realized. For the United States, they make four concrete recommendations: (1) to found a federal climate heritage coordination office; (2) to link archaeology and heritage in climate research and investment;[30] (3) to foster climate heritage demonstration projects; and (4) expand NGOs' attention to heritage.

To avoid sitting on our hands (as Giddens 2009 suggested we had a tendency to do) or squabbling (as Roney mentioned in his response to Quatermass), there are practical steps we can therefore take towards achieving the small wins necessary to help mitigate the wicked problem of climate change. This chapter has identified some examples and some of the challenges we face as archaeologists and heritage scientists in telling the good and compelling stories that might actually persuade people to change their ways or introduce good policies that can make a difference. It isn't only about using archaeology to show that climate change happened in the past and that, as humans, we often adapted to it. Rather it is about using that knowledge to change the way we behave, and the way we think, and to take some ownership of the problem.

It is encouraging to note that writing this chapter coincides with an important and timely publication (Morel et al. 2022) emerging from a co-sponsored meeting involving UNESCO and ICOMOS as well as IUCN, amongst others. The meeting and its report proposed that the heritage and cultural practices that it presents

[30] They currently recognize a situation that is 'fragmented' at national level (Rockman and Hritz 2020, 8297).

(and which align closely with ideas presented in this chapter), 'act as a bridge between different ways of knowing, embody inherited knowledge accumulated over generations, and serve as entry points for climate action. To do so requires acknowledging, respecting and implementing a plurality of knowledge systems inherent in culture, heritage and creative practices' (2022, 2).

Some of the headlines appear obvious (to work collaboratively, across disciplines and sectors), while others highlight messages that are less prominent in climate change discourse, such as the significance of Indigenous knowledge. Knowledge gaps are identified and examples presented from around the globe that describe how these gaps can be addressed. The report also presents four sets of actions, which set an agenda of sorts, recalling the need to think further into the future than is currently the case (Lyon et al. 2021). These actions include: working across knowledge systems, empowering culture and heritage stakeholders to take action, enhancing meaningful collaborations among research, policy and practice, and funding. It is an important document that helps move archaeology and heritage practice beyond what may seem a natural focus on loss and damage, to one that is more proactive, recognizing the benefits and inevitability of changes while mitigating the risks that those changes pose to people's homes and lifestyles.

But to conclude the chapter I will return to a point made in Chapter 1, by Conklin (2006, 11–12) on the nature of messy problems and how success is measured: that learning and attempting to create a solution for a complex and messy problem such as climate change is not a linear process. Recalling Schwartz's (2022, 138) comment from the start of this chapter, that climate change is an economic, political, and epistemological problem (primarily), and Dugmore et al.'s (2013) reference to the appeal of clumsy solutions (from Chapter 1), Conklin describes how

> the natural pattern of problem-solving behaviour may appear chaotic on the surface, but it is the chaos of an earthquake or the breaking of an ocean wave—it reflects a deeper order in the cognitive process. The non-linear pattern of activity that expert designers go through gives us fresh insight into what is happening when we are working on [such] a complex and novel problem [as climate change]. It reveals that the feeling that we are 'wandering all over' is not a mark of stupidity or lack of training. This non-linear process is not a defect, but rather the mark of an intelligent and creative learning process.

This non-linear pattern of problem solving (closely aligning to what Greta Thunberg referred to at the head of this chapter as 'cathedral thinking') is one we shall see again in the next chapter on the related topic of marine plastic pollution. And that won't be the last time we talk about it, either.

Chapter Headlines

- Climate change is a wicked problem (and probably even a super wicked problem). However, this statement bears a contradiction. The planet follows a natural rhythm, alternating warm and cold, interglacial and glacial. For much of human history, people have adapted to this rhythm even though they never noticed the longer-term changes within their lifetimes. But with the Anthropocene, human actions have changed the rhythm, causing rapid global warming and creating weird events that people do notice.
- Numerous scholars and policymakers have helped define this exaggerated rate of climate change as a wicked problem, amongst them archaeologists and professionals working across the heritage sector.
- As a wicked problem, climate change provides a backcloth to most other wicked problems, such as environmental pollution, health and well-being, and social inequality.
- Archaeology can make meaningful contributions to addressing climate change, through a small wins framework. Archaeology provides good data from which narratives can be generated, stories told. These narratives can be persuasive and influential. Archaeology also teaches us to think in new ways about our fast-changing planet from the perspective of deep time.
- Heritage practice operates as an area of research-led policy, changing how things are done (e.g. striving for carbon neutrality through reusing historic buildings as opposed to building new ones) and highlighting areas of good practice.
- Archaeology and heritage practice provide opportunities for people to get directly involved in climate change action, which will help them to think about the issues in new ways and enhance their well-being.
- IPCC is key to the climate change debate, yet questions remain over how effectively (if at all) the Panel is using archaeological data and heritage insight in formulating strategies.
- There is an argument, increasingly compelling, that addressing climate change is less about understanding natural systems and more about understanding social and political systems.
- This is one area where the future is at the forefront of archaeological thinking and practice, or at least it should be.

3
Environmental Pollution

Care should be taken lest an appreciation for human impact becomes conflated with an anthropocentric belief in the power and reach of human managerial control. Waste, in all its variety and complexity, should serve as a reminder that we can never fully grasp the planetary processes to which we contribute, nor can we assume that they are easily managed.

(Reno 2015, 566)

The whole world *can* be plasticized, and even life itself since, we are told, they are beginning to make plastic aortas.

(Barthes 1972 [1957], 99, emphasis in original)

Our garbage is not about to overwhelm us; there are a number of options available; and most communities have time to think about those options and choose among them wisely. The worst thing to do would be to blow the problem out of proportion, as if garbage were some meteor poised to strike the planet.

(Rathje and Murphy 1992, 237)

Away

Wherever you might be in the world, take a short walk and you are likely to encounter plastic waste.[1] Depending on where you are, you may just see a few items, for example, trapped in a rural hedgerow, or you might see many, in various stages of decay, strewn in gutters along urban streets: perhaps a casually discarded bottle or sweet wrapper, or rubbish that has blown out of a recycling bin on collection day. More recently it is likely to be a disposable face mask, a material legacy of the COVID-19 pandemic. Anyone who drives along motorways or takes the train will be familiar with transects of waste, thrown from car and train windows or pulled away from stations and service areas by the gusts generated by fast-moving vehicles.

[1] Of course, it isn't all about plastic. There are many other types of litter (paper, glass, tin, and other metals) that look unsightly even if the environmental damage isn't as significant or as long lasting. But the worst polluter (ignoring for now nuclear waste) and the most common is plastics. Hence the emphasis of this chapter.

In all of these instances, it is the macro-plastics that we see. We are also increasingly aware, however, of near-invisible and sometimes actually invisible micro- and nanoplastics within the environment, in the water, in the food chain and ultimately within us, in our lungs for example, as recent research has demonstrated (e.g. Jenner et al. 2022). Plastics even exist within archaeological sediments, and have done so since at least the late 1980s (Rotchell et al. 2024). In some parts of the world, the problem is significantly worse than in others. But in all of these situations, what we see on a daily basis will likely fall into the same categories of object, which include: empty plastic bottles, food containers, bags of one kind or another, and—more recently as stated above—personal protective equipment (or PPE), typically in the form of facemasks. Most of us spend much of our time at or near our homes. But visit the beach or travel at sea and we will witness this same problem, not least because much of this familiar material eventually passes from the terrestrial to the marine environment by a combination of cultural and natural processes. This then creates entirely new places, such as the Great Pacific Garbage Patch (Figure 3.1).

Waste exists everywhere, therefore. And waste is what archaeologists investigate most of the time, whether in the form of debitage resulting from the manufacture of stone tools or as sherds of broken pottery. As Rathje and Murphy stated in introducing their book *Rubbish! The Archaeology of Discard* (1992), 'it is from the discards of former civilizations that archaeologists have reconstructed most of what we know about the past.' In the context of what is now referred to as archaeology of the contemporary world, it is archaeologists like Rathje and Murphy who paved the way to using archaeological methods and perspectives to examine today's garbage for what it tells us about the present, creating knowledge for example about 'politics, economics, and the ineradicable quirks of human behaviour, as well as providing information on population size, age, and sex, ethnic differentials, and buying habits' (1992, i). Typically, all these mostly discarded but occasionally accidentally lost materials are referred to as 'waste', 'litter', 'rubbish', 'trash', or 'junk', (although this last term is often now confined to the material in space).[2] But whatever terms are used, together within the contemporary world, these materials constitute the wicked problem of environmental pollution, a problem that cannot be easily managed, as Joshua Reno says in one of the chapter's opening quotations.

Mary Douglas (1966 [2002], 44–45) in her influential book *Purity and Danger* provides another term that can be used to describe this waste, introducing the idea that pollutants of the kind described in this chapter constitute 'matter out of place', relating them therefore to notions of dirt that contravenes ordered

[2] And it is notable that an archaeologist has adopted this as her pseudonym—Dr Space Junk (Gorman 2019).

systems.[3] She presented some scenarios that together illustrate how dirt (and consequently waste) is a relative idea:

> Shoes are not dirty in themselves, but it is dirty to place them on the dining table; food is not dirty in itself, but it is dirty to leave cooking utensils in the bedroom, or food bespattered on clothing; similarly, bathroom equipment in the drawing room; clothing lying on chairs; outdoor things indoors; upstairs things downstairs; under-clothing appearing where over-clothing should be, and so on. In short, our pollution behaviour is the reaction which condemns any object or idea likely to confuse or contradict cherished classifications.

Much of the waste discussed in this chapter meets Douglas's definition of 'matter out of place'. It is 'out of place' because it shouldn't be where it has ended up. It has become unsettling and disruptive of the natural order of things. But how? Who is responsible? If one were to identify the person whose behaviour proved to be the cause of a plastic item appearing 'out of place' in this way, they'd likely say that they *had* acted responsibly by throwing it away in a place designed for the purpose. Yet however true that might be, and however responsible they thought they were being, other factors will often then come into play: the bin may get turned over, for example, by people or by animals, or the contents blown out and about by sudden gusts (unnaturally strong winds, such as those weird storms described in Chapter 2).

For all of these reasons and more, the notion of 'away' is problematic, being simultaneously both a place and a non-place. Away is typically where we put things when we want them to become invisible; it is an actual place (a rubbish bin) and an abstract concept (the act, to throw something away). Both imply a negative connotation, that the thing is somehow bad or 'in the way'. For plastics this isn't always the case. Barthes's plastic aorta for example (cited at the start of the chapter) is vital to the person's health yet nonetheless is best kept out of sight: no-one needs to know, least of all the bearer. Within archaeology there are many examples of things being hidden away or deliberately placed: whether hiding precious metalwork for safe-keeping and future retrieval in the Iron Age or Roman periods in north-west Europe, animal bones formally and deliberately placed 'away' in a structured and formalized manner at sites that are believed to have been ceremonial, for example in the late Neolithic of Wessex, close to Stonehenge in England. It seems that any consideration of putting material away somewhere, and for whatever purpose, involves a recognition of the need to render things invisible. This also raises the broader issue of how visible pollution has become and how that visibility relates to the way people engage

[3] This was also discussed in Chapter 1.

with it and take it seriously. As Davies (2019, 1) argues, toxic pollution is a form of violence, which

> pushes back against framings of toxic landscapes as entirely *invisible* to the people they impact. Instead of accepting the standard definition of slow violence as 'out of sight', we have to instead ask the question: 'out of sight *to whom?*' In asking this question, and taking seriously the knowledge claims of communities who inhabit toxic spaces, we can begin to unravel the political structures that sustain the uneven geographies of pollution.

Davies goes on to describe how:

> Toxic environments are not always sensuous spaces that give up their clues and dangers. Indeed, chemicals that evade human perception can often prove the most deadly. But toxic geographies are also lived environments, where people encounter hazards in their day-to-day lives, in mundane and incremental ways. It is the gradual velocity of slow violence—that communities are forced to endure over years, or even decades—that allows people to accumulate knowledge about pollution.

Most people would once have agreed with de Coverly et al. (2008) who argued that waste should be kept out of sight *and* out of mind. The reality, however, is that 'away' is now a ubiquitous notion that is both present and predominant in the form of street litter as soon as we leave our homes. Perhaps now, given the scale of the problem, it should be visible, thus ensuring that we keep our minds focused on the wider and deeper concern for planetary health. As this problem crept up on us over the period of the 1960s to early 2000s, it likely did so because it was largely out of sight, at least to most people.

If we think of this in terms of waste's contribution to an increasingly complex cultural landscape, this chapter on environmental pollution could be described as referring to the archaeology of a place called *Away*; a cultural landscape of waste that is variable and fluid both in its spatial and temporal coordinates, like any place in fact. An example of such a place might be the Great Pacific Garbage Patch, a place where no humans live and beyond the view of all people except those researchers or clean-up crews who choose to visit, or who fly over it while crossing that part of the Pacific Ocean. Yet, in terms of the nature–culture dichotomy described in Chapter 2, this becomes a rather asymmetrical view. Animals live in the Garbage Patch (Lebreton et al. 2018). It is also now documented and recognized as a physical location, having grown to that status over recent years. As either a non-place or a cultural landscape, however, archaeologists are well placed to use their skills and experience in analysing its material components to better understand the form, character, and evolution of the

Garbage Patch, and perhaps even to use those skills and experiences to help predict and ultimately shape its future. As we have seen already, it doesn't matter that this material culture is sometimes more contemporary than it is historic. As archaeologists, our role (and our ability, our superpower) is to understand human behaviours through the traces people leave behind, and to create new meanings (and build and tell stories) through that understanding. Many of those traces that people now leave behind, inadvertently or otherwise, are plastic. Unsurprisingly therefore, the contemporary world is now increasingly being referred to as The Plastic Age.

This chapter will focus mainly on this specific and material form of environmental pollution: that which comprises plastic waste (although there will also be a brief overview of other forms of environmental pollution with which archaeologists have become involved). Much of this plastic waste ends up at sea and on beaches, and this will be the chapter's main theme, exploring how archaeology can contribute to mitigating this particular wicked problem, given the clear and demonstrable link that exists between plastic waste and pollution, through the filter of human behaviours. This is also a materiality where wickedness aligns with the monstrous, and the notion of horror. As Godin (2022, 116) has argued for drift materials like plastics, 'as they embark on their post-abandonment journey, things' immense scale, spread, and refusal to serve as proxies for human narratives result in the impossibility of fully grasping and making sense of them.' These factors (scale, spread, and their refusal to serve as proxies) help define the wickedness of plastic pollution.

We do not need to dwell on the science behind this pollution, as this is not directly relevant to the book's main thesis, but we should at least have a basic understanding of it. For that we can cite Max Liboiron (2016, 92) who describe simply how: 'Plastics pollute in two ways: *chemically*, when added chemicals (monomers and plasticizers) escape plastics and interact with bodies and ecosystems, and *physically*, when pieces of plastics themselves (polymers) interact with systems' (my emphasis).

We can stay with Liboiron also for their clear definition of plastics which, as they state, are most commonly derived from petrochemicals. When their paper was published (Liboiron 2016), the annual worldwide production of plastics was around 300 million tonnes. Liboiron (2016, 95) then outline how their material form influences the way in which they pollute, which summarize as occurring through three steps:

First,

Plastics consist of long molecular chains of individual units joined by strong molecular bonds. The resultant polymers, with their staunch bonds, can be thin and light yet strong and permanent. While all plastics are polymers, not all polymers are plastics. Hair, proteins and DNA are polymers, but each of these

substances has developed over evolutionary time in tandem with microbes that can digest them. The synthetic plastic polymers that came onto the scene all at once in the 20th century, in contrast, last significantly longer because of both the strength of their bonds and the general absence of microbes that can digest them.

(Liboiron 2016, 95)

Second, polymers in themselves are not versatile. To make them more so, smaller molecules known as plasticizers are added, of which there are about a hundred different types. As Liboiron state (2016, 95): 'While these individual molecules are not molecularly bound to the polymer chain...they are nonetheless referred to as "monomer additives"...[which] nestle among the polymers' strands'. This means that they can leave their plastic hosts.

That brings us to the third stage, when the monomers do indeed leave their host and find their way into, for example, the human body. A study in Canada, for example, has revealed that 91 per cent of tested individuals had bisphenol A (a plasticizer) in their urine (after Bushnik et al. 2010, cited in Liboiron 2016, 96). BPA is one of the major chemicals produced worldwide and is used in hard, polycarbonate plastics including water bottles. The fact the chemical is metabolized and flushed out of the body in six hours makes the high level perhaps surprising and certainly disconcerting. Also disconcerting, and focusing back on the main topic of this chapter, is the fact that floating plastics exposed to sunlight and wave action, lose their monomer additives, become brittle and fragment into smaller pieces (microplastics and eventually nanoplastics), even though their polymer bonds remain intact (Liboiron 2016, 99).

That, briefly, is the chemistry. In the next part of this chapter I will briefly review the scale of the problem, its origins, its projected future impacts and the harm that it creates, to animals, people, and places. In doing this, I will briefly review some literature that addresses this environmental pollution specifically as a wicked problem. I will then proceed to review a few other examples of environmental pollution, to outline the breadth of the wicked problem and its likely longevity. I will review the work of scholars who have considered plastic pollution as material culture. I will also consider how archaeology and critical heritage thinking provide a particular perspective on the problems that environmental pollution represents. For the second half of the chapter I will present some examples of ways that archaeology can help address this problem, through the perspective of small wins and through archaeologists acting as policy entrepreneurs. I also emphasize, through all of these examples, how archaeologists perform as activists, working as part of multi- and transdisciplinary teams prepared to push the boundaries of what is possible, and to liberally and creatively interpret how their subject is defined.

Plastic Pollution as a Wicked Problem

Since it became ubiquitous from around 1950, plastic waste pollution has become a large and complex global governance problem to solve. While littering was seen as a small problem in the 1970s and 1980s that could have been solved by clean ups and recycling, the situation has exacerbated and has now reached a level at which these activities cannot reduce the overall amount of waste in the environment. In the context of small wins these activities are helpful, but only in the immediate term and on a local scale. Such activities rarely have a longer-term or wider geographical benefit. One element of the perception of an emerging and significant problem was a shift of focus from consumer-based waste to one recognizing the sheer amount of plastics being produced combined with the realization that macroplastics do not biodegrade but break down into microplastics, which are then difficult, if not impossible to remove from the environment. Having often been described as a 'wicked problem' (e.g. Landon-Lane 2018; Vince and Stoett 2018) and a 'creeping crisis' (Mæland and Staupe-Delgado 2020), plastic pollution has far-reaching consequences not least geographically, being found in terrestrial and marine environments across the globe, from the Swiss Alps (Bergmann et al. 2019) to the deep ocean (Chiba et al. 2018), island groups (e.g. Vogt-Vincent et al. 2023; Muñoz-Pérez et al. 2023), and in the most remote places in the world such as Henderson Island (Lavers and Bond 2017). In terms of the marine environment, it was recently estimated that 170 trillion plastics particles are afloat in the world's oceans (Eriksen et al. 2023).

The impacts of plastic pollution are diverse and widespread. It has an estimated social and environmental cost of US$2.2 trillion each year (Forrest et al. 2019). It has been linked to climate change with plastic degradation contributing methane and ethylene to the atmosphere (Royer et al. 2018; see also Ford et al. 2022; Lavers et al. 2022). The impact on human health is still being investigated, although there is some evidence that the leaching of endocrine disrupters from plastic causes a range of physiological responses (Flaws et al. 2020). We know that plastics exist within human lungs and other organs (e.g. Jenner et al. 2022). In short, as a material, plastic has very quickly (over a mere seventy years) become culturally embedded in society (da Costa et al. 2020) through its practicality and purposefulness to the extent that it is now considered across disciplines, including archaeology, as a key signature of a Plastic Age (Edgeworth et al. 2022; Pétursdóttir 2017; Schofield et al. 2021a; Thompson et al. 2009b) or, as an epoch, the Plasticene (Ross 2018). It has also been recognized as an exceptionally accurate chronological indicator of phases within the Plastic Age and, through zone technofossils, of the Anthropocene:

> The patterns into which plastics have been shaped infinitely multiply the dating possibilities. The plastic credit card and the Bic Cristal ballpoint pen, for instance,

both first produced in 1950, may be regarded as zone technofossils for the Anthropocene, while compact discs (surprisingly widely dispersed as trash) only date from 1982. The technostratigraphic possibilities are almost endless, as technodiversity (if measured as the number of specific kinds of technofossil) is now far greater than biodiversity, measured as the number of species.

(Zalasiewicz et al. 2017)

Despite developing a better understanding of the environmental problems caused by plastics over the last few decades, there have been more plastics entering the environment, not less. This is acknowledged on a global scale with the United Nations (UN) calling for the implementation of 'long-term and robust strategies to reduce the use of plastics and microplastics' (Res 71/312 of 6 July 2017). In March 2022, the UN Environment Assembly agreed to the development of an international legally binding agreement to end plastic pollution by 2024 (Draft Res of 2 March 2022). Nation states have therefore (finally) recognized that the plastic issue is something that needs to be addressed through policy in their jurisdictions. Yet, solutions are slow to be placed onto political agendas.

Addressing plastic pollution problems usually involves some combination of recycling and waste management, while studies into the impact of the pollution continue to emphasize its detriment to the environment, a trend that began in 1960 with a report of rubber bands in a Puffin's stomach (Bennett 1960). Recent examples of studies that address specific aspects of marine pollution as a wicked problem, and with a focus on plastic waste, include (as an indicative sample across geographical areas and thematic coverage): Shah et al.'s (2019) study of the faults and weaknesses in waste management systems in Trinidad and Tobago, Kirschke and Kosow's (2021) review of pharmaceutical residues in fresh water, and Hughes et al.'s (2012) research to investigate a diversity of factors (including pollution) that are impacting China's coral reefs. In all of these cases, wickedness is clearly evident, not least in the fact that solutions will inevitably create additional (and perhaps unforeseen) problems either down the line, or elsewhere, or both. In all of these cases, policy frameworks are also a prominent consideration. In Sarah Morath's (2022) book, *Our Plastic Problem and How to Solve It*, she takes a legal perspective on what she too refers to specifically as a wicked problem (and see also McIntyre 2020). The book builds on the documented extent of the problem in its broadest sense, which she summarizes in terms of the 100–250 million metric tons of plastic waste projected to be entering the world's oceans each year by 2025 (Jambeck et al. 2015) and the possibility that, by 2050, there will be more plastic by weight than fish in the ocean. The problem, it would seem, is becoming increasingly wicked in spite of the many attempts to resolve it, whether by turning off the taps and reducing the amount of plastics entering the environment, or by cleaning up the mess that the overflowing bathtub has created.

In an essay by Martin Wagner (2022, 333), plastic pollution is framed as a

> waste, resource, economic, societal [and] systemic problem. [Framing it thus] results in different and sometimes conflicting sets of preferred solutions, including improving waste management; recycling and reuse; implementing levies, taxes and bans as well as ethical consumerism; raising awareness; and a transition to a circular economy. Deciding which of these solutions is desirable is... not a purely rational choice.

Table 3.1 Characteristics of wicked problems and their applicability to the plastic pollution issue

Characteristics	Applicability to plastic pollution
(1) Wicked problems are difficult to define. There is no definite formulation.	Yes, there is a diversity of views in framing the problem.
(2) Wicked problems have no stopping rule.	Yes, we will not know for certain if/when we have solved plastic pollution.
(3) Solutions to wicked problems are not true or false, but good or bad.	Partly, some specific solutions (e.g. stopping pellet loss) can be true. Other solutions require value judgement.
(4) There is no immediate or ultimate test for solutions.	Partly, effectiveness of some local solutions may be testable but it is impossible to test for global solutions.
(5) All attempts to find solutions have effects that may not be reversible or forgettable.	Unknown but possible, especially when considering the largely unknown environmental impacts of replacements.
(6) These problems have no clear solution, and perhaps not even a set of possible solutions.	Unknown. A broad set of solutions is available in theory or practice, but their potential to actually solve the problem is largely unknown.
(7) Every wicked problem is essentially unique.	Unknown, but strong commonalities of plastic pollution with other global change issues exist.
(8) Every wicked problem may be a symptom of another problem.	Yes, for instance, plastic pollution can be framed as a symptom of a linear economy.
(9) There are multiple explanations for the wicked problem.	Yes, see (1)
(10) The planner (policymaker) has no right to be wrong.	No, there probably is a margin of error, such that multiple solutions can be tested without (much) regret.

Source: After Wagner (2022), itself adapted from Rittel and Webber (1973).

Wagner helpfully aligns the wicked problem of plastic pollution with Rittel and Webber's (1973) characteristics (Table 3.1), headlining its scientific complexity which he summarizes in the following terms:

> Firstly, plastic pollution comprises a diverse suite of pollutants with very heterogeneous physicochemical properties. Secondly, plastics have a multitude of sources, flows and impacts in nature and societies. Thirdly, plastic pollution is ubiquitous, yet its scale varies in time and space. The combination of these aspects results in complex exposure patterns causing a complex suite of effects on biodiversity and human health, covering all levels of biological organisation, as well as on the functioning of ecosystems and societies. To further complicate the matter, these effects will probably not be linear, immediate, obvious or overt but will be heavily interconnected and aggregate over timescales that are difficult to investigate.

So it is clear how the problem has been conceptualized, and what pollution in this case actually means. In the following paragraphs I will outline some further thoughts and examples of its impacts as well as some of the challenging issues around managing and conceptualizing the wicked problem of plastic pollution, for example in relation to research ethics.

The Impacts of Plastics

The ubiquity and popularity of plastic is undeniable (e.g. Madden et al. 2012). Yet alongside it's obvious and well-documented benefits, and as we have seen, plastic has evident costs to the environment and society when it becomes waste (e.g. Gabrys et al. 2013), giving form to what Hawkins (2018, 101) has referred to as a 'very disturbing future'. Often seen as a disposable material (e.g. single-use packaging), plastic can have a very short use life (a few seconds in the case of a cotton bud, for example), yet its durability means that the object's story will last far longer. With only a small proportion of plastic waste being incinerated (12 per cent) or recycled (9 per cent), the majority goes to landfill or enters the natural environment (Geyer et al. 2017). The story of the object therefore continues, potentially for decades, even centuries. Sherrington (2016) estimates that nine million metric tonnes of plastic waste reach the oceans each year. It is hard to conceive that, when Baekeland invented Bakelite in 1907, there would be 'soups' of plastic floating around the globe on gyres or ocean currents, that every beach, including those in remote places such as Galápagos (Ecuador) and Antarctica, would have plastic washing up with almost every tide (Thompson et al. 2009a; Obbard et al. 2014; Woodall et al. 2014; Lavers et al. 2019), and that plastic would exist within stratigraphic layers in geological and archaeological sequences (e.g. Rotchell et al. 2024; Zalasiewicz, Waters and Eva do Sul et al. 2016). It is equally hard to

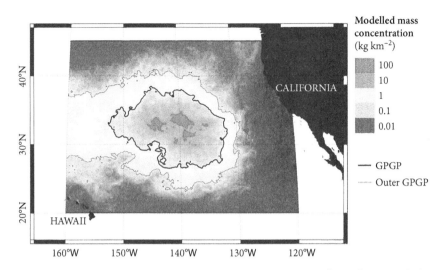

Figure 3.1 Ocean plastic mass concentrations at the Great Pacific Garbage Patch, for August 2015

Notes: As predicted by the data-calibrated model by Lebreton et al. 2018. Note the proximity of, and scale relative to nearby California.

Source: This file is licensed under the Creative Commons Attribution 4.0 International licence.

conceive that entirely new landscapes of plastic would have formed over the past few decades as plastic usage increased. The most famous of these landscapes is the Great Pacific Garbage Patch (GPGP), a fluid and ever-growing place exceeding the size of the US state of Texas and edging ever closer to World Heritage listed islands in Hawaii (Figure 3.1). As cultural landscapes like Doggerland (described in Chapter 2) disappear beneath the waves, new cultural landscapes emerge.

These new floating ecosystems (of which GPGP is probably the best known) are referred to by Haram et al. (2021) as neopelagic communities,[4] formed of an amalgamation of coastal species that have been transported on waste materials to the high seas. These new communities have caused a paradigm shift in the understanding of marine biogeography, for at least two reasons. First, that the ocean has traditionally been considered as a barrier to the dispersal of coastal marine species, thus limiting their distributions. This no longer appears the case given that floating plastic items forming rafts and ultimately coming together as garbage patches provide ecosystems where species can exist, survive, and reproduce over decades as 'self-sustaining communities on the high seas' (Haram et al. 2021). Second, this persistence of coastal organisms on the open ocean allows for stepping-stone dispersal (Haram et al. 2021).

Currently, little is known of these neopelagic ecosystems. Yet they do now exist, raising ethical concerns for how we manage marine waste within these

[4] neo = new; pelagic = in the open ocean.

environments. We should also not lose sight of their status as cultural landscapes, albeit (currently at least) devoid of human populations.

But it is not just a matter of visibility or even of scale. However large or small, this is a lethal, toxic legacy that is threatening planetary health, hence the characterization of plastic pollution as a wicked problem in its own right, if not a 'super wicked problem' given the urgency with which resolution is needed. As mentioned earlier with the example of the Puffin, plastics can have lethal and sub-lethal effects on wildlife from processes such as ingestion, entanglement, and chemical contamination (Townsend et al. 2019). To date, over 690 animal species have been recorded to have been impacted by marine debris, 17 per cent of which are listed as threatened or near threatened on the IUCN Red List for Endangered Species (Gall and Thompson 2015). Research on plastic bags specifically suggests ingestion presents a particular problem, with sea turtles, for example, consuming debris that resembles prey, especially jellyfish (Schuyler et al. 2014).

Contamination is not restricted to the gastrointestinal system of marine vertebrates. Research within the intertidal zone in Ireland has shown that the presence of both conventional and biodegradable plastic bags creates anoxic conditions within the sediment, which results in reduced primary productivity in organic matter and significantly lowers the abundance of faunal invertebrates, suggesting that both conventional and biodegradable bags can rapidly alter marine assemblages and the ecosystem services they provide (Senga Green, Boots and Blockley et al. 2015). And staying with plastic bags, their disease and smothering risks to coral reefs have also been well documented (Lamb et al. 2018).

Due to this habitat-wide effect, researchers have highlighted the importance of tracing the movement of microplastics up the food chain, to provide increased understanding of its impact on both ecosystem and human health (Carbery et al 2018).

Plastic waste has also been demonstrated to have a social cost, such as negative economic impacts to maritime industries and tourism (Leggett et al. 2014; Jang et al. 2014) but also to health and well-being (Beaumont et al. 2019; Kershaw and Rochman 2016; Wright and Kelly 2017; Wyles et al. 2016). I shall focus more on this issue in the second half of the chapter and describe how this particular aspect of the wicked problem also aligns with wider issues of planetary health.

Archaeologists usually cast their eyes (along with their analytical perspectives) to the past. But increasingly, as described in the previous chapter, archaeologists and heritage practitioners are also now turning their attention to the future or, more precisely, to alternative futures. A question often asked is: how and in what ways might knowledge and understanding of the past help us better understand what our alternative futures might look like? We saw this in the previous chapter with regard to climate change predictions and strategies for survival. Lyon et al. (2021), for example, argued convincingly to extend modelling beyond the current threshold of 2100 (a mere lifetime away) to 2500, following the same principles as

Indigenous perspectives such as Seven Generation Sustainability. A further example of the archaeological perspective might in this case draw us towards another part of this equation around the causes and consequences of environmental pollution: that part that factors in the length of time plastics will exist within the environment. As Liboiron (2021, 17) state: 'the long temporality [of plastics and their chemicals] means their future effects are largely unknown, making uncertain the guarantee of settler futures'. As they often do, Liboiron (2021, 17) support this statement with a helpful footnote:

> You may have noticed that temporal estimates of plastics breaking down (one thousand years for this kind of plastic, ten thousand for this other kind) exceed the amount of time that plastics have existed. Most of these estimates are modelled from data created in labs (in UV-saturated, vibrating, acidic set-ups that rarely mimic actually existing environmental conditions) and are based on the idea that the rate of weakening polymer bonds will proceed on a regular curve. They do not anticipate the effects of metabolites or the molecular chains that polymers might break into. They cannot anticipate how future environmental relations will absorb, adapt to, and otherwise influence these rates of breakdown or the effects of many types of plastics in diverse environments over long periods.

In other words, and for now at least, it is hard to know how long the wicked problem of plastic pollution will endure and what impact it will have on planetary health in the deep future, even if society does manage to turn off the taps and stop the flow. All we know is that it is not good, and that it causes significant environmental harm while also damaging the visual integrity of the cultural landscape in which it occurs. We might conclude therefore that we have here a relatively uncontroversial area of scientific research in which the wicked problem of plastic pollution is realized, recognized, and (more-or-less universally) prioritized. It is also encouraging to see how scientists from a diversity of disciplines are engaged with attempts to resolve it, collaborating in the creative ways that were highlighted in Chapter 1 as being likely to form the most effective and long-lasting solutions to wicked problems.

The Ethical Dilemma

Yet, as always, things are not as straightforward as they might first appear. For plastics exist in what scientists refer to as the plastisphere, in which 'tiny plastic pieces are home to plants, algae, and bacteria, the animals that feed on them, the predators that feed on these, and other organisms that establish synergistic relationships' (Liboiron 2021, 104). Examples of the places where these dilemmas

arise are the neopelagic communities described earlier. Arguably, these places hold significance in their research potential, as Haram et al. have identified. These are entirely new places that are being created and as such they present exciting possibilities for new understandings of the world.

There is therefore an inevitable and fairly obvious ethical dilemma which Liboiron (2021, 104) describe as follows. In undertaking this type of research

> do we take the tangled plastics out of the water, killing the life on and around it, or do we leave them in as the supporting structure of a functioning ecosystem? Are the animals full of EDCs [endocrine-disrupting chemicals]? Probably. Do the chemicals associated with plastics have health effects? Likely. Were the individuals and overall ecosystem alive and thriving? Yes.

The challenge therefore is in finding the balance between culture and nature while avoiding the assumption that natural relations are universal and that the only response to plastic is to clear it up to 'protect the environment'. We saw in the previous chapter how the relations between culture and nature are now being reconfigured and how there are moves to realign these realms and their relations within critical heritage thinking. Here the focus is firmly on archaeology as the study of material culture and what it reveals about human behaviours while also recognizing the highly contested nature of that material culture as an environmental pollutant, as the cause of a wicked problem (if not multiple wicked problems, or a super wicked problem) and yet also as the support structure of potentially infinite numbers of new ecosystems.

On a related ethical point, I will briefly mention one further aspect of the wicked problem of environmental pollution, being its status as a networked problem. This has been addressed in depth in the same excellent and thought-provoking book by Max Liboiron (2021) as I cited earlier.[5] While this is the same problem as represented by, for example, the impact of plastics on seabird health (being one of Liboiron's examples, pp. 104–106), it also runs deeper, into issues around place and identity and capitalism and colonialism. In their book, for example, Liboiron bring Indigenous perspectives to the fore. In fact the need to do so is their main argument. This links us back to the point made about Indigenous knowledge, in Chapter 2.

Having outlined some of the relevant contextual issues around this particular aspect of environmental pollution, the next part of the chapter takes an archaeological perspective on plastics with a close examination of some initiatives which have used a material culture-led approach to help mitigate the impact of plastics on the environment in localized areas. The examples were intended to generate

[5] And I strongly encourage readers to consult this excellent book. I am merely signposting it here.

small wins that focused mainly on influencing behaviours which might reduce the flow of plastics into the environment, while also recognizing how collecting and documenting plastics[6] can draw attention to the wider scale and impact of the problem. The focus, at least initially, is the UNESCO World Heritage listed archipelago of Galápagos (Ecuador).

Investigating Marine Plastic Pollution in Galápagos and Elsewhere

Beachcombing (the practice of walking beaches between tides to see what has washed up) has often been considered a form of archaeological survey. The approaches are not dissimilar although the motivations may vary somewhat. The Thames foreshore project (involving people 'mudlarking') has revealed many artefacts and stories related to London's recent and deeper history, while CITiZAN, described in Chapter 2, undertook various types of field recording that often involved artefact collection or recording in intertidal areas. In all of these cases, many of the artefacts collected are plastic while there are several examples now of projects that use archaeological methods specifically to investigate plastics, marine and terrestrial. One of these projects, and the one that has arguably received the most media interest, is the Lego Lost at Sea project. This has received close attention from the United Kingdom's Council for British Archaeology, its executive director Neil Redfern describing Tracy Williams's (2022) book on the project as, 'an amazing approach to engaging people on the human impact on our oceans and beaches' (Twitter, 16 July 2020). Lego is such an iconic product and to find these familiar childhood items on beaches can be unsettling, returning us to Mary Douglas's (2002 [1966]) notion of 'matter out of place'. These items should be in the playroom, not washing up on the tide! The reason they are on the tide is that they were lost in a spill when the container ship *Tokio Express* ran aground off the Cornish coast in February 1997. One of the lost containers comprised 5 million pieces of Lego which had been bound for New York. Ironically, many of these were sea-themed parts, including 54,000 pieces of seagrass, 97,500 scuba tanks and 352,000 pairs of flippers!

Plastics, therefore, have quickly become archaeological as part of a wider public recognition that archaeology is not only about the ancient past, but about human–material relations in the contemporary world as well (Harrison and Schofield 2010). It should come as no surprise therefore to see archaeology contributing to studies of marine plastic pollution in interesting, novel, and meaningful ways. It is also helpful in this context to compare surface collection methods used by

[6] In the form of surface collection, an established archaeological method with which I began my career!

archaeologists to recover artefacts drawn by agricultural processes to the field surface, often exposing them for the first time in thousands of years (e.g. Schofield 1991), with methodologies adopted for beach clean-ups and scientific sampling (e.g. Besley et al. 2017). It is also worth repeating the point made previously, that beach cleans will often amount to small wins, albeit making a difference temporarily and on a local scale, while also having health benefits for their participants. As an example of what can be achieved using archaeological methods at comparatively low cost and on a local scale, an approach built around storytelling involving the interpretation of some found items, was developed and tested in Galápagos, a well-known, iconic, and UNESCO World Heritage-listed location that forms part of Ecuador in west-coast South America (Schofield, Wyles and Doherty et al. 2020b; see also Sánchez-García and Sanz-Lazaro 2023 and Muñoz-Pérez et al. 2023 for separate studies of plastics in Galápagos). The aim of this project was to develop a method for achieving small wins in relation to the wicked problem of plastic pollution, both in terms of reducing plastic pollution on local beaches but also changing the local behaviours that might help turn off the supply of damaging plastics. The project has also had two spin-off initiatives, which I will briefly mention: one is a wider international study of the impact of discarded COVID-19 masks (Schofield et al. 2021b), and the other example concerns children's attitudes towards plastic pollution as evidenced by a storytelling activity amongst coastal communities in neighbouring mainland South America (Praet et al. 2023).[7]

But first, I will focus on the initial project in Galápagos. It is important to state that in none of these examples does archaeology exist in isolation: archaeology instead (and importantly), forms part of a multidisciplinary approach involving scientists from a range of subject specialisms. The starting point in this collaboration remains, however, the material items themselves. That is what makes the project distinctive.

Let us begin with the location and the context within which this project was developed. Galápagos is an isolated archipelago situated in the Pacific Ocean 1,000 km west of Ecuador and at the confluence of three ocean currents. It is a UNESCO World Heritage Site known for its rich and diverse marine environment (largely due to those currents), its terrestrial ecology, and its history in the understanding of evolution, following Darwin's visit to the islands in 1835. The UNESCO Inscription describes it as a 'living museum and showcase of evolution' at the confluence of major currents that render it one of the richest ecosystems in the world.[8] The history of the archipelago's occupation dates back circa two hundred years, and has been subject to some limited archaeological investigation (e.g. Jamieson 2018). Increased accessibility and affordability, and its growing profile

[7] Another project which I won't describe here relates to plastic bag use and disposal within the islands (Schofield et al. 2021a).
[8] https://whc.unesco.org/en/list/1—accessed 13 February 2019.

through television programmes such as *Blue Planet* and *Blue Planet II*[9] have meant that the archipelago has rapidly increased in popularity as a tourist destination (in particular, through sustainable ecotourism) in recent years (e.g. Izurieta 2017). Consequently more people are living on the islands to serve the needs of the growing number of visitors. Balancing the requirements of humans, both residents and tourists, with the necessity to conserve the natural environment which has drawn them to be there, has become a critical challenge in Galápagos (e.g. Quiroga 2009; Kvan and Karakiewicz 2019). I have already mentioned the fine balance between nature and the impacts of culture upon it (recognizing that this distinction oversimplifies a good deal of complexity). Max Liboiron (2021, 39) refer to 'assimilative capacity', being the theory that 'environments can handle a specific amount of contamination before harm occurs'.

Like elsewhere in the world, marine plastic pollution has become an increasing threat to both human and non-human residents in Galápagos in recent years (Mestanza et al. 2019; Jones et al. 2021; Muñoz-Pérez et al. 2023). Here, as elsewhere, plastic bags are mistaken for food by turtles and seals (e.g. Shuyler et al. 2014), and microplastics are ingested by filter feeders from small mussels (van Cauwenberghe and Janssen 2014) to large Humpback whales (Besseling et al. 2015). Many of the plastic items causing these impacts appear to be from the local region. Specifically, modelling work by van Sebille et al. (2019) using virtual plastic particles (Lange and Van Sebille 2017), suggests that the sources of plastic ending up in Galápagos from outside the archipelago are confined to both a narrow band on the west coast of South America (mostly northern Peru and southern Ecuador), and the international fishing fleets operating legally in the vicinity (and whose presence and movements are now tracked by satellite, records of which are accessible online). In the case of Galápagos, therefore, this appears to be a regional problem, which therefore requires regionally based solutions. But at the start of the project, this was only a theory and one that urgently needed testing. Archaeology proved a useful way to ground truth and add nuance to these theories.

In recent years, the Directorate of the Galápagos National Park (DGNP) has increased its intensity of clean-up operations across the archipelago and encouraged relationships with not-for-profit organizations with access to the world's foremost international expertise in the issue. Within this framework, an international team of subject specialists was brought together to help create workable solutions to the problem of plastic pollution in Galápagos. Over the course of a series of 'Science to Solutions' meetings in 2018, this group concluded that, due to a combination of oceanographic and societal reasons, Galápagos is best placed of any archipelago in the world to demonstrate how to tackle the threat of marine

[9] https://www.bbc.co.uk/programmes/p04tjbtx/episodes/guide

plastic pollution in a marine reserve. Subsequently the team developed a multi-disciplinary programme to help try to achieve a small but significant win.

Focusing here on the specific contributions of archaeology to this research programme, the approach adopted as part of the Science to Solutions initiative involved four distinct but related stages which together comprised a workshop (described in more detail in Schofield et al. 2020b). The first stage was *surface beach collection*, adopting a method familiar to most archaeologists and one generally used to get a sense of the archaeological character of an extensive area, through the distribution, frequency, and types of archaeological materials that can be found on the ground surface. For this, the Science to Solutions team visited a remote beach on San Cristobal island, Bahia Rosa Blanca, a site easily accessible but only by boat, and one to which access is tightly controlled and restricted to National Park staff. Tourists and all other visitors are strictly prohibited for reasons of wildlife conservation. Unlike tourist beaches on the islands, this beach is rarely cleaned and large areas are therefore covered in an accumulation of plastic. Some of this material (especially at the backshore area behind the beaches, some distance behind Mean High Water) was bleached and brittle and appeared to have been there for a long time. Other items were very obviously recent, as determined by Sell and Use By dates on the products, and by a relative lack of weathering. Some of the older items had been visibly transformed, by weathering and maybe also animal action, into microplastics (items of less than 5 mm diameter, Arthur et al. 2009; Frias and Nash 2019), which were also present in significant quantities.

Upon arrival, and after a rapid overall inspection of the site, the team made a representative collection of plastic artefacts. A stratified random sampling methodology was adopted for this collection (Figure 3.2, and after Shennan 1988, 315). In short, the beach assemblage was rapidly assessed in terms of the categories of artefacts present, and then a random sample of objects was drawn for each category from different areas of the beach. The main categories of artefacts were single-use plastic containers of various kinds (bags, bottles, Styrofoam cups), clothing (shoes in the form of mostly trainers and flip-flops or 'thongs', hats and caps), discarded or lost fishing equipment (mainly the plastic components of traps, fishing line, and parts of fishing rafts), toys (Lego, dolls, buckets and spades) and, far less frequent, a range of other (including unidentifiable) objects, such as a syringe, although local knowledge suggested this may belong under 'fishing equipment'. Artefacts were collected in refuse bags (one per pair, and thus about fifteen bags between about thirty people) and taken back to the laboratories at the Galápagos Science Centre, which hosted this part of the workshop. Photographs were taken of the beach collection survey, and of the area in general.

The second stage of the workshop involved systematic *sampling* of this collection taken from Bahia Rosa Blanca, to produce a shortlist of eight items that together provided a range representative of the wider beach sample for further

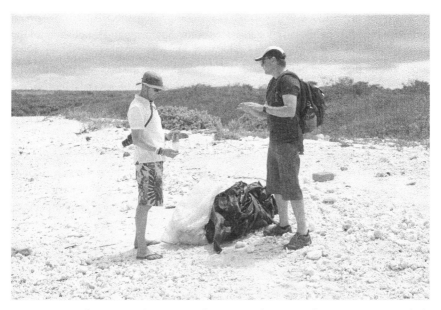

Figure 3.2 Surface survey for marine plastics at Bahia Rosa Blanca on San Cristobal island, Galápagos.
Source: Author's photograph.

investigation, and specifically for the object biographies[10] work that was to follow. All of the collected items were first laid out on the ground and, over the course of an hour, sifted to make this selection. The selected items comprise: a plastic pot once containing liquid detergent and with Japanese labelling, the sole of a child's shoe, the torso of a doll, a sun visor, a closed plastic bottle containing a toothbrush, a red container that had been re-used as a float, to act as a marker buoy (the attached string probably tethered it to the boat), a plastic water bottle with a Galápagos label, and a packet once containing snacks.

The third stage of the method was the *object biographies* workshop itself, which took place in a laboratory and involved eight teams of three to five people each moving around the collection of objects building a series of narratives around each item, a variation of the World Café method (e.g. Carson 2011; Fouché and Light 2011; Prewitt 2011). The teams were typically mixed, comprising a combination of local participants from NGOs, the National Park, as well as members of GECO, a group working on San Cristobal island to empower young people from Galápagos to make a positive difference to their community,[11] and local and international

[10] Originally this approach was described as creating object biographies. More recently I have come to think of them as first object narratives and later object itineraries (after Joyce and Gillespie 2015), which provide a more dynamic framework for this kind of investigation.
[11] https://gecoGalápagos.wordpress.com—accessed 14 February 2019.

members of the Science to Solutions team comprising specialists from several different research fields. For logistical reasons, Spanish- and English-speaking participants typically worked separately although some people were bilingual.

Following the model of the World Café methodology, the task was intentionally 'quick-fire' with five minutes on each object for each of seven stages of the narrative we sought to compile. These stages were framed as questions set out on a grid on large sheets of paper, each on a separate desk or 'workstation': Where was the object from? What was it made of, and how was it made? How had it been used, by whom and for what? How had it ended up in the sea, and eventually therefore on a remote beach in Galápagos? What human actions might have caused this outcome, and what actions might therefore have prevented it? Groups were encouraged to think about the evidence that might support their narratives and as they progressed through the collection, from object to object, each group had access to what the previous groups had already written (Figure 3.3). At each new workstation, individual groups could work on the next stage in the story, or create alternative stories for stages that had already been addressed. They could offer something for each stage if they wished, and if they had time. Each team had its own coloured pen, with every one of them a different colour—this allowed the possibility to follow each team's object biography, and their distinctive approach and perspective after the event.

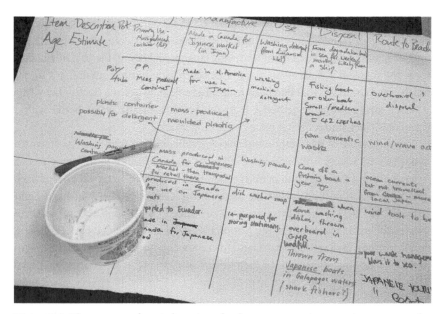

Figure 3.3 The many and varied stories of a detergent-powder container recovered from Bahia Rosa Blanca on San Cristobal island, Galápagos

Source: Author's photograph.

The final round brought the groups back to the objects with which they began. They were asked to review the various stories and possibilities that had been produced, and present the one they preferred, or which they felt the most likely, to the wider group. Some of these stories were realistic (the toothbrush in the bottle being contained on a fishing boat to retain its sterility in a polluted environment, for example) while some were more creative (e.g. that the visor belonged to a sea lion, who used it to impress other sea lions). Vitally though, all participants thought critically about how these objects had ended up on a Galápagos beach, and the behaviours that might have caused this to happen. They critically examined the cultural and natural influences that had acted upon these objects. These insights were detailed and informed. One set of participants, for example, trained in marine biology and specialists in colonization processes, noted how it was possible to establish how long an item had been in a marine environment, from the development of colonies on its surface, a process known as biofouling. Teams also thought about what might have happened to the objects next if they had not been collected, and what will happen to them now that they have.

A fourth and final stage involved scientific and web-based analysis and aimed to bring some factual elements into the stories. This had two separate components. First, small samples were taken of each of the eight items, with the aim to examine their composition and degradation. In short, what more could we learn about the origins and narrative of each object that we didn't already know? This work was undertaken at the University of Exeter. The samples were scanned by Fourier Transformed Infrared Spectroscopy (Attenuated Total Reflectance) (FTIR - ATR) to determine their polymer signature. A Perkin-Elmer Spotlight 400 was used in ATR scanning mode to identify the spectra of the eight items compared to spectra from industrial spectral libraries.

The second component, conducted separately at the University of York, involved examining and researching the various pieces of coded information visible on some of the objects. These were mainly stamps, logos, and labels which formed the basis for further Internet-based research, alongside examination for any more obvious traces of use. This second technique builds on work conducted previously by Myers (2011) as part of the forensic examination of a Ford Transit Van (Bailey et al. 2009), tracing each component part of the van to a place and date of manufacture. While time was limited in Galápagos, with a bit more flexibility this online research stage could be built into future workshops, with each team having web access.

In terms of results, for each item, a diverse range of stories and possibilities was created. The detergent container, it was suggested, came off a fishing boat, the container being ideal for keeping the powder dry on board, and small enough to tuck away. Its small size may also suggest it was the personal possession of one of the crew, and that all fishermen were perhaps responsible for their own personal

hygiene. The container was probably discarded, to save precious space aboard a crowded fishing boat, away from home for months at a time.

The shoe was hard to interpret for it had no production codes to identify what it was made of, or who it was manufactured by. Yet something could be said about its use, and its users.[12] The only text on the sole is an '8', indicating the size of the shoe, and thus of the person wearing it. It is small, so a child's size 8. It had a pointed toe, so was a smart or 'dress' shoe. One can further personalize the item through wear patterns. Shoes typically display either instep wear (supination) or outside step wear (overpronation). This shoe shows both, implying at least two users. The fact this is likely a child's shoe may provide an explanation, as children's shoes are more frequently passed on and reused. FTIR results gave a 73 per cent spectral match to polyester. Polyester is a dense polymer (1.37 g cm^{-3}; seawater has an average density of ~1.03 g cm^{-3}) and this, along with its solid construction (no air spaces), suggests that the item would not have floated far. It was not, therefore, transported by sea from distance and must have been lost in Galápagos. Furthermore, the use of polyester in the formation of shoe soles indicates a 'fast' or 'cheap fashion' culture as it is a less-expensive polymer and less durable than other polymers used in the construction of shoe soles. One website describes how 'these attributes are best suited to footwear markets with rapidly changing designs and where consumers frequently purchase new footwear styles to keep up with current fashion trends'.[13]

By contrast, the white round detergent container revealed details of its age, manufacture, and content, but not its use or users or narrative. Moulding on the base of the item indicates it was made from polypropylene by 'Berry [crown symbol] Plastics', a packaging manufacturer based in Québec, Canada. In 2017, the company changed its name to Berry Global Inc. and dropped the crown logo, indicating a production date prior to this. Product code '140916CP9' also features in the mould, a line which is now discontinued. The item was produced via injection moulding, as evidenced through the spruce mark in the centre of the base. A design featuring a globe, Japanese text, telephone number and website was subsequently screen-printed onto the container. Translation of the writing indicates the item once contained a sodium bicarbonate-based washing powder. The product is described as, 'skin, clothing and environmentally friendly' and suitable for use on baby clothes. The product was sold by Bluebell, based in Kashiwa, Japan. On the website listed on the packaging (www.bluebell-web.jp—no longer accessible) the company indicates that they do not manufacture the product, but instead 'import and sell detergents and softening agents that take into consideration the natural environment...from Canada'.

[12] This analysis was undertaken at the University of York by Sean Doherty.
[13] https://www.chemtrend.com/process/polyurethane_shoe_soling/shoe_soling_polyurethane—accessed 18 February 2019; this webpage no longer exists.

There is no visible use-by or best-before date on the container. There is also minimal marine growth and weathering/fading to the ink. The Internet Archive's Wayback Machine indicates that the 'Bluebell' website was active between March 2008 and January 2015, after which date the domain was no longer active. A pre-2017 date is supported by the older 'Berry Plastics' name, prior to the company's rebranding. FTIR provided additional information on the polymers, yielding a 94 per cent match to Polypropylene. This is a buoyant polymer that floats in seawater and is therefore susceptible to dispersion by wind and waves. Polypropylene is a typical polymer for packaging with around 10 million tonnes produced annually in Europe alone.

In summary, these Science to Solutions workshops proved successful. Local people had fun engaging with the activities. There was serious discussion, and laughter. The laughter was confined to some of the more fanciful stories that the participants created. The discussion of behaviours, and what actions might have prevented these items entering the ocean was, however, entirely serious. One item above all others demonstrated the transformative qualities of this narrative-based approach: the closed 500 cl water bottle containing a toothbrush. There was no disputing that the bottle was being repurposed as a storage container. But what was the toothbrush for? When the bottle was unscrewed, the contents gave off a strong chemical odour (much like meths). This completely changed the narrative from the initial mundane and reasonable suggestion of a toothbrush being kept sterile, for its original and intended purpose, to the idea of the toothbrush also being re-used, as a multipurpose boat-cleaning item stored in a convenient container.

The workshops and associated analysis undertaken for this project centred around stories, or narratives created by (predominantly young) local people. In creating these narratives, participants were encouraged to think of these items not simply as part of a wicked global environmental problem of marine plastic pollution, but as archaeological signatures or 'traces' that people's individual actions have caused to be left on the landscape and which therefore together contribute to this wider problem. During the workshops marine plastic items were compared to the millions of flint artefacts and related debitage found by archaeologists across the world. In these more conventional archaeological settings, each item is a signature of past human activity, around which narratives are routinely constructed by archaeologists. Plastic is no different. The shoe was left on a beach somewhere, and its wear patterns say something very specific about its owner (or owners). The detergent container may have fallen off (or been thrown off) a fishing boat or yacht. And we know something of the earlier history of these contemporary artefacts, before they were purchased, used, and discarded. We can also extend this narrative far back in time, in terms of the geological and prehistoric origins of the raw material from which the objects are made, and we can say something about their time at sea.

This approach also had the benefit of providing evidential support to the oceanographic models developed by van Sebille et al. (2019). The fact that some of the products were from Peru/Ecuador and had clearly been at sea for a while (judging from their condition) demonstrated that material was following this predicted trajectory from the mainland. Equally, the fact that much of the material retrieved was from South East Asia yet looked too fresh to have travelled that far proved two things. First, that it could not have come from South East Asia directly (which was established as 'impossible' by the oceanographic modelling), and second, therefore, that the South East Asian source was, in a sense, local. The modelling has shown how flow makes it certain these items are from the sizable international fishing fleet that operates in this area. The quantity of lost and discarded fishing gear being retrieved also supports this argument (and see Richardson et al. 2022 for a further discussion of this particular category of waste). This presents the intriguing and perhaps not so fanciful possibility that, in the future, if the damaging impacts of plastic pollution can be demonstrated, these archaeological traces could become evidence in prosecuting the polluters, or at least calling them to account.

To conclude, by taking each item of waste, each *artefact*, as a problem in itself, by revealing how people's actions can have an environmental consequence, and by telling stories about these actions and the journeys the items have taken to the beach on which they were collected, we can personalize the problem; it becomes our problem, not somebody else's problem, or the world's problem. And by involving people in the storytelling we can achieve small wins by impressing upon them their own responsibilities, highlighting the key take-home messages: that every action has consequences and that every domestic plastic item in the sea could have been avoided. As we have already seen, archaeology concerns the understanding of past human behaviours through the material traces that people leave behind. In this particular case, contemporary archaeology alongside other specialisms and academic traditions, can help develop new frameworks for addressing one of the most pressing issues—the detrimental impact of humanity on the environment.

COVID Waste

An archaeological perspective has also been used to address another very specific aspect of environmental pollution, and one directly influenced by approaches developed in Galápagos. This example relates to COVID plastics. Here it was demonstrated (by Schofield et al. 2021b, but see below, in this chapter, for other examples) that archaeological fieldwork could be helpful in creating both a documentation and a close, immediate interpretation of the COVID-19 global pandemic, as an example

of archaeological contributions to wicked problems.[14] This project also illustrated ways that archaeological fieldwork could be undertaken virtually, online, albeit making use of field data gathered and reported by others. Fieldwork, in the more conventional archaeological sense has, however, been undertaken in other places to help address this same question. I will refer to all of these examples briefly, focusing first on the study with which I was directly involved.

With the pandemic, lives around the globe have become even more digital than before.[15] One side-effect of this has been social networks increasingly becoming an important quarry for information for researchers across the social sciences (building on, for example, Lewis et al. 2012). Archaeology by contrast has tended to see social media as a diffusion tool (e.g. Zuanni 2017) rather than as a data source, although this is changing (e.g. Tenzer 2022). In this example, I argue that by drawing data from social media sources, archaeologists can begin to use them as an *archaeological* resource, to understand patterns of human behaviour through reports of objects, rather than necessarily collecting the objects themselves.

For example, since the start of the COVID-19 pandemic and the introduction of lockdowns and the requirement to wear facemasks in March 2020 in the UK, there has been a trend in evidencing COVID waste through social media.[16] On Instagram, about ten hashtags and at least eight accounts gathered COVID waste pictures in the United States, the United Kingdom, and France, with the glovedropnyc account providing 1,342 pictures of discarded gloves in New York while #theglovechallenge initiative by Clean This Beach Up gathered evidence of 17,467 single-use gloves (Algarra pers. comm.) across Facebook, Twitter, and Instagram. Even though COVID pollution had become critical on a global scale, the campaign highlighted the extended amount of COVID waste reported in the United States with 35 per cent of the testimonies coming from New York alone and 21 per cent from Miami and Broward County. Algarra also registered a peak in testimonies between 27 April and 10 May 2020 with 200 to 250 pictures of gloves daily during this period. After the second week of May, evidence of gloves started to decrease whereas masks appeared more abundant. This tendency is confirmed by Janis Jones who recorded 307 masks and 278 gloves in San Diego during her daily walks from mid April to July. An increase in discarded masks in Janis's walks in June is likely related to the World Health Organization's decision on 5 June to recommend the general use of face masks.

Although only indicative, these data demonstrate how social media can provide in-depth perspective and direct testimonies through material culture. From this rapid study, there was a clear impression that social media waste 'consciousness'

[14] And arguably two such problems in this case: COVID-19 as a health crisis and plastic pollution—and as we shall see in Chapter 5, human and planetary health are not unrelated.

[15] I am using the present tense here as the pandemic is still with us and is likely to remain so for many years.

[16] This analysis was undertaken by Estelle Praet, a co-author of the original paper.

appeared greater in English-speaking countries, arguably reflecting local differences of culture, geography (e.g. more urban testimonies), and privileges during the COVID-19 pandemic, all factors that impact the digital archaeological record. In contrast, one of the authors of the original article (Schofield et al. 2021b) did not see a single PPE item on the street while living through the pandemic in Huajuapán de León, Mexico, where most people wore reusable cloth masks, probably due to the cost of single-use examples alongside a taste for decorated facemasks.

Social media initiatives can also provide interpretive context, for example, suggesting a lack of waste disposal education and a strong sense of plastic disposability, reinforced through the low acquisition cost alongside other social and cultural factors. While a driver for this small project was to use social media analysis to document the pandemic, it was also a collaborative project that involved a policy scientist, specifically with a view to illustrating how good data can help shape policy (Vince et al. 2022).

Magnani et al. (2022) have also undertaken an archaeological study of COVID waste, in Tromso, Norway. In their study (2022, 77) they state that: 'Archaeologists are well-positioned to both document and interpret short-term and ephemeral events, recording and making visible behavioural patterns and innovation through the analysis of space and material. In moving beyond snapshots of crisis, this lens also reveals behaviours that transcend state-issued orders.'

Here Magnani et al. present another example of an approach towards achieving, easily and within the constraints of lockdown, a significant small win, through devising a

> flexible methodology to confront unexpected events, contributing to broader archaeological reflections on the pandemic as they relate to human patterns of coping, and intersections with state policy. Considering changing relationships between people, things, and spaces, and building on archaeological approaches to present-day material culture, we stress the adaptability of a framework that embraces social distancing, and a field site that was predetermined by our location when the pandemic emerged. We stress a research practice adaptable to different political infrastructures—whether confined to home isolation or allowed free movement around cities at new social distances.
>
> (Magnani et al. 2022, 77)

This is an example of a small win, not least as, according to the paper's acknowledgement, 'the author(s) received no financial support for the research, authorship, and/or publication of this article.' It's a triple hit. It is a small win generated at no cost *and* during a time of national lockdown. Like Schofield et al.'s (2021) face masks project, the research proved the validity and effectiveness of a method while also generating data with good spatial and temporal resolution (over the pandemic's three waves, in northern Norway). The conclusions are helpful in demonstrating that, 'individual, small-scale innovations and behaviours that

typified the pandemic will have the lowest long-term visibility, as they are increasingly replaced or outnumbered by more durable representations generated by centralized state and corporate bodies that suggest close affinity between state directive and local action' (ibid., 48).

But it isn't only archaeologists who have responded to the COVID-19 pandemic by mapping its material traces. On the global scale, and responding to the suggestion (by Bondaroff and Cooke 2020) that an estimated 1.56 million face masks had entered oceans in 2020 and that COVID-19 plastics were directly impacting marine life (Thiel et al. 2021 and Hiemstra et al. 2021), Peng et al. (2021) used an ocean plastic model to show that 8.4 +/- 1.4 million tons of pandemic-associated plastic waste was generated in 193 countries as of 23 August 2021, with 25.9 +/- 3.8 thousand tons of that waste being released into the global ocean. Similarly, in a paper that could easily have appeared in an archaeology journal, Ammendolia et al. (2021) map the spatial distribution of PPE debris in the city of Toronto, Canada. The aim here was to quantify PPE debris types and identify variable densities and accumulations across the city. They concluded that the majority of items were disposable gloves followed by masks and then wipes. Of the face marks, 97 per cent were intended for single use. In terms of location, the highest daily average densities were in large- and medium-sized grocery store parking areas and in the hospital district. Lower densities were found in residential areas and along walking trails.

The pandemic is a recent and ongoing crisis. Yet there are already examples of archaeologists attempting to make sense of it, work that may prove invaluable in addressing its environmental impact and how best to manage future waves.

Working with Schools

A separate but related project (related, that is, to both of the previous examples) is an initiative created through the Universidad Católica del Norte, Coquimbo (Chile). As described in Praet et al. (2023):

> To explore schoolchildren's perceptions of plastic litter's origins, impacts and solutions in Latin America and to create an engaging activity in the context of the Pandemic, we designed the project '*My Story of Plastic Litter: a Journey to the Ocean*' and shared it through the Latin American Network of Litter Scientists (Red de Científicos de la Basura – ReCiBa, in Latin America).

Praet et al. (2023) describe the research context for this project:

> Since 2018, the Citizen Science programme ReCiBa has brought together scientists, teachers and schoolchildren (from 10 to 18 years old) from Latin American Countries of the Pacific Coast to generate scientific data about litter sources,

distribution and impacts, and use scientific environmental education as a marine conservation strategy. ReCiBa currently works with around 800 students from different schools in the region. While most schools have participated since the first collaborative research in 2018, new schools (and/or schoolchildren) join the network each semester. So far, ReCiBa has conducted an environmental exploration (De Veer et al. 2022), a questionnaire survey of their local community, and a sampling of litter interacting with biota.

In the context of Schultz et al.'s (2013) review of littering behaviours and Canosa et al.'s (2021) scoping review of young people's understandings of marine debris, De Veer et al.'s (2022) earlier ReCiBa project on perceptions of litter by schoolchildren from the Pacific Coast of Latin America established that litter was found in all environments, but that perceptions of this problem were dependent on context. Two studies were conducted, one in an everyday urban context, and the other on a beach. In both cases, schoolchildren prepared hand-drawn representations of the environment that were then evaluated for the presence and perception of litter. Litter cognition was low in the urban context (appearing in less than 6 per cent of illustrations) but high in beach settings (where 32 per cent of drawings included litter). The perception of litter was negative in both environments. The findings in this project are indicative of 'litter blindness' within urban contexts (within which much of the litter originates), which might prove an obstacle to effective litter prevention.

Many of the same team were then involved in the later *My Story of Plastic Litter* project (Praet et al. 2023). In this project, students were invited to create stories inspired by a piece of beach litter which they had seen amongst a series of preselected items. Their story could take any form (including cartoons) provided it involved their selected object. These stories were created during COVID lockdowns, giving the students an activity they could undertake while away from school and experiencing social isolation. The content of the stories was then analysed using NVivo.

Conclusions included the realization that storytelling activities built around object biographies was a way to increase knowledge of plastic pollution, although the results suggest a very good understanding of beach litter's sources and impacts by those schoolchildren on the East Pacific Coast participating in the programme. In comparison, the diversity of solutions is fully explored in stories, showing a preference for preventive solutions, although recycling was the dominant response.

Sources of plastic litter, mostly the result of human behaviours, are well identified in the stories and surveys, and reflect a good grasp of the topic's latest studies. Participants were mostly aware of bio-ecological impacts of plastic litter on the landscape (in the pre- and post-survey questionnaires we conducted) and the wildlife (in the stories the children prepared), and their choice of object reflects

an awareness of objects commonly found on the beach, such as plastic bags and bottles. Harmful interactions are recurrent in the stories, showing an understanding of the impacts of plastic litter on wildlife. The choice of fish and turtle as the subject of many stories reflects their respective local importance and the turtle's emblematic nature as protagonist of ReCiBa's previously published story, 'The Sisterhood of the Turtles'.

In short, both of these projects described here formed part of the ReCiBa programme. In each case they illustrate how objects can provide an effective (and easily sourced) focus for storytelling activities that themselves illustrate the importance of this issue to young people across this region.

Having spent a fair amount of this chapter on marine and/or plastic pollution, I want now to turn attention briefly to other ways in which archaeology (or archaeologists working within the wider but related field of heritage studies) have approached other forms of environmental pollution. In this particular area of research, archaeologists not only need to act as superheroes. They also need special technical skills and often special suits to protect them from the dangers they will inevitably face. In this setting at least, archaeologists can even sometimes *look* like superheroes.

The Tainted Desert

In the early 2000s, and following some tentative heritage protection-related research at the former United States Air Force base at Greenham Common in West Berkshire (United Kingdom), I found myself in the American Midwest, investigating the archaeological remnants of a peace camp in the remote Nevada Desert. The subject of the protesters' attention was, in this case, the atomic testing taking place both above and below ground on the Nevada Test Site on land traditionally owned by the Western Shoshone Indigenous people. The protesters came from far and wide to express their opposition and vent their anger, although the majority were from the nearby city of Las Vegas, 100 km to the south-east. The protesters had a wide international network. There was also considerable cultural diversity amongst this community of opposition including representatives of the Western Shoshone, who were (and had reason to be) the most pissed-off of everyone, the Test Site being on land traditionally in their ownership.

For those unfamiliar with the American Midwest, the distances are huge and the landscape and climate unforgiving: often, if not typically, immensely hot by day and freezing at night. There is no surface water to speak of. Yet people in the protest camps lived here all year round, the numbers of residents swelling on weekends and public holidays, or when specific detonation events were scheduled. All of these people travelled significant distances only to endure hardship when they reached their destination. This was true dedication to the cause.

The Nevada Test Site was (and remains) a limited-access, government-controlled facility of about 3,600 square km. It served as the United States' primary nuclear weapons testing facility from 1951 to 1992 (Beck 2002). The town of Mercury is located on the Test Site a short distance inside the main entrance and serves the needs of the workers, providing housing, a cafeteria, offices, workplaces, warehouses, and recreation facilities. The Test Site is divided into 'Areas', Area 51 being the most famous of these and the least accessible. These Areas delineate different zones of distinct activity across the Test Site, which is mainly known for the many above- and below-ground nuclear tests conducted there. Within this extensive and unforgiving landscape survive the physical traces of these tests, additional to those representing a vast array of associated structures (Figure 3.4). From the start, activities at the Test Site were a focus for anti-nuclear activism and, within a few years, the Peace Camp was established just beyond the facility and alongside the highway route connecting Las Vegas in the south, with Salt Lake City in the north.

Peace Camp (as it became known) was evident in news footage and historic photographs, depicting the sustained presence of large groups of people in a comparatively small area close to the Test Site's only known entrance. Prior to archaeological survey in the early 2000s, nothing was known of the Camp's

Figure 3.4 The industrial remains of atomic tests, left in the desert at Nevada Test Site (USA)

Note: The image shows mobile laboratories and kilometres of cabling, all linked to a single underground test.

Source: Author's photograph.

physical trace on the landscape. The existence of a peace camp was even denied by official sources who claimed that 'nothing survived', beyond the fact that it was 'unimportant anyway'. In two field seasons the traces of Peace Camp were fully mapped and documented as covering 240 ha, stretching 2 km east–west parallel with the highway, and about 1 km south from the highway (Beck et al. 2007). The site therefore proved to be both extensive and also complex with 771 cultural features recorded, mostly composed of stones taken from the surrounding terrain. These stones were used to create rock cairns, rock caches, stone circles, foundations for sculptures, geoglyphs, rock lines, lines enclosing an area of desert plants (thus creating gardens), hearths and rock circles for holding down tent canvases. These different types of structure helped to define functional areas across the site comprising sleeping and ritual areas. There were also graffiti within the so-called Tunnel of Love that runs under the highway and connects Peace Camp with the Test Site entrance (Beck et al. 2015).

To fully realize the archaeological significance of Peace Camp, where these protesters lived, and (controversially, for some) the associated significance of the remains of the atomic tests they were objecting to, we need to extend our view out from the vast extent of the Nevada Test Site to the even vaster extent of the Midwest, and arguably also, the world. Only within this wider geopolitical arena can the significance of some rocks in the Nevada Desert be fully appreciated. And it is only in appreciating those rocks, and giving them meaning through an archaeological study such as this, that we can demonstrate again how a small win can help to address the wicked problem of environmental pollution. The small win here may not rest with solving the wicked problem itself, but it does at least help people to understand it and perhaps start to come to terms with what they have lost (whether in terms of territory, or a clean atmosphere). In this last case the small win is achieved by making the invisible visible; by being able to *place* this aspect of pollution somehow in the landscape, by making it real, much like plastic pollution as an indicator of climate change.

Let us begin with the bigger picture and then home in on Nevada and those piles of rocks.[17] In 1997 Valeria Kuletz wrote a book entitled *The Tainted Desert: Environmental Ruin in the Midwest*. It had a profound impact on the work I was undertaking at that time on Cold War landscapes. Having practised landscape archaeology[18] over several years, this study revealed new ways of thinking about and understanding landscape, recognizing different types of landscape, new ways of characterizing it, and a new terminology. It also introduced those invisible components including, notably in this case, environmental pollution. The book

[17] And recall Smith's (2006, 1) comment that this is all Stonehenge is really—a pile of rocks. It is just that we choose to think of that pile of rocks as 'heritage'. It is all a matter of perception—things we place value upon, in different ways.
[18] As in human impacts on the landscape that are evident in the traces people have left upon it.

also resonated in another important way. Kuletz had grown up within this industry, her father having been a weapons scientist working in a research and testing centre in the Mojave Desert. Like my own military childhood (and through the opportunities that I had to study some of the places where I had grown up),[19] Kuletz's story is partly reflexive and autobiographical without ever making that too obvious or prominent a theme. Her narrative skilfully navigates the margins of what is objective and where memory and the historical record intersect. It addresses environmental racism, nuclear colonialism, military secrecy, and the dangers of living with nuclear waste. For all of these reasons, *The Tainted Desert* is an important account. But it is also dark and imposing—the looming black (mushroom) cloud that is accompanied by the start of a menacing score in a superhero movie. The world is under threat and somebody needs to step up to save it.

Now, Kuletz is not an archaeologist, and I am describing her book not as an archaeological intervention but as a study in landscape that provides a backdrop to archaeological work. The small win here is to be found in undertaking archaeological work in Nevada as part of a wider documentation of how nuclear testing has impacted society and landscape. That work is made meaningful in part by Kuletz's study. It is not that one could not have existed without the other; more that each is enhanced by the other. Two different studies conducted at very different scales. Each complementing the other.

While the nuclear landscape exists across the United States (and across much of the world, given that the pollution does not respect borders), it has a particular focus on the south-west of the United States, in the inter-desert region including Nevada. Kuletz (1997, 10–11) provides a characterization of this region in which

> stand thousands of abandoned and unreclaimed open-pit and underground uranium mines and mills, two proposed national sites for deep geological nuclear waste repositories of monumental proportions...a constellation of other nuclear pollution points such as 'unofficial' waste holding stations, and secret testing sites....Home to 'downwinders', or victims of airborne radiation, this region also includes the site where the US government has detonated more than 928 above-ground and below-ground nuclear bombs, as well as hundreds of secret and previously undisclosed nuclear tests. This region contains important nuclear research and development centres, with their own 'private' nuclear waste disposal areas of significant size....Significantly, this region is home to the majority of land-based American Indians alive today on the North American continent.

There is much to unpick here. But let me focus on one aspect, given that it represents one part of this nuclear landscape on which numerous archaeologists

[19] For example, The Teufelsberg in Berlin—see Cocroft and Schofield 2019.

and heritage scholars have focused their attention. The questions that surround the disposal of nuclear waste and its longer-term (deep future) implications are just as relevant for archaeologists as the survival of its associated legacies across the visible landscape and what these legacies reveal about contemporary and recently past society. How will society ensure nuclear waste remains safe in the future, for example, at a time when language and symbolism may have evolved beyond what we'd recognize today? The principles of site preservation are comparable too—preserving something that we attach value to (in this case partly because it is so dangerous) to ensure its safe preservation into the future. The parallel should be obvious: with the preservation of ancient archaeological sites, the aim[20] is to protect them from unnecessary damage so that they survive indefinitely. We are doing the same with nuclear waste, albeit for very different reasons (Holtorf and Högberg 2021, 146–148).

That is why sites like the Nevada Test Site and Peace Camp matter. They are important for what they will tell future generations, as well as helping people to better understand the shortcomings and challenges of their own world, in this case by using specific tangible places and things to represent what is often both intangible and unimaginable in scale, in this case environmental pollution. As Charlotte Robert Maxwell has said (2016, 100), 'It is not radioactivity itself, but our attitudes towards it that become visible in the archaeological record.' Cornelius Holtorf and Anders Högberg (2021, 146–147) follow up this statement by describing how, at sites like this, 'people will be able to learn about atomic culture and the global history of nuclear power and the nuclear industry, the changing relations between (nuclear) technology and society, and indeed about the emergence of the environmental movement and its impact'.

This may therefore be an example both of small wins now, but also small wins in and for the future, providing the tangible and constant reminders of the environmental and human costs of environmental pollution, of its colonial violence, and direct health impacts on those who not only inhabit this landscape, but also those inhabitants downwind of these sites. Very similar arguments can be made of course around plastic pollution: it starts in one place, but ends up somewhere else...somewhere that is *away*, at least for those who created the problem in the first place.

Conclusion

Building on the related topic of climate change, the focus of Chapter 2, this chapter has emphasized ways that archaeologists and cultural heritage practitioners are increasingly engaging with the contemporary challenges of environmental

[20] At least according to convention.

pollution. Examples include plastic pollution, nuclear waste and the wider atomic landscapes of which it is a part. In many of these instances, archaeologists and cultural heritage practitioners are positioning themselves as activists, alongside scholars and practitioners from a diverse range of other disciplines and from other sectors beyond the academic. As with climate change research and activism, collaboration is important in achieving success, by which of course I mean small wins.

The chapter has demonstrated how significant small wins can be achieved at a local (e.g. Galápagos) and regional (e.g. ReCiBa) scale, with examples of success then being available for wider application. Such small wins can also be achieved with limited resources and under challenging circumstances. In the case of ReCiBa, for example, the success occurred in spite of COVID lockdown restrictions across the Pacific coastal region of South America. There is no disputing the wickedness of this particular problem, as described in the first part of this chapter. There is also little doubt that the problem is increasing in scale over time, in spite of growing environmental awareness and new initiatives amongst consumers and (albeit to a lesser extent) organizations involved with plastic production and the nuclear industry, for example.

Archaeology and heritage practice are disciplines that focus attention mostly (and traditionally) on the material object—the artefact, the building, the city or place, the landscape. This emphasis is the principal reason why these areas of activity have so much to offer the wicked problem of environmental pollution. By focusing attention on the physical entity (e.g. the plastic bottle, a rock pile in the Nevada desert) or the landscape in which that bottle or that rock pile was found, the problem becomes tangible, making it easier for people to comprehend. By focusing on a local scale, the impact of the pollution can also be demonstrated in ways that are personal and directly relevant; people can see actions making a difference. This might relate to health for example or Indigenous concerns around the values of polluted places. This local scale is also an ideal testing ground for methodologies, as was the case with the various ReCiBa projects described above.

Earlier in the chapter I explained how, in an essay by Martin Wagner (2022, 333), plastic pollution was framed as a

> waste, resource, economic, societal [and] systemic problem. [Framing it thus] results in different and sometimes conflicting sets of preferred solutions, including improving waste management; recycling and reuse; implementing levies, taxes and bans as well as ethical consumerism; raising awareness; and a transition to a circular economy. Deciding which of these solutions is desirable is...not a purely rational choice.

Like all of the wicked problems described in this book, environmental pollution is wicked precisely because it is difficult (if not impossible) to resolve. It can even be

framed as 'super wicked' given that time is critical, there is a lack of central authority, and that the same actors causing the problem seem to be needed to solve it (after Lazarus 2009; Levin et al. 2012; Peters 2017). I ended Chapter 2 with comments about ways to resolve such messy problems and how to measure our success, where we think this has been achieved (after Conklin 2006, 11–12). Those comments are also relevant here. As we have seen, climate change and environmental pollution are bound up together (as a super wicked bundle). The solutions must also therefore align. With small wins (e.g. through citizen-science initiatives and individual and community-based actions) this can be more easily achieved once the nature and urgency of the problem are understood.

Rathje and Murphy (1992) reflected on this point thirty years ago, in one of the 'ten commandments' with which they closed out their book *Rubbish! The Archaeology of Garbage*. In their first commandment they suggested that garbage problems shouldn't be thought of as a crisis and that we should remain calm. Specifically, to re-cite a quotation from the start of this chapter:

> Our garbage is not about to overwhelm us; there are a number of options available; and most communities have time to think about those options and choose among them wisely. The worst thing to do would be to blow the problem out of proportion, as if garbage were some meteor poised to strike the planet.
> (Rathje and Murphy 1992, 237)

Most would agree that, thirty years later, this is indeed now a crisis and a wicked problem and that, if the meteor hasn't yet struck, it is incoming, and at speed. But where Rathje and Murphy do have a point is in framing the solution. As they state, crisis thinking usually results in 'ill-conceived and counterproductive initiatives', where a better option might instead consist of, 'muddling along, making improvements at the margin all the time, applying the fruits of advancing technology and of new knowledge about human behaviour, thinking through the second-, third-, and fourth-order consequences of proposed initiatives' (1992).

Small wins, in other words.

Chapter 1 opened with the metaphor of the moon and the ghetto. The suggestion was made that putting somebody on the moon, while technically complex, was not a wicked problem, but that solving poverty was, as we will see in Chapter 6. Both climate change and environmental pollution are also wicked problems. But given the metaphor, it is worth emphasizing that both of these particular problems extend beyond our own planetary system, into space. So, how about as an exciting next step, persuading an astronaut to conduct an archaeological survey of the spacecraft on which they are travelling through Earth's orbit, one of whose roles is also to map the extent of wicked problems on Earth? In fact, this is already happening. And the archaeologist mostly responsible for

establishing this field of research? Dr Space Junk, naturally.[21] If that doesn't sound like an archaeological superhero, I don't know what does.

Chapter Headlines

- Environmental pollution is a wicked problem. While this chapter has focused mainly on plastics within the marine environment, the problem extends far beyond this, as the shorter example of atomic testing in the American Midwest has shown.
- The scale of the problem of plastic pollution alone is vast with an estimate of 170 trillion plastic particles afloat in the world's oceans, and with plastics now proven to exist within the human body and within archaeological and geological sequences.
- This wicked problem relates to climate change (as we saw also in Chapter 2) but also to health (Chapter 4) and to social injustice (Chapter 6), amongst others.
- Because of the extent and scale of the problem, because it impacts on other wicked problems, and because time is critical in resolving it, this particular wicked problem has also been referred to as 'super wicked'.
- Unlike with climate change, where the main benefits of small wins were in generating new data to grow our understanding of the problem, and to help people think about climate change in new ways, here small wins can have genuine and tangible benefits at very low cost. Beach clean-ups are amongst the best-known examples of small wins, but the work described for Galápagos, and ReCiBa are also creating benefits at local scale.

[21] Also known as Dr Alice Gorman. And see Gorman (2019) for an introduction to her work.

4
Health and Well-being

One in four people in the world will be affected by mental or neurological disorders at some point in their lives. Around 450 million people currently suffer from such conditions, placing mental disorders among the leading causes of ill-health and disability worldwide.

(World Health Organization 2001)

Having isolated myself over the past few years ... I am a step closer to joining the world again.

(Military veteran as part of the Breaking Ground Heritage project, cited in Everill et al. 2020, 224)

Unless we take better measures to conserve and interpret natural and cultural heritage in contemporary contexts, the future psychological and even physical health of both individuals and societies will increasingly be at risk. Heritage is not a romantic, nostalgic component of fragmented pasts and memories but rather an essential part of who and what we are, where we have come from and where we are going. *Heritage is something that is essential for contemporary and future wellbeing.*

(Taçon and Baker 2019, 1310; my emphasis)

'Everyone's Business'

Read that final sentence again: '*Heritage is something that is essential for contemporary and future wellbeing*'. I believe that to be true and it is for that reason that this most powerful statement (of all those included in these opening quotations) provides an essential foundation for the subject of this chapter.

In their commission for leading international medical journal *The Lancet*, Napier et al. (2014, 1607) explored the relationships that they recognized as existing between health and culture. Ideas around health, they argued, are largely cultural. These ideas do not refer only to clinical care and disease but to the cultural contexts within which clinical care and disease co-exist. Just as culture is diverse, so too is health and well-being at every level from global to local. Their point was that cultural systems of value within the health and well-being arena should not be ignored, for if they are, then biological wellness will become the sole

measure of well-being and the potential for culture to become a significant factor in maintaining and promoting good health will be ignored. This is most likely to occur where resources (and, in particular, financial resources) are scarce or absent. In their wide-ranging report, Napier et al. (2014, 1626) also discuss the benefits of social capital and recognize how 'health outcomes can be improved and money saved if caregivers are allowed time to engage with patients and help patients integrate into care communities'.

Social capital refers to 'valued social networks and reciprocal social bonds that sustain human engagement and cooperation' (Napier et al. 2014, 1616; see also Hyyppä 2010, 1–7). French sociologist Pierre Bourdieu (1980) simplified the concept into a single word: 'contacts', a vital element that can help mitigate some health impacts through simple everyday social interaction (the smallest of small wins, but often also among the easiest to achieve). Another vital element is the more proactive notion of cultural participation. I shall come on to discuss both ideas in this chapter. First, however, I will briefly outline some of the main health concerns that exist on a global scale, and I will do this by highlighting those issues already flagged as being amongst the most significant by the World Health Organization (WHO).

Founded in 1948, WHO is a specialized agency of the United Nations responsible for international public health. The WHO Constitution has as its main objective the 'attainment by all peoples of the highest possible level of health'. With a headquarters in Geneva (Switzerland), the WHO has six regional offices and 150 field offices worldwide. The scale of this operation reflects the fact that health is widely recognized as constituting a wicked problem (or multiple wicked problems) globally, with the possibility that it might even constitute a super wicked problem according to the definitions I provided in Chapter 1. The list of health topics accessible from the WHO Europe's website landing page gives a sense of the scale of this particular problem or set of problems. To pick a selection of topics more-or-less at random from that list, and to search for these as wicked problems within the literature does suggest a high level of correlation. For example: air quality (Holgate and Stokes-Lampard 2017), the COVID-19 outbreak (Angeli et al. 2021), digital health and its role in strengthening health systems and public health (Skuse et al. 2021), illicit drugs (Lee 2018), mental health (Hannigan and Coffey 2011), obesity (*PLoS Med* 2013), violence and injuries (Newman and Head 2017), and water and sanitation (Bjornlund et al. 2018) are all described as wicked problems in at least the single citation listed here. These are all broad, global, universal issues. There are many more health concerns listed by WHO that are culture- or regionally specific, such as Roma health and the current Ukraine emergency, all of which might also constitute wicked problems within other areas, such as social injustice or conflict. I will examine a few of these aspects of health as examples of wicked problems in more depth in the next section.

As archaeologists we tend to think broadly about cultures and societies. But we also recognize that cultures and societies are made up of people, individuals who had their own lives and experiences. This makes it easier for us, as archaeologists, to think about wicked problems and the archaeological projects that address them on multiple scales. We can appreciate, for example, how this diversity of themes, topics, and specific conditions and ailments that constitute health problems can be debilitating for individuals, impacting their quality of life, while also creating long-lasting problems more broadly within specific communities. In the case of Roma communities for example, a study of health inequalities in Spain (Escobar-Ballesta et al. 2018, 444, citing Fésüs et al. 2012 and Parekh and Rose 2011) has revealed that this community has, 'considerably poorer health outcomes when compared to non-Roma populations across Europe. Studies point to a persistent health gap with Roma experiencing lower vaccination coverage, higher levels of communicable and non-communicable diseases, higher unmet health needs and higher infant mortality rates.'

In archaeological terms, we can see similar inequalities among past societies, for example, by examining the human remains that represent individuals from a former community, or by comparing the remains of people from different communities.

The cause of the problem in the case of Roma people is characterized as involving the combination of a lack of political commitment and (thus) also financial investment alongside access for Roma communities to the health care that much of the rest of the population receives (Escobar-Ballesta et al. 2018). How to remedy that situation constitutes a wicked problem. I will give a comparable example later in the chapter of health-care issues related to health provision for Indigenous communities in Ecuador, aligned to the prevalence of traditional beliefs.

In this and many other situations, however, the nature of the problem runs deeper than the *physical* health provision that can often become the focus of attention. As the WHO states, there is no health without mental health. They go on to define mental health as being: 'everyone's business; it affects the lives of people living with mental problems, their careers, and the productivity of society as a whole'. This issue is a much broader, societal, and even global concern, therefore. But in the specific case of the Roma communities at least, good investment combined with 'strengthening intersectional and intersectoral policies, enabling transformative Roma participation in policymaking and guaranteeing shared socio-political responsibility and accountability' (Escobar-Ballesta et al. 2018, 444) can be helpful across the board, as well as finding technical solutions to funding and perceived social barriers.

One of the ways that mental health has been addressed within heritage studies is in the context of affect and emotion, which in turn relates to memory and place attachment, both of which are discussed later in this chapter. These are important

concepts as they relate to identity and belonging, meaning that they also have relevance in the context of social injustice, the subject of Chapter 6. It is an argument that also relates to the very definition of heritage and how this has shifted from one focused on the elite structures representing a particular version of history (the so-called Authorized Heritage Discourse, after Smith 2006), to a broader definition that also incorporates the everyday, the places for which people hold social and communal values and from which they gain their 'ontological security' (after Giddens 1991; see also Grenville 2007). Heritage is dynamic and the things we remember can shape 'the envisioning of environment, meanings and futures', acknowledging their power to 'articulate pasts, identities, events and create atmospheres of experience and creative heritage' (Tolia-Kelly et al. 2017, 3). Places and objects help us to remember.

In this chapter, I will begin by looking in more detail at the literature describing these wider health issues as wicked problems. I will then explore some of the research highlighting the benefits of cultural participation and of social capital. I will also touch on the mental health benefits to be gained through a stronger sense of place attachment, not least through the prosocial behaviours that this might encourage. I will then use some select examples to demonstrate how archaeology and cultural heritage activities can form small wins through such acts of cultural participation, with archaeologists also using some of these small wins to promote their ability to act as policy entrepreneurs within this health and mental health arena. It might seem obvious, but there are clear connections between the content of this chapter on human health and the earlier chapters on planetary health as well as those to follow on social injustice and conflict. The nature of these connections, and how we might think about these entanglements, forms the subject of the next chapter (Chapter 5), an interlude which will provide a kind of midpoint theoretical framing for the thematic chapters that form the basis of this book.

Health as a Wicked Problem

The 2021 'Geneva Charter for Well-Being' presents well-being as being underpinned by 'a positive vision of health that integrates physical, mental, spiritual and social well-being' (World Health Organization 2021). Equally, as stated by Waltner-Toews (2017, 3), health presents 'a set of wicked problems, with multiple possible, and sometimes contradictory, evidence-based solutions' (citing Brown et al. 2010). Previously, I listed a series of health issues that had individually been referred to by various authors as presenting such specific wicked problems. Mental health was on that list, as was obesity and the COVID-19 pandemic. This means that scholars and practitioners see the problem as existing on different levels, at various scales of resolution, from the very general to the more specific. One might

describe poor health (including mental health) and the need for health provision and mental health care in general terms as presenting a super wicked problem (after Lazarus 2009 and Levin et al. 2012). The justification for this definition is that these issues represent an area that is complex and messy, that time is often critical, that internationally at least there is no central authority to manage the problem (although the WHO partly fulfils this role),[1] and that contemporary or short-term solutions are often prioritized over any long-term fix.

There is confusion, however, not least as some authors have described some of the more specific aspects of poor health as super wicked problems in their own right. Auld et al. (2021), for example, describe managing pandemics as representing super wicked problems, with a focus on the particular case of COVID-19. It is worth repeating their argument here because, although the focus of this chapter is to find ways for archaeology and heritage practice to contribute to mitigating the problem, it is nonetheless helpful to understand how the problem itself is framed and why that understanding is necessary to help shape the kinds of policy-led solutions to which archaeology and heritage might contribute. I have selected the COVID-19 pandemic not least as it is a current example of a wicked (or super wicked) problem, and one that archaeologists have begun contributing to (see for example Magnani et al. 2022; Schofield et al. 2021, discussed in Chapter 3).

Auld et al.'s[2] paper begins (2021, 709), as most wicked problems research does, with Rittel and Webber's original (1973) publication, citing the ten defining characteristics of wicked problems that have 'stymied planners' (including: the lack of a discrete end point, no opportunity to test potential solutions, no opportunities for trial and error, and so forth). Auld et al. (2021, 709) also recognize the validity of those criticisms which saw these characteristics as being too broad to be helpful (as noted by Levin et al. 2012 and Peters 2017). Auld et al.'s argument is that, by following the template of super wicked problems, policy-makers might yet avoid traditional policy analyses that are not fit for purpose in favour of those better suited to the problem at hand. Bringing us back to the fact that all wicked problems are in some ways interconnected, they build their argument through comparing the super wicked problem of managing pandemics with that of managing climate change. In the case of the first criterion of super wicked problems, that 'time is running out', for example, for pandemics like COVID-19: 'Failure to take action within days or even hours, rather than years

[1] As Auld et al. (2021, 710) describe it: 'While a World Health Organization (WHO) exists, it has no power to dictate global responses or control national health agencies, policies, or regulations. Whereas the WHO performs many important functions to monitor and promote health, it primarily acts as an advisory, scientific, health intelligence, and health promotion body. Its authority is limited largely to classifying global health threats, offering advice and public health guidance, and supporting responses to essential health services in emergencies or in countries requesting assistance.'

[2] Amongst others—see also e.g. Schiefloe 2021.

in the climate case, can risk exponential effects in deaths and illness (Sun et al. 2020)' (citation in original). Herein lies the challenge, or at least part of it, that:

> Managers faced with novel diseases...must at first, and yet when time is precious, take 'best guess' efforts based on expectations rather than empirical evidence about how the disease spreads. Hence, while both COVID-19 and climate share the problem structure of time running out, micro-level differences carry implications for how to manage them. (Sun et al. 2020)

Equally, and in both cases, 'scientific evidence, rather than electoral cycles or policy windows, dictates the specific time requirements' (Sun et al. 2020).

The lack of any central authority for global health has already been discussed, and we can see the impact that this has had on COVID-19 in terms of the variable production and supply chains for PPE, for instance, and vaccinations, determined by global trade and commerce. There has also been variation in the rigour with which border controls have been enforced. For comparison, and as we saw in Chapter 2, climate change governance is also fragmented.

The comparison between managing the COVID-19 pandemic, climate change, and other wicked problems is also evident when it comes to the fact that those seeking to end the problem are also (at least partly) responsible for it. This resonates with the difficulty that can sometimes arise when dividing opinions into the binary of supporters and opponents. As Auld et al. (2021, 710) state, with gun control and abortion, for example, the cause does have a clear demarcation between camps. However:

> Like climate change, society is not divided among interests who support or oppose the spread, effects, and persistence of COVID-19. Yet the virus has diffused so rapidly because humans benefit from, and reinforce individually and collectively, domestic and transnational social networks, as well as economic benefits of global economic integration. Accordingly, the benefits of maintaining activities that cause the problem are so strong in the short and medium terms that individuals and governments may resist changing or limiting activities that can spread disease, even if they know the risks of harm to themselves and others.

As we have seen already, archaeologists and critical heritage scholars have recently begun turning their attention more towards the future (e.g. Holtorf and Högberg 2021a). As an example of this new perspective, in their 'final reflections' closing chapter to their *Cultural Heritage and the Future* collection, Högberg and Holtorf (2021, 264) present the extract of an interview with a Swedish heritage professional who states that: 'We are all well aware that there is a future, but we don't talk about it.... We think short term.' The interview is referring specifically to the daily work of archaeologists and the lack of any capacity to think more deeply

about that work. But this point also aligns well with wicked problems thinking, and the specific criterion of super wicked problems, that policies often irrationally discount the future.[3]

In Auld et al.'s (2021) review of the criteria characteristic of super wicked problems and how they relate to COVID-19 and to climate change, they conclude on this point about the future, using the term 'hyperbolic discounting' to describe situations in which 'today's preferences are often inconsistent with long-term economic benefits' (2021, 711). They go on to describe how:

> Others have found a tendency of political institutions to 'disproportionately consider certain aspects of the present' (Dietsch 2020), especially economic over environmental values (Cashore and Bernstein 2020), and the tendency to 'put off the future' (Cashore et al. 2019; Lijphart 1990). These 'irrational' logics in turn result in policies that are inconsistent with what the scientific evidence indicates is required for addressing the problem at hand.
>
> (Auld et al. 2021, 711citations in original)

Near-term biases were evident in the COVID-19 pandemic, with politicians in Italy and the United States for example reacting slowly and sceptically to the suggestion to close down cities and introduce social distancing, with economic, educational, and social well-being considerations often used to counter the strictly health-related arguments for lockdown. This example also takes us back to the issue of entanglement: the fact that a solution to one wicked problem might simply cause or exacerbate others, such as the chances that lockdown might lead to an increase in domestic violence (e.g. Bradbury-Jones and Isham 2020).

Auld et al.'s research is focused on policy design and management. The purpose of this chapter (and of the book) is to contribute to that discussion, but primarily to find ways that our own field, our specialisms as archaeologists and heritage practitioners, can help mitigate specific wicked problems in some meaningful way. In relation to health, I will give some specific examples of this later in the chapter. This question of the future and of 'hyperbolic discounting' is important, however. First, we do need to recognize that whatever we do today, as archaeologists, might have consequences later on. We also need to make decisions and act now. But—coming back to those superpowers I referred to in Chapter 1—we also need to recognize the need to think longer term. As archaeologists, we are closely familiar with a deep past. We should feel equally comfortable with a deep future. Health and planetary health (as we saw in

[3] And see Tutton (2017, 478), referred to in a previous chapter, who describes the future as 'difficult and tricky, both conceptually and empirically', and as constituting a wicked problem in its own right.

Chapter 3, on the storage of nuclear waste, for example) are both areas where this ability to look both ways is vitally needed.[4]

In turning my attention now briefly to the equally vital, yet equally wicked, problem of mental health, I want to highlight the fact that, in looking for solutions, the emphasis is often placed on fairly conventional top-down policies at the expense of co-production. Such a top-down approach presents policies that are intended as solutions but often fail because, first, they pay insufficient attention to building strong partnerships across the system as a whole, and, second, because they ignore or discount the cumulative effects of the activities. So said Hannigan and Coffey (2011, 225), as the context for observing how new collaborations were being sought across the mental health sector with the challenge to meaningfully re-engage with both providers and recipients of services in order that, 'problem formulations can be agreed by as many as possible, actions negotiated and the likely waves of consequence better anticipated'. Twenty years ago, the WHO (2001) reported that:

> One in four people in the world will be affected by mental or neurological disorders at some point in their lives. Around 450 million people currently suffer from such conditions, placing mental disorders among the leading causes of ill-health and disability worldwide.... Treatments are available, but nearly two-thirds of people with a known mental disorder never seek help from a health professional. Stigma, discrimination and neglect prevent care and treatment from reaching people with mental disorders.... Where there is neglect, there is little or no understanding. Where there is no understanding, there is neglect.

Furthermore, mental health problems are one of the main causes of the overall disease burden globally (Vos et al. 2013). Such problems impact huge numbers of people and that number is fast increasing. During the first year of the COVID-19 pandemic alone, for example, cases of anxiety and depression rose globally by 25 per cent according to WHO statistics. This was largely due to people experiencing social isolation and loneliness, the fear of infection, the suffering of oneself and of loved ones, grief after bereavement, and financial concerns. Such mental health issues clearly do therefore, in themselves, constitute a wicked problem, if not multiple wicked problems, as numerous authors (cited above) have stated. However, as Henderson and Gronholm (2018) have suggested, there is a pressing need to address not only the mental health issue itself, but also the stigma that accompanies it. They emphasize and summarize the evidence for mental health stigma reduction which shows how interpersonal contact can promote more positive attitudes to mental health, reduce the need for social distance, and

[4] And as teachers, we should be encouraging our students to learn to look both ways, backwards and forwards, as they train to become archaeologists.

improve stigma-related knowledge. They also recognize that short-term interventions can have benefits that are attenuated over time.

With wicked problems, long-term and sustainable solutions are obviously the goal and will likely have the greatest impact in achieving successful mitigation and resolution. Such long-term and often systemic solutions rest with senior management and policymakers, funders, and health specialists. But implementation and a space for creativity can occur at the local level, on (or even in) the ground. Such interventions are sometimes defined as 'social prescribing', being services that meet physical or mental well-being needs, but not necessarily in a medical context (Kimberlee 2015). Such social prescribing initiatives[5] often involve tasks that help people to enter a 'flow state', referring to the experience of being so engrossed in a task that everything else is forgotten. It is generally agreed that a 'flow state' is an important tool in helping people heal (Turk et al. 2020). To achieve such goals, therapeutic landscapes can be utilized. These are places such as gardens, libraries, and museums which can be aesthetically pleasing, non-judgemental, foster social connection, and have free admission which creates a low barrier to entry (Turk et al. 2020). As I will explain, excavation sites can also act as therapeutic landscapes to support people in reaching the flow state.

As I will explain later in the chapter, some of these frameworks can include provision for interventions involving various forms of cultural engagement such as archaeology and heritage practices, the tactile elements of field archaeology providing tangible benefits to people's physical health not least through having direct contact with the soil and with the artefacts it can contain, along with the physical and cognitive exertion and socialization that this activity entails, as we saw in Chapter 1. Such interventions can occur within a policy framework of social prescribing.

All of these suggestions constitute examples of the small wins referred to previously. Perhaps we should acknowledge that, as archaeologists within this area of health and well-being, our superpowers are somewhat limited, but they can be significant in terms of their potential impact. As archaeologists, we can influence aspects of policy through our role as policy entrepreneurs, and produce excellent and creative examples of good practice, providing opportunities that allow people suffering from some of the health and mental health problems outlined above (such as loneliness, depression, anxiety, and general levels of fitness) to improve their personal health and connection with the world through this direct form of cultural participation. We cannot change the world, but we can significantly improve some people's experience of it. Much of this relates to what Bourdieu (1980) referred to as social capital, referred to previously. In the next

[5] One example of which is 'Archaeology on Prescription', a project being undertaken in York by York Archaeology. For details, see: https://community.yorkarchaeology.co.uk/archaeology-on-prescription/

section I will examine further what this (and social prescribing) means in practice, and how it relates to ideas around cultural participation. I will examine how such participation has had proven benefits for people's health and longevity, involving research within the health sciences and psychology but also commissioned and undertaken within archaeology and across the heritage sector. With these foundations in place, I will then present some examples of the small wins that can be achieved within the complex and challenging area of health and mental health.

Social Capital and the Health Benefits of Cultural Participation

As has already been implied, social capital is an important concept when dealing with individual and societal health. It has been defined in a number of ways but refers, essentially, to the social fabric of communities that individual people are part of, and the resources and opportunities that this network provides access to. This broad definition is built around the way that scholars have used the term in the past. Bourdieu (1980), for example, defined social capital in terms of the aggregate of actual or potential resources which are linked to the possession of a network of relationships of mutual acquaintance and recognition. Lin (2001) took a similar view, recognizing a definition directly linked to the resources embedded in one's social network which can be accessed and mobilized through the ties within that network. Putnam (2000), on the other hand, saw social capital in terms of features of social organization such as trust, norms, and networks that can improve the efficiency of society by facilitating coordinated actions (Hyyppä 2010, 13). These and other definitions are helpfully highlighted in Hyyppä's (2010) wide-ranging survey of social capital and its relationships with health and longevity.

Several longitudinal studies have now demonstrated the direct causal link between cultural participation and longevity through the filter of people's improved health and mental health. A leading example is the study undertaken by Løkken et al. (2020). Here the authors undertook a study of over thirty-five thousand participants using the Norwegian Nord-Trønderlag Health Study (the 'HUNT Study') and incorporating participation (or not) in a combination of both passive and active cultural activities. Passive activities included those in which the participant was receptive (watching sports, concerts, theatre), while active activities involved participants being creative (playing musical instruments or doing outdoor activities). The purpose of this study was to consider the types of activity and the mode of participation, and the extent to which they offer protection against all-cause mortality. Løkken et al.'s primary conclusion was that frequently attending at least one cultural activity had a positive influence on longevity. They also found that creative activities lowered mortality rates in both genders while the benefits of receptive activities were mostly seen in men.

Although previous studies had suggested similar conclusions (e.g. Hyyppa et al. 2005; Johansson et al. 2001), Løkken et al.'s was the first to present data showing a *longitudinal* association between all-cause mortality, single receptive and creative activities, and the amount and frequency of cultural participation. That 'doing stuff (ideally comprising some kind of cultural activity) helps people live longer', is one way to summarize the study's take-home message.

With that in mind, we can now examine how this concept of social capital relates directly to health and to the examples of small wins involving archaeologists that follow later in the chapter. Key to these relationships is the significance of the strength of ties or bonds that develop to exist within and thus characterize social capital networks. To explore this we can take Hyyppä's (2010, 14) citation of Granovetter's (1973) paper concerning 'the strength of weak ties'. Strong ties, according to Granovetter, are those close and intimate bonds between family members or close friends which are regularly or permanently in play. However, perhaps misleadingly labelled 'weak ties' are those non-intimate bonds between acquaintances who may barely know one another, except by sight, being bonds that are infrequently or inconsistently maintained. An example of so-called weak bonds might be the membership of a choir, or a group of volunteers working for a local museum, or membership of a local society. Within a social network characterized by such weak ties, some strong ties might develop involving select individuals. But that is not to discredit or devalue the significance of those remaining weak ties. As Granovetter has stated (1973, 1376), 'weak ties are more likely to link members of different small groups than are strong ones that tend to be concentrated within particular groups.' Granovetter demonstrated the significance of weak ties by demonstrating how their cohesive nature helped people to find new jobs.

One additional concept that has relevance here (again citing Granovetter 1973) relates to the nature of the connectivity within and between such groups. Here we can distinguish three types of connectivity or modes of connecting between groups: bonding, bridging, and linking. Bonding refers to the strong ties that exist within homogenous groups of individuals who share similar interests and characteristics, these being groups of friends or family members. Bridging relates more to heterogeneous groups with weak ties and an open circle. These groups often comprise a membership displaying significant social and cultural diversity. They are typically more open to new membership, often being proactive in pursuing this. Finally, linking describes a hierarchical and unequal organization, often also driven by institutions for a particular purpose. I would argue that much of what I describe later in the chapter, and the model best suited to achieving community and individual health benefits, is the bridging strategy, reliant as it is upon so-called weak ties.

By understanding this terminology and using this framework of social capital, we can better visualize the connections that might helpfully be created to exist

between various forms of group activities[6] and the health benefits that arise from cultural participation. Hyyppä (2010, 40) describes this cultural participation as often comprising either volunteering or civic participation and outlines how it fits well with the notion of empowerment, referring to the 'ability of people to gain control over personal, social, economic and political potential in order to improve their life situations', further noting how empowerment is, by definition, 'proactive, positive and beneficial'. To conclude his point, Hyyppä (2010, 40) also refers to WHO reports (which are not specified) that also emphasize empowerment, for example, in the relationships between voluntary group membership, public health and health promotion through citizen empowerment.

What then is the evidence for linking cultural participation, well-being, and health? While the connections might seem obvious and logical, we should begin with a note of caution. Galloway (2006) undertook a literature review comprising participation in a diverse range of cultural activities such as film, literature, the performing and visual arts, listening to and making music, arts festivals, heritage, attending cultural events, and reading books. In her review, little evidence was found to suggest that such cultural participation would contribute in a positive way to individual quality of life. The exception was amongst older participants, for whom increased participation in such activities over time did lead to a perceived quality of life improvement. For Galloway, this suggested that the benefits older people were observing may relate more to social relationships, self-esteem, self-efficacy, and avoiding social isolation. Similarly, in a study of the impact of cultural activities in British Columbia, Michalos and Kahlke (2008) reported the conclusion that arts-related activities contributed very little to people's quality of life. We should, however, recall the distinction referred to previously between activities that are passive, and those that are active, which may be relevant in these instances. The relationship between cultural participation and health and well-being is ambiguous, therefore, and a compelling case remains to be persuasively made.

One attempt to make this case and demonstrate a relationship, within the UK heritage sector, was the (then) Heritage Lottery Fund's report on the values and benefits of heritage (Heritage Lottery Fund 2012; National Lottery Heritage Fund 2019 2019). Under the heading 'Social benefits', data were presented in these reports on learning and personal development, cultural activity and well-being, physical health, and benefits for communities. A few highlights from this itemized summary give a sense of the degree to which data do seem to support the argument that benefits of heritage can occur across the population, providing justification for the types of activities discussed later in the chapter while showing how bridging strategies can be successful at being inclusive, developing successful

[6] Which, as we know from the lockdowns characteristic of the COVID-19 pandemic, can include virtual groups.

'weak links' across diverse groups in often challenging social and economic situations. There is an argument that some of these instances are more anecdotal than scientific. However, even if that is the case, these examples do at least represent hypotheses that can underlie and provide justification for a next generation of funded research projects within the heritage and health arena, incorporating the aim of measuring impact and further developing proofs of concept.

Learning and Personal Development

Under the first of these headings, on learning and personal development, the data present evidence that appears to demonstrate how learning helps improve people's confidence and changes attitudes through delivering new skills and new experiences. This supports other findings such as those reported in Schuller et al. (2004, 54), who noted for example how learning and education contribute to a combination of psychosocial and health outcomes. The psychosocial outcomes comprised: self-esteem and self-efficacy; identity, purpose, and future; communication and competences; and social integration. The health outcomes were: well-being, mental health, and effective coping. For the most part, the cultural activities referred to here are largely passive and therefore take no account of the physical exertions that one might experience on archaeological excavations or the advanced cognitive functioning that they also entail.[7]

One of the examples provided by HLF (2012, 13) was an evaluation of the In Touch programme delivered in the United Kingdom by Manchester Museum and Imperial War Museum North with two of the city's colleges. This evaluation demonstrated how In Touch was successful in 'engaging individuals who were socially, economically or culturally excluded. The programme enabled individuals to engage more deeply with museums and learn how to work as a volunteer. This was found to improve self confidence, develop literacy and other skills and help individuals re-engage with society.'

Equally, and with a direct bearing on the better-known example of the Operation Nightingale project (and other comparable programmes, discussed later), an evaluation of the Veterans Reunited Programme also provided evidence of a positive impact for participants. This programme brought together different generations within the United Kingdom in 2005 to commemorate the sixtieth anniversary of the end of the Second World War. As HLF describes it, this programme reached over 11 million people and over a thousand people completed evaluation forms. From the evidence,

[7] And similar to gardening activities, as we saw earlier, and will see later.

78% felt the experience gave them enjoyment, inspiration or creativity, 39% developed new or better skills and 64% experienced progression in either activity or changed their behaviour. Most striking, 82% of veterans involved in the programme felt more respected as a result or had pride in their contribution and 39% felt differently about themselves and their abilities.

Finally, and at the more passive end of the scale in terms of types of activity, Matarasso (1998) and Linley and Usherwood (1998) undertook surveys of the benefits of public libraries to individuals, concluding that their benefits fell under two headings: personal development (in terms of supporting literacy, encouraging self-confidence and aspirations, and enhancing well-being); and empowerment, by raising people's awareness of rights and providing a way out of isolation, particularly for older people.

Cultural Activity and Well-being

This refers to the psychological notion of well-being and the relationships that exist between this and culture, as it is broadly defined. The types of survey referred to here tend to be of a higher, more strategic level than the examples provided later in the chapter, and were often run through government departments or through their agencies. An example is the CASE programme undertaken by the British Government's Department for Digital, Culture, Media, and Sport (DCMS), published in 2010. This survey measured the engagement of people in culture and sport and the impact this had on subjective well-being. Results showed that regular cultural activity (once a week) has a positive impact on well-being that is about a third that of being in employment, and about a quarter that of being in good health. In a literature review on the benefits of volunteering there was clear evidence that volunteering does deliver health benefits, including: decreased mortality and improved self-rated health, mental health, and life satisfaction and feelings of self-worth. Some studies also showed that the more one volunteers, the greater the health benefits, up to a certain threshold. Finally, and returning to the topic of literacy and libraries, one study found that: 'Women who had poor literacy skills at age 21, and who improved their skills by age 34, were less likely to have symptoms associated with depression compared to those that had remained with poor literacy levels.'

Physical Health

We can draw particular parallels between the various findings reported in the HLF report (2012) and the benefits of physical combined with cognitive exertion out of

doors, as experienced for example through archaeological excavation. The HLF reports on a study by the University of Essex into 'green exercise' which demonstrated how combining exercise, nature, and social components (all being characteristic of archaeological excavations) can play a key role in managing and supporting recovery from mental ill health. For excavations or heritage projects in rural areas, parks, or woodland, there is relevance in a report by the United Kingdom's Forestry Commission which described the benefits of such spaces to mental health, beyond the physical. Supporting the findings of others (e.g. summarized in Abraham et al. 2010), a recent study by Maes et al. (2021) reinforced this message, highlighting how woodlands and other outdoor green spaces will benefit cognition and mental health specifically amongst adolescents, while Liu et al. (2022) have demonstrated the strong correlation between nature connection with well-being and pro-environmental behaviours.

It is difficult to separate the benefits of physical health from mental health, and typically there will be benefits to both, particularly where the form of cultural participation is active rather than passive (examples of the latter might include reading or painting, as we have seen). In Chapter 1, I referred to the close comparisons that exist between gardening and archaeological excavation. The five main similarities are: the physical activity itself; the degree of cognition required; the fact that both activities exist in the open with the benefits of fresh air if not also countryside and vistas;[8] sociability (at least with allotment gardening, through the social capital argument described earlier); and exposure to the soil and the physical benefits that this entails (as described in Chapter 1). While few comparable studies have been undertaken amongst archaeologists (but see later in the chapter for a few examples that touch on this topic), studies have been undertaken amongst gardeners.

To take just one of these, and featuring the same lead author as the example cited in Chapter 1, Soga, Cox and Yamaura et al. (2017) used Tokyo allotment gardeners to explore the health differences between them and non-gardeners from the same city and from the same demographic. To quote from their abstract:

> We compared five self-reported health outcomes between allotment gardeners and non-gardener controls: perceived general health, subjective health complaints, body mass index (BMI), mental health and social cohesion.... [R]egression models revealed that allotment gardeners, compared to non-gardeners, reported better perceived general health, subjective health complaints, mental health and social cohesion. BMI did not differ between gardeners and non-gardeners. Neither frequency nor duration of gardening significantly influenced reported health outcomes. Our results highlight that regular gardening on

[8] A study by CABE (Woolley et al. 2004) described how natural views lower blood pressure and stress.

allotment sites is associated with improved physical, psychological and social health. With the recent escalation in the prevalence of chronic diseases, and associated healthcare costs, this study has a major implication for policy, as it suggests that urban allotments have great potential for preventative healthcare.

On mental health, the evidence appears clear that gardening has a positive benefit. In addition, a study by van den Berg and Custers (2010) showed that gardening promotes relief from acute stress and that a positive mood was fully restored after gardening. During reading, on the other hand, a positive mood can deteriorate.

Benefits for Communities

Finally here we can mention community benefits.[9] This topic also relates closely to the main focus of Chapter 6, on social injustice. A couple of examples taken from the HLF report are worth emphasizing specifically for their focus on health.

First, archives can provide a significant community resource, whether that archive directly relates to a specific community and its history, or whether the community has become guardian or curator of an archive, almost by default. Either way, at the time of the HLF's (2012) report, some three thousand community archives existed within the United Kingdom supported by around thirty thousand volunteers. A questionnaire survey amongst those volunteers showed that community archives can: serve to promote understanding, tolerance, and respect between generations and between diverse communities; promote active citizenship; provide training opportunities and life skills; and create pride and interest in communities that have become marginalized.

Second, as a segue into the next section on place attachment, the HLF report cites a study by Dines et al. (2006) which showed the significance of unexceptional hard spaces such as streets and markets in East London (UK) which enable contact between different social groups and thus, through facilitating cohesion, enhance well-being at community and individual levels. This example can be described as a heritage application insofar as it relates to planning and development. Complementing the point I made earlier about the importance of green spaces for people's physical health, these hard 'grey' spaces in the city are equally vital for people's well-being. This point is clearly borne out also in Gard'ner's (2004) study of heritage values in the same area (East London, UK), in which nationally recognized listed buildings are not valued by the local community, who instead attach higher value to the types of hard places previously described. And as we shall see in Chapter 6, these kinds of values for people's ordinary everyday places

[9] Briefly, because some of the examples that follow touch directly on this category, as have some of the examples previously discussed, such as those relating to military veterans' groups.

can enhance prosocial behaviours within communities. But for now, let us draw back and look briefly at place attachment as a specific type of social capital from which communities can benefit should they wish to invest and participate in it.

Place Attachment

Place attachment is a term used to describe the emotional bond that exists between people and places, a bond often developed over time through personal experiences (after Altman and Low 1992). It relates to the notions of place identity (Proshansky et al. 1983) and of favourite places (Korpela 1992). All of these ideas serve to connect places with memories, perceptions, and social events or situations (Gatersleben et al. 2020) meaning that these factors will also come into play in the next thematic chapter on social injustice. There is also a close correlation between these notions and 'affect' (discussed briefly at the start of this chapter) and the heritage concept of social value (as discussed for example by Jones 2017). As Jones states (2017, 22):

> Social value is a complex concept. It has been variously used to refer to some or all of the following: community identity; attachment to place; symbolic value; spiritual associations and social capital.... [S]ocial value is defined as a collective attachment to place that embodies meanings and values that are important to a community or communities. The concept encompasses the ways in which the historic environment provides a basis for identity, distinctiveness, belonging and social interaction. It also accommodates forms of memory, oral history, symbolism and cultural practice associated with the historic environment.
> (Citations removed from original, but see notably Byrne et al. 2003).

Gatersleben et al. (2020) outline the relationships that exist between all of these various notions including social value and place attachment on the one hand, and health and well-being on the other (see also Scannell and Gifford 2017). They describe for example how places can function as important attachment figures to individuals, providing that sense of ontological security discussed previously (e.g. Grenville 2007). They refer to how visiting or imagining favourite places can improve people's mood and self-esteem (Korpela and Ylén 2009) and can support stress recovery alongside emotional and cognitive self-regulation (Ratcliffe and Korpela 2018). These positive associations have been demonstrated within neighbourhoods, rural communities, politically unstable regions, and areas of social housing as well as amongst specific populations including children, college students, refugees, and the elderly (see Scannell and Gifford 2017, 360 to view this list with citations). Some of these studies are what are referred to as correlational (and thus cannot determine whether attachment is a cause or a consequence of

attitudes and behaviours); however, those studies which are longitudinal can help to determine causes and consequences. As Scannell and Gifford (2017, 360–1) state by way of an example of what we might conclude from such longitudinal studies:

> Children and youth who lose their homes in a natural disaster are more likely to experience post-traumatic stress disorder than those who do not lose their homes. Other studies have similarly demonstrated that following place loss, psychological distress, including grief, nostalgia and alienation can ensue, as can physical health problems and disruptions in work performance and interpersonal relationships.

Equally and on the other hand, the disruption to or loss of favourite places can have negative impacts on well-being (e.g. Knez et al. 2018; Read 2011). However, it is important to recognize that significant variations will exist between people's capacity to feel attachment and draw positive experiences and attitudes from it, while also appreciating that this variation will exist for multiple and complex reasons. This is not the place to review that complexity and I simply state the fact that such variation exists.[10]

Beyond the self-reporting and more experimental and planning-oriented approaches undertaken previously, and upon which much of the understanding of place attachment is based, a recent study has presented the first neuroscientific study of meaningful places (Gatersleben et al. 2020). Within an MRI scanner, participants of this study (commissioned by the United Kingdom's National Trust 2020) were exposed to pictures of meaningful places, meaningful objects, and neutral places. Only in the case of meaningful places was the amygdala (that part of the brain associated with processing emotion) stimulated. The same levels of response were not seen for meaningful objects or for neutral places.

I will conclude this short section by highlighting the fact that such levels of attachment can exert a strong influence over people's prosocial behaviours within these places, which can enhance a place's appearance and its condition, thus (arguably) further strengthening people's attachment towards it. In theory this can also work in reverse. How one recognizes traces of such behaviours is not straightforward, however. For some people, graffiti or street art in a neighbourhood may appear as a negative contribution, damaging a place's positive character and appearance. Yet for other members of the community, graffiti or street art may be a meaningful and important way for them to articulate positive feelings

[10] More information can be found in Bowlby 1988, Mikulincer and Shaver 2019 and, for the specific example of how autism spectrum disorders can impact people's thoughts and perceptions of the built environment, Schofield et al. 2020a.

towards a locale. NIMBYism[11] can be equally contested in this sense, with some people valuing change and recognizing its importance and some resisting it, both for reasons that prioritize people's social values towards a meaningful place. As we have seen, the fact of feeling such attachment is generally considered to make a positive contribution to people's health and well-being. The presumption would be that this remains the case irrespective of whether or not one is a NIMBY.

Having now reviewed a selection of the evidence that exists in theory and across the health and psychology literature for connections between cultural participation and place attachment on the one hand and health and well-being on the other, I will now introduce examples. The rationale behind this particular selection of some examples amongst many, is that they offer diversity in the types of encounter and activity described, in the object of those activities, in the communities involved and the scope within those communities for various types of benefit, and in the location in which they took place.

Archaeology, Health, and Well-being: Some Examples of Small Wins

In this section of the chapter I will use the ideas, theories, and perspectives of the earlier sections as the framework for some specific examples, all of which constitute good practice in one way or another, and all of which could be described as representing small wins in the terms defined in Chapter 1. The focus remains on archaeological practice but broadening that definition where appropriate to also include some instances of what I have termed heritage practice to take account, for example, of instances of place attachment and the ways in which this might be explored through a cultural heritage lens. I will begin with two examples of participation in excavations that have benefited particular communities. I will then give two examples that relate to the objects or artefacts that are retrieved from those excavations. Finally I will give two examples where archaeological perspectives relate specifically to Indigenous communities, in South America and Australia.

Excavating

But I begin this review in the United Kingdom and with a specific, award-winning and well-known project (one of several comparable projects in fact) that address

[11] NIMBY = Not in My Back Yard. It is a term for members of a community who react against a new development within their local area, while accepting that it should be put somewhere, see Devine-Wright 2009. Note also YIMBY, as a pro-housing development movement, YIMBY meaning Yes, in MY Back Yard.

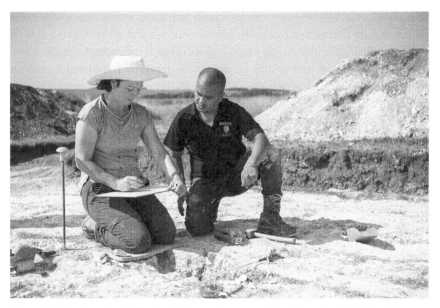

Figure 4.1 Archaeologist Janine Peck teaches one of the Operation Nightingale veterans, Jesse Swanson, how to draw features at Dunch Hill on Salisbury Plain (England)
Source: Harvey Mills Photography.

the very particular needs of servicemen who were injured and/or suffer from poor mental health as a direct result of their military service.

For over ten years in the United Kingdom, archaeology (as an activity and as a field of research) has been used as an opportunity to help support servicemen to recover from a combination of mental and physical health problems, usually the result of their participation in recent conflicts, notably in Iraq and Afghanistan. Initiatives include Operation Nightingale (Figure 4.1), established in 2011, which itself then inspired the creation of, for example, Breaking Ground Heritage, Waterloo Uncovered, and (in the United States) American Veterans Archaeological Recovery (AVAR). All of these initiatives[12] involve trained archaeologists as well as serving or recently retired military personnel working alongside one another. This spawning of new organizations all inspired by a single project is reminiscent of earlier discussions around small wins, and around policy entrepreneurship, with key and inspiring individuals persuading others to take up the baton while encouraging budget holders to invest alongside health-care professionals recognizing the benefits of such activities for the wider community of injured servicemen and those suffering from mental health conditions. Winning

[12] And there are others—see Everill et al. 2020.

prizes (as Operation Nightingale has done) also helps to build momentum, not least through exposure and publicity.

It is widely recognized that many generations of military veterans have been psychologically if not physically affected directly or indirectly by their experience of conflict. Those returning from the First World War are perhaps the best known of these examples, being people who were often advised not to discuss their traumatic experiences given the possibility that this would disturb and upset their loved ones (e.g. Burnell 2010). More recently, however, this advice has been reversed, with veterans now actively encouraged to discuss their experiences. As Everill et al. (2020, 216) put it, 'peer support, as a non-medical intervention, is thought to be a promising way to help veterans, and can complement psychological intervention. Thus an important aspect of archaeological fieldwork may be the peer support that it provides.'

It was against this psychological and medical background[13] that Operation Nightingale was established in 2011 and, as Everill et al. (2020) explain, the first intervention involved a group of serving soldiers from 1st Battalion, The Rifles excavating at East Chisenbury Midden, a Bronze Age site on Salisbury Plain in England, a military training area for over a century. As already stated, American Veterans Archaeological Recovery (AVAR) was inspired by Operation Nightingale, beginning life in 2016 as Operation Nightingale USA. By 2020, seventy-five veterans had participated in AVAR activities.

We have already seen, earlier in this chapter and previously in Chapter 1, how outdoor, physical pursuits can support people's well-being as a form of social prescribing, noting that success will not necessarily or always be achieved, with external factors such as personal choice alongside social dynamics contributing perhaps to people's underlying unhappiness (after Sayer 2015). But in the specific case of servicemen, we can recognize, through the observation made by Everill et al. (2020), that the social and peer support networks of an excavation can provide meaningful psychosocial interventions in the treatment of, for example, post-traumatic stress disorder (e.g. Caddick et al. 2015). Returning to that first Operation Nightingale excavation at East Chisenbury in 2011, a study by Nimenko and Simpson (2014, 297, cited in Everill et al. 2020, 220) suggested some clear benefits of participation. They assessed twenty-four soldiers working on this project over the course of two five-day excavations and concluded that the results indicated a positive reaction to the experience and that, 'the exercise helped isolated and distressed battle-injured soldiers return to effective operational roles within the regiment'. Finnegan (2016, 16) makes an interesting observation on why this might be the case, specifically referencing archaeology as an activity:

[13] Operation Nightingale was developed by Sergeant Diarmaid Walshe VR of the Royal Army Medical Corps with Richard Osgood, senior historic advisor to the Ministry of Defence's Defence Infrastructure Organisation.

'Veterans may identify more strongly with outdoor activities that involve physical challenge, camaraderie and achievement of an objective.... [Equally] there is a close correlation between the skills required by the modern soldier and those of the professional archaeologist [including] scrutiny of the ground.'

Everill et al.'s (2020) paper reports the findings of the most detailed study yet undertaken of the benefits of participating in archaeological activity for the health and mental health of military veterans. Data were collected from forty individuals who participated in archaeological projects over the summer of 2018. The details can be consulted in the original source, but to summarize, the authors (Everill et al. 2020, 223) describe results which, 'demonstrate decreases in the severity of the symptoms of depression and anxiety, and of feelings of isolation, along with an increase in mental well-being and in sense of value'. They go on to state that: 'Longitudinal data and investigation of clinically significant change are still required. Despite this, the data...show evidence of a significant relationship between participation in archaeological fieldwork and improved well-being among veterans' (2020, 225).

This example relates specifically to veterans groups, noting the comment previously made which draws comparisons between the discipline, physical exertion, and camaraderie of military service and of archaeological excavation.[14] This raises the question: how might such benefits translate into a very different and non-military context?

Much has been written about the various benefits that archaeology brings to communities and for visitors and tourists (e.g. Little and Schackel 2007; Walker 2014). Some of that literature is further discussed elsewhere in this chapter. To summarize, these benefits can include but are certainly not confined to health and well-being. They might also relate to social injustice, for example, by raising and tackling social issues such as prejudice or discrimination through exploring a location's past through excavation. Sometimes these various factors (and these different but related wicked problems) are closely enmeshed or entangled (see Chapter 5).

An example of this is in Manchester, England, where psychologists undertook a study which applied social psychological theories to help better understand how community archaeological projects created opportunities to enhance place-based social identity and positive intergroup relations (Coen et al. 2017). This work was undertaken across five areas of Manchester involving twenty-four participants who had volunteered for Dig Greater Manchester, a community archaeology programme. We have already seen how place attachment can enhance well-being. Here the authors specifically asked participants whether

[14] And I am reminded here that many well-known excavation archaeologists, especially in the subject's formative years, had military careers. From the subject's deeper history we can cite General Pitt Rivers and Mortimer Wheeler, while amongst the current generation is Martin Carver.

'physically engaging with the environment (and its history) through community archaeology informs social identities rooted in place' (2017, 213).

The results suggest that it does. While recognizing that members of the focus groups were already invested in the process by having volunteered to participate in the excavations, it is nonetheless striking how:

> Insights from the focus groups suggest that the boundaries of place and what it means to be 'local' are continuously negotiated. By participating in the dig, participants moved from the personal to a more social (community based) account of local history and heritage. Digs create opportunities for place-based history and heritage storytelling, which facilitated connections to both place and community. This in turn enabled participants to move from 'my' place to 'our' place. At the personal level, people might not strongly identify with the local area but by interacting with other members of the community and learning about local heritage, they can establish a sense of belonging. Participants also emphasised the importance of the 'home dig', illustrating how heritage in place can strengthen an individual's connection to community through the emergence of place-based social identities. (Coen et al. 2017, 224)[15]

This notion of community archaeological excavations benefiting participants is also demonstrated in collaborative work built around social identity theory. In a project described by Brizi et al. (2023), social identity theory is presented as a means by which 'important group memberships can be incorporated into one's self and become self-defining—in other words, people can develop a sense of identification with social groups' (2023, 3, citing e.g. Turner et al. 1994). In their study of sixty-six individuals involved in small test-pit excavations in the Netherlands and in the United Kingdom (and involving a control group), it was suggested that 'taking part in a test-pit excavation could enhance a sense of community identification, which would lead to increased well-being via stronger perceptions of social support and trust, higher community esteem, and increased efficacy' (Brizi et al. 2023). This proved to be the case, at least in part, while in addition to the effect on well-being, participants reported 'stronger perceptions of community support, higher self-efficacy, marginally higher community identification, and marginally higher perceived temporal continuity of their community' (2023).

These very different examples (veterans working on excavations, and wider community interest in Dig Greater Manchester and in Brizi et al.'s study) demonstrate that active participation in heritage activities (in this case excavation) can

[15] A similar argument can be made, also in Manchester, through the community excavation of the city's Reno nightclub as a place of significance for '1950s-born mixed heritage people in the 1970s' (Nevell and Brogan 2021, 151).

have health and identity-reaffirming or identity-creating benefits for the participants, beyond any other health benefits that might accrue from the fresh air, the physical exertion, sociability, and contact with the soil (as discussed earlier in the chapter and in Chapter 1).[16] Even with archives-based work, these same identity-related benefits can be seen. A pilot study undertaken by Lyons and Jones (2017) for example, showed how, after a local history archives workshop, children who participated had an increased sense of belonging to the surrounding neighbourhood as well as increased altruism.

But let me shift attention now from the physical activity of excavation to a more cognitive encounter with the materials that are revealed by those excavations and with the places where they are kept. Next I want to look briefly at artefacts and the museums that hold them. What benefits might exist here for people's health and well-being?

Investigating Objects

As archaeologists, we are used to the reaction of people who, on their first excavations, have their first direct contact with newly recovered artefacts last seen and handled at some point in the past. They roll it through their hands, weigh it up, and think about what it means, both in terms of its interpretation but also for themselves. The feeling can be emotive and joyful; it can also be challenging especially where the artefact is unfamiliar or provides a memory of something personally difficult and potentially traumatic. Most archaeologists will remember their first find and what it meant to them. So it is logical to suppose that others might also benefit from the experience of object handling and thinking through what these objects might represent.

As Camic and Chatterjee (2013) have noted, object handling was once forbidden (or at least discouraged) within museums. Now it has become a key part of in-house and outreach programmes, not least for the reasons stated above, that touch and tactile interpretation can have significant well-being benefits, as documented through biopsychosocial and neuroscientific research. In this, they refer to the project by Chatterjee et al. (2009) which demonstrated the health-care potential of museum objects to assist with counselling on issues of illness, death, loss, and mourning, and to help restore dignity, respect, and a sense of identity. For these reasons, numerous museums now offer artefact-based activities that are known to have a positive effect on mood and general well-being. To be more precise, Camic

[16] And there are many other examples to draw on, including those which are more specific and tightly focused on particular groups of people (such as involving people with disabilities in archaeological work, e.g. Phillips et al. 2012) and those that are wider ranging and more extensive in scope (e.g. Lewis et al. 2022).

and Chatterjee repeat a list of possible outcomes from such activities, initially presented by Wood (2007), which comprised:

- Sense of connection and belonging
- Human capital: using and improving skills
- Optimism and hope
- Moral values, beliefs
- Identity capital, self esteem
- Emotional capital, resilience
- Opportunity for success
- Recognition of achievement
- Support
- Quiet, rest, sanctuary
- Social capital, relationships
- Meaningful pursuits
- Safe, rich museum environment
- Access to arts and culture.

It is a field of research that has grown significantly in recent years, as museums have seen the potential first in promoting various forms of social inclusion before going on to focus attention more specifically on health and well-being, including the ways these can be enhanced through those identity-forming and reaffirming activities mentioned previously (and see e.g. Morse 2019; 2020).

With these outcomes in mind, the Psychosocial Research Unit at the University of Central Lancashire investigated a series of projects across six museums in the north-west of England, under the headline 'Who Cares?', to further investigate this relationship between museum collections and health and well-being, while highlighting some examples of good practice or, as I refer to them, small wins (MLA Renaissance North West 2011). One example was Manchester Museum's 'Health Rocks' project which took its inspiration from the Museum's fossils, rocks, and minerals collection. Here the participants spent time with curators and took inspiration from the aesthetics and the meanings that the objects carried. A second project, 'Integrated Inspiration', involved participants visiting the collection stores with curators and learning about the objects kept there, from ancient coins to butterflies. They then wrote poems about them under the direction of a performance poet. The aim of both projects was to encourage creativity specifically in the form of creative writing as a way to enhance people's sense of self-confidence and well-being. As the authors of the MLA Renaissance Report state in their overview, across the entire project:

> Museum objects were used in a variety of ways by participants: as a source of information, a means to familiarize themselves with the institution, a cultural

resource that connected them to local histories and identities. This form of relation can be thought of as connectivity which imparts a sense of access to a shared culture.... Some participants used the attachment they developed to museum objects as a route to communicating personally with other group members. In particular, the objects allowed participants to bring up difficult issues for sharing with the group that may otherwise have remained buried. This sharing also enabled the group to bond over shared fears and hopes, and forge group identities. (MLA Renaissance North West 2011, 13)

One specific aspect of health to have received particular recent attention is dementia. Morse and Chatterjee (2018) have presented a methodology through which museum collections (and specifically object handling) might benefit people with moderate to severe dementia within hospital settings. Key to success in this case was collaboration between academics, museum professionals, and health and social care partners. Separately, Finlay (2022) has recently argued for an archaeology *of* dementia, constructing an argument around a collection of stones made by somebody suffering from the condition. Equally, at York and in a collaborative project involving the University's Department of Archaeology and York Archaeology, a project was established by a Masters student to use some of the artefacts in the Trust's collection of Roman materials to form the basis of conversations with local people in a care home, suffering from dementia and suffering more than most because of the COVID-19 pandemic lockdown (Figure 4.2; see Drew 2021). This last example, in particular, is an outstanding example of how smaller projects can be established with a view to achieving small wins, in this case by a student with a very particular vision to help support a specific and vulnerable community. This project exists at the opposite end of the scale to, and nested within, the higher-level initiatives described earlier in the chapter.

A final example involves the unique and constructive ways in which archaeology can allow and facilitate conversations around death, dying, and bereavement (Croucher et al. 2020; see also Büster et al. 2018; 2023; and Büster 2021 for a more archaeological perspective on valued objects and what they might represent for people left behind).

For many, death is taboo, at least where it relates to loved ones and people we have been close to. Death in these instances may have followed a period of illness or it may have come suddenly, as a shock. However, in their study to explore people's reactions to a diverse range of materials associated with the dead over time, Croucher et al. (2020, 1) concluded that the past is a 'powerful instigator of conversation around challenging aspects of death, and after death care and practices'. Of the 149 participants in this study, 93 per cent agreed with this viewpoint. This was one of many pointers and conclusions related to the issues around the difficult topic of death, as applied within the United Kingdom. But to

Figure 4.2 A participant examines a Roman lamp, part of the Romans at Home project

Source: Image taken by well-being staff at Amarna House Care Home, used with permission from the Romans at Home project, CC-BY Romans at Home. Romans at Home.

switch the emphasis from results to the status of this project as a small win, the case seems entirely persuasive. Here, with minimal investment and adopting a methodology for which proof of concept now exists, archaeology can become a 'tool for enabling discussion and challenging perceptions and biases around death, dying and bereavement' (2020, 16). One of the criteria for helping to resolve wicked problems was to do so by finding creative solutions. As Croucher et al. (2020, 16) state, collaboration between archaeology, end of life care, nursing, and psychology is rare. It has also proven successful, as have recent studies that use inventorying material culture (Grote 2022) and the combination of archaeological perspectives (deep time and contemporary) with memory and personal narrative (Bjerck 2022), to tell the stories of one's loved ones in new and creative ways.

Indigenous Cultures

I have previously written about traditional medicine as a specific form of intangible cultural heritage alongside some of the ethical difficulties that this might entail (Riordain and Schofield 2015). Previously in this chapter I have referred to the various ways that heritage work (a term used by Orthel 2022), including excavation and object handling, can help to enhance people's sense of well-being

and their health, often through tactile encounter and sometimes through activities which help shape or reaffirm a sense of identity. We might also extend these types of initiatives outwards beyond the scale of the individual object or the archaeological site to a landscape scale and see benefits there too (after e.g. Darvill et al. 2019; Nolan 2020). But in this final section I focus not on the scale of a particular type of activity or a specific research context, but on Indigenous communities who are often disadvantaged when it comes to both physical and mental health. There are social, cultural, political, economic, and environmental reasons for this, which adds to its status as a wicked problem. The issues that Indigenous communities face are also often distinct, however, because Indigenous definitions of health differ from those held by non-Indigenous people, meaning also that access to conventional health care may be restricted, deliberately or otherwise.

These issues formed the basis of a recent study focused on Indigenous communities in Ecuador (see Currie et al. 2018 and Currie and Schofield In Press for more details of the study areas and the survey undertaken).[17] The primary focus and methodology of this project was to adopt alternative approaches to and understandings of concepts of health, illness, and healing, and how these relate to overall cosmology/ontology and epistemology amongst a study group of Indigenous Andean peoples, peoples whose experiences of and understandings of the world differ diametrically to those of the European colonists. The overall and long-term objective of this project was to generate models of how people adapt over time to alien cultural influences that impact their sense of identity and their belief systems. The intention was that this would then generate bridging scenarios and policy tools for people working with Indigenous, First Nations, migrant and refugee peoples, to offer alternative approaches to meeting their health, social, and welfare needs in a more culturally appropriate and sensitive way.

Despite the provision of modern medicine via local health clinics and better access to hospital outpatient facilities in many rural sierra regions, the practice of traditional medicine (ethnomedicine) is still commonplace across much of South America, both in fully Indigenous populations as well as amongst rural people across the Sierra region of Ecuador which formed the focus of this study (Figure 4.3). In fact, within Ecuador, there is a national policy that people should have access to both traditional healing methods, as well as those of modern Western biomedicine.

Many people nationally, both in towns as well as in rural communities, continue to believe in traditional Andean folk illnesses such as '*malaire*', '*susto/espanto*', and '*mal de ojo*', 'magical' illnesses that affect a person's soul and cause

[17] Some of the following text related to the Ecuadorian example is adapted from Currie and Schofield's (In Press) publication.

Figure 4.3 Don Rubelio Masaquiza Jimenez performing a healing ceremony with Elizabeth Currie at Taita Punta Rumi, near Huasalata, Salasaka, Ecuador
Source: Elizabeth Currie.

debilitating and wasting physical conditions, generally believed to be contracted through witchcraft and sorcery and requiring the offices of a local shaman or healer to diagnose and cure them. Equally, there are many traditional healers found throughout communities, although this survey found that increasingly people are now more inclined to seek out treatment in modern health facilities. Many people employ the wide range of healing herbs readily found in the countryside or grown in people's gardens to self-medicate for many conditions, employing them as infusions or for topical applications.

Yet, for the most part, Western systems of biomedicine are those which are commonly available, and it is not at all uncommon that no provision whatsoever is made for alternative systems of diagnosis and healing. This is borne out by the findings of Rasch and Bywater (2014) in a study of the effectiveness of public health provision, where community-based research studies from an impoverished rural community in southern Ecuador indicated that the public health-care system had been unable to address a health epidemic, a failure, they argue, as stemming from the continued functioning of the biomedical model of healthcare as the dominant health discourse in Ecuador. This, they point out, has resulted in a top-down imposed health-care system delivering what they refer to as 'episodic'

emergency-style care. They accordingly recommended that the country's Ministry of Health created a nationwide community-based health promoter programme, and one guided by the principles of health promotion.

As part of Currie and Schofield's (In Press) study, interviews were conducted with modern clinicians and academics familiar with the health-care system of Ecuador which supported a view that the continuity of ancestral health-care practices can in some ways function as another level of 'primary care' provision, for the many people who are not able to use or who do not trust the modern biomedical services. It was, however, noted that this could have the adverse consequence that people with serious conditions not amenable to treatment with ancestral therapies were presented late in the biomedical system when the condition had become advanced. Interviews carried out for the survey phase of this study confirmed this, as many people said that they went first to a traditional healer at the onset of an illness, and then to a conventional doctor if the traditional healer had not been able to heal them. However, there were also people who said the reverse, that they went to a traditional healer when the modern clinician had not been able to effect a cure. As the survey of Indigenous communities also found, there is an increasing trend for people to use the free local primary care services, or even hospital outpatients facilities, and are growing sceptical of traditional healers who can charge high fees for their services. However, the traditional Andean illnesses such as *malaire, susto*, and *mal de ojo* are generally viewed as only amenable to diagnosis and treatment via the ancestral healing system.

Other views which emerged from the formal interviews with clinicians/academics were that what really mattered (in terms of provision of health care) was less a physician's level of knowledge, but how patients were treated, reflecting deficiencies in their training which needed addressing, and that physicians needed to respect the rights of their patients and better understand their needs. There needed to be better basic training in how to deal with ranges of different people, ethnicities, gender and age groups and better sensitivity to how to address patients appropriately. Casual and condescending forms of address to people of Indigenous or African-Ecuadorian ethnicity, particularly of women, and of older women, was highlighted.

Such improvements, amounting to small wins, might result in a more equitable, inclusive service that better meets basic primary and secondary care needs. The survey that formed the central part of Currie and Schofield's (In Press) study suggested that there needed to be more community involvement in the organization of care provision to reflect community perceptions of need. Community services organized by community committees should reflect community values, and policy should reflect people's needs. The project concluded with the following recommendations made to national health-care providers. Some of these recommendations were generic and some very specific. All are grounded in the idea of

traditional medicine as a form of intangible cultural heritage directly relevant to contemporary society:

- Commitment to and consistency in the provision of effective intercultural health care which reflects fully the range of different needs by multi-ethnic/cultural societies.
- Reorganization/restructuring of the provision of primary care to better reflect community needs and values, through the inclusion of 'bottom-up' approaches.
- More flexible approaches to including key intercultural maternity services, including offering the traditional 'vertical birth' in suitably adapted labour suites.
- Training, or re-training where indicated, in basic human rights-oriented approaches to patient management skills and modules in diversity and sensitivity to diversity.

This study of Indigenous practices and attitudes towards health-care provision in Ecuador has highlighted a diversity of issues that need resolution, but also opportunities where policy work can make significant contributions that benefit those Indigenous communities. The need for such an approach exists amongst many Indigenous communities around the world for whom health and well-being are significantly poorer than for non-Indigenous people. As Gwynne and Cairnduff (2017, 115) have said for Australia, for example:

Aboriginal people fare worse than other Australians in every measure of health including in a ten-year gap in life expectancy, infant mortality, cardiovascular disease, dental disease, mental health, chronic disease, and maternal health. Despite sustained, whole of government effort, progress to improve Aboriginal health has been very slow.

For these authors, this qualifies Aboriginal health as a very specific wicked problem, yet one that they suggest can be addressed through a strategy they refer to as collective impact, which they define (citing others) as being, 'more than collaboration[;] it provides a framework for bringing multiple parties together to define the problem and its complexities and priority, and to jointly develop, implement and evaluate multifaceted solutions' (2017, 117).

Health and well-being amongst Australian Indigenous communities formed the subject of the Well-being in Aboriginal Communities research project, begun in 2006 with the aim of exploring how Aboriginal heritage contributes to the health of Aboriginal communities (Carrington and Young 2009). Although specifically concerned with well-being, this concept is closely aligned with community and individual health, as we have seen already throughout this chapter. Within this Australian Indigenous context at least, well-being is something

these authors define as, 'an everyday event that can be connected to all things that we do. Well-being is the satisfaction that people get from doing things their own way, sometimes according to the values that are important to them, and which results in positive feelings of self expression' (Carrington and Young 2009, 4).

This project is an example of how small wins can accumulate, gathering momentum and creating tangible benefits for participants. The wider project grew through a series of smaller interventions that each resulted in books telling the stories and recounting the memories of people within a specific community, and how telling these stories helped those communities grow a stronger sense of identity, thus enhancing their individual and collective well-being. The first such book, *Aboriginal Women's Heritage: Nambucca* was published in 2003 and was the first of twelve such books published by the time of an overview volume (Carrington and Young 2009, 4). This overview project involved returning to those communities to ask how the experience of contributing to the books had an impact on participants. As Carrington and Young (2009, 4) have stated:

> Contributing to [the] creation of the Heritage Series books had been a significant experience for many. A number of the Elders who told their stories were doing so for the first time and spoke to us about the courage that it took for them to look back at the past and recall their life experiences.

They go on to describe how:

> The Heritage Series has become a community resource and has resulted in local knowledge building and sharing, and new relationships between Elders and local schools and libraries, correctional institutions, Local Aboriginal Land Councils, and health centres.... The Heritage Series has also played a significant role in the personal lives of a number of Aboriginal people. Families that have experienced dislocation, due to past government policies or for other reasons, have found that these books have helped them to locate lost relations and to discover expanded family connections. The books have also made it easier for some people to talk about the past.

What these examples show is that small-scale interventions can make significant inroads into improving both community and individual well-being locally while extending outwards to have regional-scale impact. The South American example was focused on the wider Indigenous community but with policy implications for any displaced or disenfranchised Indigenous communities; while the Australian examples demonstrated impacts at both community and individual scales. In both cases, the methods were developed around interviews designed to give people the opportunity of expression while in the Australian example publications

introduced a tangible outcome in which the communities and the individuals themselves had a sense of pride and ownership.

Heritage Policies for Health and Well-being

An iterative process connects the types of examples described previously and policy work. Good examples of practice can help shape policy, while policy provides the framework within which good practice can occur, develop, and thrive. Practice can exist without policy but policy would be difficult to define and implement without examples of good practice. I have already given examples of some of the ways that practice and policy might inform one another, in the case of traditional medicine and Indigenous well-being for example. In this section I will extend that discussion by reviewing a specific and relevant strategy document (Historic England 2021) alongside a few of the initiatives that relate to that strategy, before reflecting again on the archaeological work with military veterans and one specific outcome of that project, in the form of some guidelines for further involving people with mental health issues in heritage projects in the future. Together, these various instances give an indication of how heritage organizations and individuals can use their positions as subject specialists to shape policy and influence practice.

The Historic England *Wellbeing and Heritage Strategy 2022–25* (Historic England 2021) is built on some specific and important principles. First is the recognition of heritage as a 'powerful and positive influence in people's lives. It helps us understand where we come from and gives us pride and confidence in the places where we live and work. Heritage brings people together and provides the foundation for a prosperous future.'

We have seen evidence for this already in some of the examples referred to in this chapter and we will see it again in Chapter 6. Historic England also sees heritage as ubiquitous, in the sense of it being everywhere and for everybody (mirroring the central messages of the 2005 Faro Convention on the *Value of Cultural Heritage for Society*). They describe how:

> Unlocking the potential of our heritage is what Historic England does best. We help people discover and celebrate our shared history. We share our knowledge. We enable people to take an active role in decisions about the future of our heritage. We help create beautiful, interesting and successful places that people can proudly call their home. These are the ways in which we can make a significant positive difference to the general wellbeing of our citizens and communities.

With this aspiration, the strategy is built around three pillars: thriving places, connected communities, and active participation, noting how 'our intention to consider the well-being potential of our work will encourage us to maximize our social impact and ensure people and heritage work together to improve lives.'

This Strategy builds on a review of Wellbeing and the Historic Environment undertaken by Historic England a few years previously (Reilly et al. 2018). By providing a framework for considering well-being designed to help Historic England to make meaningful contributions to this agenda, alongside identifying some strategic objectives and a logic model (all forming the basis for the Strategy outlined above), Historic England created a template through which policy and practice can be aligned at national scale. For example, referring back to the examples covered earlier in the chapter, this document highlights the seven ways that heritage (often through archaeological practice) can engage with the health and well-being agenda (Reilly et al. 2018):

1. The combination of physical activity with outdoors and cultural heritage.
2. The formation of a new relationship with the past that creates new perspectives and meaning.
3. The combination of the past connection with skills and feeling meaningful through [making a] productive contribution to something.
4. The social interaction and creativity that relates to the links with the past.
5. Long lasting benefits increased [people's] awareness of themselves and their place and social networks.
6. Our capacity to promote mixed projects with mixed evaluation methods including longitudinal analysis.
7. Potential to develop a wider collective sense of community, belonging, order, balance, stability and place through place-based initiatives.

This framework is summarized in Figure 4.4, highlighting the ways in which different types of heritage work operate as social capital to help support different aspects of well-being.

This approach aligns well with principles for supporting people's well-being devised by the New Economics Foundation (Aked et al. 2008). This study outlined 'five ways to wellbeing' that are actionable and applicable in any individual's life. These five principles are:

1. Connect: The act of spending time with people around you, such as friends and family, in everyday settings such as at work or school.
2. Be Active: The act of moving your body in a way that is accessible and enjoyable.
3. Take Notice: The act of being curious and paying attention to the world around you.

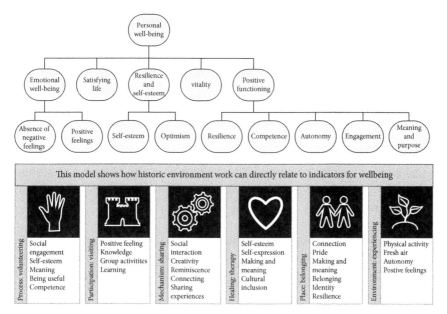

Figure 4.4 Some of the ways in which heritage practice can relate directly to aspects of well-being
Source: From Reilly et al. (2018).

4. Keep Learning: The act of pursuing an old or new interest to learn something. This could be mental such as learning a new language, or physical such as learning a sport.
5. Give: The act of doing something positive for someone else, someone around you, someone in your community or a stranger.

As an example of how strategies like these can help shape and facilitate practice, Historic England's well-being web pages provide numerous examples of those small wins referred to earlier, all examples of work either undertaken directly by Historic England or through commissioned work (and see Heritage Alliance 2020 for more examples and context). These web pages give good examples of small wins relating to, amongst other things: social prescribing,[18] well-being and younger people, well-being and older people, loneliness, and mental health.

[18] As described earlier in the chapter, social prescribing is a means of enabling GPs, nurses, and other health and care professionals to refer people to a range of local, non-clinical services. Schemes can involve a variety of activities, such as volunteering, arts activities, gardening, befriending and group support, and exercise activities, often provided by voluntary and community sector (VCS) organizations. (See Roberts et al. 2021.)

These web pages and accompanying documents deserve to be widely read in that they provide numerous and diverse examples of good practice. One concern, however, is the capacity across many of these projects and the organizations that run them to evidence the benefits that are claimed. And this may be the next step in developing this area of practice: to collaborate routinely with social scientists to ensure that rigorous systems are in place that have the capacity to demonstrate impact. A recent example of such a collaboration concerned the role of heritage sites during the lockdowns that characterized the COVID-19 pandemic in the United Kingdom (Sofaer et al. 2021). In this study, the authors (which include a social scientist) noted the ways in which heritage sites offered distinct opportunities for combining hedonic (subjective) and eudaimonic (psychological) wellbeing effects. Their study concluded by stating that:

> A consistent trend in visitor responses aligns the perceived value of heritage with fundamental aspects of psychological wellbeing, including capability, social connections, ontological security, and trust. These provide a suite of dimensions which the [heritage] sector can use to tap into the potential of visits for wellbeing. Furthermore, heritage sites offer opportunities for experiencing a combination of hedonic and eudaimonic wellbeing effects that visitors do not always anticipate. It may be helpful for heritage providers to explore this and place their aims and activities within such a framework.
> (Sofaer et al. 2021, 1129)

By collaborating with a social scientist, evidencing impacts is built into the project at the outset, and forms part of project design and implementation. By taking this approach, demonstrating proof of concept and success is never an afterthought.

To conclude this section I refer back to the work with veterans, as this important series of projects (led, as we have seen, by Operation Nightingale) provides the foundation for a new further set of guidelines for involving people with mental health issues in heritage projects (see Burnell et al. 2021). These guidelines provide an important next step additional to demonstrating impact: building on experience to create templates for successful and impactful future interventions. As the authors of this 'guidelines' report state:

> Ten thematic areas were developed under three headings: Project Preparation, Project Delivery, and Project Follow-up. A particular focus for the guidelines concerned aspects of safeguarding, understanding risk, and duty of care, as well as the expertise that should be brought into the project delivery in terms of the appropriate management of both heritage/historic environment assets, and mental health.

Doing things well, and doing them ethically, are both vital considerations and this checklist format for the various stages of project delivery, preparation, and follow-up provide an outstanding yet straightforward model that should have wide application given its flexibility and simplicity. With strong policies in place alongside examples of good practice and robust and user-friendly project management guidelines, archaeologists and heritage practitioners are well positioned to create small wins and gather the momentum needed to tackle the wicked problem of health and well-being in meaningful ways.

Conclusions

As Brian Head (2022, 64) has recently stated, the wickedness within health care often relates to the complexity in both the technical and managerial knowledge required to manage a modern health-care service and in designing health-care systems. The complexity relates to disagreements on values, ideologies, priorities, and partner responsibilities which can lead to policy gridlock. Head goes on to align this with the concept of small wins, which has been repeatedly used in this chapter. He begins by citing Daviter (2017, 578) who defined the notion of coping strategies as having the aim, 'to reflect the fragmented, uncertain and ambiguous nature of wicked problems by relying on a more disjointed and tentative process of formulating policy responses'. As Head (2022, 81) then states:

> On the one hand, this suggests that there are many elements and dimensions of wicked problems that need to be mapped, debated and tackled. On the other hand, the rational quest for comprehensively integrated and joined-up approaches for managing wicked problems might not always be feasible and could be unnecessary, in cases where an iterative and decentered approach—with multiple local initiatives and 'small wins'—would suffice to achieve progress.

In their overview of heritage and well-being, from which I took a quotation to open this chapter, Taçon and Baker (2019) explore some of the ways these two areas of practice (health and heritage) intersect. Because of the significance of their relationship, they also recognize the corollary of the argument I am presenting: that threats to heritage can have a negative impact on human health. In this chapter, I have focused on the positive health benefits of heritage participation. But by taking those opportunities away, or threatening or destroying someone's meaningful heritage objects or places, the impact could be entirely negative, damaging even.

Taçon and Baker (2019) also highlight another concern raised earlier, that studies claiming to demonstrate the health benefits of heritage or archaeological engagement are rarely supported by hard data (after Sayer 2018). But even this is not straightforward. As Taçon and Baker (2019, 1303) summarize:

> Anthropological perspectives...caution against 'an over-preoccupation with measuring wellbeing...as concentrating on universal indexes may be done in detriment to other ways of knowing and understanding human wellbeing practices' (Ferraro and Barletti 2016, 1–2). Much of the evidence of the impact of heritage on wellbeing is anecdotal (Power and Smyth 2016), suggesting that even when the nexus is not measured definitively using qualitative and quantitative tools, the heritage wellbeing relationship can nevertheless be observed.
>
> (citations in original)

In this chapter we have seen how health and well-being issues can and do constitute wicked problems on multiple scales and with various degrees of urgency. I have considered a diversity of case studies that present data in various forms, often using examples where the evidence is indeed 'anecdotal'. A key dimension for this book, however, is that of scale and how some wicked problems (such as Indigenous health amongst Australian Aboriginal communities) can be evident and managed through policies defined on a national scale, while other issues (such as obesity, mental health, and COVID-19) are globally relevant. We have also seen throughout this chapter how archaeological and heritage-related interventions can constitute meaningful small wins.

The chapter began with a quotation, from a military veteran who participated in the Breaking Ground Heritage project (cited in Everill et al. 2020, 224). He said that: 'Having isolated myself over the past few years...I am a step closer to joining the world again.' This constitutes a success, a small win. Across the various examples given in this chapter there are thousands of such testimonials, all small wins which can accumulate to successes for entire communities. Often these communities are those who most need the benefit of success. Creating a success that has legacy and is sustainable is perhaps the greatest challenge. I will pick this theme up again in Chapter 6 (and again in the book's final chapter), having taken a break from the book's thematic content to reflect on complexity and on how we should not lose sight of the connections that exist linking all of these many wicked problems to one another. It makes sense and is easier to deal with wicked problems in isolation, but their very nature—their complexity, their innate wickedness—means that the 'meshwork' within which each problem separately exists, must always remain in view.

HEALTH AND WELL-BEING 163

Chapter Headlines

- Health and well-being presents a wicked problem. In fact many different health and well-being issues are wicked problems, such as loneliness, obesity, the COVID-19 pandemic. Some researchers describe health and well-being as a whole as a super wicked problem, in the sense that it requires urgent resolution; that time is of the essence.
- Social capital or 'contact' is vital in helping to resolve this particular wicked problem, or set of problems. Social prescribing is one way to deliver on this.
- These various health-related wicked problems impact different groups of people in different ways and to various degrees. Statistics show that Indigenous people suffer more than non-Indigenous people, for example.
- 'One in four people in the world will be affected by mental or neurological disorders at some point in their lives. Around 450 million people currently suffer from such conditions, placing mental disorders among the leading causes of ill-health and disability worldwide.' (World Health Organization 2001)
- There are many ways in which archaeology and heritage practice can help improve people's health and well-being, whether through physical activities like excavation or more cognitive exercises such as citizen science or object-based projects. There are many success stories, all of them constituting small wins. These small wins also help to address instances of social injustice.
- Heritage organizations have now created policy documents, frameworks, and templates to facilitate promoting these opportunities.

5
Entanglement

All beings—not only humans—are deeply entangled with, and even permeated by, the material world they jointly exist in.
(Rahm-Skågeby and Rahm 2022, 74)

Our histories, biologies, languages, cultures, genes, atoms, and ideas are thoroughly entangled.
(Bauman 2017, 9)

Matter and meaning are not separate elements. They are inextricably fused together, and no event, no matter how energetic, can tear them asunder.... Matter and meaning cannot be dissociated, not by chemical processing, or centrifuge, or nuclear blast. Mattering is simultaneously a matter of substance and significance, most evidently perhaps when it is the nature of matter that is in question, when the smallest parts of matter are found to be capable of exploding deeply entrenched ideas and large cities. Perhaps this is why contemporary physics makes the inescapable entanglement of matters of being, knowing, and doing, of ontology, epistemology, and ethics, of fact and value, so tangible, so poignant.
(Barad 2007, 3)

While this last is a lengthy quotation, and one drawn from a publication that on first inspection seems to be concerned only with quantum theory,[1] it is included because it provides a relevant starting point for this chapter. In Barad's words, her book, subtitled *Quantum Physics and the Entanglement of Matter and Meaning*, is more than just about quantum physics, concerning instead, 'how and why we must understand in an *integral* way the roles of human and nonhuman, material and discursive, and natural and cultural factors in scientific and other practices' (2007, 25; emphasis in original).

The ideas promoted in Barad's ground-breaking book are already being discussed in archaeology, notably in relation to notions of material entanglement across and throughout the archaeological record. I will return to this point shortly. But equally, many of the ideas presented by Barad have direct relevance to the question pervading all of the chapters so far, and those to come: how to best

[1] How wrong can you be!

manage and attempt to resolve wicked problems where those problems are so intractable and so complex; where they are so *entangled*, on a practical level, between people and the environment and, on a theoretical level, between matter and meaning. Recognizing how the factors that render these global challenges so wicked, being the fact they are closely interrelated and interdependent, is vital if meaningful, sustainable solutions are ever to be found.

In this shorter chapter, serving almost as a 'middle-eight', to borrow a musical parallel, I will move away from the thematic format of the book to adopt a more theoretical stance, presenting the various foundations of an argument that all point to the same conclusion: the need to recognize the complexity and entanglement of wicked problems if even the smallest of small wins are to prove successful. After all, simply and as we have seen, everything is connected. This means that resolving one problem in isolation may create further problems in other areas.

But I will begin this chapter by briefly explaining how the ideas of scholars like particle physicist and feminist Karen Barad and archaeologist Ian Hodder have been influenced by and have helped to shape ideas around entanglement, not least from an archaeological perspective. I will also define what entanglement theory actually is and what it means for scholarship and practice in general. Having talked about entanglement specifically, I will then briefly cover some of the other frameworks that align with entanglement theory and how useful these have also proven to be within the context of wicked problems: messiness for example, as well as systems thinking, assemblage theory, ecosystems, multiple causality, and complexity theory. These perspectives do vary in terms of their relationship to wicked problems. I see entanglement, for example, as conceptually helpful and useful as a description (by way of metaphor) for the types of problem this book is concerned with. Ecosystems provide a helpful framework and an alternate metaphor for visualizing and devising management strategies for wicked problems, while messiness and complexity theory are helpful in highlighting the full extent of the problem. Finally, with all of these conceptual ideas and frameworks in mind, I will return to two of the examples from the first half of the book (ocean health and climate change) to review their relevance through applications.

I will begin by briefly reviewing how entanglement has been used (and also developed through its application) in archaeology.

Entanglement

Over a decade ago, archaeologist Ian Hodder (2011) presented novel ideas on what he termed 'human-thing entanglement', framing this as a step towards an 'integrated archaeological perspective'. Hodder described, for example, that: humans depend on things; that 'all things depend on other things along chains of interdependence' (2011, 154); that things depend on humans; and that traits

evolve and persist, their success or failure dependent upon the overall entanglement of humans and things. In developing these ideas, Hodder drew on work by Bruno Latour (e.g. 2005), and specifically Latour's discussion of the entanglement of humans and materiality. Latour's thinking has also been taken up by another archaeologist, John Robb (2013), who drew specifically on his actor network theory to investigate the transition to farming. Meirion Jones (2021) cites an example from Tim Edensor's work as an illustration of the shortcomings of Latour's ideas, specifically his recognition of networks as often being restricted only to things and humans: 'As Tim Edensor (2011) discusses in his analysis of a Manchester Church, networks may also be composed of other elements [which Latour does not accommodate], including salts, weather and chemicals' (Meirion Jones 2021, 39). Edensor (2020) takes this same approach in his more recent study of building materials and the lives of buildings in Melbourne, Australia, further highlighting complexity and diversity within these networks and reaffirming some shortcomings in the approach promoted by Latour. Meirion Jones further describes Hodder taking from Latour the 'notion of a dialectical dependence between humans and things' (Hodder 2012, 94) or, put another way: 'rather than viewing things and humans as being in relational networks...[they are] caught: humans and things are stuck to each other. Rather than focusing on the web as a network we can see it as a "sticky entrapment"' (2012, 94).

This idea of elements of a network being 'caught' feels like a fitting analogy for some of the wicked problems described in this book; marine pollution for example where entanglement is a specific and physical manifestation of the problem. A sea turtle entangled in discarded fishing line thus becomes a metaphor for the wider and wicked problems of food security, colonialism (after Liboiron 2021), environmental pollution, and climate change, amongst others. That this and similar examples might involve a form of 'sticky entrapment' also seems like a helpful and appropriate parallel.

An alternative way to describe such complex entanglements is that entities exist within a 'symmetrical relationship', an idea originally suggested by Latour (1993) as an attempt to: 'recast the relationship between culture and nature, or humans and the natural world; in effect decentering the human and unsettling the dominance of humans by foregrounding the important role of things.... [Thus] fixed entities like "humans" are pitted against other fixed entities called "things"' (Meirion Jones 2021, 40). A symmetrical approach within archaeology has also been promoted by authors including Shanks (2007) and Witmore (2007), in a special issue of the journal *World Archaeology*, dedicated to this topic.

Archaeology and archaeologists have recognized and attempted to build theory around this concept of entanglement and (more recently) symmetry to help better understand such things as longer-term changes in material culture, and the increasingly complex array of material culture over time. Hodder (2011) provides a comprehensive summary of important examples, at least as they existed a decade

ago. Hodder's more recent publications on this topic (e.g. 2018; 2020) draw on his own excavations at the Turkish Neolithic site of Çatalhöyük (Turkey), alongside the ideas of other scholars such as mathematician and philosopher Alfred North Whitehead whose influential work included emphasizing the significance of processes over objects.[2]

But these archaeological examples are not the central point of this chapter. This discussion is included really just to illustrate how some of these ideas are not unfamiliar to archaeologists, meaning that their application to broader wicked problems discourse should not appear too far-fetched within this scholarly tradition and area of practice. These are both concepts and a language that we as archaeologists are already familiar with, at least to an extent. Let us therefore widen the discussion out to entanglement theory in general: what it is and how it might be applied to wicked problems of the type described in the preceding and following chapters.

I have already discussed some of the ways that Bruno Latour's work has been applied and critiqued by Ian Hodder amongst others. But beyond archaeology, the scholar whose work holds arguably the most significance in this area is Karen Barad, whose words helped to open this chapter. Meirion Jones (2021, 40) provides a clear and helpful characterization of Barad's work, which is mostly encapsulated within her *Meeting the Universe Halfway* book (2007), which I have referred to already. Essentially, and put simply, Barad's work engages with physicist Neils Bohr's account of quantum mechanics which argued for the inseparability of matter and meaning. As Meirion Jones describes it:

> Barad (2007, 140) proposes that entities (such as materials and humans) do not pre-exist relationships[;] rather they emerge through specific intra-actions. Whereas the term 'interaction' implies action linking pre-existing entities, 'intra-action' implies action that connects, entangles, and co-constitutes entities. This is a quite different conceptualisation of entanglement from that proposed by Ian Hodder. Matter is not distinct from human agency and discourse as traditional representational approaches would have it; instead matter is substance in its intra-active becoming. Matter is not a thing, but a doing, it is a congealing of agency (Barad 2007, 151). Central to Barad's analysis is that matter is a dynamic and shifting entanglement of relations, rather than a property of things (Barad 2007, 224). The entanglement of relations depends on the dynamic of these relations; different encounters produce differing outcomes as relations intra-actively 'cut' each other.

[2] Better than Wikipedia, the Stanford Encyclopaedia of Philosophy provides a thorough overview of North Whitehead's career and influences: https://plato.stanford.edu/entries/whitehead/

As Barad herself states (2007, 33):

> The notion of intra-action is a key element of my agential realist framework. The neologism, 'intra-action' *signifies the mutual constitution of entangled agencies.* That is, in contrast to the usual 'interaction' which assumes that there are separate individual agencies that precede their interaction, the notion of intra-action recognizes that distinct agencies do not precede, but rather emerge through, their intra-action. It is important to note that the 'distinct' agencies are only distinct in a relational, not an absolute, sense, that is, *agencies are only distinct in relation to their mutual entanglement; they don't exist as individual elements.* (emphasis in original)

And why is this point so important, and so worthy of re-emphasis? Because, as Barad (2007, 33) goes on to state,[3] this notion of intra-action causes

> a lively new ontology [to emerge]: the world's radical aliveness comes to light in an entirely nontraditional way that reworks the nature of both relationality and aliveness (vitality, dynamism, agency). This shift in ontology also entails a reconceptualization of other core philosophical concepts such as space, time, matter, agency, structure, subjectivity, objectivity, knowing, intentionality, discursivity, performativity, entanglement and ethical engagement.

We have already seen how these ideas relate in various ways to archaeology. It is hopefully also now more obvious how this 'agential realism' provides a framework for investigation of wider concerns and issues where multiple factors (actors, processes, materials) are at play, and where transdisciplinary collaboration is required: like wicked problems.

Alongside Karen Barad's ideas around intra-active agential realism are some other relevant and helpful notions around entanglement, ideas that perhaps render the concept and its applicability even more obvious and tangible than those I have discussed previously. Whitney Bauman (2017, 8, and cited also at the start of the chapter), for example, describes how 'entanglement' is, 'one word [which] could describe life on planet Earth'. She explains, for example, how widely applicable the term entanglement is, being used in physics to describe how seemingly disparate entities affect one another from a distance (2017, 8) and in biology, recognizing bodies as ecosystems within themselves (2017, 9).[4] However, perhaps more relevant in the context of wicked problems is the entanglement of our daily lives through processes of globalization, with each and every one of us intersecting with global actants on a daily basis. Bauman takes a quotation from

[3] Noting that she 'can't emphasize this point enough' (2007, 33).
[4] And I will briefly discuss ecosystems later in the chapter.

the philosopher Rosi Braidotti to describe the nature of this particular set of entanglements (cited in Meskimonn 2011, 10), referring to them as 'figurations':

> Figurations are not figurative ways of thinking, but rather more materialistic mappings of situated or embedded and embodied positions.... By figuration I mean a politically informed map that outlines our own situated perspective. A figuration renders our image in terms of a decentred and multi-layered vision of the subject as a dynamic and changing entity.

As Bauman states, such figurations can apply to individuals but equally to cultures and traditions. As we saw at the start of this chapter: 'our histories, biologies, languages, cultures, genes, atoms, and ideas are thoroughly entangled' (2017, 9). In other words, we live in a world of agency and causality dispersed 'through the spectrum of life' (after Barad 2007; Bauman 2017, 10). Thus, 'we are not fully in control of our own selves', our actions being the result of 'multiple histories, networks and processes' (Bauman 2017, 10). In Bauman's terms (2017), interdependence includes: technologies, a plurality of cultural and religious traditions and beliefs, and a 14 billion years expanding universe and a 4.5 billion year old planet. As archaeologists, we might also add the duration of life on earth (and specifically human life on earth) to that list. This is the wider temporal and cultural context within which we, as archaeologists, can address wicked problems. Arguably, it is this context (simply, a deep-time perspective) that makes our approach towards wicked problems so distinctive and, arguably also, so worthwhile.

I will conclude this section by citing Christina Fredengren (2021) who recently gave a critical overview of entanglement, emphasizing human–animal relationships, with a view to studying more-than-human world-making through archaeology. Irrespective of the bigger picture with which this book is concerned, one of the points made by Fredengren is that these issues of complexity and uncertainty, and entanglement, also exist on a far smaller scale, much closer to home; within our bodies in fact. Fredengren cites Donna Haraway's (2008) work, in which she famously stated that, 'we have never been human' (Haraway 2008, 1–3), pointing out that only 10 per cent of the human body contains human genomes while 90 per cent is filled with genomes from fungi, bacteria, and microorganisms.[5] This means that, in Fredengren's words (2021, 15), 'both human and animal bodies are situated and entangled knottings of several more-than-human contributors'. But it is what we do with this knowledge that has the greater relevance here. Fredengren concludes her paper by calling for a future multi-species archaeology. She lists five items in what may amount to a manifesto (or a call to arms), the last of which

[5] And there is plastic in there too, as we saw in Chapter 3.

asks questions of how and under what circumstances archaeology can contribute to what Haraway (2008, 3) names *autre-mondialisation*—a worldmaking that is less damaging than that of today. Archaeology in this context provides a range of source materials that can show multiple ways of living with animals—how history can inspire [...] other lifestyles—and other ways of worlding the world. Such studies may also be of interest for how to unlearn unhelpful practices—identifying when the knots are tied in harmful ways—and to figure out where they may need to be re-tied in more respectful ways, as well as to highlight and acknowledge the importance of 'making with' others.... Archaeological knowledge is important for giving insights into how to world the world differently. (Fredengren 2021, 29)

Messiness

As stated earlier, messiness has relevance for helping to better understand the full extent and the intractability of wicked problems. Thinking of entanglements and figurations might imply some degree of order, at least as a framework through which the infinite number of actants can be positioned relative to one another, and in which their capacity to influence change can therefore be better understood (Figure 5.1). If we think in terms of messiness, however, as we saw in Chapter 1, the implication is quite the opposite: chaos! In that first chapter I described how Emery Roe (2013) spoke about 'mess', emphasizing that policy messes cannot be cleaned up or avoided; rather they need to be managed. One way to achieve this might be through the notion of clumsy solutions, which I will discuss in the concluding chapter, having presented numerous examples of these along the way. But for now, having looked at three thematic chapters, let us briefly consider the idea of mess and messiness as an alternate way to make sense of (or even help to manage) wicked problems. We might think that mess and chaos are bad. What if the opposite was true?

In a broad overview paper, focused on mess in science, and relating to wicked problems, Schickore (2020) cites other authors, including Helga Nowotny whose (2017) book *An Orderly Mess* describes messiness as the 'new background condition of science, society and our personal lives' (Schickore 2020, 483). Schickore also cites John Law's influential (2004) *After Method: Mess in Social Science Research* in which he called for research methods to better accommodate a messy world. One conclusion from this earlier work is that science educators should put messiness at the forefront in science teaching (e.g. Metz 2005, cited in Schickore 2020, 483); that they should embrace the chaos.[6]

[6] And I am reminded here of my membership of the Punk Scholars Network, and that famous quotation from the Sex Pistols that 'We are not into music, we are into chaos'. They did OK, arguably! Perhaps chaotic science is also punk science.

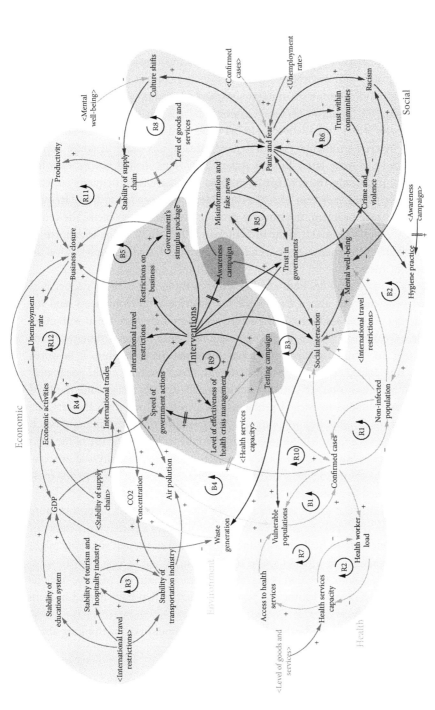

Figure 5.1 An example of entanglements, in this case a preliminary causal loop diagram demonstrating the complexity of the COVID-19 pandemic environmental–health–socio-economic system, where any intervention triggers responses in all of those various fields.

Source: After Sahin et al. (2020).

We don't need to dwell here on the role of mess in scientific research and methods, other than to acknowledge its significance,[7] 'as a necessary step for theoretical or methodological innovation' (Schickore 2020, 490). A more helpful direction to consider might be the question of how this notion relates to science policy and environmental issues, in the context of both the understanding of, and attempts to mitigate, wicked problems. As Schickore states (2020, 494), the concept of mess entered the discussion of social science methods with Rittel and Webber's (1973) paper and in direct association with the label 'wicked problems' (which I have already discussed at some length in Chapter 1). A year later, Russell Ackoff (1974) published his *Redesigning the Future*, proposing the concept of mess as an alternate but equally suitable term for describing a system of societal problems that needed to be addressed, such as 'the race problem, the poverty problem, the urban problem, the crime problem' (Ackoff 1974, 21, cited in Schickore 2020, 495), all of which are of course sufficiently entangled to render definition of such complexity as an example of mess.

Mess therefore provides both an alternative to Rittel and Webber's concept of wicked problems but also a framework for describing the complexity and for considering possible solutions, in the same way as entanglement, albeit with more chaotic implications. Mess is useful both as a metaphor and as a framework for addressing and thinking through wicked problems. In that sense, it is worth emphasizing John Law's observation that, 'only messy science could adequately deal with its (messy) target' (cited in Schickore 2020, 493), recognizing the need for creative solutions to wicked problems. As is well known from the arts, the creative process is often best when messy. And to return to the metaphor of beach clean-ups, it does appear helpful to keep in mind the wider general use of the term 'mess' to describe particular categories of wicked problems, in a physical or social sense: the physical mess created by plastic pollution, and the social policy mess that has resulted in poverty, for example.

I am favouring the use of entanglement to mess, however, as it appears more positive, more resolvable in the sense that it characterizes a particular category of problem; something to be dealt with and worked at even though solutions might seem impossible. It gives greater scope, to my mind, for the success of small wins. Mess implies a chaotic situation being left for others to clean up, with the obvious metaphor of volunteers clearing the beaches of plastics that have floated in from an unknown elsewhere.

But let us look at some further alternatives, as frameworks for thinking about wicked problems.

[7] See John Horgan (1993) for a good review of this issue, under the title: 'Are scientists too messy for Antarctica?'

Ecosystems and Assemblage Theory

Ecosystem management has been identified (e.g. by DeFries and Nagandra 2017, 269) as being relevant to a particular type of wicked problem for which, in the spirit of the small wins framework, an incremental approach is recommended. But more relevant here perhaps is the degree to which the very notion of ecosystems represents and provides a further parallel to the inherent complexity of wicked problems.

The concept of ecosystems was first introduced in ecology to help resolve problems associated with predominant notions (at the time) of succession and ecological communities that were first posited by Frederick Clements (1916). These notions have been reviewed elsewhere (e.g. by Pickett and Cadenasso 2005) but include the idea that communities of organisms that were devoid of disturbance were considered 'stable and persistent climaxes' (Pickett and Grove 2009, 2). For many, this theory was considered far too simple and, effectively flawed. Central to the notion of ecosystems that emerged in response to these earlier ideas was Tansley's (1935) suggestion of a system or a complex driving 'a more neutral approach to the structure of assemblages in nature' (cited and discussed further in Pickett and Grove 2009, 2). As Tansley put it: 'The... fundamental conception is... the whole system (in the sense of physics), including not only the organism-complex, but also the whole complex of physical factors forming what we call the environment' (1935, 299).

Tansley further subdivided the physical complex of his ecological system into components comprising a climatic complex, a soil complex, and an organism complex. The ecological system also required spatial and temporal boundaries, which separate this particular system from others (and which co-exist within 'the environment').

This degree of complexity, and how the different complexes interact with and influence one another, is the reason this concept feels like a helpful parallel at least for describing and explaining, if not also for understanding, wicked problems. But the relevance of the concept can be extended even further when we introduce an additional element in the form of a social complex and give the notion of ecosystems relevance and application also in urban settings (after Pickett and Grove 2009, 3). Tansley seemed to have realized the potential for this wider definition. As he put it: 'What we have to deal with is a system, of which plants and animals are components, though not the only components' (1935, 301). He then goes on to state that 'modern civilised humanity upsets the natural ecosystems' but equally that 'human activity finds its proper place in ecology' (1935, 301).

These ideas align closely with those being explored currently in heritage studies and in archaeology around nature and culture, discussed elsewhere in this book, the headline being the complex interactions that exist between human and non-human worlds to the extent that separation becomes not only problematic in terms of theory and definition, but also unhelpful and potentially even damaging

in terms of restricting archaeologists' approach to, for example, climate change. Put simply, and to cite Harrison in his discussion of Aboriginal people's relationships to the world, (2015, 29): 'Humans are connected by bonds of kinship with particular plant and animal species, and with the "natural" environment more generally. This explains why [for Aboriginal people] it is impossible to disentangle the "cultural" from the "natural".'

One approach to addressing such perceptions and conceptions within an archaeological framework and specifically through heritage studies is Historic Landscape Characterisation (HLC, discussed for example by Fairclough and Herring 2016), an approach which takes an extensive view of the wider landscape as defined in a holistic sense, documenting and interpreting the past influences evident within the contemporary landscape, both urban, peri-urban, and rural. It is an approach that is both descriptive and interpretive, but not judgemental. HLC sits alongside another method, Landscape Character Assessment (LCA) which tends to emphasize the physical components of landscape and is focused predominantly on rural areas. Through these related and parallel approaches, areas of landscape are represented by databases and maps, all generated through Geographical Information Systems (or GIS) and based on existing records with some additional analysis of data sources where this is needed, for example, of aerial photography. In both cases (HLC and LCA), human and non-human worlds are drawn together (e.g. fields and ancient relict woodland) as a framework for future decision-making, while also holding research potential.

The data generated through HLC and LCA are complex and, compared to traditional heritage datasets, they have proved hard to use in the everyday work of planners and decision-makers. But they are complex because the issues are complex. The original concept of wicked problems first emerged from conversations around planning (as was discussed in Chapter 1), and the intractability of these planning problems (such as poverty and inner-city urban development linked to lack of investment and social injustice, and poor health) meant that solutions were hard, if not impossible, to find. Within the United Kingdom, in the 1990s, HLC and LCA also emerged from the demands of a planning system struggling to keep up with the processes of change driven by industrial-scale development, in urban and peri-urban settings. As with the types of solutions to wicked problems identified in Chapter 1, creativity was required, as was the need to think and work across traditional disciplinary boundaries. Nature and culture are traditionally divided by one of those boundaries. By thinking in terms of systems and ecosystems, and using methods like HLC to help address planning-related issues that exist today at landscape scale, heritage practitioners may be able to achieve small yet significant wins.

HLC, with its notion of time depth, provides an explicitly archaeological approach to complexity (and in some instances also to elements of wickedness), framed by and available to use within the context of heritage practice. It also embraces another helpful archaeological concept: that of an assemblage, being a

collection of objects that are associated with one another in some way. Another way archaeologists might address the complexity of wicked problems therefore, using terms they are closely familiar with, is assemblage theory, described helpfully by Deleuze and Parnet (2007, 69):

> What is an assemblage? It is a multiplicity which is made up of many heterogeneous terms and which establishes liaisons, relations between them, across ages, sexes and reigns—different natures. Thus, the assemblage's only unity is that of co-functioning: it is a symbiosis, a 'sympathy'. It is never filiations which are important, but alliances, alloys; these are not successions, lines of descent, but contagions, epidemics, the wind.

As Delanda (2016, 1) then states, in his overview of assemblage theory: 'In this [above] definition, two aspects of the concept are emphasised: that the parts that are fitted together are not uniform either in nature or in origin, and that the assemblage actively links these parts together by establishing relations between them.'

This isn't the place for an in-depth and critical assessment of the concept, but rather to highlight its usefulness as both conceptual framework and another relevant metaphor for the types of complexity with which this book is concerned. For example, Daniel Little (2012) offers some thoughts on how assemblage theory might be applied to one type of location where many of the wicked problems addressed in this book are arguably at their most tightly entangled: urban areas. Little says that, by viewing cities through the lens of assemblage theory, we might observe that:

1. A city consists of population, businesses, roads, organizations, government policies, political movements, disaffected youth, and slogans.
2. Population dynamics have a temporal scale of decades, while businesses have a temporal scale of months.
3. The interaction effects of gradual population change, the voting system, and gradual environmental change are difficult to calculate.
4. We can nonetheless make efforts to disentangle the effects of population change, institutional design, and environment on things like land use and effective taxation rates.

As Little (2012) then states, 'this reformulation suggests that large social entities are "messy" but still amenable to analysis and study.'

In the context of urban planning therefore, this would seem a helpful framework. These ideas also align well with the previous discussion around the concept of ecosystems and their application in an urban setting to what are characteristically urban issues. We should also not lose sight of the metaphor used to begin this book, of the moon and the ghetto and the origin of wicked

problems in discussions around the potential to use NASA research in the 1960s to help address contemporary urban problems.[8]

Systems Thinking and Complexity Theory

Related to the discussion of solutions, and making sense out of chaos, the entangled web (the mess, as previously discussed) can also benefit from something referred to as systems thinking, an idea that emerged in modern science in the 1920s (Capra 1996; Churchman 1968), eventually coming to be viewed as a theory, a paradigm, a belief system, a perspective, and a method (after Grewatsch et al. 2021, 3).[9] As a theory, systems thinking applies general systems theory, which unifies, 'all natural and social sciences in one grand conceptual model.... It aims to explain unrelated findings by exploring the interrelationships between organisations and the external environment' (ibid.). Equally, to cite Ackoff (1974, 21), as a key systems theory scholar who also spoke about 'mess':

> Every problem interacts with other problems and is therefore part of a system of interrelated problems, a system of problems...a mess...The solution to a mess can seldom be obtained by independently solving each of the problems of which it is composed...Efforts to deal separately with such aspects of urban life as transportation, health, crime, and education seem to aggravate the total situation.

As a paradigm, systems thinking provides a set of assumptions that give shape and meaning to the world and influence how issues are studied and interpreted. As Grewatsch et al. (2021) state, this is important and goes beyond theory in seeking to develop knowledge and coordinate actions across disciplines. As a belief system, systems thinking relates to changing behaviours. In essence: 'To solve wicked problems, corporate and political decision makers need to be influenced toward systematic changes' (Grewatsch et al. 2021, 3). As a perspective, systems thinking aligns theory with practice. As a method it allows multi-level studies to 'better capture large scale and complex problems' (2021, 4).

At its core, systems thinking provides a relational view of the world, as a 'network of *interconnected* and interdependent relationships among elements that produce patterns of dynamic stability across temporal and spatial scales' (Grewatsch et al. 2021, 4, emphasis in original). Most such systems are open and interact with other systems (Grewatsch et al. 2021).

Key to these interrelationships are the feedback loops that provide the connectivity between the different components within any system. Central to

[8] It is all connected. That is the point.
[9] And see this source for an excellent summary table with additional citations.

systems thinking is the realization that these relationships, and hence the character and significance of the feedback loops, are constantly changing. Cause and effect are in a constant state of flux, in other words. The systems are not stable, just as the behaviours are emergent, adapting and learning from experience. All of these elements are characteristic of systems thinking and can be related directly to the way in which we think about and create solutions for wicked problems.

Related to this notion of systems thinking is complexity theory. This has been defined by Eppel and Rhodes (2018, 950) as a theory that helps to explain the way, 'many, repeated non-linear interactions among elements within a whole result in macro-forms and patterns which emerge without design or direction. [It sees the future as a] contingent, emergent, systemic, and potentially path-dependent product of reflexive nonlinear interactions between existing patterns and events.'

As Brian Head (2022, 63) has described it: this area of theory originally developed in the biophysical sciences. Like systems theory, it draws attention to, 'multiple interconnections, feedback loops and surprising side effects that can often undermine the aspirations of leaders to "control" their socio-political systems'.

The term complex is used here to highlight the interactive and organic aspects of systems rather than the mechanical aggregation of elements or components (Head 2022, 63). Put simply, and as Head (2022, 64) describes it: 'a "system" understanding is needed to understand how the structure of the system influences the behaviour of the system.'[10]

Multiple Causality in an Age of Uncertainty

I began this chapter on entanglement with a lengthy quotation from Karen Barad's excellent and thought-provoking (2007) book, *Meeting the Universe Halfway*. Her main argument, as summarized by Bauman (2017, 12) is that agency is distributed throughout the universe of entities, from the smallest sub-quantum level to the largest levels of the universe itself. All of these 'actants' work on one another across all of these levels of reality. Barad also said:

> The very nature of materiality is an entanglement. Matter itself is always already open to, or rather entangled with, the 'Other'. The intra-actively emergent 'parts' of phenomena are co-constituted. Not only subjects but also objects are permeated through and through with their entangled kin; the other is not just in one's skin, but in one's bones, in one's belly, in one's heart, in one's nucleus, in one's

[10] There is much more that can be said on this topic, just as it can on all of the various perspectives briefly outlined in this chapter. If you need more, go to the original sources which I have found to be clear and straightforward, in spite of my coming from a very different disciplinary tradition to most of their authors.

past and future. This is as true for electrons as it is for brittlestars as it is for the differentially constituted human.... What is on the other side of the agential cut is not separate from us—agential separability is not individuation. Ethics is therefore not about right response to a radically exterior/ized other, but about responsibility and accountability for the lively relationalities of becoming of which we are a part. (Barad 2007, 392–393)

This quotation once again makes that significant point (notably for archaeologists, as Meirion Jones 2021, for example, acknowledges):[11] that human agency is all about entanglement, with multiple actants (past, present, and future) across the universe. Barad's final point about ethics is important too. As Bauman suggests (2017, 15): An environmental ethic must deeply challenge notions of value, meaning, and purpose. With wicked problems (or however we choose to describe them) we have to move beyond the comfort zones of our own disciplines, our own perceptions of the world, and what we think is important, to recognize complexity and the need to find creative, messy, or clumsy solutions to resolving them. I do not claim for one moment that archaeology or archaeologists (or earth scientists, or quantum physicists like Karen Barad for that matter) have a pre-eminent position within this area of theory; nor do they have any privileged claim to be well placed to address wicked problems. But their perspectives are all important, and arguably equally so. My main argument about archaeology in this book, and my reason for writing it,[12] is that archaeologists have not even been close to this arena, let alone within it. And they need to be. We have a superpower and we should use it far more often than we do. As Rahm-Skågeby and Rahm have stated (2022, 74), 'the "deep present" can be seen as an analytical perspective on our current times that emphasizes the interplay of long-term, ancient geological events with short-termist, late-modern capitalism and techno solutionism'. Archaeologists are well-positioned to investigate the 'deep present'.

This therefore builds convincingly on Irvine's (2020) argument that geological time and biographical time intersect in the fabric of everyday life (cited in Rahm-Skågeby and Rahm 2022, 74). We are part of our world. We shape it and it shapes us. Recognizing how deeply entangled the elements of wicked problems are is an essential prerequisite to creating solutions. Archaeology is therefore relevant for two reasons, to restate what I have said previously: first, for highlighting and providing evidence for the temporal perspective on the changing planet (as a context for the problem, if not an element of it); and second, for finding some of those creative, messy solutions to specific parts of particular wicked problems, creating those small wins with big implications. These are among the reasons why archaeology is such a vital discipline within the wicked problems arena. As Irvine

[11] He also recognizes that the full implications of Barad's work have not yet been widely realized by archaeologists!
[12] If this is not already obvious then I have failed!

(2020) puts it: 'A grounded understanding of the relationship between human life and the time span of geological formation allows us to recognize the disembedding nature of our extraction from deep time—a present fixation that severs humanity from the material conditions of its existence.'

An Example

Having already discussed both climate change and ocean health separately, I will now briefly present them in unison to illustrate the applicability of the various ideas that I have drawn together in this chapter which I will do, for convenience, with an emphasis on systems thinking (as an approach) and mess and entanglement (as framing concepts).[13] The literature that I have reviewed in this short chapter[14] is highly selective, but the sources were chosen for a very particular reason: notably, that all of these authors have used as their example either climate change or ocean (as part of wider planetary) health. These wicked problems (the subject respectively of Chapters 2 and 3) are often treated separately and sometimes even viewed as competing. Yet that is far from the reality, as Ford et al. (2022) describe:[15] plastic contributes to greenhouse gas emissions from the beginning to the very end of its life cycle; while extreme weather and flooding associated with climate change exacerbate the spread of plastic throughout the environment. So in the final section of this chapter, I will briefly review some of these applications within the context of the theory which they illustrate.

Take systems thinking for example. As Grewatsch et al. state (2021, 4), most systems are open and interact with other systems. They maintain structures but exchange materials with other systems, such as matter and energy. The earth receives shortwave radiation from the sun, for example, which can be absorbed to maintain stability in living systems and avoid a state of high entropy. In systems thinking, climate change studies will recognize this exchange alongside the importance of a dynamic perspective (recalling Ingold 2011, for example), of always becoming, by

> capturing the dynamic interplay among firms, societal actors, and carbon accumulation in the atmosphere. By embracing these dynamics and the interconnectivity between the social and biophysical environments, strategy scholars can develop broader understandings of not only how individual firms' actions affect climate change, but also how individual firms interact with others to shape what is to come. (Grewatsch et al. 2021, 7)

[13] However, in taking this example, we shouldn't lose sight of what should now be clear, that this is not the extent of the entanglement. Both of these issues also relate to every other topic within this book (and not least human health, after e.g. Romanello et al. 2022) as well as others not specifically covered such as food security.

[14] A theoretical pause for breath is how I thought of it... or a pause for theoretical thought.

[15] See also Lavers et al. 2022.

This perspective, Grewatsch et al. state (2021, 7), has the benefit of bringing new solutions into view, by widening the lens from the organization to a system of organizations.

In Schickore's (2020) essay on *Mess in Science*, climate change is given as an example of a very messy wicked problem,[16] the mess in this case relating mainly to the very different perspectives that various stakeholders consider to be priorities or drivers. Here the entanglement comprises, for example, food and water security, damage to ecosystems, health impacts, and economic inequalities which are all factors that need to be taken account of in deciding what to monitor and measure and whom to entrust with this task (Schickore 2020, 499). The different stakeholders also have very different views on how to first approach and then ultimately make these decisions (Schickore 2020, 499).

In Bauman's (2017) essay, she refers to the work of the IPCC, which I discussed in Chapter 2, and uses the term 'climate weirding' to highlight the fact that there is not only overall climate warming to contend with but additionally the prevalence of odd weather patterns everywhere. As she states elsewhere (Bauman 2015), this is not just climate change as usual, but something *un*usual, beyond the regular cycle of change, of ebb and flow. The entanglement that Bauman (2017) refers to rests with planetary systems, thus rendering this specific problem especially wicked. As she states:

> Just as our identities are constituted by planetary forces, so our bodies and species help co-constitute the planetary community of which we are a part.... [A]ll entities are [thus] entangled with all other entities in this process of becoming. We are mattered by the planetary community, and we also help to matter the planetary community. This is the nature of our entangled reality with all other planetary bodies. It is not that we have ushered in some new era known as the Anthropocene, but rather that we have become aware of how the anthopos is entangled evolutionarily and ecologically with the planetary past, and entangled with the future of planetary becoming.... *We are not the only actors or causes of the planetary community, and we must begin to think outside of the terms of efficiency and management so adored by the modern, industrial human worlds we have created.* (Bauman 2017, 11–12; my emphasis)

It is here, on this final point, that I believe archaeology can be most helpful through the small wins framework that I am promoting: to understand both the depth and the complexity of the entanglements that characterize climate change (and climate weirding) and its interconnectedness with other wicked problems such as oceanic and planetary health; and to help find creative (and often clumsy)

[16] Recognizing that it has also been identified as a super wicked problem, for example by Lazarus 2009 and Levin et al. 2012.

ways to further that understanding and begin to find some solutions. Authors including Hodder (2011; 2012; 2018; 2020), Robb (2013), and Meirion Jones (2021) have addressed the various ways archaeologists have engaged with concepts on entanglement through materiality as a way of understanding past worlds (recalling Karen Barad's observations about matter and meaning at the start of this chapter). Here the reference to entanglement is slightly different, building on this earlier work but identifying it also in organizational terms: referring to how we act and who we interact with, alongside a realization that material matters; that it has agency now just as it did in the past. I will elaborate on this archaeological perspective in the book's concluding chapter.

Having briefly moved away from the book's thematic structure to present a more theoretical perspective on those themes, we can now return to the thematic content to address two further wicked problems which come more under the heading of socio-cultural than environmental problems: social injustice and conflict. As should now be obvious, these two themes are interrelated, not just to one another but also to those themes that have come before.

Chapter Headlines

- All of the wicked problems described in this book are interconnected or entangled in various ways. Other wicked problems not represented in the book also form part of that same entanglement.
- Entanglement is a concept that numerous archaeologists have written about. It is also a topic that interests scholars from other disciplines including the influential quantum physicist Karan Barad. It is therefore a concept widely understood across disciplines.
- This notion of entanglement is therefore a helpful framework for scholars and practitioners working with wicked problems, who also need to recognize the nature of wickedness, and the key characteristic that resolving problems in one place may create additional problems (or even new problems) elsewhere.
- But entanglement is only one way of describing this complexity. There are other terms that have been widely used by scholars researching wicked problems, notably: messiness, systems thinking, assemblage theory, ecosystems, multiple causality, and complexity theory.
- One example which illustrates clearly the entanglement that exists between wicked problems is planetary health, comprising environmental pollution and climate change, with impacts also on human and non-human health and well-being, and social injustice, for example.

6
Social Injustice

Slums and their populations are the victims (and the perpetrators) of seemingly endless troubles that reinforce each other. Slums operate as vicious circles. In time, these vicious circles enmesh the whole operations of cities. Spreading slums require ever greater amounts of public money – and not simply more money for publicly financed improvement or to stay even, but more money to cope with ever widening retreat and regression. As needs grow greater, the wherewithal grows less.

(Jacobs 1992 [1961], 270)

Change life! Change society! These ideas lose completely their meaning without producing an appropriate space. A lesson to be learned from soviet constructivists from the 1920s and 30s, and of their failure, is that new social relations demand a new space, and vice-versa.

(Lefebvre 1991, 59)

In some contexts, scholars (and others) are invoking rights discourse as a way to address inequalities, injustices, or violations of heritage or cultural rights that they encounter in their work. But do these instruments provide a voice for all 'communities of connection' (indigenous, subaltern, descendant, and local communities) to mediate how their heritage is represented? In some cases they do not. A social justice approach can be positioned in ways that take seriously the people on the margins and, alone or in concert with human rights frameworks, could be considerably more far-reaching in calling attention to how inequalities and oppression are reproduced.

(Baird 2014, 141)

Social Justice

Earlier in the book, in Chapter 1, I discussed Richard Nelson's (1977) use of the moon-ghetto metaphor to address the concept of wicked problems and what it was that made such problems uniquely problematic. I suggested that landing somebody on the moon is a significant technical challenge but it doesn't constitute a wicked problem. Poverty, of the kind Nelson was referring to, does

and this is because of: (1) its complexity as a problem; (2) the levels of disagreement entailed in defining the problem and therefore also in defining possible solutions; and (3) uncertainty in how successful those potential solutions might actually be and their knock-on effects into other wickedly problematic (and deeply entangled) areas.

The landscape (in a physical, cultural sense) forms an important backdrop to this particular wicked problem, and the two opening quotations refer to this in the form of both physical spaces within which poverty can occur (in the first quotation, by Jane Jacobs) and the new spaces that are required to help alleviate it (Henri Lefebvre).[1] The third quotation refers to the ways in which a social justice approach, perhaps aligned with human rights issues and thinking, can provide a framework for addressing these problems within these kinds of physical (but also social and policy) spaces. Poverty is embedded within society and its social structures, which partly explains why it has become such a difficult and wicked problem to try to resolve. It is also deeply entangled with most if not all of the other wicked problems discussed in this book. But while poverty is itself a wicked problem, it is only part of the wider (and arguably super) wicked problem of social injustice and it is that wider issue that forms the focus of this chapter.

So what is social injustice? This can be defined and summarized as follows:

1. Social justice is the balance between individuals and society measured by comparing distribution of wealth and other differences, from personal liberties to fair privilege opportunities. Social *in*justice therefore exists where there is *im*balance but is also the way unjust actions are done in society.
2. Social injustice occurs in a situation where the equal are treated unequally and the unequal are treated equally. Examples of social injustice might include discrimination based on ageism, and homophobia.
3. It's about the lack of human rights that are manifested in the daily lives of people in society. This links directly into the Universal Declaration of Human Rights (UDHR) which I will discuss later.
4. Social injustice therefore concerns the quality or fact of being unjust. An example is the inequity regarding fair pay especially in the social and economic treatment of workers or any situation in which the rights of a person or a group of people are ignored.

[1] It was tempting to also include a quotation from one of Charles Dickens's novels from his so-called social trilogy, in which social injustice plays such a prominent role, not least in *Great Expectations* (Hagan 1954), Dickens' thirteenth novel and the one that deals most obviously with the issue of social injustice in the class-driven society of the Victorian era. The novel's protagonist, Pip, strives to escape his social class, to become a 'gentleman', despite lacking the associated wealth, education, and birthright to do so.

5. Social injustice might involve a violation of one's civil rights that could inhibit the ability to realize full potential and ultimately impede one's career success.

Social justice has been the subject of critical attention by Melissa Baird (2014). A quotation from this research was amongst those that opened the chapter. In her paper, Baird set out to distinguish human rights and a social justice framework, recognizing the ways in which they align but also emphasizing how a social justice framework can provide 'advocacy and voice to communities whose needs have been marginalised' (2014, 139). Baird uses the term 'communities of connection' to describe the avenues down which indigenous, subaltern, descendant, and local people can both identify their heritage and challenge how it is represented. The homelessness projects that I present later in this chapter are examples of exactly the benefits this approach can create. As Baird (2014, 142) states, 'promoting human rights principles and agendas is essential' as they 'bring to the fore discriminatory practices that can then be debated and mediated within the global consciousness'. Yet she argues that this may not be the best framework for addressing issues of social injustice as human rights atrocities and contraventions still occur in spite of the UDHR, signed in 1948 and discussed further later in the chapter (and see Stacy 2009). As Baird states, from her own work, for example: 'In some cases what are being invoked as human rights issues are clearly not. In my ethnographic study of World Heritage experts, it became clear that experts frequently invoked universalist and normative ideas of rights in their conceptions of indigenous cultural landscapes' (Baird 2009; see also Povinelli 2002).

Another significant point raised by Baird (2014) is the position that social justice frameworks take up, at 'the nexus of practice and discourse' (2014, 141). Because of their position, these frameworks have the capacity to engage a diversity of stakeholders and interest groups, including academics, governments, and non-traditional groups, those who have the most to gain from community-based social justice initiatives alongside or including those who have the skills and the authority (and the positionality) to act as policy entrepreneurs. Through this lens there is the opportunity to 'expose systems of domination' (2014, 142), countering the authorized heritage discourse (after Smith 2006) which was discussed in Chapter 1, while giving heritage practice direct relevance and purpose. There is also the opportunity to promote a cause, to champion it and bring it to the attention of decision-makers.

As has already been suggested, much of this particular problem's wickedness (and the deeper history of this wickedness) relates to poverty which exists (as it has for a long time) in both urban and rural areas (see Debucquet and Martin 2018, for example, who discuss rural poverty). Poverty is the cause of (or at least is closely related to) many other problems in society such as crime, homelessness,

and mental health for example, but it is also a consequence of many things. There is also clear evidence (in fact whole areas of research) which demonstrate how feeling better about one's place (whether or not this constitutes 'home') promotes prosocial behaviours, which improve neighbourhoods and enhance well-being in an increasingly and mutually productive cycle (e.g. Nettle 2015; I will discuss this topic further, with an example, later in the chapter, building on an earlier discussion of place attachment in Chapter 4). But how can people be encouraged to feel better about their neighbourhoods if they are struggling merely to survive? And (returning to the specific subject of this book), how can archaeology or cultural heritage perspectives help make a difference? How can archaeologists use their superpowers to address this particular threat to society, on both local and global scales? What can archaeologists do, beyond undertaking excavations to help people better understand what poverty looked like in the past, and how people survived it, if indeed they did?

This chapter will address these questions, focusing on the book's main purpose: to demonstrate that archaeology (and people working across the wider cultural heritage landscape) can play a meaningful role in helping to address this seemingly irresolvable wicked problem of social injustice, in its many forms. As we have already seen in the previous chapters, there is no panacea and archaeologists cannot hope to resolve these problems alone. It is also unrealistic and naive to expect a complete resolution to the wicked problem of social injustice. Like all good superheroes, to achieve what they can, archaeologists will ideally form part of wider multidisciplinary teams and, within those teams, they'll have particular, distinct, and important contributions to make. Their successes will likely be small wins which make a difference to some people, provide examples of good practice, and gradually take us, in small steps (or nudges), towards the bigger wins that make a difference on a larger societal scale. In Lefebvre's (1991, 59) terms, a small win may require new physical spaces within which solutions can begin to emerge (an excavation site may be an unforeseen example of this) but also what we might refer to as new 'head spaces', new ways of thinking and of being open to creating bold new ideas. Archaeologists and other heritage professionals may also need to give up their authority as experts on occasion, and let others lead. I will talk about this 'translational' approach when I discuss archaeologists successfully working with homeless people later in the chapter. But ultimately, as numerous authors have said about wicked problems, the best way to find a fix is often by seeking out or crafting the most creative and unlikely collaborations, between scholars and practitioners, policy entrepreneurs and industry.

As with previous thematic chapters, I will begin by examining the wider policy context. For this I will focus the initial discussion around the UDHR and its incorporation into approaches to heritage practice through the 2005 Council of Europe Framework Convention on the Value of Cultural Heritage for Society

(better known as the Faro Convention, or simply 'Faro'—see Council of Europe 2005; 2009). I will then review some of the recent approaches to promoting equality, equity, and diversity within a lead national heritage body in the United Kingdom. Against that policy and aspirational background I will then review some of the literature related to aspects of social injustice that contribute to rendering it a wicked problem, focusing in particular on research into aspects of poverty and homelessness, two significant and closely related areas where injustices occur. Beginning with a short outline of conventional archaeological work that has sought to address inequality and diversity, I will then review some examples of archaeological work that have specifically sought to address social injustice, with a focus on projects that I have been involved with in recent years. These examples refer to fieldwork and interventions mainly in Bristol although I also refer to projects undertaken amongst homeless and other marginalized communities in the United States and, briefly, in the chapter's Conclusion, in a post-colonial context in Malta. Archaeological and heritage projects that involve and relate to refugee communities and other displaced peoples have direct relevance here too but, because many[2] such people are displaced because of conflict, this topic will be discussed in the next chapter.

The Right to Social Justice

At its core, social injustice refers to the lack of human rights in people's daily lives. As stated previously, this can occur in situations where the unequal are treated equally while the equal get treated unequally.[3] Homophobia, ageism and ableism are three common examples of equals being treated unequally. The human rights referred to here are set out in the 1948 UDHR and I will come to this important landmark document shortly. First, and if only to emphasize the relevance of the last chapter's content on how many of the wicked problems I describe in this book are interconnected, I will briefly list some social issues that can create a situation of social injustice and cause or enhance poverty:[4]

[2] But definitely not all such people are displaced because of conflict. It is way more complicated than that. To give just one example of this complexity, Denis Byrne has said (2023) that, 'heritage practice brings a nation-centric lens to the heritage of migration, privileging narratives of arrival and settlement over narratives of return, circulatory transnational flow, and cross-border connectivity.' To help escape this frame of reference, and based on Chinese migration to Australia between the 1840s and 1940s, Byrne proposed what he refers to as the 'heritage corridor' concept.

[3] Aristotle said that 'equals should be treated equally and unequals unequally'. This principle of justice states that individuals should be treated the same, unless they differ in ways that are relevant to the situation in which they are involved. This principle is helpfully discussed further and with clarity in Andre and Velasquez (1990).

[4] Much of the content of this text box is taken directly from the website sintelly app, and published by sintellyapp (2021).

Some Social Issues That Can Cause Social Injustice

1. Affordable Health Care

Not all countries offer their citizens guaranteed healthcare that comes from the government. Most people simply rely on employers for their health insurance. Unfortunately, this means that those who work part-time jobs or are unemployed end up with expensive health-care bills once they get sick or are involved in an accident. People clamour for their governments to adopt a version of a government-run, universal, and expanded health care. Universal health care can help reduce medication costs and ensure that people don't fall into financial ruin just to stay healthy and alive.

There is obvious connectivity between this and the wicked problem of health and well-being, discussed in Chapter 4. One solution to this (responding to the need for 'a government-run, universal, and expanded healthcare') is obviously through adopting a high-level approach and campaigning, which is an approach few would argue with. But as was demonstrated in Chapter 4, and within this same area of health-care provision, small wins that positively impact people's health can also be achieved by people operating within the heritage sector, including as archaeologists. Examples of good practice, such as York Archaeology's Archaeology on Prescription project, can then be promoted through the work of policy entrepreneurs and through promoting open access 'toolkits'.

2. Climate Change

In recent years, climate change has been affecting humans and the Planet in dangerous ways. The scientific community has already reached a consensus about this and they have been issuing warnings for years. The United Nations Foundation has listed climate change as one of the top global issues with the continuous rise of global emissions of harmful chemicals and gases. With no significant changes in major industries and people's ways of life, the planet's climate may soon become unfit to live in for a lot of species. This can then collapse the global food chain and threaten the existence of humanity. The poorer nations are the ones that will feel the effects of climate change first. Social justice organizations strive to mitigate its effects on ecosystems, individual communities, and nations. This particular wicked problem was the subject of investigation in Chapter 2.

3. Food Insecurity and Hunger

Millions of people across the globe face hunger and millions also live in total poverty. Even today, food insecurity is still an issue that is impossible to

Continued

> *Continued*
>
> resolve. It has been revealed that Gen Z[5] seems to believe that hunger and poverty are critical issues that need to be addressed while the older generations tend to rate this lower in the list of social issues.
>
> This particular wicked problem therefore highlights the important matter of perception. In both this and the previous (climate change) example, some people see significant problems where others do not, preferring maybe to blame the victims for finding themselves in situations that they have been unable to escape from.[6]
>
> ### 4. Income Gap
>
> The income gap is getting bigger and it is expected that the divide will soon reach its largest ever. Disparities in pay can be a factor based on gender, sexuality, and race. In the field of social work in the United Kingdom, for example, there is an existing gender pay gap where there is a notable difference in the way women and men get compensated for the same type of job.
>
> Here archaeologists can at least help themselves through their professional institutes and agencies and the unions that represent workers across the heritage sector, to ensure these disparities are removed and as quickly and as painlessly as possible.
>
> ### 5. LGBTQIA+ Rights
>
> For the past twenty years, LGBTQIA+ community members have made remarkable progress with their fight for equal rights. The non-heteronormative culture has already changed how people perceive what used to be considered as gender expressions and traditional values. However, there are still many institutions and individuals that discriminate according to sexual orientation or gender. It wasn't too long ago when some countries lifted their bans on same-sex marriage. But, these couples still deal with discrimination in various parts of the world. Same-sex relationships remain illegal in some countries.
>
> As citizens we can encourage those organizations that represent us and our interests to ensure their policies encourage and promote inclusivity in this area. As archaeologists, we can also use our subject and its findings to ensure equalities are represented in the way we understand and interpret the past, and in the ways we use the past to think about the present and the future.

[5] The group of people who were born between the late 1990s and the early 2010s.

[6] Who remembers British Conservative government minister Norman Tebbitt advising men who had lost their jobs as a result of his government's mine closures in Thatcher's Britain, to 'get on their bikes' and go and find work elsewhere, for example?

6. Racial Equality

In particular, the United States has seen a disturbing history of racism that dates as far back as the founding and colonization of the country by the white landowners who turned millions of African people and their descendants into their slaves.

Even when the Civil War put an end to the legal slavery practice in the United States, systemic problems, racist attitudes, and racial disparities have continued. This inequality was revealed in a *New York Times* (2019) report that discovered that the wealth of average white Americans is seven times bigger than that of average black Americans.

This racial inequality permeates society and affects health care, representation, education, and even law enforcement. There are many widely reported instances for example of Black Americans being unreasonably charged, arrested, and facing jail time. One more disturbing statistic is that it is more likely for the police to kill black Americans compared to white Americans.

The Black Lives Matter movement has highlighted many cases that have helped increase the awareness of the public to racial injustice as well as the racially motivated violence committed by authority figures including police officers.

As archaeologists and heritage practitioners, we can encourage those organizations who represent our interests to actively promote policies and projects to stand as exemplars that highlight good practice across and throughout society. Some heritage organizations in the United Kingdom (for example Historic England, an example I will return to later in the chapter, and the National Trust), have succeeded in bringing these issues into the open, often exposing themselves to significant criticism from politicians and members of the public for having done so.

7. Voting Rights

One of the major social justice issues today is exercising voting rights. There are two reasons why people are urged to vote. First is to encourage people who can vote to exercise this important right; and second is to get rid of barriers or hindrances to participation. Millennials in particular are being encouraged to vote through promoting understanding of the barriers that could hold back minorities, senior citizens, college students, low-income individuals, and more. The challenges can include stricter identification requirements, shortened windows for early voting, and difficult voter registration.

This example highlights a vital point, being the right (as set out within the UDHR) of every individual to participate in cultural life, and to be able to exercise their democratic right to vote forms a part of that participation. Yet many people cannot or do not participate (or vote), for a variety of reasons. The most commonly cited might be their perceived inability to do so (for physical or mental health reasons), and another might be that they don't see

Continued

> *Continued*
>
> the point as no one is interested in what they think. There are also complicated dilemmas involving displaced peoples and prisoners.
>
> These are just some examples, taken from the sintellyapp (2021) website, and with added commentary. But it provides a useful summary of the issues that can compromise, curtail, or even prevent people from exercising their human rights. Many if not all of these issues also relate directly to the chapter's underlying theme of poverty.
>
> (adapted from sintellyapp 2021)

As we saw in Chapter 2, higher-level policies are vital, at governmental and international level, in helping to resolve particular wicked problems. I gave some examples of how the scientific community has already reached consensus about the wicked problem of climate change and how that community has been issuing warnings for years. Also, with climate change, I gave some examples of how, at the other end of the scale, small wins can make a difference. The same is true of environmental pollution linked to climate change, and how these problems relate to social inequalities and thus social injustice. One example of this is the archaeology of garbage-based settlements in cities like Tehran (Iran). In this case Dezhamkhooy (2023) has highlighted how the collection of material (artefacts), the documentation of places, and qualitative research can create a significant small win, by giving voice to 'deeply marginalised and temporary communities... revealing their hardship and transience but also their resilience and aspiration to permanence'. I will return to discuss further examples of some small wins achieved through archaeology and heritage practice and how these can help address the wicked problem of social injustice later in the chapter. Now though, I will introduce (for those who need it) the UDHR as a crucial foundation for any discussion around injustice, noting Baird's (2014) comments at the start of this chapter, about how UDHR and injustice offer different perspectives but are aligned nonetheless. The reason UDHR is crucial has already been discussed, but to recap and put simply: social injustice is about the lack of human rights that are manifested in the daily lives of people in society.

Universal Declaration of Human Rights (UDHR)

The United Nations (UN) web page[7] provides a short history of the UDHR. It states the main points of this history being that:

[7] https://www.un.org/en/about-us/udhr/history-of-the-declaration

[It] was adopted by the UN General Assembly on 10 December 1948, as the result of the experience of the Second World War. With the end of that war, and the creation of the United Nations, the international community vowed to never...allow atrocities like those of that conflict to happen again. World leaders decided to complement the UN Charter with a road map to guarantee the rights of every individual everywhere. The document they considered, and which would later become the Universal Declaration of Human Rights, was taken up at the first session of the General Assembly in 1946.

I will discuss the archaeological and cultural heritage responses to conflict in the next chapter, including specific mention of the Second World War, and it is important to recognize that the UDHR emerged directly from the atrocities committed on a vast and international scale during that conflict. But human rights extend beyond those who need to be protected in wartime. They are, as the name of the document makes plain, 'universal', for everyone, everywhere, and at all times. They provide a

> common standard of achievement for all peoples and all nations, to the end that every individual and every organ of society, keeping this Declaration constantly in mind, shall strive by teaching and education to promote respect for these rights and freedoms and by progressive measures, national and international, to secure their universal and effective recognition and observance. (UDHR)

The articles of UDHR highlight the rights and freedoms of everyone without distinction (Article 2): the right of everyone to life, liberty, and security (3); freedom from slavery or servitude (4); recognition as a person before the law (6); freedom of opinion and expression (19); education (26); and to 'participate freely in the cultural life of the community, to enjoy the arts and share in scientific advancement and its benefits' (27). UDHR also recognizes the right for everyone to move freely within the borders of each State and to leave any country, including their own, and to return to it.

Sounds wonderful, doesn't it? And in many ways it is. As a statement, it carries weight and says many if not all of the right things relating to the values of equity, inclusivity, and diversity, for example. But there are concerns (again, recalling Baird 2014). One of these concerns is its implementation. It is after all just a document and, without strong mechanisms for implementation and for compliance, the impact has the potential, inevitably, to be limited. A second concern regards segmentation, and here we can see clear resonance with the subject of the previous chapter: that by trying to resolve one problem or issue, we run the risk of exacerbating others. By separating rights off into those which are social, economic, or political, for example, there will inevitably be a focus on some at the expense of others. As with wicked problems, none of those rights can be fully addressed

without a comprehensive approach that deals with all of them together. Arguably, therefore, human rights are themselves a wicked problem in this regard and the only effective way to deal with this is the small wins approach (or 'nudging' towards a solution) referred to earlier.

A further and more specific shortcoming might be the fact that UDHR doesn't explicitly state that people have the right to identify and engage with the *heritage* of their choice (my emphasis). The closest we come to this is the right to liberty and a freedom of belief while the right to 'participate freely in the cultural life of the community, to enjoy the arts and share in scientific advancement and its benefits' is also directly relevant. But for addressing how these principles can be translated across into heritage practice which itself connects to people's sense of identity, we can refer to another important landmark document and one that emerged more recently (in 2005) through the Council of Europe: the *2005 Framework Convention on the Value of Cultural Heritage for Society*.

The 2005 Framework ('Faro') Convention on the Value of Cultural Heritage for Society

The Council of Europe Framework Convention on the Value of Cultural Heritage for Society (the 'Faro Convention') was signed on 27 October 2005 (Council of Europe 2005). Taking into account the early stages of its preparation, that makes it nearly two decades old at time of writing. Yet it still seems fresh and contemporary. It aligns well with critiques published around the same time that described problems with an authorised heritage discourse (e.g. and especially Smith 2006), recognizing the need for heritage to be more inclusive and more about process than about specific things, places, and buildings, for example. In that sense of inclusivity, and as we have seen already, this also meant that Faro needed to align directly with the UDHR.

Just as UDHR emerged from the cultural and literal ruins of the Second World War, Faro owes much of its origin to the fragmentation of the former Soviet Union and the emergence (or re-emergence) of nations swallowed up by the Union in previous but recent centuries. This new political landscape also required a new way of thinking about culture and heritage, and inclusivity was central to this new approach. To highlight some of the Faro Convention's key points, the member States of the Council of Europe:

- recognised the need to put people and human values at the centre of an enlarged and cross-disciplinary concept of cultural heritage;
- emphasised the value and potential of cultural heritage wisely used as a resource for sustainable development and quality of life in a constantly evolving society;

- recognised that every person has a right to engage with the cultural heritage of their choice, while respecting the rights and freedoms of others, as an aspect of the right freely to participate in cultural life enshrined in the UDHR; and
- were convinced of the need to involve everyone in society in the ongoing process of defining and managing cultural heritage.[8]

Focusing on one of the key words in the Convention's Preamble (that word being 'everyone'), and noting its resonance specifically with regard to this chapter's focus on equality and equity (terms I will define shortly), it is worth recalling also Faro's definition of heritage as: '[a] group of resources inherited from the past which people[9] identify, independently of ownership, as a reflection and expression of their constantly evolving values, beliefs, knowledge and traditions. It includes all aspects of the environment resulting from the interaction between people and places through time' (Article 2).

Article 2 of the Convention also helpfully defines the concept of heritage communities, these consisting of: 'people who value specific aspects of cultural heritage which they wish, within the framework of public action, to sustain and transmit to future generations'.

There is much to celebrate about Faro. The fact it recognizes that 'everyone, alone or collectively, has the right to benefit from the cultural heritage' (Article 4), for example, and that Parties undertake to 'foster an economic and social climate which supports participation in cultural heritage activities' (Article 5) is commendable. Under Article 8 (addressing Quality of Life), Faro aims to 'reinforce social cohesion by fostering a sense of shared responsibility towards the places in which people live.' Finally here, in Article 12, Faro states that the Parties undertake to: 'Take steps to improve access to the heritage, *especially among young people and the disadvantaged*, in order to raise awareness about its value, the need to maintain and preserve it, and the benefits which may be derived from it' (my emphasis).

A few years after the Faro Convention was signed into existence, a book about the Convention was produced (Council of Europe 2009). This collection of thoughtful, short, and focused reflective essays alongside case studies, highlighted the purpose of Faro and how its implementation and impact were being felt across Europe in the few years after its introduction. Some of the essays dealt directly with the alignment of Faro with the UDHR. Meyer-Bisch's contribution (2009), for example, focused on the idea of the 'right to cultural heritage' and its alignment

[8] And I recommend reading this final bullet point again, lingering on the words 'everyone' and 'ongoing process of defining'. These phrases represent, to my mind, the very essence of Faro.

[9] And the term 'people' does not refer here to 'experts' or 'specialists' but to the inclusive 'everyone' highlighted previously!

with the UDHR's 'right to participate in cultural life'. Important here is the meaning of culture, a subject to which entire research careers have been dedicated. Like Meyer-Bisch (2009, 59), we can take as our benchmark the definition incorporated into the 2001 UNESCO Universal Declaration on Cultural Diversity: 'Culture should be regarded as the set of distinctive spiritual, material, intellectual and emotional features of society or a social group, and that it encompasses, in addition to art and literature, lifestyles, ways of living together, value systems, traditions and beliefs' (Preamble).

As Meyer-Bisch says (2009, 59), 'the culture in question is that of a group or society, that is to say a cultural milieu.' He goes on to recognize that culture bonds together the cultural works that constitute heritage and that this heritage then provides 'vital resources for the identity building processes of persons and communities' (2009, 60).

Cultural heritage (broadly defined, as it is in Faro) is therefore central to identity and also therefore place-making amongst an almost infinite diversity of 'heritage communities' (as defined within the Faro Convention, above) which interlock and overlap in complex ways. This highly entangled cultural heritage landscape is a far cry from those heritage landscapes identified within Smith's (2006) authorized heritage discourse as being deeply problematic, where expert views predominate and designated heritage assets (ancient sites and iconic or historic buildings) are a very clear focus of attention. As Jim Gard'ner (2005) showed in the Brick Lane area of East London (United Kingdom), historic 'listed' buildings may meet the national heritage criteria for designation, but they mean very little to the local Bengali community which makes up around 90 per cent of the local population. On the other side of that coin, those local buildings and places which are valued by this local community fail to meet the national criteria for designation. Through this approach, therefore, a community is effectively excluded from the heritage discourse and denied any official recognition for those places that are so important for their identity-making.[10]

This brings us to the point where further definitions of terms will be helpful, and in particular the definitions of key terms provided by the kinds of heritage organizations one might expect to lead the way in defining new pathways towards inclusion, diversity, and equality. It is these three vital elements that can ensure cultural heritage plays a central role in identity-shaping, for communities and for individuals, seen through a lens of cultural participation.

[10] Although Local Listing, as a new form of local designation, may provide some resolution to this particular heritage dilemma—see https://historicengland.org.uk/listing/what-is-designation/local/local-designations/.

Defining Inclusion, Diversity, and Equality

I have already described how Historic England is the lead national agency for heritage policy in England. It should come as no surprise therefore that this organization has a Strategy for Inclusion, Diversity and Equality, the current version[11] covering the period 2020 to 2023. Not directly referencing them, but in the spirit of Faro and UDHR, the Strategy opens with the recognition that: 'Heritage is for everyone. The work we do ensures that a diverse range of people are able to connect with, enjoy and benefit from the historic environment' (Historic England 2020b, 3). In the Introduction, the author also states that, 'we know that we're not currently reaching large sections of the population' (Historic England 2020b, 3).

But what of those three key terms: diversity, inclusion, and equality. How are these terms defined by Historic England (in Historic England 2020b)? In fact, their definitions helpfully[12] follow those previously adopted by the Museums Association (Museums Association 2017, 3):

> Our definition of **diversity** is any characteristic which can differentiate groups and individuals from one another. This includes the protected characteristics as defined by the Equalities Act 2010 but also includes others, such as socioeconomic background and status. It also includes and values diversity of perspectives and life experience, for example.
>
> Our definition of **inclusion** recognises that people need to feel connected and engaged. Inclusion can be defined as a state of being and feeling valued, respected and supported. Practising inclusion is necessary for diversity initiatives to work effectively.
>
> Our definition of **equality**[13] recognises that every individual should have equal opportunity to make the most of their lives and talents. It recognises that certain groups of people with particular characteristics have in the past, and today, experienced discrimination.

The need for Historic England's Strategy for Inclusion, Diversity and Equality is framed around the recognition that heritage promotes communities and increases connections across and throughout society through people's shared values. Heritage also aligns people today with their past and with the places where they

[11] At time of writing.

[12] 'Helpfully' because this provides a degree of consistency across key parts of the heritage sector and presents one voice on these vital issues.

[13] Equality is often considered to mean that everybody is treated the same. Equity (another important aspect of this agenda) means that everybody gets what they need in order to be successful.

live which in turn play a significant role in shaping their identity and their futures (Bonaiuto et al. 2006; Eggert et al. 2015). In the past, under the authorized heritage discourse (previously discussed and after Smith 2006), heritage had been assumed by many people to refer only to histories that are connected with land ownership and control, and being relevant only to those who had the time and resources to invest and participate in such things: the castles and country houses model which Smith (2006) refers to, and predominantly (within the United Kingdom specifically) the white middle classes of middle England. A sense of community, of rootedness and the need for identity are universal, yet some people may require more support than others to create the opportunities for cultural participation and to identify and manage their 'constantly evolving values, beliefs, knowledge and traditions' (Council of Europe 2005, Article 2). As Historic England also recognizes (2020, 10): 'The benefits of heritage are not automatic. People need to connect with heritage and feel represented by heritage to gain these benefits. If people feel invisible, or wrongly represented, heritage can divide rather than bring people together' (citing Legner et al. 2019).

Any such division would of course represent social *in*equality, and preventing such a division is something that archaeologists and those employed as heritage practitioners can achieve through the small wins approach. I include some examples of this approach later in the chapter. By way of context for those examples, Historic England (2020, 10) presents data that show the extent to which barriers to participation exist in the ways people currently engage in heritage activities. The data show, for example, that people in socially and economically deprived areas are significantly less likely to participate in heritage. In 2019/20, for instance, 51 per cent of adults in the most deprived areas of England had visited a heritage site in the past year, compared with 83 per cent for those adults in the 10 per cent least deprived areas. Further, young people of Black Caribbean origin had relatively low levels of heritage engagement: 39 per cent, compared to 59 per cent for white young people. These figures are mirrored for employment within the heritage sector, with the same groups being underrepresented.

It is important to recall Historic England's purpose, to: 'improve people's lives by protecting and championing the historic environment'; and also its vision for diversity, inclusion, and equality, that: 'heritage is for everyone'. With these headlines in mind, the Historic England Strategy for Diversity, Inclusion and Equality covers three strands: Historic England's work, its people, and the wider historic environment sector. In terms of its work, it seeks to 'identity, understand, conserve and celebrate heritage that speaks for all'. For its people, it sets out to ensure that it is 'inclusive in who we recruit, how we communicate and with whom, and how we lead'. And for the historic environment sector, it wishes to create 'the conditions in which inclusion becomes the norm'.

The Strategy then sets out what Historic England has achieved already, with examples of good practice, and some goals and challenges. All of this together aligns closely with the principles of social injustice, as defined earlier in the chapter. I will shortly go further in explaining why social injustice is such a wicked problem. But to summarize, the argument is that UDHR provides a framework for helping those who need heritage most of all to establish a stronger sense of identity and have access to the kinds of cultural participation opportunities discussed in Chapter 4 which, if taken up, can help enhance people's sense of identity and their well-being, possibly kick-starting a slow process which will lift them out of poverty or related difficulties. The Faro Convention, in turn, provides opportunity and encouragement to State members, to facilitate these opportunities, emphasizing also their responsibility to create them. Strategies, like those created by Historic England, provide the framework within which such actions can be prioritized (e.g. for funding and through strategic programmes and projects).

While recognizing overlap between this chapter and the subject of health and well-being in Chapter 4 (and reflecting also on a discussion that happened in Chapter 5, about entanglement), we can now ease ourselves towards those examples that illustrate what can be achieved by way of small wins or nudges. I will do this by first taking a look at some of the literature around social injustice as a wicked problem.

Social Injustice as a Wicked Problem

I began this book by referring to the metaphor of the moon and the ghetto (after Nelson 1977), to illustrate how some highly technical challenges can be more easily overcome than significant socio-economic problems. As I suggested in Chapter 1, the term 'ghetto' is not one we would use today, preferring instead to label these areas as, for example, socially deprived neighbourhoods. Jane Jacobs, in her classic *The Death and Life of Great American Cities* (1992 [1961]) refers to such areas as slums. It is in these areas that social injustice is often at its most acute, and where some of the heritage and archaeological interventions that I will describe later can have the most impact. They can also be amongst the most challenging areas in which to work. But before we reach that point, I will talk more about the ways social injustice has been recognized as a wicked problem. To begin to do that I will present a metaphor, or maybe it is a parable? Noah Rosenberg (2021) presented, as a 'topography of injustice', the story of a miner and a doctor. He describes how, 'a tunnel collapses in Africa, fatally injuring a young miner. Common concepts of individual liability are inadequate to account for the injustice that led to his death' (2021, 189).

The comparison is between this young man mining for tungsten along the border of the Democratic Republic of Congo and Rwanda, and another young

man, a doctor, surfing off the coast of the United States. Both suffer very similar severe injuries but their stories end in very different ways. Simply, the miner dies, but the surfer does not, although his injuries are severe enough to prevent him from leading a normal life after his accident. This is a crucial difference. As Rosenberg says, he will at least have a life: 'With the right mobility devices and nursing care, he could enjoy some measure of comfort, dignity, and even productivity' (2021, 190). By contrast, Rosenberg goes on: 'Survival after a high spinal cord injury in Rwanda is rarely more than a few months. Resources are limited. Few have money for mobility devices and adequate nursing care. The disparity seems unjust because of the difference in outcome and circumstance and of injury' (2021, 190).

There is much to disentangle about this particular story of injustice.[14] The fact of the injustice is itself a serious and universal concern.[15] Clearly, the issue is not so much about a miner and a doctor who liked surfing, but about global health and the socio-economic gradients that exist to offer different degrees of care in different regions and countries, these relating to what Rosenberg (2021, 198) refers to as 'human-made structures of the world—rules, traditions, and history that form the hills and valleys of social injustice, as real and hard in a sense as tungsten ore in the ground'. Inevitably, some individuals will hold some responsibility for the outcome, at least in the case of the miner (the mine owners, for example), but more significant are the higher-level systemic causes of these two people's injuries.

So what does this mean for small wins? Within this same framework that presents systemic causes alongside individual liability and local conditions, small wins can be problematic because their unintended consequences can result in further harm to the vulnerable. These unintended consequences also have implications. As Rosenberg (2021, 197) states: 'This error [of causing unintended consequences] is particularly prevalent when we valorize individual action but ignore the political, financial, and cultural institutions that form the topography of structural injustice.' Small wins, Rosenberg argues, must always be framed within their wider context. In the case studies that follow later in the chapter, I focus on a few specific examples where archaeology or cultural heritage participation has already proved a success by creating small wins that successfully took account of that wider context. But these are inevitably just a few small wins within a vast and complex policy landscape that also includes related challenges that comprise, as

[14] This example would sit comfortably also in the chapter on health and well-being (more comfortably, it could be argued) but I decided to hold it back for at its roots is injustice. It is the consequences of an injustice that relate in very obvious and tangible ways to the health of these two people.

[15] Here, Rosenberg helpfully reminds us of the utilitarian philosopher Peter Singer (1972), whose ideas revolve around the human need to act to reduce the suffering of others, unless by doing so we impose comparable suffering upon ourselves.

Head (2022, 110) has outlined: child protection, domestic and family violence, health insurance, nutrition, racism and sexism, Indigenous cultures, and so forth. As we have seen already, in all of these instances, and especially in the examples that follow, sub-group differences are central to the problem at hand. These differences also form part of the context that must be addressed. This idea of difference also causes us to think critically about what we mean by normal and what it means to conform. It also requires us to be sensitive to the times in which we live. As Brian Head puts it (2022, 110): 'In prosperous times, the pressure for all groups to adhere to mainstream values and behaviours has been partially relaxed, assisted by appeals to the principles of tolerance and civic rights. In times of crisis and social turmoil, discrimination tends to be strengthened.'

For the remainder of this contextual 'framing' section, I will focus on a topic with direct relevance to the wicked problem of social injustice and one of its more tangible manifestations: poverty. I will begin by briefly discussing the city as a landscape in which this particular wicked problem is often most visible (recognizing, as stated earlier, that rural poverty also exists as a significant problem, but is often less visible, to city-based politicians, for example). I will then talk about poverty in the city.

Jane Jacobs' (1992 [1961]) timeless study *The Death and Life of Great American Cities* captures the essence of the problems (and the opportunities) that cities present in her final paragraph, where she states (1992, 448) that: 'dull, inert cities, it is true, do contain the seeds of their own destruction and little else. But lively, diverse, intense cities contain the seeds of their own regeneration, with energy enough to carry over for problems and needs outside themselves.' Poverty and multiple other manifestations of social injustice will occur in both types of city, but probably less so and with far greater chance of resolution in the latter than the former.

In an important chapter dedicated to what she refers to as 'slums', Jacobs (1992, 270) describes how slums and their populations

> are the victims (and the perpetrators) of seemingly endless troubles that reinforce each other. Slums operate as vicious circles. In time, these vicious circles enmesh the whole operations of cities. Spreading slums require ever greater amounts of public money—and not simply more money for publicly financed improvement or to stay even. But more money to cope with ever widening retreat and regression. As needs grow greater, the wherewithal grows less.

This is one of the quotations with which I opened this chapter, emphasising its significance. Jacobs goes on to describe the reasons why slums form, and how these reasons have changed very little over the centuries. What has changed more significantly in recent years is the speed with which these processes can happen, with desertion occurring more swifty and the areas subject to depopulation spreading more widely than before. In an entirely separate and thought-provoking

contribution, architect Greg Keeffe (2010) describes these areas as sometimes warranting the label 'collapsoscapes' or even 'compost cities', using Hulme in Manchester[16] as his example of such places and of the processes that shape them and cause their regeneration. As Keeffe states (2010, 157), 'cities are dynamic, living things, and... they and things in them bloom and decay, and... this process is difficult, if not impossible to manage.' He describes, for example, how creating arts quarters (sometimes considered solutions in these cases of urban decline) often results in failure either because money runs out or because culture is generally an underground thing and that most actors within this scene would sooner go elsewhere. Keeffe helpfully introduces the concept of compost cities as an alternative strategy. The idea, as Keeffe describes it, is based on the practice of composting that is familiar to gardeners who use their waste to produce fertilizer which itself then encourages new growth.[17] Similarly in the city: culture is emergent and thrives in those poorer neighbourhoods where rents are cheaper and more space is available for cultural production. These areas thus become creative neighbourhoods populated by those who cannot afford to live elsewhere, some at least of whom are involved directly with cultural production of one kind or another. As a result, galleries, clubs and independent music venues pop up, encouraging yet more cultural activity in the area. Eventually the area gains recognition, attracts visitors and new residents, becoming effectively gentrified, pushing up rents. At this point another collapsoscape begins to emerge elsewhere and so on. Just as in the garden with compost heaps, these areas will typically relocate periodically, and also, just as in the garden, these areas form an essential component of successful urban development. The garden needs its compost heap, just as the city needs its cultural neighbourhoods, just not created or manufactured as 'quarters' but organic initiatives that emerge from the ground up. Recognizing this process, as opposed to trying to 'plan away' these vital areas, is one way that planners can begin to address the wicked problem of poverty. It also has the benefit of giving those people who live within these areas a sense of pride at doing so. And we probably shouldn't call them compost cities, even though the analogy is very persuasive.

Correlations exist between the attachment that people feel for their neighbourhoods, prosocial behaviours, and (as we saw in Chapter 4) health and well-being. It is a virtuous circle (as opposed to the vicious one described earlier by Jane Jacobs): by feeling a sense of attachment to one's place, one wants to care for it; by caring for it, one enjoys it more and has a greater sense of pride in it; and through that pride comes the desire to participate more, to be more proactive, and to learn more about this place, thus growing that sense of attachment still further. And this

[16] Famous in part for being the backdrop to iconic black-and-white photographs featuring 1980s Manchester band Joy Division.

[17] We are back to gardening again. It is interesting how often this parallel comes up.

circle can exist whether the neighbourhood is deprived or whether it is prosperous. The difference is that those who live in the prosperous neighbourhoods may already be involved in prosocial behaviours, may have more time on their hands, and the financial wherewithal (the luxury) to spend time on cultural activities; they may even be National Trust members! For those working in more deprived neighbourhoods, encouraging residents to engage in these types of cultural participation, will find it a much harder sell, for all sorts of legitimate and understandable reasons. But, should people in these areas choose (or have the opportunity) to participate, the benefits will likely be greater, both for them as individuals, for the communities of which they are a part, and for the neighbourhoods that they call 'home'. My examples later in the chapter are all aligned with this particular and challenging (wicked) conundrum.

We can see both the benefits of participation and some of the challenges and contradictions that represent injustice in an example of Tyneside neighbourhoods, in the north-east of England. Daniel Nettle's (2015) study of two neighbourhoods in Newcastle-upon-Tyne set out to investigate the relationships that exist between social behaviour, socio-economic deprivation, and place attachment within the Tyneside conurbation. His particular focus was on prosocial behaviours and on how and why these might occur. The study area is heavily urban with a population of around nine hundred thousand people, making it the seventh largest population centre in the United Kingdom (2015, 9). As Nettle points out, economic decline began to impact Tyneside after the Second World War, caused by deindustrialization. Coal mines closed in the 1950s while heavy industries like shipbuilding declined through the 1970s and 1980s. The principal sources of employment for many people therefore disappeared leaving many families without an income and reliant on social benefits. Some neighbourhoods were impacted more than others, emphasizing within this one city the types of injustice I described earlier using the parable of the miner and the doctor—the injustice of unequal opportunity. Within the United Kingdom, social deprivation is mapped using the Index of Multiple Deprivation. For Newcastle, as Nettle shows (2015, 10), many areas of the Tyneside conurbation are listed amongst England's 10 per cent most deprived and several amongst the 1 per cent most deprived neighbourhoods. There are, for example, concentrations of 'extreme deprivation...along the riverside to both the West and East of the city centre. These were areas particularly tied to heavy industries that no longer exist' (2015, 10).

The purpose of this study was to examine how deprivation is related to prosocial behaviours and how these relationships also and inevitably refer back to place.[18] In this context, Nettle introduces us to the work of the nineteenth-

[18] And I encourage you here to recall the section in Chapter 4 covering place attachment and the well-being benefits of having an attachment to one's neighbourhood and a sense of pride in the place where one lives, or that one came from originally.

century polymath and anarchist thinker, Piotr Kropotkin, who travelled extensively in Siberia and Manchuria, noting in particular the harshness of the environments through which he travelled. One of his notable observations, Nettle tells us (2015, 17), was the way that people (as well as other living things) experiencing these harsh conditions cooperated as a strategy for survival. To survive, Kropotkin argued, individuals developed mutually beneficial social relationships. His book *Mutual Aid* (2009 [1902]) has ensured that his name is now firmly associated with the idea that 'harsh environments foster prosociality' (Nettle 2015, 17). By complete contrast, Nettle reminds us also of another scenario which he takes from Colin Turnbull's (1972) work amongst the Ik people of northern Uganda in the 1960s. In this case:

> Drought had led to very severe famine [and] all social norms had basically collapsed; people were, in Turnbull's words, 'unfriendly, uncharitable, inhospitable and generally mean' (p 32). People were so desperate they could focus only on trying to survive themselves. The elderly died first; children were left to fend for themselves and died second; husbands fed themselves at the expense of their wives and vice versa; the dying were abandoned or stolen from. (Nettle 2015, 19)

Here, then, are two hypotheses, one built around prosociality and helping and supporting others, and the other around self-sufficiency and the survival instinct. Using a variety of quantitative measures, these two contrasting models or hypotheses were then examined in the two Tyneside neighbourhoods, one (B) being more deprived than the other (A). As Nettle says in his summary (2015, 112), there is some evidence for greater sociality in Neighbourhood B, aligning well with expectations built around Kropotkin's observations: 'People are more socialised on the streets, were less likely to be alone, greeted one another more as they moved around the neighbourhood; and their children were more likely to be found in multi-household groups.'

However, there is also evidence to suggest the opposite, with residents in Neighbourhood B 'stealing' from others far more than was evident in Neighbourhood A, for example. There was also more littering in B than A, while crime and anti-social behaviour were more common in B than A.

Of particular note is the minibus experiment, whereby some residents from the two neighbourhoods were taken to the other neighbourhood, while some stayed put as a control (see Nettle 2015, Chapter 6 for a full description). This experiment revealed some findings that have particular relevance to this chapter and to the case studies that follow. As Nettle describes it (2015, 113):

> Our minibus experiment suggested that low trust and high paranoia might represent an immediate response to being in an environment full of visual cues of disorder. This is consistent with recent work on the spreading of disorder, and

the 'broken windows' theory of crime.[19] The minibus findings are perhaps the most intriguing and potentially useful of the whole project, not least since they suggest avenues for intervention, such as a thorough neighbourhood clean-up, that could be relatively *quick wins*. (my emphasis)

Nettle (2015, 119) is wary of quick (or in our terms small) wins however. As he quite reasonably points out (and mirroring the arguments presented in Chapter 1), such easy fixes are hard for anyone to object to and do not require major reform in how economic or political systems work. However, to quote Nettle directly (2015, 119): 'If the fundamental structural issues are not solved, how long will the gains last? How long before someone who is materially desperate and close to the edge breaks a few windows and the whole cycle starts again?'

And on that note of caution, we can move to some case studies which address this precise issue, hopefully demonstrating that, in some situations, small wins can make big differences, for some people at least.

How Can Archaeology Help to Address Social Injustice?

Archaeologists have long held interest in the ways inequality can occur across and throughout society and how such inequalities are represented through material culture. Robert Paynter (1989) addressed this in an overarching review, before collaborating with Randall McGuire on an edited volume on this theme two years later (McGuire and Paynter 1991). As well as using these terms, archaeologists around this time also referred to rank and status to articulate arguments around inequality and how it might appear in the archaeological record. More recently the debate has moved to more focused discussions around gender inequality and racism and colonialism, both in terms of interpreting archaeological evidence from the past but also in terms of the unequal opportunities for people to work and progress within archaeology (see Flewellen et al. 2021, for an example of how this debate is currently playing out, and Graeber and Wengrow 2021 for the ultimate overview on inequality in the past).

We have already seen in previous chapters how archaeology can help aspects of injustice through its contributions to climate change and well-being, for example. We have seen also in Chapter 5 how all of these wicked problems, and therefore also their solutions, are inevitably and indelibly entangled. It is partly because of that entanglement that wicked problems are deemed to be so 'wicked'. As this present chapter states, social injustice is another such problem that archaeology

[19] See Gau and Pratt 2010 for more about this.

can help to address. But here we do need to be especially cautious and realistic in our aspirations, and careful in our approach. As archaeologists, we are never going to resolve social injustice. But there are significant contributions that archaeologists can make towards addressing it, mitigating its impact in some instances. For one thing, and as stated above, archaeologists can use their capacity and skills to better understand and present evidence to wider public audiences about the origins of social injustice, and about how people have dealt with such injustices in the past, as well as the impacts they can have if left unchecked (and see again Graeber and Wengrow 2021, for a book that has received wide public exposure). We can present such injustice within a deep-time perspective in other words. But as we shall see in the examples that follow (and see also Kiddey 2020), we can also use these same archaeological approaches and a cultural heritage framework (combined with other forms of cultural participation) to identify and document social injustices in the contemporary world, including those instances which exist in plain sight. These interventions can help on three levels: first, by generating good data; second, by using this archaeologically derived information and insight to help inform policymakers by providing both good data and captivating and socially meaningful stories, and giving an active role to policy entrepreneurs; and third, through the direct (e.g. health) benefits of participation. Here the overlap with the chapter on well-being is at its most obvious. On the significance of archaeological data, for instance, and continuing the example used earlier about garbage-based settlements in Tehran, Dezhamkhooy (2023) explains how: 'Archaeological research can transform trash and abandoned items to a record and a material treatment that can document hidden and ignored inequalities and sufferings. Archaeology can challenge and deconstruct dominant official narratives, produced by political discourse and mainstream media.'

I will build on those ideas here, emphasizing how archaeological and heritage interventions can help resolve the various forms of social injustice and in particular inequality and its manifestation as poverty. It is worth also re-emphasizing, by way of contextual background, the relevance of the Faro Convention, and notably its recognition of the need to involve 'everyone [in society] in the ongoing process of defining and managing cultural heritage' and the alignment of its core principles with those embedded with the UDHR and notably the right to actively participate in cultural life. With that background in mind, and the example of Kropotkin and the Mountain People in our peripheral vision (after Nettle 2015), alongside additional thoughts on the urban environment embedded within the writings of Jane Jacobs and others, we can proceed to some examples.

As an archaeologist based in the English city of York, I might very easily be accused of hypocrisy in presenting this chapter from the privileged position of my provincial ivory tower: because there is no poverty in York, right? York is a prosperous city with two universities and a significant annual income largely

generated through the 7.7 million[20] tourists who visit the city every year, to visit its many heritage attractions, stay in local hotels, eat in the city's restaurants, and spend money in its shops. But you'd be wrong. There is poverty in York, and it is caused by exactly these same factors. People who work in the industries that support tourism (notably in retail and hospitality) are often on the minimum wage with zero-hours contracts. Given the scale of York's tourism industry, there must be thousands of these people. To exacerbate the problem, rent and property prices are high because York is such an attractive place to live, again partly due to the city's cultural heritage and the cultural facilities that exist because of it. This means that those people that support the heritage industry cannot afford to live in the city where they work but have to commute in from cheaper places elsewhere. This can cause additional problems, placing strain on young people with family commitments, for example. The perceived prosperity and the high numbers of tourists also makes the city attractive to those members of society who are in greatest need, homeless people, who visit York and remain in the city for much of the year. I will return to this particular community later but to summarize the matter simply: homeless people find York a safer city relative to other places, and they consider the people who live there to be more generous than elsewhere.

There is new housing in York, with various schemes designed to encourage first-time buyers and those on lower incomes. One of these developments is at Hungate where, a few years ago, the York Archaeological Trust[21] conducted a long-running and intensive excavation of a poor neighbourhood occupied by people up to the middle of the twentieth century when the so-called slum housing was cleared for a new development that took decades to finally arrive. This was also the area of the city where Seebohm Rowntree conducted the research for his celebrated study of poverty in the late nineteenth century (Rowntree 1902). So even within York there is poverty and that has been the case probably for much if not all of its history. Such poverty may look very different now to how it appeared at the time of Rowntree's study, but there is nonetheless continuity and a significant wicked problem that has persisted in arguably one of the unlikeliest of places.

My points here are that poverty is nothing new, and that it exists even in those places where one might not expect to find it. Therefore, in addressing this wicked problem using some of the archaeological approaches that I am suggesting, we may not need to look far to find a problem that we can help to resolve, at least within a small wins framework.

As I have already mentioned several times in this chapter, poverty presents a very significant and universal wicked problem. Generational poverty is one aspect of this, representing those instances where persistent poverty stays within one family for at least two generations. This form of poverty can take many forms and

[20] Pre COVID-19 lockdown figure. It is now reported to be over 8 million per annum.
[21] Now called York Archaeology.

often all of them together: educational poverty, parental poverty, spiritual poverty and, of course, financial poverty. Many of these issues have been exacerbated, and the number of cases increased, through and after the COVID-19 pandemic (after Buheji 2020). These various aspects of poverty all relate to the 'steep socio-economic gradients and intimate portraits of injustice' discussed earlier, again recalling Noah Rosenberg's (2021) essay around the miner and the doctor. As we saw, in this story:

> The miner's death arises from the human-made structure of the world—rules, tradition, and history that form the hills and valleys of structural injustice, as real and hard in a sense as tungsten ore in the ground. [But] identifying a handful of individual wrongdoers in the miner's story does not adequately describe the systematic deprivation he faces. (Rosenberg 2021, 198)

Homelessness

One very obvious and often (if not increasingly) visible manifestation of this structural injustice is homelessness. This particular form of social injustice has featured prominently in the wicked problems literature, being described in precisely these terms by Head (2022, 111–116), as an 'enduring problem internationally' (2022, 111), and as a grand challenge by Painter and Culhane (2021, 85) following Padgett et al. (2016). This is also an example of social injustice where archaeology has played a prominent role, at least in the context of the small wins framework. In Brian Head's recent (2022) chapter, 'Improving Social Well-Being and Social Equity', he describes the wicked problem of homelessness as follows:

> Globally, it has been suggested that around 1.6 billion individuals lack adequate housing, while recognising different local standards (Keenan et al. 2021). Within the group of comparatively rich democratic-capitalist countries, it has been suggested that around 1% of working-age adults lack 'stable accommodation'. The homeless[22] include those 'sleeping rough' in public spaces and abandoned vehicles, people in temporary or transient accommodation and immigrant refugees displaced from neighbouring countries.... Their personal experiences are marked by distress, on the one hand, and gritty attempts to survive and adapt, on the other hand. In short, homelessness is a symptom of significant disadvantage, arising from diverse situations with multiple causal patterns. Some people endure long-term or chronic homelessness (and are more likely to be registered in official statistics on homelessness), whereas others have more hidden, informal and transitional experiences. (Head 2022, 111; citation in original)

[22] But let us, please, always refer to them as homeless *people*.

Archaeology (including participation in cultural heritage activities) is not the first thing likely to come to mind in finding ways to help resolve this particular wicked problem, although as Head states (2022, 111), 'a multi-layered approach is clearly necessary to reduce homelessness and mitigate risk'. Yet, as we have seen already, archaeology[23] has the benefit of placing human stories within a deep-time perspective, thus allowing a comparison of people's experiences over longer periods. Archaeology also has the advantage over some disciplines and practices (as we saw in Chapter 4) of bringing significant health and well-being benefits to those who actively participate in it, whether physically in the field, or through workshop-type events indoors, including artefact handling and problem-solving, or storytelling. In Brian Head's chapter (2022, 111) he refers to the need to resolve the problem of homelessness by addressing the chronic scarcity of housing while also recognizing the need for what he refers to as micro-services, such as food distribution and mobile laundry.[24] Cameron Parsell (2012) also recognizes the significance of housing in determining how homeless people feel disconnected from society and that, for them, housing is home, the physical structure of a house being vital to assuming control over their day-to-day activities.

All of which is undoubtedly true. But how about we look at this from another angle altogether? What if we could devise an activity which, through people's active engagement, helped grow homeless people's self-confidence, their self-esteem and taught them some life-skills, such as creative writing, while also instilling other essential attributes such as reliability and timekeeping? What if we found a way to help homeless people develop a sustainable resilient attitude that creates the opportunity for them to find (and stay in) work, hold down a relationship and friendships, and find a place to live?

I had the privilege to play a small part in a ground-breaking archaeology project that sought to find this distinct and meaningful ingredient to help resolve the problem of homelessness. Because of its scale, and the lack of any significant funding, the project would only ever constitute the smallest of small wins,[25] but potentially a significant one, initially on the streets of the south-west British city of Bristol, a large university port town with what is generally considered a relaxed and creative character.[26] For this Bristol project, the research was a joint venture between myself and another archaeologist, Rachael Kiddey. It involved fieldwork and an excavation, which I will describe shortly and in brief. In 2010 I left my role

[23] Which I will use here as a shorthand for both archaeological practice and other aspects of cultural participation that involve heritage activities of one kind or another.

[24] See also Painter and Culhane (2021) for ways that social investment can potentially end homelessness.

[25] Not a term or an area of research I was familiar with at the time, in *circa* 2008–10 when I was involved with this project.

[26] As a Bristol musician once said, 'Unlike many musicians in London, we have never been rushed, we have time to make music and, more importantly, simply to think about it. Bristol is friendly, slow-paced and relaxed' (cited in Cohen 1994, 121).

in English Heritage[27] and took up a position at the University of York. This is relevant because Rachael followed me there to undertake her PhD on contemporary homelessness, further developing her Bristol project and adding a second study of homelessness in the historic city of York. I have already mentioned the Seebohm Rowntree (1902) research on poverty which focused on York, meaning that this study had a particular resonance and a deeper historical context. To learn more about Rachael Kiddey's project, readers should consult her (2017) book *Homeless Heritage*, a study that manages to find that rare sweet spot between a vital academic text and a highly readable account of a socially relevant archaeology project. It also manages to give full voice to those homeless people with whom we/she worked. I cannot compete with Rachael's colourful and thoughtfully crafted text, but instead I can give my own brief account of some highlights of that part of the project with which I had direct involvement.

For two weeks in the summer of 2009 I walked Bristol's city streets with Rachael, accompanied by a number of different homeless people. Often amongst these people were two middle-aged homeless men, called Smiler and Punk Paul. Both had interesting back stories about how they came to be homeless. I will not relay those stories here but they are ingrained in my memory. These walks are memorable for many reasons, but not least: (1) the fact that we rarely covered the same route twice, except for the fact that the journeys typically began and ended at the same place: a road junction in the city's Stokes Croft area, known as Turbo Island; (2) the fact they were exhausting! These were walks that lasted all day;[28] and (3) these routes were all determined by the homeless people. This last point was central to the methodology we created for the Bristol project:[29] that, in this instance, the homeless people who volunteered to work with us were the experts, the guides. Where they led, we followed. Theirs was the specialist knowledge of an unfamiliar landscape in which we were, effectively, interlopers or outsiders. Unsurprisingly, and understandably, some aspects of their lives and daily routines remained hidden from view, but in many areas they did open themselves up and shared their lives and stories with us.

We learnt, for example, about the places where people chose to sleep rough, and how many of these places were carefully selected, for warmth or safety. Maybe it was because of who we were, but homeless people told us about their choice of rough sleeping at some historic sites, such as an abandoned church and a former glass factory (Figure 6.1). They spoke about feeling particularly safe in these historic places. They spoke of the risks attached to being homeless and of the need to survive and how, recalling Turnbull's (1972) *Mountain People*, addiction resulted in homeless people robbing one another to get the money that they

[27] Now known as Historic England. My role was in heritage policy and landscape characterization, with a particular interest in the contemporary landscape and the social values that people attached to it in different ways.

[28] I am reasonably fit, but pounding the pavements all day, often at pace, was tough.

[29] Funded by the Council for British Archaeology's Challenge Fund.

SOCIAL INJUSTICE 209

Figure 6.1 Rachael Kiddey interviewing a homeless man at a historic site in Bristol (England) where homeless people choose to sleep, often citing historical factors to justify their selection.
Source: Author's photograph.

needed for drugs or alcohol. We wondered how this sense of risk and danger might be manifested within the landscape. One evening, after a long day's walking, we sat on the low wall alongside the main road that runs past Turbo Island. We sat in a row, Rachael and me and the two homeless men we had spent the day with. I realized that we often ended the day sitting in this precise place. Either Rachael or I asked: 'Why here, exactly?' One of our homeless colleagues invited us to look around and think about our location. 'What can you see?' he asked us. I looked up and down the Gloucester Road and acknowledged that we had a good view both ways: we could see who was coming up the road, and down it, for some distance. 'How about across the road?' Again, we had a good view of the shops and the pavement on the opposite side of the road. 'Is that all?' He asked. 'Try looking again?' I did. I was struggling, but eventually I saw it. The shop directly opposite was an abandoned solicitor's office, dark and empty on the inside meaning that the large front windows acted as a mirror. I could not only see ourselves, sitting on the wall, but also everything that was happening *behind* us. This one location, on a small patch of ground frequented by homeless people, gave a full 360-degree view—a safe position in which to sit, cognizant of all that was happening in our immediate surroundings (Figure 6.2). Here, on Turbo Island, I had learnt an important lesson in landscape archaeology from a homeless man. I made sure he knew this. I am sure I managed to teach him (and other homeless people) a few

Figure 6.2 In reflection. Sitting on Turbo Island, Bristol, learning valuable lessons about landscape archaeology and personal security from our homeless colleagues.
Source: Author's photograph.

things over the course of this fortnight. But I am convinced that they taught me more. I am pretty sure Rachael would agree.

Also on Turbo Island, at the end of another long day of walking, an argument broke out amongst a number of homeless people, including those we had spent the day with and a few others who had joined us on the Island. The argument was about history, and specifically the history of Turbo Island. One person mentioned that it had once been a gallows, for pirates. Somebody disagreed, saying it had been a kind of 'speakers corner' where people could preach on any topic without fear of arrest. Somebody else said it was a bomb site. Another stated that, underneath Turbo Island was a tunnel leading to Bristol's biggest crack den.[30] I could barely believe it: homeless people arguing about history. It became increasingly fraught until Rachael skilfully drew things to a close with the suggestion: 'Why don't we dig it and find out?'

As archaeologists, we know it isn't as simple as that and several weeks passed as permissions were sought from the landowners and excavation equipment loaned from Bristol University's Archaeology Department.[31] Eventually, over three very

[30] For a more detailed account of this discussion and the excavation, see Kiddey (2017, Chapter 7).
[31] Here, we resumed the role of experts, or more properly, facilitators, although we did explain to our homeless collaborators why we needed these permissions, and how we'd secure them; how to 'go through the proper channels' in other words.

SOCIAL INJUSTICE 211

wet days in December 2009, a team comprising University student volunteers, homeless people (mostly men as I recall), two female police officers, and a few archaeologists including Rachael and me, put some trenches in Turbo Island. Strictly speaking, Rachael was in charge, but the homeless people made the big decisions. They were given the task of deciding where to put the three trenches, for example. They also took responsibility for interpreting the things we found. In Rachael Kiddey's book, for example, she includes a photograph of a lighter with a rubber band around it (2017, 121). Interpreting this find required specialist knowledge:

'See how it's burnt here?' Jane held up [the] lighter with a rubber band wrapped around it and pointed out burn marks on the upper part. 'That's where they've held the lighter upside down to light crack in a pipe. And the rubber band? That's because you need one if you're making your own pipe to smoke crack.'

After this explanation, Rachael explains that:

This is just one example of how working with diverse stakeholders—people from non-archaeological backgrounds—can fundamentally enrich understanding of how sites develop by contributing previously untapped knowledge. Gradually, the past is democratised and made more inclusive and representative.... I reiterated to anyone who would listen, including local people and journalists, that recent material remains—rubbish, if you like—were just as archaeological as older artefacts, that the age of the thing is irrelevant if the method and data are made the focus. (2017, 121)

There are many more stories that could be told about this project, including those aspects that unfolded in the separate but related study in York.[32] But these short extracts are representative and give a clear sense of how people engaged with the project. How they benefited from it is a subject I will return to shortly.

At around the same time Rachael Kiddey was working with homeless communities in Bristol, anthropologist Larry Zimmerman was working with colleagues Courtney Singleton and Jessica Welch (the last of whom has published the fact that she had experienced homelessness) using archaeological methods to document homeless places in St Paul (Minnesota) and Indianapolis (Indiana) in the United States (Zimmerman et al. 2010). By conducting archaeological surveys in selected areas of these cities, the studies revealed various types of location used by homeless people: route sites, occupied only for a short time but without any evidence that people slept there; short-term sites where people had slept and

[32] For which I highly recommend a full reading of Kiddey 2017. I can guarantee, it is unlike any other archaeology book you have ever read, for the best of reasons.

used food; and camp sites where there was evidence for intensive use with well-defined areas for shelter and sleeping, and food preparation. Together, and as in Bristol and York, these sites constitute a landscape archaeology of homelessness. In discussing the significance of these places, Zimmerman et al. cite Valado (2006, 10) who described a situation whereby homeless people 'constantly strategize to find or make private, safe, functional, comfortable, and supportive places for themselves in a landscape designed to exclude them' while transforming what 'some might think of as barren spaces into meaningful personal places'. (Zimmerman et al. 2010, 44).

Alongside recognizing that 'archaeology is really about the present' (2010, 444), Zimmerman et al.'s project is offered as an example of what they refer to as translational archaeology as activism. As Zimmerman et al. state (2010, 444), translational research is, 'derived largely from medical research and clinical practice. [It] takes the knowledge generated from interdisciplinary scientific inquiry or humanistic scholarship and transforms it into practices and solutions with goals of making a difference in people's lives.'

This chapter presents two instances of archaeological work on homelessness as examples of such a translational approach. It also highlights another observation made in Zimmerman et al.'s important study, that:

> Identifying problems to be solved requires true collaboration with the people who have the problem, and that requires developing partnerships. To do this *archaeologists have to share power*, let the partners help build research agendas and set goals, work with them and other scholars to interpret evidence and craft solutions, then try to figure out whether the solutions helped.
> (Zimmerman et al. 2010, 445; my emphasis)

This sharing of power is precisely how small wins can be best achieved in situations like this, working with such vulnerable people in a participatory way, not simply studying them from a detached and scientific perspective.

York is also currently subject to another homeless heritage project, being overseen by the Good Organisation and related to its wider Invisible Cities initiative.[33] A cornerstone of this initiative is training people who have experienced homelessness to become tour guides (Figure 6.3). By adopting this role they receive training in transferable skills, but also an income from the tickets sold to people choosing to attend their tours. In York these tours have proved popular with visitors in a city where there is no shortage of competition. For example, the

[33] In Edinburgh, Glasgow, Cardiff, Manchester, and York—see Invisible Cities—Tour Guides with a difference! (invisible-cities.org). Other initiatives that encourage homeless people to create and lead tours include one in Brisbane (Queensland, Australia), illustrated in Memmott and Bond (2017).

SOCIAL INJUSTICE 213

Figure 6.3 A tour guide with lived experience of homelessness, giving a tour of York's heritage as part of the Good Organisation's Invisible Cities initiative
Source: Photograph by Ivan Wootton, by permission of the Good Organisation.

Good Organisation website[34] describes the Guy Fawkes tour offered by tour guide Vicki:

> Beyond a tale of gunpowder, treason and plot, this tour tells the comprehensive story of Guy Fawkes, from his family history in York to growing up and the influences surrounding him as a Protestant and later a recusant Catholic.
>
> Tour guide Vicki first became interested in Guy Fawkes in 2009, and her passion is one of the reasons that she moved to the city. She interweaves her own personal journey of being diagnosed with stage 4b cancer, treatment, and remission, with the story of his life.
>
> In addition to Guy Fawkes, the tour covers Kings Henry VIII, James I, and Charles I, William Etty RA, and St Margaret Clitherow. Stay with the tour until the end, where Vicki will reveal the amazing coincidence of Guy Fawkes and her own recovery journey in a hostel for the homeless, which will leave you covered in goosebumps.

With Zimmerman's comments about activism and translational perspectives in mind, I will close this example of using archaeology and heritage practices to help understand homelessness by returning to some comments I made at the start: on the benefits of people's participation in the project undertaken by Rachael Kiddey. These benefits are not so much about health and well-being (although these are of course very relevant), but more about the social injustice issues that the project has successfully managed to address, recalling those comments at the start of this chapter about heritage being for everyone, and everyone having the right to participate in cultural life, these principles being enshrined in the Faro Convention and UDHR respectively.

Kiddey's review of the benefits felt by participants in the homeless heritage projects in Bristol and York represent an example of some of the clear ways in which archaeology can make a difference in people's lives. The results here are not quantifiable in the way they were for military veterans participating in archaeological projects, as described in Chapter 4. The surveys that are needed to generate these data are harder to achieve for people who are homeless and are unlikely to be willing to fill out questionnaires or participate in 'scientific' interviews. The results presented by Kiddey are therefore anecdotal but compelling nonetheless. In concluding her book, Kiddey (2017, 172–176) presents these results under the headings: physical exercise and serotonin, team dynamic, trust, self-esteem and confidence, communication, and hope for the future. All of these benefits also fall under the label of small wins and they can all help to redress the social injustices experienced by homeless people.

[34] http://www.goodorganisation.co.uk/index.html

In terms of physical exercise, Kiddey (2017, 172) described regularly walking for between four and eight hours each day during the project's fieldwork phase while, during the excavation, homeless colleagues reported feeling happier and sleeping better after a day of excavation, even when sleeping rough. Both fieldwork and excavation took place out of doors during daylight hours and the impact of this, too, should not be underestimated. As Kiddey (2017, 173) states: 'Taking exercise outside during sunlight hours is well known to enhance the release of endorphins and facilitate the absorption of Vitamin D, which is necessary for the creation of serotonin, a neurotransmitter that regulates feelings of well-being and happiness. Serotonin is also known to regulate memory and learning.'

Archaeology nearly always involves teamwork. It is a very sociable activity which is one of the reasons people enjoy it so much! The team dynamic was vital to the success of the homeless heritage project. It was important to establish some ground rules (such as how to speak with one another in ways that were respectful) and for team members to be recognized on equal terms. For some colleagues, 'this was the first time in many years that they had spent time socially with people who had never had addiction problems or been homeless themselves' (Kiddey 2017, 173). Kiddey (2017, 173) also stated that: 'The team aspect of the project enabled everyone involved to show and receive compassion and act altruistically towards others, which environmental psychologists recognize aids the development of nurturing environments conducive to learning.'

The experience of being trusted (with things, or telling the truth) is described by Kiddey (2017, 174) as alien to most homeless people. Yet it is also central to compassion which is 'necessary for self-acceptance, recovery and well-being'. Kiddey cites several examples of trust, evident within the homeless heritage project, including instances of trust creating better reliability amongst team members.

Finally, this project had a positive impact on participants' self-esteem and confidence. Citing the homeless person I probably knew best by the end of my direct involvement, Andrew[35] (cited by Kiddey 2017, 175) said that:

> I feel more confident talking with doctors and people in authority now. I used to think they looked down on me but working on this project... going around all them universities, giving talks (about the project)... I feel more confident talking with my doctors and key workers now and that's really helpful.[36]

[35] Previously known as Smiler, during the course of the project.
[36] I have cited enough from Rachael Kiddey's work here, all of which is covered in her (2017) book. So rather than say more, I simply encourage readers to go to the original source and read it for themselves. It is amongst the best examples of archaeology being shown to have a direct influence on people's lives, by which I mean all project participants. I know it changed the way I think about the past. And if nothing else, read the conclusion (pp. 199–201). I challenge you not to be affected by this.

To summarize, these projects were designed to work with homeless people to help better understand homelessness. In both Kiddey's and Zimmerman's work, archaeology was used successfully as a mechanism and a method for engaging with homeless people showing how significant successes can be easily achieved within a small wins framework. Beyond the health and well-being benefits (the subject of Chapter 4), people's lives can be improved by gaining self-confidence and self-esteem, by learning to trust people and develop other vital life-skills such as reliability and timekeeping. These are all small wins that can have a significant impact on participants in ways that can help reduce instances of social injustice. These examples are among the more obvious to illustrate how archaeology can be a superpower, changing lives, including our own.

Conclusions

As Melissa Baird (2014, 149) has said: 'social justice frameworks locate heritage within a field of power'. She goes on: 'This is why a social justice concept has so much to offer to heritage rights. By developing counter discourses and counter hegemonic practices, social justice frameworks seek to move beyond descriptions of inequalities and, instead, to build strategies that understand local, situated contexts' (2014, 149).

As was defined at the start of this chapter, social injustice means the quality or fact of being unjust, and this can manifest itself in many different ways. It might involve a situation in which the rights of a person or a group of people are ignored, or a violation of one's civil rights that could inhibit the ability to realize one's full potential. In the examples I have presented here, and by focusing on homelessness on the streets of various British and American cities, it is evident that such injustice does exist both on a global scale (the universal and wicked problem of homelessness) and on a local scale (its existence within York, for example). It is also evident that a small wins approach can make a difference at this local scale.[37] I have not focused on them here, choosing instead to give my attention to the various approaches to homelessness, but other examples of archaeology (or cultural heritage engagement) projects that address various aspects of social injustice include work in Liverpool (Cohen et al. 2009), Manchester (Nevell and Brogan 2021), and in Valletta (Malta). In all of these cases, the projects involve collaborative work with non-traditional communities.

[37] Initially at least. As a result of local small wins, success can be extended through publicity and the availability of toolkits arising out of those 'pilot' studies.

SOCIAL INJUSTICE 217

To dwell briefly on the project in Malta, the fieldwork here entailed interviews and conversations with former residents of the so-called 'Gut', being Strait Street, a narrow alleyway that runs through the heart of this capital and World Heritage listed city (Schofield and Morrissey 2013). Up until the time of Maltese independence in the early 1970s, Strait Street was a notorious runashore for the personnel on board many British and American naval ships that docked in Valletta, a strategically vital port at the heart of the Mediterranean. The Street was unsurprisingly therefore lined with bars and brothels, guest houses and fast-food outlets. The activities that occurred here ran up against the Catholic religion and belief systems that characterize the island and its resident communities. For them, The Gut was a street of shame. Following Malta's independence, the British and other international navies visited much less frequently, meaning that all of these businesses closed down, virtually overnight. There was nothing now to sustain them. The premises were locked up and their owners moved away (Figure 6.4). This situation remained unchanged into the early 2000s when my fieldwork began to unpick this complex and challenging story, a story many of the city's residents would prefer to have remained untold.

Figure 6.4 Strait Street, Valletta (Malta), as it was in *circa* 2009, with most of the premises locked up and abandoned

Note: The street is now revitalized, although what was left of the Strait Street 'heritage community' in 2009 is no longer present.

Source: Author's photograph.

But the story was told (Schofield and Morrissey 2013).[38] One of the benefits in doing so was to convey specific stories of people that would otherwise have remained unknown. In telling these stories, people's identities, as part of this hidden scene, were reaffirmed and rewritten into this largely forgotten landscape. And whether it is coincidence or not, the street is now reinvigorated. The bars have re-opened and Strait Street is a hive of activity once more. The resident community, still present in 2009, however, has been moved on, presumably to new accommodation outside of Valletta. They may no longer live in Strait Street, but at least their story has been told.

In Valletta, as in Bristol and in Indianapolis, archaeological and heritage interventions can help give people a stronger sense of identity which can contribute to rebuilding people's lives, while introducing some of the critical skills required to find focus and give a better balance. This then creates the situation whereby participation in cultural life becomes more possible and the benefits of participation can be fully felt.

We have seen the use of several terms for this virtuous loop: the fact it is a translational approach for example, and constitutes activism in the way that it addresses aspects of social injustice. Several of these ideas are prominent in a recently published paper by Johnston and Marwood (2017), in which they refer specifically to 'action heritage' as a means to approaching social justice. There are clear resonances in this research, and close alignment with the examples previously given. Johnston and Marwood for example (2017, 816) describe action heritage as '"undisciplinary" research that privileges process over outcomes'. In their approach they recognize that 'societies are unequal and unjust to varying degrees and heritage practitioners unavoidably work with, perpetuate and have the potential to change these inequalities' (2017, 816). As with other examples in this chapter, they nudge their way towards the higher goal of social justice and equity through some smaller-scale interventions. Like Denis Byrne (2008) before them, they recognize heritage specifically as social action. Johnston and Marwood use various examples (a homeless hostel, a primary school, and a local history group) to demonstrate how, '*researching* heritage, as a practice, can plainly and self-consciously work towards social justice within and potentially beyond projects' (2017, 825; emphasis in original). But they make two important distinctions between this approach and the participatory action research (PAR) methods which are often adopted to achieve similar goals. First, PAR sets out to achieve wider social change whereas here the aim is to address, 'the more diverse priorities within the community projects in which we were involved' (Johnston and Marwood 2017, 825). Second, there is a distinction between the 'rather narrow disciplinary approaches that characterise public or

[38] This raised ethical issues of its own—to tell the story the authorities didn't want told or go against the authoritative view and represent the interests of marginalized people whose heritage this was.

community archaeology and public history when compared with the mélange of activity (as academics we might term it interdisciplinary) that constitutes research within community heritage projects' (Johnston and Marwood 2017, 825). One might equally label Johnston and Marwood's approach a 'clumsy solution'[39], alongside the homelessness examples given previously.

To return to the earlier sections of this chapter, a diversity of policy and strategy documents and initiatives were presented, all within the context of the UDHR: The Faro Convention, for example, and Historic England's Strategy for Inclusion, Diversity and Equality. It is within these essential and helpful frameworks that all of the examples presented or referred to in this chapter can be offered as successful attempts to achieve small wins relative to the wicked problem of social injustice. Furthermore, these examples all align closely with the framing statements at the start of the chapter, around slums and poverty, for example, on social relations and space, and the need to ensure the active participation within heritage practice of everybody, even (and especially) those who occupy the margins. Archaeology and heritage practice are not claimed to be the only areas of research that can help to address the wicked problem of social injustice. But these are areas of research that can achieve significant small wins and therefore begin to address instances of social injustice.

I will close this chapter by bringing this discussion back to the very people who have the most to gain from the types of social justice intervention that I have been describing, the people who feel social injustice every day and who archaeologists like Rachael Kiddey have managed to help back to their feet, at least to some extent. Sometimes these interventions are successful and sometimes, sadly, tragically, they are not. I mentioned earlier that one of the homeless men I came to know best during my involvement in the Bristol project was Punk Paul. Paul died a few years later. We enjoyed many good conversations around history and music as we walked the streets of Bristol. He and Smiler were guests on a local radio show I once co-hosted. Rachael used his words to close her book. I will use those same words to end this chapter:

> Hopefully (the Homeless Heritage project has been about) constructing an insightful view on things and implementing change in society, making order of our modern times, seeing us as no different from the Egyptians or the Romans... I love you for being interested... The truth is if you dig deep enough you uncover... truth... The time we spent together was power, truth and hope. You have this big heart in a bigger community and it was good to think that we might actually change the world we live in. Inshallah!
>
> (Punk Paul, cited in Kiddey 2017, 201)

[39] This being a compliment, obviously.

Chapter Headlines

- Social injustice is a wicked problem, and arguably super wicked in its complexity and in its urgency. One could easily argue that many aspects of social injustice constitute wicked problems in their own right.
- Social justice is the balance between individuals and society measured by comparing distribution of wealth and other differences, from personal liberties to fair privilege opportunities. Social injustice therefore exists where there is imbalance but is also the way unjust actions are done in society.
- In that sense, social injustice is closely aligned to human rights. Particularly relevant here is the right to participate in cultural life, but many (if not all) human rights remain directly relevant.
- The 2005 Faro Convention on the Value of Cultural Heritage for Society has aligned people's right to heritage with the UDHR.
- Inclusion, diversity, and equality all relate to social justice, noting that one achieves equality through equity. Heritage organizations (such as Historic England in the United Kingdom) now have policies for these issues as well as staff members responsible for overseeing them.
- Archaeologists have long held an interest in social inequality, often referred to in the past as 'rank'.
- Recently, archaeologists have secured significant small wins in addressing social injustice. The examples given in this chapter relate to one specific community: homeless people.
- It is by working with people experiencing social injustice in ways that are participatory that successes in the form of small wins are most likely to be achieved.
- Furthermore, to achieve success with this specific wicked problem, archaeologists must be prepared to surrender authority and adopt a more 'translational' approach.

7
Conflict

> We cannot preserve the place but we can save our non-material things, our memories or proverbs.
>
> (Shamsi, an English teacher in Aleppo,
> in The Guardian, 15 July 2019.)[1]

While there is no doubt that difficult heritage, both in the narrow sense in which I deploy it and more capacious ones, is likely to be fraught with various kinds of problems for those whose heritage it is, those represented by it and those tasked with its representation (three categories that usually but not inevitably overlap), I suggest that the act of publicly addressing terrible historical acts undertaken by the collective is no longer necessarily a disruption to positive identity formation. On the contrary, increasingly it seems to be a sign of moral cleanliness and honesty, and, as such, a performance of trustworthiness. It might, of course, be subject to containment or act as a diversion from other, perhaps more immediately pressing and controversial political problems. But nevertheless, self-disclosure and self-reprimanding have, in themselves, come to be widely regarded as a positive development by those inside as well as outside the societies that are performing them.

(Macdonald 2015, 19)

Conflict, on Many Scales

For at least the last ten thousand years there has been conflict of one kind or another involving humans. But its origins likely extend much further back in time. Groups of animals fight and one must assume that the earliest humans did too. Over millennia, it would seem, neither humans nor animals have figured a way of always living together peacefully. At time of writing, there is a war in Europe and we have no idea how that will play out. Maybe a diplomatic solution will be found. Perhaps one side will surrender, or the invader will return to their own territory, feeling that they have made their point or caused as much damage and destruction

[1] https://www.theguardian.com/cities/2019/jul/15/how-war-shattered-aleppo-is-preserving-its-culture

to another country and its people as they had intended. Mission accomplished. Or maybe they return home with their tails between their legs, undefeated but exhausted and irreparably economically damaged. Or maybe the war will just drag on for years, sapping the lifeblood from both countries, gradually diminishing the economic potential of the region by flattening infrastructure and contaminating the landscape. Or it might yet become a wider conflict. There has even been talk of a Third World War.

Whatever the outcome, and however long it lasts, one thing is certain: conflict destroys lives and places and has a long-lasting legacy. Conflict can remove much of a people's identity, not least through the targeting of its cultural heritage. This doesn't only include a country's iconic monuments (like Afghanistan's Bamiyan temples which were destroyed by the Taliban in 2001, or the bombing raids on British and German historic town centres during the Second World War) and its traditional industries, but also its wider cultural fabric—it's towns, market places, houses, streets, and fields—all of those places and things which together constitute communities' collective memory, not to mention the individual memories that are made and recalled there. Peter Read's (2011) work has shown how people are directly and adversely impacted by the loss of their familiar places. Losing one's home to an earthquake or a reservoir scheme is one thing and bad enough. But losing an entire community and a landscape, alongside the lives of many who populated and worked that landscape, through the avoidable impacts of conflict, is another matter altogether. I am thinking about such places and people now as I begin this difficult chapter; towns and rural areas that have been flattened and rendered un-occupiable in eastern Ukraine, for example, and about all the people who lived there, whose stories, lives, and heritage are from there.

It should therefore be obvious why I describe this chapter as being particularly difficult. But to be clear, it is difficult primarily because, of all the thematic chapters in this book and the many examples they contain that explain how archaeology and cultural heritage can make a difference to people's lives, that small wins matter, here that argument is hardest to make. Where people have lost their lives and their homes and communities are destroyed, what can be done by those of us who use our skills as archaeologists and heritage practitioners to improve their world through our own practice, for example through creating new knowledge, new perspectives, or new design? Yet, perhaps counter-intuitively, and as Sharon Macdonald stated in her comments at the head of this chapter, I believe that there are valuable, significant, positive, and distinctive contributions that can be made even in these most challenging of circumstances. With our skill set we cannot prevent conflicts from happening, but we can perhaps mitigate their impact or help in the post-conflict cultural rebuilding process. In our work we can also help to understand why conflicts occur and how societies can recover from them. There are contributions to be made, so I will be positive and talk about those contributions, even though it is hard to take such a position at the present time.

I will begin by returning to a discussion first raised in Chapter 1. At what point does conflict become a difficult topic? Or put another way, is there a point where 'difficult' becomes 'easier'? Is it purely a matter of time and the fact that 'time heals', or are there added complications around geographical distance or familiarity, or the details of an event that are known or revealed, for example by excavation or through the release of historical documents? The presumption is that everybody finds the idea of contemporary conflict difficult, perhaps increasingly as it becomes closer to home, directly impacting people's lives, even remotely with battles playing out in real time on our screens. Yet, even though it is now largely beyond memory, aspects of the Second World War remain difficult to comprehend and to research, especially if specific events have a direct personal or cultural connection. People in some countries find this harder than others because of their country's historic role as perpetrators, for example, or in view of the war crimes known to have been committed in that country's name, or on its soil, or to one's people. By comparison, for the First World War, over a hundred years ago and now a distance beyond living memory, our relationship to the scale of its destruction appears more straightforward. It has become a historical episode, albeit one we are reminded of every day in the language we use, in screen media and popular publications, and in the war memorials that exist in almost every town and village, at least in the United Kingdom. As Siegfried Sassoon famously said in his poem 'Aftermath' (1919): 'Have you forgotten yet?' It seems unlikely that we ever will, given that reminders are ubiquitous.

But arguably, the further back in time the events, the easier they are for us to deal with and to comprehend. That is the theory at least. Yet there are inconsistencies within this argument. For example, in Chapter 1, I described the case of a Holocene massacre site at Nataruk, west of Lake Turkana in eastern Africa, where excavation revealed horrific events that occurred nine thousand years ago. I described some images from this excavation and cited the report's author (Lahr et al. 2016), who described how:

> Ten of the twelve articulated skeletons... show evidence of having died violently at the edge of a lagoon, into which some of the bodies fell. The remains from Nataruk are unique, preserved by the particular conditions of the lagoon with no evidence of deliberate burial. They offer a rare glimpse into the life and death of past foraging people, and evidence that warfare was part of the repertoire of inter-group relations among prehistoric hunter-gatherers.

Students listening to my descriptions of this site and of its burials in a lecture[2] found the content surprisingly difficult, given that, for most of the audience,

[2] And also conference-goers at a keynote lecture on heritage and conflict in Germany in 2016 (Schofield 2017).

eastern Africa was both far from home and a place they had never visited, while nine thousand years is a very long time. The shock and empathy towards the victims felt by the students in hearing about this massacre was a surprise for many because of these factors. Maybe this reaction was because they were relating this ancient example of inter-group violence with something more contemporary, an incident they had read about in the news that also resulted in multiple deaths—a fight between rival gangs maybe, as suggested in Chapter 1? So perhaps it is not just about time depth. Perhaps it is more about the story, the immediacy of the evidence and the level of detail the story contains, and how closely this detail aligns with or mirrors our personal experiences in the present? As I have suggested already, this is one of the superpowers that archaeologists have: the ability to travel across time periods and, in doing so, to make the unfamiliar familiar (after Graves-Brown 2000, 1). By creating academic reports laden with scientific detail, archaeologists have the capacity (rarely taken up, thankfully) to make a modern atrocity impersonal and deeply unengaging, the horror masked by the science, effectively. But creative storytelling and increasingly also using digital media to enhance and extend the impact of that storytelling, archaeologists also have the capacity to make everyday events from the deeper past highly relatable. This they do increasingly often and increasingly well.

This chapter will examine some of the ways that archaeologists and people working across the cultural heritage sector have adopted and defined creative approaches that contribute small wins to help mitigate the impact of conflict on communities and the places they call home. In the first part of the chapter I will define what I mean by conflict, reflecting on variations in both scale and scope, from local civil disturbances to international armed conflict. This touches on political instability which, as we have seen, connects with other wicked problems including well-being and social injustice, for example. I will also provide examples of some current and recent conflicts that are having an impact on local communities. Having discussed the nature, scale, and impact of conflict, I will then review the literature that refers to this as a set of wicked problems, and why this definition is justified. Why is it, for example, that conflicts are not 'tame problems' for which the solution and those responsible for finding it are actually straightforward; where intransigence is the only obstacle? In some cases, for example, state fragility may be the wicked problem and conflict is either a cause or a consequence of that. Equally, the aftermath of a conflict (for example, refugee crises) may be the more wicked problem, as opposed to the conflict itself. I will then briefly review some examples of archaeological evidence for past conflicts before focusing on instances whereby archaeological interventions and heritage activities can create the small wins referred to earlier, discussing how much of a meaningful difference these interventions can actually make to the places impacted by conflict, and their inhabitants.

First, though, I will define what is meant by conflict and outline the various forms this can take.

Defining Conflict

At its simplest, and for the purposes of this chapter, conflict involves people fighting with one another usually following some form of disagreement. Conflict can take other forms (such as a verbal argument) but for the purposes of this chapter it is taken to involve (or at least culminate in) a physical encounter. Such physical encounters can take many forms.

When English Heritage's (now Historic England's) Historic Battlefields Register was created in 1995, there was some discussion about how a battlefield should be defined.[3] Eventually, and after deliberation, lines were drawn (so to speak). For example: 'The Register does not include all sites of conflict. Skirmishes (engagements between military forces not in battle array), and also some smaller engagements, are typically excluded unless they form part of the course of a larger engagement.'

And then, for more recent conflict:

> England was fortunate in the twentieth century in being spared pitched land battles on its own soil. However, sites of aerial or naval bombardment and places such as aerodromes or bomb sites are potent markers of the impact of war. While these places are beyond the scope of the Register they can be recognized through other designations... Furthermore, the mobile character of naval battles and often the issues of securely identifying their location means that they are beyond the scope of the Register.
>
> Events of civil unrest or rioting, even though they may possess acknowledged cultural and historical significance and may have involved troops to enforce control, are of a different, less definable, nature to pitched military battles, and are not covered in the Register either. There may be a case for adding some of these additional sites of conflict to local Historic Environment Records, and to local lists of heritage assets, compiled and curated by local planning authorities.

These points of definition are taken from Historic England's designation guide (Historic England 2012). Interestingly and perhaps surprisingly given Historic England's ability and willingness to recognize and designate historic sites and buildings of all periods, the description of battlefields only runs to 1750, implying (though never explicitly stating) that battlefields after this date will not be considered for the Register, although it is acknowledged that other means of recognition and protection are available for them. That aside, the document provides a useful framework for at least two reasons. First, that a typology of sorts is presented for historic conflict (civil unrest, rioting, 'the mobile character of

[3] Noting that this exercise was undertaken for the purpose of designation, and was concerned only with *historic* battlefields.

naval battles'); and second that this typology can be aligned with other typologies of conflict, and in particular those that are more contemporary.

For contemporary armed conflict, the United Nations (or UN) suggests there is no treaty definition, including within the text of the 1949 Geneva Convention or the 1977 Additional Protocols. Nonetheless, case law and state practice highlight two categories of armed conflict within the existing treaty regime: international armed conflicts (abbreviated to IAC) occurring between two or more states; and non-international armed conflicts (NIAC) which occur between state and non-governmental armed groups, or only between armed groups. The additional detail that the UN provides is helpful here:

> The level of violence necessary to constitute an armed conflict differs between international armed conflicts (IAC) and non-international armed conflicts (NIAC). With respect to IACs, since there is a general prohibition against the use of force between States (as is reflected within article 2(4) United Nations Charter), it is generally presumed that any use of such military force which is governed by International Humanitarian Law (IHL) is attributable to deliberate belligerent intent. This is regardless of the factors leading to the use of force or its degree of intensity. As the International Criminal Tribunal for the former Yugoslavia determined in the case of *The Prosecutor* v. *Dusko Tadić a/k/a 'Dule'* even minor instances of armed violence, such as an individual border incident or capture of a single prisoner, may suffice to cross the threshold for IHL to apply. (1995, para. 70)

It goes on:

> In contrast to an IAC context, the threshold for non-international armed conflicts (NIACs) is significantly higher to allow for the fact that during peacetime, law enforcement activities (including to counter terrorism) may necessitate the use of force against individuals or groups which is appropriately governed by domestic criminal as well as human rights law. Specifically, article 1(2) Additional Protocol II expressly excludes the following categories from coming within the scope of a NIAC: 'situations of internal disturbances and tensions, such as riots, isolated and sporadic acts of violence and other acts of a similar nature, as not being armed conflicts', for these reasons.

> Generally, the threshold is crossed when peacetime law enforcement approaches are unable to deal with the intensity of violence, thereby necessitating the deployment of the State's armed forces. The test for this, articulated by the International Criminal Tribunal for the former Yugoslavia, is the existence of a situation of 'protracted armed violence' between a State and organized armed groups or between such groups (*Prosecutor v. 'Dule'*, 1995, para. 70). Evidential

factors for determining whether or not the armed conflict threshold test has been crossed in NIAC situations include:

> The number, duration and intensity of individual confrontations; the type of weapons and other military equipment used; the number and calibre of munitions fired; the number of persons and type of forces partaking in the fighting; the number of casualties; the extent of material destruction; and the number of civilians fleeing combat zones. The involvement of the UN Security Council may also be a reflection of the intensity of a conflict.
>
> (*Prosecutor v. Haradinaj et al.*, 2008, para. 49)

Usually, and historically, for IACs at least, conflicts end either in uncontested victory over the opponent or a negotiated peace treaty. For both types of conflict, and especially more recently, hostilities often diminish with a gradual reduction of intensity through ceasefires and the involvement of peacekeepers.

This categorization therefore provides a well-established framework for addressing the many different types of contemporary conflict. And I am about to present one more. But to pause briefly, it seems important to explain why these frameworks are helpful. To do this we can return to the complexity of definitions for wicked problems in Chapter 1, and how each of those different types of problems (on the tame/wicked spectrum) require different types of solution. In other words, we need to understand the nature and scale/extent of the problem in order to work out how best to resolve it. It is the same with conflict. Different types require different solutions. And to return to the point made earlier: some conflicts may only constitute tame problems, which can be resolved with relative ease; others however may be wicked or even super wicked in their scale and in their complexity.

And so to that additional framework. For the non-international armed conflicts that occur more frequently around the globe, Jan Angstrom (2001), has suggested a further typology which makes it easier to comprehend both the scale and diversity of conflicts, as well as their causes and consequences. As stated, such a framing gives a better chance of assessing or predicting where the small wins might be achieved. Angstrom (2001, 104) describes, for example, how such non-international armed conflicts are classified according to two spectra: one based around ideology, and the other on whether the state itself is being contested. Any attempts at small wins will need to recognize where the conflict is positioned on this spectrum if they are to have any chance of success. As Angstrom (2001, 104) describes it:

> The 'state' is commonly defined as comprising a territory, a population, and a government with control thereof. Consequently, if the territory of the state is contested (perhaps by groups aspiring to a state of their own) or if the population

is contested (perhaps by groups wanting to seize the state as a vehicle for the benefit of the group, rather than the entire population) the state can be said to be contested. Meanwhile, if the government is contested we have to ask: in what way? Conflicts about the rule of the state can be separated by asking if this is contested in ideological terms or in individual terms: that is, is the conflict about how to rule, or who rules?

We can see this argument in simplified form in Table 7.1.

If the rule is contested in ideological terms while at the same time the state's population or territory is uncontested, an ideological civil war is being conducted (1, in Table 7.1). On the other hand, if the ruler of the state is contested, while the state itself is uncontested, it can be termed a 'leadership' conflict (2). However, in cases where the state itself is contested based upon ideological grounds, we have 'resource conflicts' (3). And similarly, in cases where the state is contested based upon state ownership, we have an ethnic conflict (4). (Angstrom 2001, 105)

While this discussion may seem unnecessarily detailed, it is worth restating the observation that any kind of solution to something as potentially intractable as conflict first requires understanding of the nature of that conflict. As implied earlier, for international conflicts (IAC) this can be straightforward and will usually involve some kind of political disagreement or territorial aspirations perhaps based around a dispute over land (the Falklands War, for example). For non-international armed conflicts (NIAC) or civil conflict, however, the causes can be far more complex and hence the solutions may be harder to find, even if the opportunities to try might seem easier.

As was often the case historically, the legacies of conflict are another matter altogether. As we have seen already, these legacies can present wicked problems even if the conflict itself proved a tame problem to resolve and even where that conflict was resolved some time ago. These legacies of conflict can last for generations and sustainable resilient solutions are vital for shaping and rebuilding places, communities, and identities. For example, the destruction of or damage to

Table 7.1 Angestrom's (2001) framework for investigating non-international armed conflicts

		THE STATE	
		Uncontested	Contested
THE RULE	**Idea**	Ideological conflict (1)	Resource conflict (2)
	Individual	Leadership conflict (3)	Ethnic conflict (4)

historic fabric impacts a community's sense of identity while it can also damage the income stream, for example, where tourism is a significant contributor to the local economy.[4] Damaged and destroyed infrastructure is another factor, requiring rebuilding to ensure economic growth. The movement of people as a legacy is also a vital consideration, both where people leave a town, region, or country with no intention to return, impacting a place's social fabric and also its capacity to rebuild, but also where people arrive in a town or country, often in large numbers and all at once (relatively speaking). All of these legacies can be addressed by those working in the heritage field, for example, through projects that aim to conserve or rebuild historic fabric or to engage refugees in heritage programmes, to ease their transition into unfamiliar new places and into new communities (see examples in Hamilakis 2018; Holtorf et al. 2019). As we shall see later in the chapter, archaeology projects have successfully been undertaken that involve people who are directly impacted by conflict as part of post-conflict rebuilding operations. I made mention of this in Chapter 4. I will present some examples of these situations, in the context of small wins, later in the chapter.

Conflict as a Wicked Problem

As stated earlier, various aspects of conflict can constitute wicked problems. I will now present some examples of this, questioning whether conflict must always constitute a wicked problem given that the solution can be straightforward, at least in theory. Is conflict a bit like landing somebody on the moon? Is it a simple (or 'tame') problem, even though it is technically (or maybe in this case politically) complex to resolve? Or perhaps the wickedness of the problem becomes more acute precisely in those aspects where archaeology could perform a role by generating those small wins, in the aftermath of a conflict. I will argue in this chapter that, in these situations, archaeology and heritage practice can: first, facilitate better documentation of those past conflicts (e.g. in museums of reconciliation), with the hope of reducing the risk of any future repeat (the old 'learning from the past' argument); second, help to rebuild communities and provide support in regaining their sense of identity; and third, support refugees in adapting to their new surroundings. Examples of all three situations follow later in the chapter.

But to return to the nature of conflict as a wicked problem, several authors have discussed this, albeit with different terms of reference. Authors often refer to state fragility as a wicked problem for example, with conflict a likely outcome or cause of that fragility. Kenneth Menkhaus (2010, 85), for instance, identifies state

[4] Although we shouldn't ignore the potential contributions of dark tourism, to war zones or areas where the impacts of conflict remain clearly visible.

fragility as a wicked problem because it is 'maddeningly difficult to pin down' and 'constitutes a complex cocktail of causes and effects, a syndrome that has proven largely impervious to quick, template-driven external solutions'. As Menkhaus suggests, organizations involved with state-building assistance programmes often regard the problem of conflict as 'tame', (as I have said previously), the wickedness in this case relating more to what happens *after* the cessation of hostilities and where rebuilding begins. Another aspect of the wickedness of conflict is state failure: the fact that the Fund for Peace 'Failed States Index' 2009 lists 131 of 177 states as either critical, in danger or borderline for state failure is an indication that, scaled up, this problem is indeed wicked. However, when broken down, the problems in individual states may sometimes be 'tamer', and here at least therefore, small wins may become more achievable. There is also marked regional variation in these Failed States Index data. As Menkhaus describes (2010, 87), for example, 'only a handful of states in the global south—such as Argentina, Chile, Mauritius, Oman and Uruguay rank as "stable"'.

Franklin Kramer (2011) specifically describes ways that wicked problems relate to irregular conflict which he describes as 'neither neat nor fair' (2011, 75). Successful resolution of this particular wicked problem, he states, 'demands strategies that take account of the independent, evolving, and multistakeholder nature of irregular conflicts—factors that make such conflicts so-called wicked problems—and can produce satisfactory results despite imperfections in motivations, capabilities, and techniques' (2011, 75). But as he states, this doesn't mean they cannot be resolved. He notes, for example, that 'Resolution in this context means a strategy that reasonably copes with the issue and halts enough of the antagonistic and destructive behaviours in which parties are engaged to be deemed "good enough"' (2011, 84). He cites Nancy Roberts (2000) who identified three mechanisms that might characterize such a strategy for resolution: authoritative, competitive, and collaborative. First, authoritative mechanisms involve putting, '"problem solving into the hands of a few stakeholders who have the authority to define a problem and come up with a solution." As Roberts points out, authoritative solutions have drawbacks for wicked problems: "Authorities and experts can be wrong— wrong about the problem and wrong about the solution"' (Kramer 2011, 84).

Second, according to Roberts:

'Competitive strategies have a long history. Whether they have been played out on the battlefield, in politics or in the market, stakeholders following this strategy assume a "zero-sum game." If my opponents win the right to define the problem and choose the solution, then I lose. If I win the right, my opponents lose. A win-lose mind-set thus permeates interactions.' Roberts notes that the value of competitive strategies depends on the ability to achieve a significant degree of power. (Roberts 2000, cited in Kramer 2011, 84)

Finally,

> Collaboration is premised on the principle that by joining forces parties can accomplish more as a collective than they can achieve by acting as independent agents. At the core of collaboration is a 'win-win' view of problem solving. Rather than play a 'zero-sum game' that seeks to distribute 'pie shares' based on winners and losers, they assume a 'variable sum game' that seeks to 'enlarge the pie' for all parties involved. Alliances, partnerships, and joint ventures are all variations of the theme as they find expression in government, business, and international relations. (Roberts 2000, cited in Kramer 2011, 84)

This sounds promising as a set of mechanisms but, as Roberts states, this strategy also has its disadvantages:

> Adding stakeholders to any problem-solving effort increases 'transaction costs'. There are more meetings, more people with whom to communicate and get agreement—interactions that can take a great deal of effort. Sorting out which operating procedures and whose norms of conduct will prevail takes time. As the number of stakeholders grows, so does the difficulty of achieving synergy. Skills of collaboration are limited, too, especially among people who work in a traditional bureaucracy with a strong hierarchy that limits participation and team-based approaches to problem solving and decision making. Collaboration requires practice; it is a learned skill. If members do not have these skills, they need to acquire them and that takes additional time and resources. Then in the worst case, collaboration can end poorly. Dialogue can turn into debate and debate into protracted conflict with little to show for the hours of preparation and meetings. Positions can harden making agreement even more difficult to attain in the future. There are no guarantees that the outcomes of collaboration will be satisfactory to everyone. (Roberts 2000, cited in Kramer 2011, 85)

Having presented Roberts' various options and arguments, Kramer (2011, 85) concludes by suggesting that a combination of these strategies can nonetheless result in some meaningful resolution and success:

> Collaborative strategies will involve the negotiation between and among initially opposing interests with no trust and no sense of 'win-win'. Competitive strategies will try both incentives and coercion, including force, to change the calculus of stakeholders. Authoritative strategies will most often be a penultimate result arrived at from a mix of actions, rather than an early agreed common approach.

It is important to recognize, however, that alongside the typologies of conflict types (described above), and the different ways to approach irregular conflict,

there are also typologies of fragile states. The solution, once again, will partly depend on the type of fragility we are dealing with. Menkhaus (2010) summarizes three such typologies.

First is a typology by degree of failure, with most of those states higher on the scale of weakness being in sub-Saharan Africa where twenty-two of the twenty-eight weakest governments (according to the Brookings Institution's Index of State Weakness) are located. However, this is a fluid scale. Weak states can become stronger, and stronger states can become fragile and weak. Equally, the deterioration of fragile states is difficult to predict, making it hard for policy-makers and diplomats to order their priorities. In the well-known case of Rwanda, a 'never-again' promise was made in the aftermath of the country's 1994 genocide. Here as elsewhere, there is a political argument about the nature of conflict resolution and the scale of investment in rebuilding and peacekeeping. There are also the arguments around identity and memory (e.g. Bolin 2012), which are crucial factors in framing that 'never-again' argument.

Second is the typology by type of state failure. Variations in the type of state failure matter as they pose different threats to their own people and to the wider international community (Menkhaus 2010, 89). The different types of state failure (which need not be mutually exclusive) include: complete or near-complete state collapse, which is usually temporary; hinterland failure, where a weak government might exert some control over the capital city, but lacks the will or the capacity to extend authority to the countryside; nocturnal anarchy, where order may exist in the daytime but collapses at night; deinstitutionalized states where governments are stripped of their institutional capacity; warlord or criminal states; and besieged states where the state is confronted by insurgencies. I have not listed all of the types detailed in Menkhaus's (2010) paper, but enough to highlight that there is significant variation in the nature and causes of the instability and that, depending upon these variations, different types of solution will be required.

Third is a typology of threat potential, which is based around the idea that stable states are threatened more by the fragile ones than by conquering ones. The costs of threats emanating from failed states are well known: failed states with nuclear weapons or economic assets being taken over by a radical movement; states being used as a terrorist base; or a terrorist safe haven; or for terrorist recruitment; or as a criminal base; the humanitarian costs, often borne by the local population; refugee threats; and health threats.

To repeat the point, each situation will be unique in terms of the balance of these factors and where the priorities or pressure points lie, meaning that the solution must be designed and bespoke. As is so often the case with wicked problems, there is no panacea just as ill-chosen solutions can create further (and worse) problems elsewhere or down the line.

To summarize the argument thus far, recognizing at-risk fragile states is a necessary first stage, classifying them by type is a second, and assessing the type

of threat they pose is a third. The next and final stage is shaping the strategies to help fix these threats. For this, the willingness and capacity of fragile states to address their weaknesses is vital. Some states will be: willing but not able; some able but unwilling; there will be some states that are neither willing nor able; and perhaps there will be cases where fragile states are both willing and able. Possible solutions and mitigations will also need to align with the state's position within this matrix.

Menkhaus (2010, 98) closes his typological overview with some thoughts on conflict resolution which has particular currency for this chapter. He asks, for example, what the international community can do, 'when a state's condition of failure poses serious threats to its own population and to the wider world...'? He recognizes what should by now be an obvious point, that 'our toolbox for responding to wicked state failure is limited'. However, and much more hopefully, he also describes how politicians, policymakers, business leaders and others can

> cajole, encourage, and shape the leaders in question; attempt to reshape the interests of political elites through the usual array of carrots and sticks; work around them by searching for 'clusters of competence' on which to build within the weak government; or, as has occurred in several places, work to replace incorrigible leaders in the hope that the replacement leadership will exhibit a greater commitment to state building. (Menkhaus 2010, 98)

Archaeologists occupy a very different position of course. This will never be an obvious arena in which they can exert significant influence on the peace-making process, even as policy entrepreneurs. However, as we will see later in the chapter, contributions through archaeology and heritage practice can still hold significance and make a difference, being focused less on the political systems and more on the people these systems are affecting, through displacement, poverty, social injustice, and ill-health. This therefore becomes another example of the entanglement described in Chapter 5: wicked problems are always interrelated, always interdependent. In this case it is vital that archaeologists and heritage practitioners understand the political context in which they wish to operate, which means understanding the issues and the language described previously.

As a cautionary note, Derick Brinkerhoff (2014) makes a related but different point, that creating such typologies, and thereby separating state fragility or conflict into its various component parts and types, can reflect a desire to tame the problem.[5] He is clear that any attempt to create solutions in this way will likely end in failure and more frustration. As is now well understood, this is because wicked problems are beyond simple solutions and may ultimately prove

[5] For an overview of fragile-states discourse, focused on theoretical approaches, see Ferreira (2017).

irresolvable. And while we can create small wins to help fix certain very specific aspects of the problem, even that can present challenges if we look for those small wins within a purely political context. As Brinkerhoff (2014, 335) states, for example, reporting the views of numerous analysts and observers, 'policy and operation efforts to simplify the fragile states dilemma have (in the past) led to coordination problems, inter-agency turf battles and perverse outcomes'. In summary, Brinkerhoff (2014, 335) describes how: 'the consequences of dealing with the wicked problem of fragile states have included oversimplification, unclear and conflicting objectives, intervention policies and strategies, fragmentation of effort and limited results'.

Having said that, there is evidence (including that presented by Brinkerhoff, for example) that peace-building and rebuilding approaches are having some effect in mitigating the wickedness of problems that can arise within fragile states. He cites two examples: the emergence of peace-building operations that involve 'the mixing and melding of international and local structures and practices' (after Roberts 2013; see also Millar et al. 2013); and dialogue between donor countries and the representatives of fragile states that lead to stronger mutual alignment and commitment to addressing fragility (McCandless 2013). In the context of small wins specifically, 'iterative, smaller-scale efforts' are being made to, 'limit... spread, sending resources to local actors who are already engaged in conflict mitigation and peace building' (Brinkerhoff 2014, 341). As we will see later, this is an area where archaeology and heritage practice can perhaps play a significant and meaningful role. The 2005 Council of Europe 'Faro' Framework Convention on the Value of Cultural Heritage for Society and other policy documents have relevance in this context and will be discussed at the end of the chapter.

This section on typologies presents some important lessons, therefore, that resonate throughout this book. One of those lessons, and amongst the most important, is that to find workable solutions that might constitute effective and sustainable small wins, one must first have a detailed understanding of the problem and be able to adjust the solution accordingly. With this particular category of wicked problem, the complexity of both the problem, its underlying causes and possible solutions can be particularly complex.

Archaeologies of Past Conflicts

I have already mentioned the Historic England Battlefields designation guide, with its definitions and outline of Britain's historic battles. I have also referred (twice, now) to the Holocene massacre at Nataruk in eastern Africa. These are just two examples, at different ends of the chronological spectrum, where archaeologists have been responsible for unearthing the evidence for past conflict, whether in the form of excavated human remains or taking designation

decisions for historic battlefields where archaeological evidence has helped define their extent,[6] alongside historic maps and documentation.

For earlier periods, the archaeological evidence for conflict comprises human remains that show signs of trauma and injuries consistent with combat, as at Nataruk; weapons, taking care to ensure their interpretation as 'weapons' is correct and that they are not in fact either ceremonial items or items used for hunting; and sites and places that appear to be defensive, again taking care not to mistake actual defences as one would expect at a fortification, with ramparts that are merely intended as a show of strength.

Interpretation is key, and this is an important lesson that archaeologists can provide, the deep-time perspective on the contemporary world being one aspect of their superpower. To take an example of how we might interpret what we think are defences, we can follow Ian Armit's (2007) close examination of the arguments around British Iron Age hillforts and their role in response to warfare. This was their original interpretation, suggested by Mortimer Wheeler, the original excavator of one iconic hillfort, Maiden Castle in Dorset, England (Figure 7.1). Wheeler, a former army officer, perhaps unsurprisingly saw this and the other British Iron Age hillforts as, 'responses to a specific form of warfare based around the massed use of slings' (cited in Armit 2007, 25). The 'ubiquitous slingstones found throughout the excavations' (2007, 27), appear to support this argument that hillforts represent defensive structures in the immediate pre-Roman period. Further, these archaeological traces align with documentary evidence. Michael Avery (1986), for example (and cited in Armit 2007, 28) saw changes in the rampart and entrance design of hillforts as a response to progressively more sophisticated assault tactics of stoning and fire, a tactic cited by Julius Caesar as existing in Gaul in the 1st Century BC. As Armit points out, Avery saw Iron Age armies at least across the Wessex region where Maiden Castle is located, as 'highly organised, with special assault squads' (Avery 1986, 226), with the hillforts occupied by a 'permanent garrison' (1986, 226). Hillfort defences were 'highly functional' with 'terrified clans each huddled timorously into a massive defended hilltop refuge' (1986, 228).

Armit goes on to describe how the received wisdom relating to hillforts as being primarily defensive began to weaken from the 1970s and especially in the 1980s. Researchers at this time began to identify weaknesses in hillfort design, with Bowden and McOmish (1987) for example interpreting some of the hillforts' 'defensive' features as relating more to the 'social isolation and prestige of the dominant elite within' (Armit 2007, 30). There were other factors too, such as the deep ditches at Maiden Castle effectively offering attackers the advantage of 'dead ground' where they could not be reached, and where they could hide prior to an

[6] Often through the surface distribution of cannon balls and other munitions that have found their way to the field surface through recent agricultural disturbance (e.g. Claxton 2018).

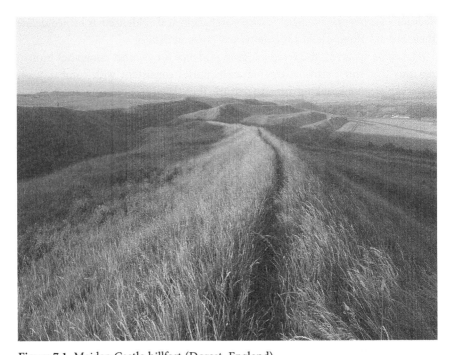

Figure 7.1 Maiden Castle hillfort (Dorset, England)

Note: The impressive ramparts may either have been for defence, or they might have served a symbolic focus. Archaeology teaches us to question the evidence. This file is licensed under the Creative Commons Attribution-Share Alike 4.0 International licence.

assault (Bowden and McOmish 1987, 77). Bowden and McOmish also point to the fact of there being little evidence for violent attacks on hillforts. These arguments are supported by Niall Sharples' later (1991) excavations at Maiden Castle, which suggested that maintenance of the defences related to the site being an 'arena in which relations of dominance and subservience could be enacted and reinforced' (Armit 2007, 30) and that the defences were symbolic not practical, as Wheeler had previously suggested.

All of these arguments can be made and countered, with stories told and retold as the evidence is reinterpreted, or new evidence found. That is the strength of archaeology as a discipline and as a practice. It allows critical engagement with what some might consider 'truth' or reality. Equally, and returning to the subject of Chapter 5, on entanglement, even in the deeper past, we cannot separate one type of activity or one aspect of life from everything else. Everything is interconnected. As Armit states (2007, 35):

> War is not an activity that can be meaningfully studied in isolation from wider social practice. Neither is it necessarily an unusual, aberrant, or dysfunctional

condition. All societies have embedded patterns of conflict and culturally specific modes of dealing with them. Patterns of conflict may range from full scale warfare organised on a communitywide scale, to smaller and more fractured patterns of raiding or feuding between households or kin-groups. Societies may address these circumstances through various combinations of aggression, submission, negotiation, and flight. The question is not 'were hillforts used in war' but rather 'what can hillforts tell us about the nature and scale of conflict, interpersonal violence, and power in Iron Age societies'. The answer will vary temporally and spatially across Iron Age Britain.

Archaeology therefore helps people to understand past conflict and its role within past societies and also to give context and meaning to conflict in the present. Understanding why and how people fought in the past, and recognizing how conflict was rarely (if ever) straightforward and always entangled with other aspects of life, helps to frame our responses to conflict today. There is a reason why military trainees at officer training academies are taught about past conflicts, the successes and the failures, what went well and what went less well. We learn from the past, and archaeologists are better at helping people to do this than most.

It is important also to recognize that this archaeological view of the past does not only apply to periods beyond memory. We can equally apply this archaeological lens to the recent and contemporary past, as I have done in a number of conflict-related projects over the past twenty-five years (e.g. Schofield 2009). In a sense, all of these projects (my own, and the many others now being undertaken by archaeologists on aspects of recent conflict) have the potential to be small wins, in that they can change attitudes and perceptions, build understanding and, through understanding, build degrees of tolerance and trust, and help people learn to collaborate better. The places where conflict occurred are themselves important for achieving such ambitions, as is the process of research which often involves the excavation of such places and then the display and promotion of their evidence either through museums or increasingly online. In 2009, I wrote:

> Places are powerful things; emotionally draining, demanding, sometimes joyous, and familiar or (at times) unfamiliar to those who inhabit or visit them. We feel close to places, comforted by their existence, by the fact that sometimes they don't change—Giddens' ontological security (1991). Sometimes we are encouraged by the fact that they do [change]—that places can be given a new lease of life, or new meaning and significance. But places can also be challenging and difficult, often because they are contested. People from different social or cultural backgrounds might value the same place in different ways for different reasons, and those reasons can be contradictory, especially where militarised landscapes are concerned. (Schofield 2009, 59)

These challenges can become more acute for more recent events. The above text was from the introduction to a thematic section of a book I wrote about archaeologies of recent conflict, this particular section being on memory and place. Within that section were five chapters describing such contested contemporary places. In each case archaeology was used to document the place with a view to better understanding its contested nature, in the hope of building bridges between the heritage communities that have an attachment to that place. Those five places are:

1. Berlin (Germany), with a focus on different attitudes towards the Berlin Wall as a monument and the city's Cold War legacies in general;
2. Peace Camp Nevada, in the United States, where very different Cold War narratives are represented on the atomic Test Site and at the adjacent Peace Camp, both of which occupy land traditionally owned by the Western Shoshone Indigenous people;
3. Twyford Down in southern England, where a motorway bypass incurred the wrath of local communities and environmental protesters, involving a contested landscape embracing designated heritage sites, while creating new ones;
4. Greenham Common Airbase, just up the road from Twyford Down, where locals, anti-nuclear activists and the US Air Force came into conflict over the stationing of the NATO nuclear deterrent on British soil, as part of a wider show of strength by NATO and Warsaw Pact forces at the height of Europe's Cold War; and
5. Strait Street, in Malta's capital city Valletta, where Catholic values came into conflict with a street that provided the allied navies with all they needed for their runs ashore (as we saw in the previous chapter).

In all of these chapters, conflict was described alongside some of the various ways that archaeology and heritage practice can be used to help develop people's understanding of these places and their cultural significance. In all of these cases, to some degree, resolution can be seen through people coming to terms with aspects of a difficult past, exactly as Sharon Macdonald suggested in one of the chapter's opening quotations. By engaging directly with that past renders it more manageable as a problem. Again here, we see evidence of the superpower that archaeologists hold.

Conflict Sites as World Heritage

I have already made the point that conflict impacts directly on the lives of individual people and their families, whether through death or life-changing

injury, or through the destruction of a home, neighbourhood, or livelihood, or through psychological impacts as we saw in Chapter 4. Thus, a major conflict (national or international) can impact thousands of people and communities, ultimately potentially destroying an entire people and eradicating their identity and the heritage that represented them. This strategy (for usually it is a strategy) is often referred to as ethnic cleansing. We saw evidence of this in the Balkans War from 1991 to (arguably) 1998, with local ethnic and national identities re-emerging from the ending of the Cold War and the removal of the borders between East and West, and their re-introduction between countries that had previously formed part of the Soviet Union. Something similar may also be happening currently, in Ukraine (e.g. Mick 2023).

Attempts at conflict resolution or avoidance through dialogue in situations like these are typically the domain of politicians and international courts and tribunals. But what about the heritage sector? How does this particular sector deal with conflict at this scale, in a way that recognizes its impact upon humanity? One way is through the 1972 World Heritage Convention which defines the types of site (cultural and natural) whose preservation will benefit the whole of humanity through their 'Outstanding Universal Value'. Where sites hold this 'OUV' they can be inscribed onto the World Heritage List and become World Heritage Sites. Very few such sites are listed (or Inscribed) on the World Heritage List that relate directly to conflict, partly because it is hard to judge how specific conflicts align with OUV, at least where value is assumed to have positive attributes (for aesthetic or architectural values, for example). But three such sites are worthy of mention in this context:[7] 'Auschwitz Birkenau German Nazi Concentration and Extermination Camp (1940–1945)' in Poland; Robben Island prison in South Africa; and Hiroshima (Japan). These World Heritage Site Inscriptions can constitute small wins, it is argued, precisely because of the Outstanding Universal Values that are attributed to the horrendous cultural events which these sites represent and the wider societal attention that their Inscription attracts. In other words, these sites have been singled out for what they mean (and can mean in the future) for all of humanity.

Auschwitz was Inscribed onto the World Heritage List in 1979, and is listed under Criterion vi of the 1972 Convention,[8] being 'directly or tangibly associated with events or with ideas or beliefs of outstanding universal significance (the Committee considers that this criterion should justify inclusion in the List only in exceptional circumstances or in conjunction with other criteria)'. The assessment of Auschwitz against this criterion states that Auschwitz Birkenau is a

[7] And I will mention a fourth one later on, being the bridge at Mostar.
[8] https://whc.unesco.org/en/list/31/

monument to the deliberate genocide of the Jews by the German Nazi regime and to the deaths of countless others, bear[ing] irrefutable evidence to one of the greatest crimes ever perpetrated against humanity. It is also a monument to the strength of the human spirit which in appalling conditions of adversity resisted the efforts of the German Nazi regime to suppress freedom and free thought and to wipe out whole races. The site is a key place of memory for the whole of humankind for the Holocaust, racist policies and barbarism; it is a place of our collective memory of this dark chapter in the history of humanity, of transmission to younger generations and a sign of warning of the many threats and tragic consequences of extreme ideologies and denial of human dignity.

It is that third sentence that contains the central message about this Inscription: that this is vitally a site of memory for the whole of humankind, not just for survivors and their families but related to racist policies and barbarism in general. In other words, it is a place of collective memory. Having visited the site and having seen concerts performed there on key anniversaries, it is easy to recognize the significance of specific places like Auschwitz as being necessary if not essential for creating small wins to help address the wicked problem of conflict through healing processes and reconciliation, for example. The site's continued use, in ways that are entirely respectful to the events that occurred there, keeps the issues in mind and ensures they never get forgotten.

A similar argument can be made for Robben Island, near Cape Town in South Africa,[9] the prison where Nelson Mandela was famously detained (although interestingly he is not mentioned in the UNESCO site description or under the criteria assessment). This site was Inscribed in 1999 (Figure 7.2).

Criterion vi is once again used, stating that 'Robben Island and its prison buildings symbolize the triumph of the human spirit, of freedom and of democracy over oppression.' Also relevant is Criterion iii, being 'to bear a unique or at least exceptional testimony to a cultural tradition or to a civilization which is living or which has disappeared'. For Robben Island it states under this criterion that 'The buildings of Robben Island bear eloquent witness to its sombre history.'

While not referring specifically to Nelson Mandela, the description does, however, position the site relative to the Apartheid regime in which he played a central defining role:

The symbolic value of Robben Island lies in its sombre history, as a prison and a hospital for unfortunates who were sequestered as being socially undesirable. This came to an end in the 1990s when the inhuman Apartheid regime was rejected by the South African people and the political prisoners who had been incarcerated on the Island received their freedom after many years.

[9] https://whc.unesco.org/en/list/916/

CONFLICT 241

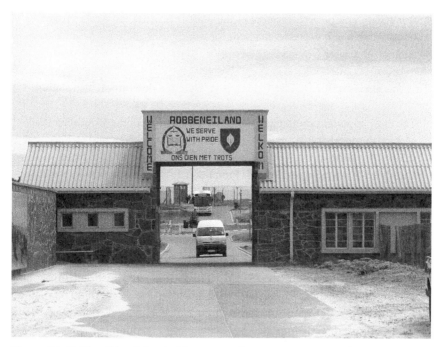

Figure 7.2 Robben Island, South Africa, now a heritage attraction and World Heritage Site. This file is licensed under the Creative Commons Attribution-Share Alike 3.0 Unported license.

Robben Island has become a symbol of those freedoms and of the scars of apartheid policies of discrimination and prejudice. The Inscription of the site on the World Heritage List no doubt helped give voice to these issues, alongside the area known as District Six in nearby Cape Town where the Group Areas Act of 1966 allowed the Apartheid regime to clear a mixed-race neighbourhood and deprive people of their homes and livelihoods. I will return to this example later in the chapter.

Finally is the 'Hiroshima Peace Memorial (Genbaku Dome)', Inscribed in 1996.[10] The documentation begins by stating that:

> The Hiroshima Peace Memorial (Genbaku Dome) was the only structure left standing in the area where the first atomic bomb exploded on 6 August 1945. Through the efforts of many people, including those of the city of Hiroshima, it has been preserved in the same state as immediately after the bombing. Not only

[10] https://whc.unesco.org/en/list/775/

is it a stark and powerful symbol of the most destructive force ever created by humankind; it also expresses the hope for world peace and the ultimate elimination of all nuclear weapons.

This was also Inscribed under Criterion vi. Here the description also states:

> The most important meaning of the surviving structure of the Hiroshima Peace Memorial is in what it symbolises, rather than just its aesthetic and architectural values. This silent structure is the skeletal form of the surviving remains of the Hiroshima Prefectural Industrial Promotional Hall (constructed in 1914). It symbolises the tremendous destructive power, which humankind can invent on the one hand; on the other hand, it also reminds us of the hope for world permanent peace.

In this regard, and with these three comparatively recent examples of conflict-related sites Inscribed onto the World Heritage List, we can begin to see how remembering conflict can hold a value for humanity. One might think it is natural to want to forget, but remembering is important, for those directly affected but also for others indirectly impacted by events, not to mention (we might suggest) future generations. In that sense, the decision-making and evaluative processes that result in sites like Auschwitz Birkenau, Robben Island, and Hiroshima being Inscribed on the World Heritage List become small wins in the cultural response to conflict resolution, mediation, and avoidance. This also works at a national scale where agencies (such as Historic England, for England) create policies and devise strategies to manage and sometimes protect sites of recent conflict, as memorials or reminders that serve also as warnings. Such sites do mean different things to different people, however, meaning that their presence (or removal) will always be contested. As Dolff-Bonekaemper put it (2002, 247):

> A 'site of memory' always carries the potential as a 'site of dispute'; both are inseparable, like the two sides of a coin. And who knows when a monument of the past will become once more a site of dispute, because it serves as a catalyst for new controversies in actual political and cultural life. There is nothing like a finally-appeased patrimonial status: cultural heritage will always include political and social conflicts, inscribed on the substance and history of its objects.... One day it will be useful to dig up those historic conflicts to see more clearly what happens in the present. This is when a monument's capacity to create dispute or to make it visible will be precious once more.

This is also where archaeology comes directly into play, with the changing landscape and the survival of traces within that landscape, traces that can act as warnings, reminders, evidence, and signs of hope. Every decision, to remove the

trace of something, or to preserve it, is impactful and holds significance for the way a particular story (in this case involving conflict) is told. As stated earlier, it also allows all decisions made to have the potential to become small wins in the way they help society to think about future conflict. Recent traces hold particular poignance in this way although, as we saw with Nataruk, even nine-thousand-year-old traces can leave a significant impression. In the final part of this chapter, let us now move from this more general discussion into a more focused investigation of what some other small wins might look like.

Small Wins in Conflict

So far in this chapter, I have provided ideas around the definition of conflict and how different organizations have engaged with it and with its repercussions. I have also outlined some examples of how archaeology and heritage practitioners have worked in various ways with the material remains of conflict, including some very recent examples from the Second World War and post Second World War era. An additional point that has been implicit through this discussion is that conflict relates to other wicked problems, for example, social injustice and well-being. This is the case now just as it was in the past. One particular and notable entanglement is between conflict and health, as discussed in Chapter 4, where archaeological work is being undertaken to help rehabilitate military veterans suffering from poor mental health or physical disability as a result of conflict. This example, the World Heritage Site Inscriptions mentioned above, and the other examples I will describe later in this chapter, constitute what were defined in Chapter 1 as small wins, being those 'concrete, complete outcomes of moderate importance [that] build a pattern that attracts allies and deters opponents. The strategy of small wins incorporates sound psychology and is sensitive to the pragmatics of policymaking' (Weick 1984, 40).

In this final section of the chapter I will give a clearer focus to what small wins can look like in this particular and challenging context and will do so under two headings: projects and policies. The projects will include some select and specific examples of initiatives that have made a difference on a local scale, albeit often with wider implications. The policy section comprises the brief discussion of two important initiatives that provide important framing opportunities for such projects but which can be argued to represent small wins in their own right. First, some examples of projects.

Projects

Many of the small wins described in this book involve projects that galvanize specific communities, either because they have common interest in a specific place

or building, or because they form a more dispersed group, perhaps a diaspora, who share some element of heritage or identity. In all these cases, the win may be small in global terms, but nonetheless significant for the people concerned. In some cases the small win will be personal on the level of specific interventions but with wider implications for the community as a whole. Good examples of how small wins might impact both individuals and a wider community are the various programmes and research projects that aim to recover and return those who are either 'disappeared' (as they are often referred to) or missing in action. The return of these human remains are definitely small wins for the families concerned, but also in terms of the publicity they generate, and for wider perceptions around conflict and the direct impact it inevitably has upon societies and communities.

In an earlier co-edited book (Schofield et al. 2002), four examples are presented of different types of archaeological work within these related areas: in Vietnam and Laos (Hoshower-Leppo 2002), Cambodia (Jarvis 2002), Guatemala and the former Yugoslavia (Saunders 2002) and Argentina (Crossland 2002). In the case of Vietnam and Laos, the chapter describes work of the US Army Central Identification Laboratory, Hawaii (CILHI). Created after the Vietnam War, CILHI is the organization that recovers American troops who are Missing in Action (MIAs) worldwide, from all of the conflicts in which they have fought. The aim of each intervention is to 'Recover sufficient material evidence to identify the loss incident and the individual(s) involved through the archaeological recovery of human remains, life-support equipment, personal effects and aircraft wreckage' (Hoshower-Leppo 2002, 81).

For ethical reasons, details are hard to locate about individual cases. However, a common theme where some details are provided is the importance of repatriation for surviving family members and the military units in which the missing personnel served (recalling here the notion of the 'heritage community', embedded in the 2005 Faro Convention). This involves the drawing of a line that allows people to move on with their lives. This motivation is important, besides any additional advantages to do with evidence-gathering. People usually need to know, and knowing can be essential for recovering from loss. Although written after the First World War, Siegfried Sassoon's poignant question, 'Have you forgotten yet?' from his war poem 'Aftermath',[11] has direct relevance here, and especially one might argue, where personal grief combines with a known unknown. At least through these projects the unknown can become known and an important stage in the grieving process can begin. Thus every repatriation becomes a small win.

Another aspect of this topic is the role of evidence in bringing perpetrators to justice. This again allows hard lines to be drawn enabling people and communities to move on with their lives. In an important paper on this topic, Zoe Crossland

[11] Also the title of my (Schofield 2009) book, being a collection of essays on the subject of recent conflict.

(2000, but also 2002) described her experiences as an undergraduate volunteer on a project in Argentina, during which she was taken to visit some forensic excavations at the Avellaneda cemetery outside Buenos Aires. This excavation was to recover people who had been 'disappeared' during military dictatorships of the 1970s and 1980s. As Crossland says (2000, 146): 'The forensic excavations left an indelible impression, as did the commitment of the archaeologists to the difficult task of excavation and identification.'

The archaeologists working on this project had a tough time not least because the excavations were controversial, with reactions ranging from acceptance and reburial of the remains (involving families and human rights groups) to a refusal to admit that the 'disappeared' were even dead, alongside claims that excavations were part of a conspiracy to suppress the truth about crimes undertaken by the military dictatorships. The last of these dictatorships collapsed in 1983 and the newly elected democratic government established a commission to compile evidence and testimony in order to bring those responsible to trial (2000, 148). The aim of the excavation of mass graves was partly to generate such evidence.

As Crossland described it (2000, 150):

The forensic excavations captured the public's imagination, both in Argentina and abroad. A significant aspect of the ... work that received media attention was their role in creating an alternate form of narrative about the years of the repression. The visible, tangible proof of state-sponsored murder that they provided could challenge the lies, rumours and silences of the years of the 'dirty war'. When, after an abduction, people demanded to know the whereabouts of their relatives, they were often met with silence, secrecy and obfuscation.

Again, in this case, as with the repatriation of military remains from theatres such as Vietnam and Laos, the recovery and return of remains was vital to the families concerned. Crossland described some touching examples. For instance:

Karina Manfil's family was abducted when she was a child. She explained in an interview ... that only after finding their remains could she feel at peace, as finally, along with the remains of her family, she recovered a sense of her own identity (Verbitsky 1993, 9). Thus in a personal sense, as people are united with the remains of their loved ones, there is a final coming together of the bones and the disappeared person. One scholar, Andrea Malin (1994), considers the psychological aspects of the lack of knowledge of the whereabouts of the physical remains of the disappeared for relatives. She cites Chaim Shatan's work on genocide to emphasise the importance of the mourning process for individuals in ... 'helping the mourner let go a missing part of life and acknowledging that it continues to exist only in memory'. (Malin 1994, 196–197)

In most cases, archaeological work of this type produces results that represent good news, for the reasons already described. But there is also a downside. Citing David Lowenthal's view that 'the memorial act implies termination' (1985, 323), Crossland emphasizes that closure can release many families from the struggle to find out what actually happened to their loved ones and thereby 'lessen the desire to seek punishment for those responsible' (2000, 154).

So here, the superpower that archaeologists hold can be powerful in allowing closure and bringing those responsible to justice, but it must be applied with care, recognizing the implications of rehabilitation. It is a reason not to forget and, in some cases at least, not to let go either.

One of the inevitable consequences of conflict is the movement of people to a place of safety, often in vast numbers and typically at significant risk to their own lives. Nonetheless they see this risk as being worthwhile given the far higher risks of staying put and taking their chances, often in a warzone. But it is not just their lives that are at risk; their livelihoods and homes are also often destroyed, as are their communities and their social networks. In these cases archaeology and heritage practice can help in at least two different ways. First, through the post-war reconstruction of those places which may be iconic for the wider national community (e.g. as World Heritage Sites) as well as being essential for the identity and lifestyles of local communities. Such places might include religious buildings, libraries, markets, and infrastructure. Heritage practice can help rebuild these places either by reconstruction or by rebuilding to a new design that takes account of the building's original form and function. Second, archaeology and heritage practice can provide opportunities to help refugee communities settle in a new location, by encouraging them to actively learn about that place or by establishing projects which encourage stronger, faster integration. I will give an example of each of these two aspects.

We have already discussed the importance of place attachment (in Chapter 4) alongside the traumatic effects of losing one's home or a place to which one attaches particular value (Read 2011). This discussion included the notion of ontological security (Grenville 2007; and Giddens 1991) whereby such places provide anchors, a sense of stability in a turbulent world. With post-conflict reconstruction, this ontological security can provide the justification for cultural and financial investment, either by reinstating that anchor, or putting a similar one in its place.

In the proceedings of a conference in 2016, entitled *Catastrophe and Challenge: Cultural Heritage in Post-conflict Recovery* (Schneider 2017), the opening lecture, by Bijan Rouhani, an architect and engineer and Vice President of the ICOMOS Scientific Committee on Risk Preparedness, asked whether post-trauma cultural heritage reconstruction was even possible. Giving his paper (published as Rouhani 2017) entitled 'In Search of Lost Values', he discussed the post-conflict recovery phase as an opportunity for improvement, development, and investment. But it is

important to recognize that post-conflict redevelopment must be carefully thought through and well executed, with public support if it is to be successful in achieving its aims of recreating a sense of identity. Rouhani describes Beirut's historic downtown and its redevelopment after the Lebanese Civil War of 1975–1990 as an example where reconstruction has not worked. The aim in this case, he states (citing Calame and Charlesworth 2009, 195) was to 'reconstruct the notion of the multi-ethnic city centre' (Rouhani 2017, 44). As he goes on to say (2017, 44):

> The project resulted in a fabricated city centre that has lost the connection to its history.... [M]any historic buildings and public spaces were demolished during the reconstruction project and the areas were reconstructed with luxury shops, offices and properties. In the post-conflict phase, new socio-economic and political dynamics put pressure on the local inhabitants to move out and be replaced by the new stakeholders.

An example of success is the historic bridge in Mostar (in Bosnia and Herzegovina), widely known as a reconstruction project designed to 'build bridges' between divided communities. The original bridge was destroyed during the Balkans conflict on 9 November 1993 (Figure 7.3). The reconstruction was

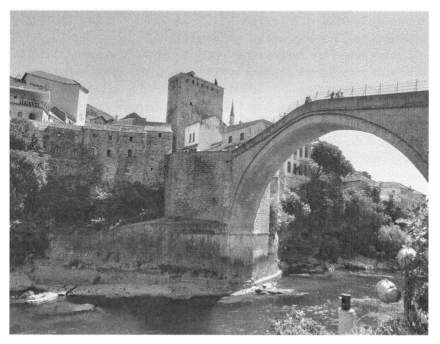

Figure 7.3 The reconstructed Mostar Bridge, in 2020. This file is licensed under the Creative Commons Attribution-Share Alike 4.0 International licence.

completed a decade later. As Rouhani suggests, this example illustrates the peace-building purpose of reconstruction with the main aim of reconciling a divided society. On one level this is a small win, but it has immense significance for those communities concerned and as a global symbol of reconciliation and peace, akin in some ways to the cultural significance (and the Outstanding Universal Value) of the Genbaku Dome. And like the Genbaku Dome and the other sites referred to earlier in the chapter, Mostar and its bridge comprises a UNESCO-Inscribed World Heritage Site, Inscribed in 2005 under Category vi (as were the earlier examples). The Inscription in this case states that:

> With the 'renaissance' of the Old Bridge and its surroundings, the symbolic power and meaning of the City of Mostar—as an exceptional and universal symbol of coexistence of communities from diverse cultural, ethnic and religious backgrounds—has been reinforced and strengthened, underlining the unlimited efforts of human solidarity for peace and powerful cooperation in the face of overwhelming catastrophes.

Rouhani also gives the example of war-torn Aleppo (Syria) which, since 2012 has experienced significant destruction as part of the armed conflict in the country. Specifically, Aleppo became a divided city with one half controlled by the Syrian Army and the other half by armed rebels. As a result, much of the old city was irreparably damaged while the majority of the population were displaced, creating a 'refugee crisis', as many news outlets referred to it.

This is a case where the reconstruction has begun and is underway, at least for some parts of the historic city, such as its iconic and vital central market or *souk*. As Rouhani (2017) states, the reconstruction will need to work within the constraints of this, too, being a World Heritage Site. Here we can learn from the lessons of other such sites and cities. We can rebuild or redesign to ensure the character of the old city remains to provide an anchor for people's identities, but we also need to invest in new initiatives to help the new city or neighbourhood to grow again. In such cases it is the rebuilding of historic infrastructure that creates the opportunity for growth:

> As a living city, the rehabilitation of the old city of Aleppo should not be limited to reconstruction of the iconic monuments and rebuilding the damaged structures; it should address the regeneration of the socioeconomic vitality of its historic centre as well as help the local community to recover from the social, economic, political, and psychological impacts of the war. (Rouhani 2017, 48)

In summary, 'the reconstruction process should serve society' (Rouhani 2017, 49). Only where that is achieved are small wins ever likely to last. Munawar and Symonds (2022) present an additional and important argument which is also a

prerequisite to achieving success: that post-war reconstruction should not be a top-down governmental process, however reliant it might be on expert conservation advice; but rather one that is bottom-up and participatory, building consensus among all members of society. It is only by developing such an approach that, 'cultural heritage assets [will] provide a unifying force for reconciliation, reintegration of displaced people, and future social cohesion' (2022, 1017). They give examples of both types of approach. Top-down or externally conceived approaches have managed to isolate and neglect local people. This was the case, they argue, in Beirut and the Balkans. However, those reconstructions that involved local participation with the aim to develop local capacity were more successful, gaining greater acceptance among the victims of social injustice, terrorism, and war trauma. They describe Mali and Khabul as examples of such success. They conclude by stating:

> Our theoretical framework aims primarily to construct a useful connection between the material culture of the past, contemporary conflict, and society. We promote this consensual and collaborative approach in an attempt to ensure that the process of writing the cultural history of conflicts can be an inclusive and participatory process that has the potential to bolster social cohesion and bring people together to rebuild the nation in the aftermath of war. (Munawar and Symonds (2022, 1031)

This focus on involving people ties into the second category in post-conflict reparation which concerns the people themselves, many of whom will have become displaced as refugees, seeking refuge (and often a new start) elsewhere. In the *Catastrophe and Challenge* book (Schneider 2017) I referred to previously, Rouhani's (2017) opening lecture is bookended with my own closing chapter which emphasizes this very point: that the immediate priority is to ensure people are safe before focusing on conserving fabric or rebuilding (accepting that this a complex interaction, as rebuilding lives can be enhanced by the re-emergence of familiar buildings and vital infrastructure, as Munawar and Symonds 2022 have suggested). In that closing chapter I explained that archaeology is well positioned to undertake such work because, as a subject and as archaeologists, we have always put people at the very centre of our investigations.

Archaeology can also be used to frame our understanding of this contemporary challenge of migration. A recent essay (Altschul et al. 2020) made this point, the authors highlighting the scale of the issue as it exists today, while also describing some of the ways an archaeological lens can shed new light on contemporary migration. They describe how, every day, '37,000 people leave their homes and join the 258 million migrants who live in a different country from where they were born.' This isn't only related to conflict, recalling the subject of Chapter 5 on entanglement. As the authors state: 'Climate change alone is expected to force 200

million people to leave their homeland by the year 2050 and some expect the number to reach 1 billion by...2100' (2020, 20342).

As was described in Chapter 2, with regards to climate change, these authors recognize that 'past efforts by archaeologists to influence public policy have mostly failed' (2020, 20344). They refer to the Intergovernmental Panel on Climate Change (IPCC), noting (as I did in Chapter 2) that 'archaeology is generally lacking in IPCC reports and absent in the crafting of public policy'. Migration and mobility have always happened and, for much of human history, such movement was quite normal. There is an argument (presented in Altschul et al. 2020, for example) that the deep-time perspective provided by archaeology can shed new light and help inform policy related to contemporary migration, in ways that have not yet been successful with climate change. The big question is how.

It is important to begin by saying that there are many other ways, through other disciplines and areas of practice, to help address 'wicked' elements of the challenges that arise from refugees and migration. Bulut (2016) is just one example, presenting a study that explored attitudes towards Muslims in the United States. Specifically the aim here was to investigate whether attitudes were the result of nativist beliefs that nothing could beat the American way of life, that immigrants present a threat to traditional American values, or that immigrants should give up their foreign ways and learn to be like other Americans. Bulut, a sociologist, concluded that such nativist attitudes, coupled with a lack of contact with Muslims, appeared to be the strongest predictors of respondents' attitudes. This raises the question and highlights the potential benefits of better and more opportunities for integration.

Archaeology and heritage practice can make meaningful contributions too, not least in terms of just these kinds of opportunities. On the one hand, work within these related areas of practice can create a documentation of contemporary migration, a material record that represents and commits the stories of these people 'to the record', as it were, effectively rendering the invisible visible, the unknown known. There are now numerous examples of archaeologists working in various ways across this particular field of study. Amongst the first was Dan Hicks and Sarah Mallet's (2019) work at the Camp de la Lande, in northern France, from March 2015 to October 2016, the 'controversial and euphemistic name used by the French authorities for the site of the "Jungle", as it existed as a "tolerated encampment" on the eastern borders of Calais' (Hicks and Mallet 2019, 2).

In this example the concern was for an 'undocumented present' (Hicks and Mallet 2019, 114), a field in which, 'archaeology brings to the anthropological study of the near-present...a distinctive sense of interventionist or transformational practice that weaves together the anthropological sense of discovery and making the undocumented visible' (2019, 17). The authors then elaborated on what this archaeology might look like:

Archaeology need not involve excavation (although it could) but performs the sustained disclosure of unspoken material coordinates and dimensions of social life. In this view, Contemporary Archaeology begins with the commitment that the more carefully we attend to objects, buildings and landscapes, the more human our account of the world may become. (Hicks and Mallet 2019, 19)[12]

By approaching archaeology in this way, not as a form of evidence to compare with other evidence but rather as a way of seeing and of critically engaging the world through material objects, interventions such as that at the Jungle can become a notable small win, and one that policy entrepreneurs can present in ways that have capacity to change both attitudes and approaches to migration and the conditions under which people are held. In such instances and through such examples, archaeological interventions can inform and shape policy. But for that to happen, we need policy entrepreneurs as well as people beyond our discipline who are prepared to accept that archaeology and heritage practice can provide unique insight and do so in a very particular and engaging way. How we might do this, across the wider range of wicked problems, will form the focus of the book's final chapter.

Beyond this example of a particular place, other studies have addressed the wider landscape of migration, notably Jason De Leon and colleagues' (e.g. Stewart et al. 2018) counter-mapping of undocumented migrations in the United States-Mexico borderlands. This is just one example of a range of studies to be undertaken in recent years (see, for example, the two edited collections of Hamilakis 2018 and Holtorf et al. 2019, the former of which describes this contemporary period as the 'New Nomadic Age') that address this global issue at landscape scale.

Many of these studies are built around material culture and the various ways this is represented in people's thoughts, experiences, and memories. The role objects play in helping displaced people retain a sense of their identity while supporting well-being are now well established within refugee camps and other resettlement settings, in both conventional (e.g. Abell 2014) and contemporary (e.g. Dudley 2011 and Trabert 2020) contexts. Stephanie Martin's recent (2023) paper takes this research in a different direction, however, in exploring the role of material culture for migrants in transit. As she states:

Migrants carry and make use of certain objects in order to navigate complex journeys and overcome structural, social, and political barriers to migration. Some objects are discarded while others are carefully kept and valued. Newly acquired objects may create opportunities to both imagine and establish new lives, while lost or absent objects manifest as perceptible voids in daily life.

(Martin 2023, 3)

[12] This quotation also appeared in Chapter 1.

Within the field of artefact studies (in archaeological terms), or more correctly in this context perhaps, material culture studies, archaeologists have significant contributions to make in better understanding the ways in which displaced refugee communities can be supported. What these examples show, for example, is that objects and possessions play an important part in helping people to develop (or redevelop) some sense of security and of belonging.

In Chapter 6 I referred to Rachael Kiddey's work with homeless communities. Following these studies, Kiddey began working with refugee communities (Kiddey 2020; Kiddey 2023). In one aspect of that work, Kiddey visited Athens (Greece) to investigate sites of refugee shelters (Kiddey 2020), presenting this as an archaeological study and explaining why this perspective can be helpful.[13] One aspect of this project involved running 'Made in Migration' drawing workshops with migrant children living in temporary accommodation (Figure 7.4). Her comments on this project provide an appropriate and compelling conclusion to this section:

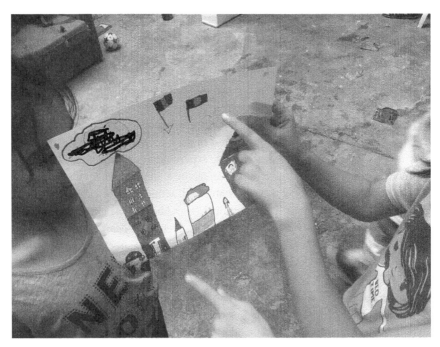

Figure 7.4 Rachael Kiddey running a drawing workshop with migrant children living in temporary accommodation, Athens, Greece, 2019. Photograph: Rachael Kiddey, with permission.

[13] And see also her work with the Made in Migration Collective, reported in Kiddey 2023.

By approaching the city through a distinctly archaeological lens, it is possible to see how refugees (and those working in solidarity) use empty buildings and adapt other materials in resourceful and creative ways that both retain pre-exile ways of life for refugees (e.g. carpenter Hussein's benches and tables made from discarded wooden shutters) and also transform cultural norms. In these ways, objects play key roles in enabling refugees to both hold onto their cultural identity and also find other ways to be Syrian (Iraqi, Afghan, etc.). It is not the job of archaeologists to allocate humanitarian resources, but we are good at identifying relationships between people, places and things. As an archaeology of the contemporary world, [archaeologists can] contribute usefully to debates on how lived experiences in refugee accommodation might be improved.

(Kiddey 2020, 618–619)

Policies

The final chapter of this book will investigate ways that all of these many ideas and examples, including those related to conflict, might help inform policy and also therefore future practice in their respective areas. The focus of these thematic chapters is more about how archaeological and heritage practice can help people now, directly and on the ground as it were. Nonetheless, I will close this chapter with a short section on policy as it has such a direct bearing on the way that archaeology and heritage have been working directly with communities in this particular thematic area of conflict. The two areas (people and policy) are indelibly linked, perhaps more so here than in other thematic areas. I will give just two examples to illustrate what I mean, and ways that people working within archaeology and heritage can provide support within this area of policy work.

First, Blue Shield International[14] is one organization with the capacity and the aspiration to go beyond small wins to create larger scale and lasting solutions to the impact of conflict on communities (see Stone 2015). Individual projects may constitute small wins (through the kinds of reconstruction initiatives described earlier), but through strategy and influence they can do more. The Blue Shield website describes how, as an organization, it is 'Committed to the protection of the world's cultural property, and is concerned with the protection of cultural and natural heritage, tangible and intangible, in the event of armed conflict, natural- or human-made disaster' (Article 2.1, Blue Shield Statutes 2016).

[14] https://theblueshield.org/about-us/who-we-are/

It goes on to state that:

> The Blue Shield network, often referred to as the cultural equivalent of the Red Cross, was formed in response to the changes in international law and today works globally to protect cultural heritage in emergency situations. We are a non-governmental, non-profit, international organisation committed to the protection of heritage across the world. This includes museums, monuments, archaeological sites, archives, libraries and audio-visual material, and significant natural areas, as well as intangible heritage. We have national committees operating across the world, with more under construction. The national committees are coordinated by an international committee—the Blue Shield International Board.

Much of the work of Blue Shield is project-based and conducted under the label of 'missions' to particular places where conflict (and natural disasters) have impacted a place and its people. Crucial though is the strategy and the overarching 'mission' which can ensure wider impact. Returning to the website:

> The Blue Shield aims to be *proactive*, developing and coordinating knowledge and measures wherever possible that prevent or mitigate damage before it can occur. In order to do this, the Blue Shield champions the importance of cultural heritage, raising awareness of its importance to demonstrate that it is *not a luxury*, and should be given full consideration in line with its place in international law.
>
> Blue Shield's mission and goals are delivered through six areas of activity. With respect to cultural property protection (CPP) in the event of armed conflict and natural/human-made disasters, the Blue Shield works in the areas of:
>
> 1. Proactive protection and risk preparedness;
> 2. Emergency response;
> 3. Stabilisation, post-disaster recovery, and *long-term/ongoing support activities*;
> 4. Legal compliance, *policy*, and their implementation;
> 5. Capacity building activities, and *education and training* in support of the Blue Shield's Areas of Activity;
> 6. Coordination—of Blue Shield members and with partner organisations.[15]
>
> (My emphasis throughout)

The highlighted words and phrases give a sense of how Blue Shield recognizes and works on the basis of immediate impact but also longer-term sustainability and

[15] https://theblueshield.org/what-we-do/internation-board-activities/

resilience. This is where the distinction between projects and policy can be seen. Post-disaster recovery projects (or missions) are set alongside longer-term ongoing support. There is also emphasis on education and training, again focusing on legacy. At both scales, heritage is recognized as essential, stating unequivocally that heritage is 'not a luxury'. They regard heritage as a fundamental part of people's identity and therefore also their well-being,[16] as was discussed here and in Chapter 4.

Finally I return to the 2005 *Council of Europe Framework Convention on the Value of Cultural Heritage for Society* (also known as the Faro Convention). It is no coincidence that this Convention emerged at a time when the political landscape of Europe was undergoing rapid transformation, following the end of the Cold War with its binary division of the capitalist West and communist East. In the former Soviet Bloc, countries with distinct identities and with their own particular heritage were re-emerging, making it essential to find some way to ensure that rights to people's cultural heritage as a way of affirming identity, were widely understood and, where appropriate, protected. The alignment of Faro to the Universal Declaration of Human Rights was discussed in an earlier chapter and is vital in this context. Equally, the recognition of heritage communities holds significance. This is often thought of in local, parochial, or even thematic terms, but it can and does apply nationally as well. As Thérond (2009, 10) put it:

> Stated for the first time in a treaty instrument, the notion of the 'common heritage of Europe' also conveys the idea that all the layers of heritage which characterise the diverse local features of this continent make up, here and now, a source of prosperity, employment and quality of communal life for the local populations and their visitors. Rather than encourage revival of past conflicts, it expresses a hope of living together. The concept of a common heritage is thus consistent, in a pluralistic democracy, with the sense of cultural 'pluri-affiliation' for individuals and groups, reconciled with respect for fundamental shared values that underpin a common political design for Europe.

To summarize this section, archaeology and heritage practice stand as valid and helpful ways of thinking and of doing. By both thinking *and* doing, practitioners and researchers will work with material traces in a diversity of ways, and with the people for whom these traces hold value. The examples of practice (the projects) stand as examples of small wins; Blue Shield and Faro are examples of initiatives which can impact and shape policies that are potentially longer-lasting, sustainable, and resilient to change.

[16] https://theblueshield.org/why-we-do-it/the-importance-of-cultural-heritage/

Conclusions

This chapter has dealt with a wicked problem that exhibits exceptional levels of complexity. On the one hand is the argument that conflict is often not a wicked problem in and of itself given that resolution can be straightforward. Just as landing somebody on the moon is technically complex, ending conflict may be politically complex but otherwise tame. In other words, individual conflicts will often represent a tame problem, the resolution of which is straightforward at least in theory. However, the *consequences* of conflict can present immeasurably wicked problems not least in ways that relate to social injustice and well-being.

This chapter has provided some examples of the ways archaeologists and heritage practitioners can successfully generate small wins that benefit the communities affected by conflict of various kinds and in various ways. Some of these wins relate to the documentation of migration (as the basis for understanding and policymaking) while others focus more on social engagement, for example, building that understanding through conversations, dialogue, and co-participation. Rachael Kiddey's (2017, 2020) work is an example of successfully conveying a clear and important message through archaeological interventions that combine material culture with conversation. Similarly, but in the act of physically rebuilding, Munawar and Symonds (2022) highlighted the importance of involving people in post-war reconstruction, noting that participatory approaches were more likely to be successful in bolstering social cohesion and bringing people together than were top-down government-led approaches.

An archaeological perspective is also helpful in demonstrating that conflict has a long history and there is advantage to understanding that *longue durée* in order to better contextualize contemporary events. Archaeology is well placed to help deliver this contextual understanding, and some brief examples were presented which illustrate its capacity to reveal stories from the past, alongside the challenges of interpretation. My focus, however, is on the role of archaeology in directly contributing to the well-being of individuals affected by war and conflict (bearing direct comparison with the subject of Chapter 4). Returning to Siegfried Sassoon's anti-war poem 'Aftermath', this presents an important message in providing a frame of reference with which both archaeology and heritage practice closely identifies. By working with material culture, from the deep past and from the contemporary world, there is no danger of forgetting with archaeologists around.

However, archaeology is a contemporary discipline, reflecting on the present, on how the past shapes the present, and how past and present together shape infinite and alternative futures. The ongoing conflict in Ukraine is therefore very relevant for archaeologists, in terms of the history of the region and of national identity, as well as documenting, protecting, and (in the future) reconstructing cultural property and heritage communities. Given that this war only commenced in its present form a year ago at time of writing, the conflict in Ukraine has not yet

received much academic attention (at least not in terms of publications, but see Mack 2003, Bolin nd, citing Iakovlenko 2022 and Pavlyshyn 2022; and see Pereira et al. 2022 for an examination of the impacts of the war on heritage, infrastructure, and ecosystems and how all of this has a direct bearing on human health). Yet significant attention is being paid to cultural property within Ukraine by UNESCO and the Smithsonian Cultural Rescue Initiative, alongside other organizations. As Bolin notes, and importantly, these initiatives include digital preservation including the digital footprint of Ukraine's heritage organizations. All such initiatives constitute significant small wins in a time of national (and indeed international) crisis.

In drawing this chapter to a close, I am reminded of District Six in Cape Town (South Africa), an area once occupied by sixty-two thousand people who were classified as 'Coloured' under the Apartheid Regime's Population Registration Act. Under Proclamation 43 of the 1966 Group Areas Act, District Six was declared 'white's only' and the area was largely cleared (for more on this example, see Schofield 2006). Those who had lived in District Six for generations were forcibly removed and their homes destroyed. The vacant plot (which has been referred to as a scar) remains and the area has become a kind of memorial to these removals and to a population that was dispersed amongst the city's townships. Following an initiative of former residents, a District Six Museum opened in 1994 going on to become a popular and important site, both for tourists visiting Cape Town and—vitally—for former residents. When I last visited, the floor of the museum comprised an interactive map onto which people could write their memories or highlight the location of their former home. Early in the Museum's history, a man walked in and offered the curator all of the street signs from District Six. The curator was overcome as there had been no suggestion that these had been retained. The man was one of the bulldozer drivers commissioned to clear the District. These street signs were soon exhibited, hanging like mobiles from the ceiling, offering the opportunities to recall important memories for all who lived there and for whom these street names were everyday markers.[17] Word caught on and former residents started returning to the District to visit the Museum, spending time looking at the signs and recalling and discussing their memories.

This, arguably more than any other example I have encountered, and as much as any described in this chapter, highlights the power that material items have to reconcile people with a painful or difficult past. By definition it may be a small win, but for those who returned to see these street signs, the impact was immense. Such interventions can become, as Macdonald says (in one of the quotations that opened this chapter), a positive development, a 'performance of trustworthiness'.

[17] https://www.districtsix.co.za/project/streets-retracing-district-six/

Chapter Headlines

- Conflict *can* present a wicked problem. However, unlike with other chapters, conflict is not always or necessarily a wicked problem as ending conflict can be straightforward when the will is there to find a resolution. However, the legacies, repercussions, and impacts of such conflict usually will constitute wicked problems.
- There are many different types of conflict and many different ways of thinking about it. It is important to recognize this plurality as this provides a helpful if not essential framework for considering solutions, not least in the form of small wins.
- The deep-time perspective that archaeology provides, alongside heritage and conservation approaches, also provides a helpful framework: for example, to recognize the longer-term impacts of conflict on landscape and on people and communities, and on how evidence for conflict is interpreted.
- There are many examples of good practice that illustrate some of the ways that archaeology can be used to generate small wins relative to conflict and its impact on people and the places where they live. It is emphasized here that participatory methods are generally more likely to be successful than top-down governmental approaches. In this chapter, particular emphasis is placed on refugee communities, recognizing that not all refugees become displaced due to conflict, or at least not directly.
- There are also good examples of ways that heritage and conservation practice can be used to help rebuild both places and communities.
- Archaeologists and heritage professionals have made significant progress in shaping policy that can facilitate the kinds of projects described in this chapter. Blue Shield and the Faro Convention are two very different examples of what can be achieved.
- Both archaeology and heritage practice ensure that past conflict is not forgotten, alongside its inevitable and debilitating implications.

8
Transformations

Humanity faces some formidable challenges, and it is in no small part thanks to the blind spots and mistaken metaphors of outdated economic thinking that we have ended up here. But for those who are ready to rebel, look sideways, to question and think again, then these are exciting times. 'Students must learn how to discard old ideas, how and when to replace them... how to learn, unlearn and relearn', wrote the futurist Alvin Toffler (1970, 374–5).

(Raworth 2017a, 12)

Why is it that archaeology—a discipline that deals with human experience over the long term—is failing to achieve its potential in tackling global challenges?

(Chirikure 2021, 1073)

Introduction

Shadreck Chirikure asks a good question, and one never far away from my thoughts as I wrote this book. In fact, this question has been with me from my time as a PhD student, throughout my career with English Heritage (now Historic England) and then as a full-time academic.

Chirikure's paper is important, not only for what it says about archaeology in general, but also specifically for what it says about archaeology in a particular part of the world, the Global South, and especially Africa, for which a helpful systematic review describing the extent of its wicked problems has been recently produced (Niskanen et al. 2021). Many of the world's wicked problems are at their most acute within this region, often with far more severe implications than exist elsewhere. Chirikure frames his argument around those parts of Africa where

> colonialism ended Indigenous ways of farming, introducing new crops that are drought intolerant and farming practices that are unsustainable. Archaeology provides records of past successes with food security and crops fit for purpose. Therefore to tackle the global challenge that is hunger, archaeology must produce solutions. This might not be a challenge in the USA, but in Africa it is a question

of life and death. The relevance of archaeology is, to some extent, determined by who, for whom and how archaeological work is undertaken.... Some current African archaeology is out of touch with the everyday needs of the continent's populations. (Chirikure 2021, 1073)

Chirikure is therefore very clear on the problems archaeologists face, and not only in Africa and other parts of the Global South, stating that 'studies of culture-histories, ceramic designs and stone tool typologies [will not] earn archaeologists invitations to the Global Challenges agenda-setting table at the UN' (2021, 1074). Instead, and aligning with one of this book's central messages, archaeology: 'must go beyond the self-interested concerns of individual researchers to align with the societal needs and expectations in both research and teaching' (2021, 1075).[1] However (he goes on), 'archaeologists lack the skills necessary to translate potential into reality.' I will discuss these issues (education and the skills gap) later in this chapter. Where I disagree with Chirikure is in his assertion (2021, 1074) that 'transdisciplinary cooperation and innovation are luxuries that will not make archaeology relevant and help the world reduce the gap between the rich and poor'. As we have seen several times already, small wins are a legitimate (if not the only meaningful) way to address wicked problems, and that creativity and cooperation are essential as ways to ensure that these small wins can be successful. Translating practice (and good data and stories) into policy is also essential to creating these small wins. I will deal with both of these points in subsequent sections. Where I agree with Chirikure is in what archaeology needs to be if it is to address these global challenges. It needs a 'shift in mindset' along with a 'reform of the academic curriculum'. Or, put plainly, archaeology needs to reinvent itself; as archaeologists we need to think about our subject in a completely different way. These ideas are addressed in the sections that follow.

In summary, this book responds to Chirikure's (2021) opening quotation and these ideas in two key ways. First, by highlighting that the wicked problems referred to (albeit defined by an alternative term, 'global challenges') are by their very nature irresolvable: they are difficult to define; there is no clear solution, or even a set of possible solutions; every problem is unique; every problem is a symptom of another problem; every problem has multiple explanations, and so forth (after Rittel and Webber 1973; Peters 2017, 388). So it is not as simple as using archaeology to tackle a wicked problem. However, and second, progress not

[1] While not quite the same point, this statement aligns nicely with a comment by one of the anonymous reviewers of my original book proposal, who stated: 'Whether focussed on the contemporary world or the deeper past, archaeology's survival as a discipline is now firmly wedded to heritage and archaeologists' willingness and ability to engage with questions that matter, such as pollution, social justice, health and wellbeing, and climate change, rather than interesting but arcane details of what Neanderthals ate for breakfast or how the Minoans painted their palaces.' These things are important too of course, as should be obvious from the chapter on health and wellbeing, but resolution of the bigger questions is more urgent.

only can be made, but is being made through archaeology, and this progress is being achieved through the small wins framework which, alongside the definition of wicked problems, was defined in Chapter 1. The following chapters presented examples of how this small wins framework is being used successfully in archaeology, recognizing that small wins do make a difference but only ever by addressing a part of the problem.

In this final chapter I want to pull back from the more focused thematic approach of earlier chapters and look instead at the bigger picture. In particular, I will focus on some broader ideas under which many of the themes and examples of the earlier chapters fall. Having first made some summary remarks around the alignment of wicked problems with the UN's Sustainable Development Goals and ways we might think about these as archaeologists, I will focus on how archaeologists can make distinctive and meaningful contributions to wicked problems by doing what we do best: using our superpowers, emphasizing for example the need for creativity in our work, and the benefits of collaborations, trans- and interdisciplinary approaches and networking. I will then discuss the different ways of framing wicked problems within the policy arena. I will introduce some terms and concepts which might help give structure to the work we undertake, and provide an opportunity to deliver our research effectively to new audiences. I will then look at managing our efforts at addressing wicked problems, reflecting on important areas such as leadership and how we measure impact. The next section will focus on education, before concluding with final thoughts on some key concepts such as the long-term perspective that archaeology provides, and the role of activism. But we begin by returning to the problems themselves, focusing on how these have been defined by the United Nations.

Wicked Problems—a Recap

As was discussed in Chapter 1 (and illustrated in Figure 1.2), the examples of wicked problems discussed in this book are closely aligned with the United Nations Sustainable Development Goals. The systemic nature of these global challenges is described in the UN Assembly's (2015) report, *Transforming our World: The 2030 Agenda for Sustainable Development*. This report identifies some of the world's more urgent challenges and underscores the importance of finding ways to address them. According to the report:

> Billions of our citizens continue to live in poverty and are denied a life of dignity. There are rising inequalities within and among countries. There are enormous disparities of opportunity, wealth, and power. Gender inequality remains a key challenge. Unemployment, particularly youth unemployment, is a major concern. Global health threats, more frequent and intense natural disasters,

spiralling conflict, violent extremism, terrorism, and related humanitarian crises, and forced displacement of people threaten to reverse much of the development progress made in recent decades. Natural resource depletion and adverse impacts of environmental degradation, including desertification, drought, land degradation, freshwater scarcity, and loss of biodiversity, add to and exacerbate the list of challenges that humanity faces. Climate change is one of the greatest challenges of our time and its adverse impacts undermine the ability of all countries to achieve sustainable development. Increases in global temperature, sea-level rise, ocean acidification, and other climate change impacts are seriously affecting coastal areas and low-lying coastal countries, including many least developed countries and small island developing states. The survival of many societies and of the biological support systems of the planet is at risk.

(United Nations Assembly, 2015, 8–9)[2]

Most of these issues, threats, and problems have been discussed in the earlier chapters of this book, with sections specifically aligning them with the various criteria that define wicked problems. But here we can look at this in a slightly different way, by viewing the problems not only (or primarily) in terms of their complexity, but in terms of the knowledge that informs the problem, and the role of stakeholders. This situation is helpfully articulated by Head (2022, 120–121) in recognizing the conditions under which policy problems are more likely to be considered to be wicked, in the sense of being intractable:

- Structural complexity: inherent intractability of the technical (i.e. non-stakeholder related) aspects of the problem.
- Knowability: Not only is there little knowledge about the issue, but the nature of the problem or its solution is such that it is unknowable—that is: the relevant information is hidden, disguised or intangible; it comprises multiple complex variables; and/or its workings require taking action to discover causal links and probable outcomes.
- Knowledge fragmentation: the available knowledge is fragmented among multiple stakeholders, each holding some but not all of what is required to address the problem.
- Knowledge-framing: some of the knowledge receives either too much or too little attention because of the way it is framed, thereby distorting our understanding.
- Interest-differentiation: the various stakeholders have interests (or values) which are substantially in conflict with those of others.

[2] And see Steidle 2021, who explores these UN Goals specifically in the context of wicked problems thinking.

- Power-distribution: There is a dysfunctional distribution of power among stakeholders, whereby very powerful actors can overwhelm less powerful ones, even if the latter constitute a majority consensus; or whereby sharply divided interests are matched by sharply divided power (this last point, after Alford and Head, 2017, 407).

Here we move from the nature of the problem to the extent to which it becomes a policy problem which depends, as we have seen, on divergence between stakeholders' viewpoints, including 'different values and different assessments of complexity' (Alford and Head, 2017, 407), but also on governance capacities. This is how the UN Goals frame this final chapter. Because it is through governance that progress will ultimately be made, if we are ever to progress beyond or grow and develop small wins. As Head (2022) states, these capacities and their associated resources will include organizational resources, analysts, competent managers, and strong, performance-oriented leadership. Some of these aspects will be considered later in this chapter.

Both the complexities inherent within wicked problems and the challenges of resolving them are made plain and public by the Sustainable Development Goals. While the public who encounter these goals may not use the term, the alignment with the notion of wicked problems is close; the correlation is strong. The graphic through which the seventeen Goals are represented is perhaps less helpful however, mapping them out schematically as independent of one another, not interdependent, as we know they are, not least from the discussion in Chapter 5. This is crucial in terms of how we think about wicked problems, recognizing that they are interrelated, interwoven, and deeply entangled. Resolving an aspect of one wicked problem is likely to create other (perhaps unforeseen) problems elsewhere. It is within this context of deep and entangled complexity that this chapter has been framed. As archaeologists and heritage practitioners, what do we need to be aware of to help us make a difference, focusing on those areas of practice and policy with which we are traditionally less familiar, and in which we do not generally receive training or guidance? This chapter has the aim of starting that conversation. Let us begin by framing this conversation around some distinct approaches before looking at some more specific frameworks.

Approaches

This book has promoted the idea that small wins provide a realistic and proportional approach to tackling some of the world's wicked problems. The disadvantage of this small wins approach is that the problems remain largely unresolved, at least on a global scale, and in particular in those regions where the problems are

most acute (to return to Chirikure's 2021 observations). The advantage, however, is some resolution and an improvement to people's lives on a local level. The question is then how to achieve those small wins, while at the same time using those successes to promote methodologies and approaches to generate further success in other areas, gradually working away at the problem, thereby reducing it piece by piece. This book has provided many examples of such small wins, where the approach has been successful and either lives have been improved or an understanding of the issues has been achieved. In this section of this final chapter, I want to step away from the details and the examples, and think about these approaches in a more generic way. What is it that makes these projects successful? What are the common factors? Or in some instances, what more must we do to achieve success?

Success in addressing most if not all wicked problems will depend, ultimately, in creating better, more resilient, and sustainable communities. It was said recently (by Shadi Brazell, then of the Impact Investing Institute,[3] personal communication) that to achieve this requires us to improve places and the lives of the people who live in them. Interestingly, this is one of the key drivers across the cultural heritage sector, using the historic character of places and often also the regeneration of historic buildings and neighbourhoods, to improve lives. This relationship was discussed in Chapter 6, where prosocial behaviours were identified in two Tyneside neighbourhoods where people began to feel a stronger sense of place, of belonging and ownership through such behaviours. The impact is felt, therefore, at a local scale. But both the initiatives and the roll-out of successful models of good practice might be felt also at a higher level, more extensively. In the case of initiatives, these might stem from what the European Commission refers to as mission-oriented research (Mazzucato 2018), with its mission-oriented policies being defined by Mazzucato (2018) as, 'systemic public policies that draw on frontier knowledge to attain specific goals or "big science deployed to meet big problems"' (citing Ergas 1987, 193). Not for the first time, this approach takes us back to Nelson's *The Moon and the Ghetto* book (1977, and see also 2011) and its metaphor. As Mazzucato (2018, 9) says, and as mentioned in Chapter 1, Nelson argued that politics was partly the reason why somebody had been landed on the moon, yet poverty, illiteracy, and so forth remained unchecked. However:

> The real problem was that a purely scientific solution could not solve such problems. There is a greater need to combine understandings of sociology, politics, economics and technology to solve these problems, as well as to make the conscious decision to point innovation towards them. This is exactly what a well designed mission can achieve.

[3] https://www.impactinvest.org.uk/

Accepting that one size does not fit all, missions need to be flexible, ensuring they deliver relevant impact but in often very different situations where the same problems may occur. They also need to incorporate new knowledge and innovation (including technological innovation where appropriate) into the design of models, methods, and potential solutions. As Mazzucato says (2018, 10), this whole approach is therefore 'serendipitous, non-linear and very high risk'.

One of the advantages of this particular approach is the ease with which its scale and ambition can be aligned with the global challenges previously discussed and which are expressed in the United Nations' seventeen Sustainable Development Goals. Put simply, the missions are granular and sit comfortably between the higher-level challenges (the wicked problems, effectively) and concrete projects of the kind discussed in the earlier thematic chapters (which will often align to the notion of small wins). This hierarchy is represented in Figure 8.1.

Mazzucato (2018, 11) also describes the need for missions to be: 'Broad enough to engage the public and attract cross-sectoral engagement; and remain focused enough to involve industry and achieve measurable success.'

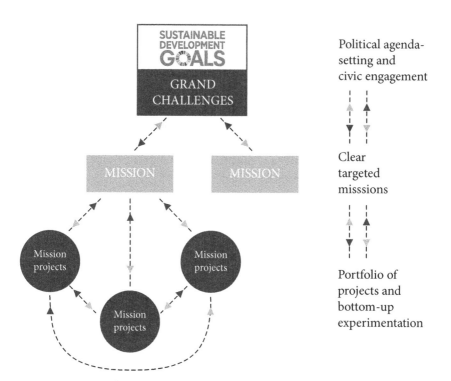

Figure 8.1 How wicked problems (labelled here as Grand Challenges) align with concrete projects (potentially generating small wins), through missions
Source: After Mazzucato (2018, 11). © European Union, 2018.

But if the suggestion is that what lies between these two levels (the global and the local) is vital to achieving success, how do we decide what to position there or, as Mazzucato puts it (2018, 14): how to select the missions. In short, they need to be:

1. bold, inspirational with wide societal relevance;
2. targeted, measurable and time-bound;
3. ambitious but realistic;
4. cross-disciplinary, cross-sectoral and [display] cross-actor innovation; and
5. [offer] multiple, bottom-up solutions.

This approach is not offered as a panacea but as one option for addressing these wicked problems from the perspective of governance, for determining priorities, and devising strategies that can operate between the highest levels (the irresolvable wicked problems) and on-the-ground project-based interventions that can make a difference locally (the small wins). By harnessing that local effort, the impacts of those results can be maximized. One of Mazzucato's three examples[4] is climate change, this being the grand challenge or, in our terms, the wicked problem and the subject of this book's Chapter 2. The mission in this case is to create 100 carbon neutral cities by 2030. Feeding into the mission are eight areas of interest and cross-sector collaboration, including for example 'food', 'environment', 'energy', and 'construction materials'. Research and innovation projects then align with the mission through the lens of various of these areas of interest. How the heritage sector engages with this would likely involve aspects of social sustainability (similar to examples discussed in Chapter 6) but also energy savings through the sustainable re-use of older buildings. A missions approach would not be a huge diversion for heritage organizations that currently produce research strategies as these could easily be aligned.

While Mazzucato says in her conclusion that the missions approach is, 'both a means of setting economic growth in the direction of where we want to be as a society and a vehicle we can use to get there' (2018, 28), it is also much more than that. It highlights the need for cross-sector and cross-disciplinary thinking and for innovation, both aspects that Chirikure (2021) noted as being unhelpful in addressing global challenges. It creates the framework within which researchers and practitioners across all disciplines can find a position and grow a collaborative network that contributes in a structured way to global challenges. It also provides an environment within which communication can occur, and can be encouraged to occur, between the researchers and the policymakers; the framework is tailor-made, in other words, for those vital actors within this network, the policy entrepreneurs.

[4] The other two are clean oceans and health and well-being.

This brings us to the subject of impact. But before discussing that at various points in the sections that follow, I will detour into areas of practice, focusing a little more on what makes research innovative, and why that innovation is so important. I will do this by briefly considering the role of creativity in research, and then present some ideas around networking and collaboration.

Creativity and Knowing

Undertaking research which is both collaborative and creative, for example in the methods adopted or developed, or in the audiences with which the researchers wish to engage, is something archaeologists have been very successful with over a long period. Archaeologists are naturally collaborative in constantly seeking new ways to help interpret and understand behaviours in the past often from the subtlest of archaeological traces. By thinking through what these behaviours might mean with psychologists, or presenting the research in partnership with artists or writers or VR specialists, or using new developments in chemistry or AI to learn more from the traces recovered, archaeologists strive for innovation and creativity in both thinking and doing. Archaeology has always been like this, but seems to become more collaborative and creative with age.

In his book, comparing creativity within the arts and the sciences, Tom McLeish (2022) cites Karl Popper (1976[2002]), philosopher of science, who described how hypotheses may be refuted, but said nothing about how they are imagined in the first place. As McLeish states, similarly: 'If art is shy about the sweat and tears of working out the form of an original idea, then science is almost silent about its epiphanies and moments of inspiration' (2022, 4). Creativity might exist at all stages of the research process, but where it is arguably most needed is at these two stages: in forming the original idea, and in communicating those magical moments of discovery. This is certainly true for wicked problems where innovation and creativity are recognized as being central to finding solutions. As Einstein and Infeld have said, famously (1938, cited in McLeish 2022, 9): 'I am enough of an artist to draw freely upon my imagination. Imagination is more important than knowledge. Knowledge is limited. Imagination encircles the world.'

It is not so much about knowledge therefore, although obviously that is important. It is also about how that knowledge is used, and how to engage with it using the imagination. McLeish (2022, 10) clearly encapsulates the significance of this statement for us, and for wicked problems, when he says: 'The great scientist knows that we find our way to encircling the Earth, not principally by experiment, theory, deduction, falsification, or any of those important features of scientific method, but by imagination.'

We can translate this perspective directly into our own approach to wicked problems, as archaeologists. Recalling the 'seismograph' model to problem

solving, discussed and illustrated in Chapter 1 (Figure 1.5), it was stated that this approach does not reflect inefficiency or indecision. Rather, those problem solvers working with such complex problems are being creative and learning quickly, ensuring that their 'thinking pattern is full of unpredictable leaps' (Conklin 2006, 11). In addition, to repeat an important statement: '"wandering all over" is not a mark of stupidity or lack of training. This nonlinear process is not a defect, but rather a mark of an intelligent and creative learning process' (Conklin 2006, 12).

'Wandering all over' is therefore good and indeed necessary in dealing with wicked problems. We are not trying to land somebody on the moon. We are trying to rid the world of poverty (amongst other things). We will never even come close to achieving the small wins necessary to help us achieve the bigger goal without creativity and imagination, and the use of both must begin at the project design and formulation stages, taking risks from the outset and doing the unexpected where the outcomes are unknown.

In applying these ideas to wicked problems, Weber et al. (2017) recognize the need for science (as a means to helping resolve wicked problems) to move beyond its traditional approach in which: 'The authoritative power...stems from its treatment as a truth-seeking enterprise in which neutrality or objectivity—the idea that what is true is independent of what we believe—is central' (2017, 4). They go on to state how the core of a traditional or 'normal' approach involves: 'Testable hypotheses; experimentation; empirical, or evidence-based conclusions; and replicability. It also means...that the role of scientists in the policy process is distinct and separate from that of policy makers or politicians, because scientists' primary role is limited to discovering, purveying, and interpreting objective facts' (2017, 4).

In other words, scientists advise policymakers who take their science into account when making policy decisions. For tame problems, this approach is fine and works very well. It is why the approach is considered 'traditional' and 'normal'. But what about wicked problems, being those scenarios where, as we have seen already, 'facts are uncertain, values in dispute, stakes high, and decisions (often) urgent' (Funtowicz and Ravetz 1993, 739)? In these situations, and as we saw briefly in Chapter 1, Funtowicz and Ravetz support the notion of a post-normal science as a 'model for scientific argument...not (as) a formalised deduction, but an interactive dialogue...involv[ing] broader societal and cultural institutions [including] persons directly affected by a [policy] problem' (Funtowicz and Ravetz 1993, 739, cited in Weber et al. 2017, 5).

Weber et al. (2017) helpfully describe what this postnormal approach must include, and there is strong resonance here with the argument around how to approach wicked problems presented throughout the book:

> An extended peer community that purposely involves a broad array of stakeholders in order to (1) increase public understanding and/or literacy through participation; (2) represent different viewpoints in the decisions about how

problems are defined, what counts as evidence, what it means and, in some cases, the selection of programmatic (policy implementation) alternatives; and (3) democratise knowledge production and its application to wicked-problem decisions.

Or, as Sardar (2015, 37) put it: 'only variety can deal with variety.'

In short, the argument is for greater transparency within the research process, greater flexibility and ambition in terms of the expectations of research, for example, in assessing funding applications against strong criteria and a sense of having expected outcomes, and greater fluidity between the various actors, which include but are not confined to: the researchers; communities and citizen scientists on the ground; the policy entrepreneurs who use findings from that research to influence policymakers; the shapers of strategies and the creators of missions (after Mazzucato 2018); and the politicians and members of organizations (including influencers and funders) who have the capacity to make things happen. Currently the systems through which these various actors interact appear rigid and very well suited to resolving tame problems. But to raise the stakes and to tackle wicked problems effectively, requires change in all of these areas. It requires greater creativity, as McLeish (2022) puts it. Or, as Einstein and Infeld said, imagination, for 'imagination encircles the world' (1938).

Let me close this section with some final thoughts about the importance of the imagination. Brown et al. (2010, 5) highlight the fact that, across society, the imagination is central to decision-making on complex issues. Taking a similar position to that adopted by McLeish (2022) and others, they describe how: 'Accepting a central role for the imagination does not mean that we abandon standards for assessing the validity and reliability of the knowledge so generated; it indicates the potential for change and shows us where to look.'

Particularly with wicked problems that are characterized by complexity, Brown et al. (2010, 5 citing Rittel and Webber 1973) emphasize that: 'Such wicked problems require us to welcome paradox (conflicting propositions can reveal root causes) and tolerate uncertainty (recognising that there can be many solutions). An active imagination is a primary requirement if one has to deal with paradox, uncertainty and complexity.'

The imagination is also central to overcoming the structural confinement I referred to earlier. We need this to be loosened or removed altogether if we are to have any chance of success with using our discipline to help resolve wicked problems. We must also think about knowledge, however, and what this means. As we saw earlier, knowledge is important, but sometimes the process of gathering it can be equally if not more important, especially with such issues that involve citizen science, where public participation is what is needed most, for example, to address the wicked problem of poor health and well-being. It is also important to recognize knowledge not as something static and fixed but something that is alive,

'open to revision and improvement' (Russell 2010, 31). Equally important is recognizing the benefits of plurality and the fact we cannot know everything. Imagination helps us to form and consider knowledge from different perspectives, but it is vital to realize its fluidity. This is something that archaeologists have always had to contend with, given the sometimes fragile or ambiguous nature of archaeological evidence.

Trans- and Interdisciplinary Working

Amongst the key messages to emerge from this discussion, therefore, are the facts that partnerships are vital, and that we need to bring disciplines together more and to be creative if we are to successfully address wicked problems. We need to approach this from trans- and interdisciplinary perspectives in other words. I touched on this in Chapter 5 while addressing the question of entanglement. Put simply, wicked problems are deeply entangled, so perhaps the solutions need to be as well. In other words, repeating what I said in that earlier chapter: we should identify the benefits of an entangled approach in organizational terms, referring to how we act and who we interact with, alongside a realization that archaeological material matters; that it has agency.

To be interdisciplinary means collaboration between disciplines: archaeologists working with psychologists and marine biologists on marine pollution for example. But what does it mean to be *trans*disciplinary? There is less consensus on this, but Lawrence (2010, 17–18) does provide a helpful summary. Lawrence notes, first, that transdisciplinarity 'tackles complexity in science and ... challenges knowledge fragmentation' (after Sommerville and Rapport 2000). There is a close alignment again here with wicked problems in that transdisciplinary approaches deal with research problems and associated organizations, including climate change and health. Lawrence (2010) also notes that this approach is characterized by its 'hybrid nature, non-linearity and reflexivity, transcending any academic disciplinary structure' (after Balsiger 2004). Second, transdisciplinary research is context specific, accepting both local situations and uncertainties (after Thompson Klein 2004). Third, transdisciplinary approaches are intercommunicative, meaning that research and practice must remain closely collaborative throughout the research process. This essential relationship has been referred to also as border work or boundary work, as previously discussed in relation to climate change in Chapter 2. Finally, transdisciplinary research is often action oriented, both between disciplines and between theory and practice. So, with wicked problems, research will generate knowledge about the problems while also looking for contributions to their resolution. But as Lawrence concludes (2010, 18) this is not to imply that all transdisciplinary research must be applied. In fact that would be restrictive, given that successful research into the analysis

and interpretation of complex social and environmental matters can also be achieved in this way.

As Lawrence (2010, 28) concludes, there are good signs that this approach is actually working. Citing Thompson Klein (2004), who states that people today are beginning to realize the need to deal with interrelated problems and not confine themselves within preordained disciplinary boundaries, Lawrence (2010, 29) aligns this integrated transdisciplinary approach with post-normal science, which I defined in Chapter 1, referred to earlier in this chapter, and will refer to again later. Lawrence (2010) rounds this all off by defining open transdisciplinary inquiry as an approach which 'includes the knowledge held by civil society, and recognizes the necessary role of the imagination among the diverse contributions'.[5]

One aspect of that 'knowledge held by civil society' is Indigenous knowledge, which was discussed under the issue of climate change, in Chapter 2. In the case of the Inuit (northern Canada), I highlighted the dynamic nature of traditional or Indigenous knowledge and how this held significance for its capacity to 'equip Inuit for rapidly changing climates' (Desjardins et al. 2020, 246). We saw a similar argument from East Africa (after Richer et al. 2019) and how this traditional knowledge can translate into policy. These examples also highlight the connections that exist between themes that unify on the one hand Indigenous philosophers and on the other hand deep ecologists who view the Universe (and our place within it) as 'inherently dynamic, constantly changing in a process of renewal and profoundly interrelated... opportunities to establish new truths in knowledge systems—the need to seek alternative ways of living and to create a balanced respectful set of relations with other peoples and the Earth' (Arabena 2010, 262).

Arabena, a descendent of the Meriam people, from Murray Island in the Torres Strait, approaches all knowledge indigenously, to 'unify diversity in a way that promotes equality between any human to assist others of any species' (2010, 264). To achieve this, Arabena provides what she describes as an 'Indigenous paradigm', as a 'different kind of knowing, a different way of knowing':

> When do I listen? What are my ceremonies? What do I need to know? Wouldn't it be interesting if...? What is sacred? What am I prepared to die for? What would make me want to live? What would allow me to supplicate or surrender? What am I held by? What is the largest construct that holds me? (Arabena 2010, 264)

It is worth continuing this citation to explain how this paradigm and how these questions shape the way we could helpfully think through wicked problems, as

[5] There is that word again: 'imagination'.

archaeologists even if not also as Indigenous people. Arabena goes on to say, for example, that:

> These questions helped me to gain a certain level of consciousness in relation to myself and in relationships with others. First, these questions as they are written were the inward journey. When coupled with and about relationships with others, they helped me to acquire sensitivity to the wisdom and the nature of relationships. From this I was able to make the necessary adjustments for synergistic thinking and action. I found that when I gave myself disciplined attention to these types of questions, I was able to have the experience beyond the belief, the meaning beyond the mind, intuition beyond reason.
>
> (Arabena 2010, 264)

This perspective seems vital to successful transdisciplinary working, moving beyond the conventional relationships (between researchers and policymakers for example) and the typical ways of thinking and doing. By shifting gears and paradigms we can begin to view these wicked problems from another angle entirely, using our imagination and creativity to offer new approaches and maybe find some new solutions. This could[6] be a universal objective. This book concerns the contributions archaeologists and heritage practitioners can make to achieving it. How we think, as archaeologists and heritage practitioners, and how we approach and frame our work around these problems, is vital if we are to be successful.

Let us now look at some of the frameworks within which that success might happen.

Frameworks

The Doughnut and the Rainbow

The missions approach that I described earlier is a framework. But I would argue that this is also a way of thinking through how we approach wicked problems. It is an intellectual framework in other words. The two frameworks that I am about to describe—the Doughnut and the Rainbow—are more practical, for example in terms of how one might approach planning such a mission. But there are overlaps and the boundaries around this definition admittedly are blurred.

Let us begin with the Doughnut, the intellectual context for which featured in the chapter's opening quotation. At its simplest, the Doughnut (as the basis for

[6] Should!

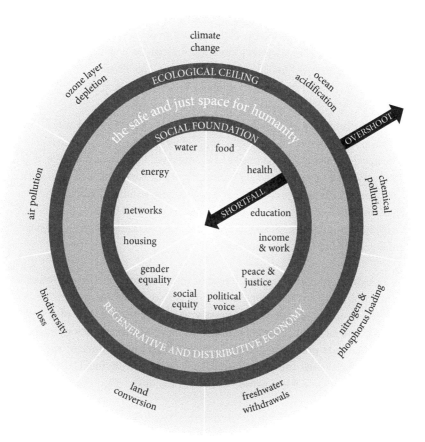

Figure 8.2 The Doughnut of social and planetary boundaries

Notes: Doughnut Economics aims to reach the sweet (and safe and just) spot between the social foundation of human well-being (the inner circle) and the ecological ceiling of planetary pressure (the outer circle).

Source: After Raworth (2017a). Credit: Kate Raworth and Christian Guthier. CC-BY-SA 4.0.

what has been referred to as Doughnut Economics, after Raworth 2017a and 2017b) comprises two concentric circles, the outer circle representing the planetary system and the inner circle the societal system (Figure 8.2). Together, these circles provide what we might consider to be the 'boundaries of acceptability'.

To provide some depth to this simple description, we can cite the person who developed Doughnut Economics as a 'new model of human well-being... to guide humanity in the Anthropocene' (Raworth 2017b, 48). Kate Raworth (2017b, 48) presents the following summary of the model:

> The Doughnut combines two concentric radar charts to depict the two boundaries—social and ecological—that together encompass human wellbeing.

The inner boundary is a social foundation, below which lie shortfalls in wellbeing, such as hunger, ill health, illiteracy, and energy poverty. Its twelve dimensions and their illustrative indicators are derived from internationally agreed minimum standards for human wellbeing, as established in 2015 by the Sustainable Development Goals adopted by all member states of the United Nations.

The Doughnut's outer boundary is an ecological ceiling, beyond which lies an overshoot of pressure on Earth's life-supporting systems, such as climate change, ocean acidification, and biodiversity loss. Its nine dimensions and their indicators are defined by the planetary boundaries framework, which seeks to identify and safeguard critical processes that regulate Earth's ability to sustain Holocene-like conditions, and this framework was likewise revised in 2015. Between these two sets of boundaries lies an ecologically safe and socially just space in which all of humanity has the chance to thrive.

The Doughnut provides a useful frame of reference for considering responses to wicked problems, not least for the very facts that define them as being wicked: their irresolvability alongside the urgency with which some kind of a solution is required. The fact that solving a problem in one place (thematic or geographical) might exacerbate problems elsewhere is also a defining feature of wicked problems. Helpfully also, the Doughnut aligns directly with the UN's Sustainable Development Goals which, as we have seen previously, align closely with wicked problems.

As Raworth (2017b, 48–49) concludes, the Doughnut has four key implications, 'for the pursuit of human wellbeing in the Anthropocene'. And as the source of these ideas I will quote the author directly and in full:

First, it highlights the dependence of human wellbeing on planetary health. The Holocene is the only epoch in Earth's history in which it is known that humanity can thrive. The best chance of enabling a life of dignity and opportunity for more than 10 billion people over the coming century therefore depends on sustaining Holocene-like conditions, such as a stable climate, clean air, a protective ozone layer, thriving biodiversity, and healthy oceans. Second, the concurrent extent of social shortfall and ecological overshoot reflects deep inequalities—of income and wealth, of exposure to risk, of gender and race, and of political power—both within and between countries. The Doughnut helps to focus attention on addressing such inequalities when both theorising and pursuing human wellbeing. Third, the Doughnut implies the need for a deep renewal of economic theory and policymaking so that the continued widespread political prioritisation of gross domestic product growth is replaced by an economic vision that seeks to transform economies, from local to global, so that they become regenerative and

distributive by design, and thus help to bring humanity into the Doughnut. Last, the Doughnut might act as a twenty-first-century compass, but the greater task is to create an effective map of the terrain ahead. Thanks to ongoing socio ecological systems research, this century is likely to be the first in which humanity begins [to more fully] understand and appreciate the complex interdependence of human wellbeing and planetary health.

The Doughnut is therefore a helpful framework not only because of its close alignment with wicked problems, but also for the structure it can provide for archaeological and heritage-related projects that might provide small wins for some of those problems. It also provides a clear way of articulating the need for balance and how that can be achieved. The fact that the Doughnut makes archaeological references (to an optimum Holocene existence for example, and future orientation in the form of 'the terrain ahead') can only help. Certainly, the Doughnut is better known and understood within fields such as economics and business management, as well as within social science circles, but I would argue that it has a much wider relevance than that. A Doughnut Economics Action Lab exists at Oxford University, and this transdisciplinary research environment may be just the place for the creative boundary work referred to earlier, to take shape, incorporating Indigenous knowledge alongside the evidence and opportunities that archaeology can provide.

So from one circular model let us now consider another—this time the Rainbow.

In Chapter 1, the trajectory of the notion of wicked problems was described and illustrated. Use of the concept began very slowly with regular citation coming only thirty years after the original publication (being Rittel and Webber 1973). While nothing like as slowly, the Rainbow Model (also known as the Dahlgren-Whitehead Model, after Dahlgren and Whitehead 1991; see also Dahlgren and Whitehead 2021) took a while to emerge; its creators describe it as an 'accidental success'. However, as Dahlgren and Whitehead (2021, 21) explain:

Thirty years on, a Google search for the model produces half a million hits in peer reviewed papers, student textbooks, dissertations, government reports, online training courses and so on. The image has been recreated on medals and badges awarded as prizes. It has even been used as a symbol for public health work in general, with public health officers in one Swedish county wearing pins on their jackets with this symbol.

In 2015, the model was chosen by the United Kingdom's Economic and Social Research Council as part of its 50th-anniversary celebrations as one of the 50 key achievements over the past 50 years of social science research that were 'important work of research that have had a major impact on our lives', with the citation:

'The Dahlgren-Whitehead rainbow model remains one of the most effective illustrations of health determinants and has had widespread impact in research on health inequality and influences.'[7]

It will be obvious already, just from these introductory words of explanation, that the Rainbow Model is mainly used within the context of population health. However, not exclusively so.[8] It is significant, for example, that the same model has been used to address the wicked problem of ocean health (de Salas et al. 2022). de Salas et al. helpfully summarize how to read the Rainbow Model (and see Figure 2 in de Salas et al. 2022 for a simplified illustration of this). It is, in essence, a socio-ecological model, so it involves, primarily, mapping relationships between people (or actors, in terms of actor network theory) and the environment within which they operate. These different determinants of health and policy interventions are then arranged on five hierarchical levels, as illustrated in Figure 8.3.

As de Salas et al. explain (2022, 5), the higher the level (the furthest from the centre), the larger the entity and group of individuals it encompasses. In addition, the model 'allows for interactions between and within factors on the different levels' (2022, 5).

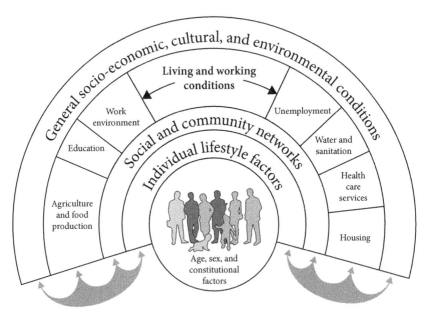

Figure 8.3 The Rainbow Model showing, in this case, the main determinants of health
Source: After Dahlgren and Whitehead (2021).

[7] https://esrc.ukri.org/about-us/50-years-of-esrc/50-achievements/the-dahlgren-whitehead-rainbow/
[8] Just as Doughnut Economics needn't be confined to economics!

It seems like a very simple model. So why is it so helpful? In their 'reflections' paper, written to accompany the Model's thirtieth anniversary, Dahlgren and Whitehead (2021, 21) highlighted five areas where it had made an impact in relation to its original intended scope of health science. First, they described how it triggered a 'lightbulb moment', encouraging people to think beyond just health services and the health sector to the wider social determinants of health in local environments and society as a whole. It seemed particularly helpful for professionals and policy-makers operating in diverse sectors outside the health sector. Whitehead

> vividly recalls a housing officer for a city council coming up to her early on and explaining that the model caused a 'lightbulb moment' for him: he recounted how he suddenly realised that his work in housing could influence the health of local residents and where he fitted into the grand scheme of things.

Second, it has facilitated the multisectoral action that is needed to successfully begin to address wicked problems, such as health. As Dahlgren and Whitehead themselves state (2021, 21), 'the model has proved useful in getting people in different sectors to work together on a common goal'. Third, it combines a holistic perspective with relative simplicity, meaning the model is not overwhelming, for example to non-academic or non-professional people. Fourth, it takes a broader view of the problem rather than focusing on specific aspects of it. This may seem to run counter to the small wins framework that I have been advocating, but in fact the two work together well, with the Rainbow providing the overall context within which small wins can be articulated and then achieved. Finally, the Rainbow Model provides a theoretical framework with the capacity to identify, 'layers of influences on health, expanding perspectives outwards to the possible role of wider and wider determinants of health, and building up a complete picture. It has even been used as a kind of logic model in systematic reviews to help identify relevant intervention studies in diverse fields' (2021, 21). This last point aligns the Model almost precisely to the small wins framework.

As previously mentioned, de Salas et al. (2022, 12) explain how this same model can be applied to another wicked problem: that of ocean health. In their conclusions they state that one way to do this is to:

> Encourage and grow the development of cross-discipline teams that [comprise] members with expertise in the relevant levels of the rainbow model of ocean health. A further recommendation pertains to improving our understanding of how issues, such as ocean health, become salient social problems that necessitate policy changes—and how to influence such changes in problem understanding.

Here three central themes of this book come together. One is the need for new understandings, new knowledge. In the case of ocean health and linked to the

Galápagos project described in Chapter 3, this new knowledge may relate to 'taps' (where the plastic is coming from), 'sinks' (where it is ending up) and the human behaviours and natural processes that are causing plastics to take a particular journey from one to the other. The second is the contribution that small wins can make to help mitigate the wicked problem. And third is the role of policy entrepreneurs being, as described in Chapter 1, those people well positioned and qualified to communicate the significance of research results to policymakers. This brings us seamlessly to the question of policy.

Policy

This is a complex and wide-ranging subject area meaning that realistically I can only scratch the surface in this chapter. I will do this by retaining a specific focus on the transformative role of archaeology and heritage and on the relationships these areas of research and practice can expect to develop with policymakers, through policy entrepreneurs, as we saw in Chapter 1. I will refer here to what I consider some of the key concepts and messages that I think archaeologists and heritage practitioners should be aware of if their work is to have policy impact. Obviously this is not exhaustive and equally some aspects (many, in fact) have been presented at various points throughout the book, not least in Chapter 1. I will discuss windows of opportunity for policymaking. Attention will then turn to the various types of relationships that exist between practice and policy. I will then refer to evidence-informed policymaking. Finally I will discuss COVID-19 as an example of all of this, building on what was said previously around the COVID-19 pandemic specifically by archaeologists, in Chapters 3 and 4.

But let us begin with a brief word on policymaking, and then on windows of opportunity. Here we can return to the classical world and to Aristotle, following Herbert Gottweis (2006), who has analysed the concept of policy in terms of argumentation (and see also Wagenaar et al. 2023 for an application of these ideas to heritage management). Gottweis presents Aristotle's notions of 'logos' (the logical construction of arguments), 'ethos' (the legitimacy of the speaker), and 'pathos' (how the speaker can appeal to the emotions of the audience). A compelling argument, Gottweis suggests, will involve a combination of all three elements. Gottweis's (2006, 476) main argument in drawing on Aristotle is that too much attention is usually paid to 'logos' in policy analysis, and not enough to 'ethos' and 'pathos'.

Policymaking is the process by which governments translate their political vision into programmes and actions to deliver 'outcomes', these being desired changes in the real world. As we have seen in Chapter 1, this translation often involves policy entrepreneurs playing a vital role in lobbying decision-makers or at least those advisors who have direct access to policymakers. Examples might

include the promotion of new archaeological evidence related to climate change in the hope this might merit inclusion in the next round of IPCC reports. As was stated in a recent summary of the significance of these IPCC reports: 'When it comes to getting decision makers to pay attention to scientific evidence, there are few better—or perhaps better-known—examples than the Intergovernmental Panel on Climate Change' (Anon 2023).

The relationship between science and policy within this particular arena is the subject of a review by De Pryck and Hulme (2023). There are certainly many positives within this particular example and archaeological evidence *can* be closely and critically reviewed to the point where it has the potential to at least help shape policies on climate change. One of the reasons for this is that: 'researchers employed by participating governments are among the members of the teams reviewing the literature. Scientists representing governments sign off the "summary for policy-makers", which synthesizes the research into a booklet using language that can be understood by non-experts' (2023).

Of course this is excellent. Language is vital, and good communications are an essential part of this relationship. But returning to some of the arguments presented in Chapter 2, there is an absence of archaeological evidence being scrutinized. It is almost as though 'the scientists' exclude archaeologists (which they do, as we have seen), and have little enthusiasm for reviewing the archaeological evidence which is produced by them.

Other examples covered in this book include (from Chapter 3) the opportunity to use the results of archaeological (and other related) work in Galápagos to inform policy around single-use plastics and arguably also fishing activities close to the marine reserve, on the basis that many of the plastic items washing ashore are originating with the international fishing fleet. As archaeologists we might also highlight (from Chapter 4) the role of cultural participation in promoting people's physical and mental health, as well as archaeological approaches towards social injustice (Chapter 6) and mitigating the impacts of conflict on populations and on cultural property (Chapter 7). These are all areas where archaeology can make a difference through policymaking, at least in theory. However, to do so requires good evidence that makes good stories (which exist in abundance), and it requires strong advocates in the form of policy entrepreneurs. This is where I think the priority lies, and where a significant gap currently exists.

However, policy windows or (to use another term) windows of opportunity are also vital. I co-authored a paper about this specific issue recently in relation to the COVID-19 pandemic and single-use plastics, at a time when virtually the world's entire population came to rely on a particular category of single-use plastics in the form of personal protective equipment, or PPE. In exploring the role of media (and in particular social media) in framing these policy windows, we said the following:

> In times of crisis, focussing events or external unexpected shocks, such as Covid-19, open policy windows to initiate change. Media are particularly quick to respond to focussing events and can contribute to how long an event is considered important and eventually to the size of policy windows. Policy entrepreneurs are often the people to drive policy change, and these include people from various professional backgrounds, bureaucracy, financial institutions, think tanks, NGOs and academia. The visible participants in agenda setting (such as politicians, elected officials, the media and decision makers) are often influenced by policy entrepreneurs who also raise public concern, come up with innovative solutions and ensure laws and policies are passed. Policy windows opened by focussing events can be found on all jurisdictional levels. However, they differ in how each level conceptualises the issue onto the agenda and how long the policy window remains open. (Vince et al. 2022, 739; citations removed)

With this COVID-19 example, however, it was complicated, not least as the health needs at this time effectively closed the window for those campaigning to reduce single-use plastics. As the pandemic began to recede, and the waste implications in terms of mountains of discarded PPE became obvious, the window around single-use plastics opened once again. And that is just the plastic. COVID-19 also presented other windows of opportunity. Bricout and Baker (2021, 94), for example, describe how:

> The Covid-19 pandemic has occasioned a sudden and drastic shift to digital technology-mediated, pervasive, applications across broad swathes of society, including education, business, health care and government with effects that are anticipated to extend beyond the immediate health crisis.... Technologies such as the Internet of Things (IoT), big data analytics, artificial intelligence (AI), and a variety of tools for overcoming social isolation and enhancing digital lives, such as virtual reality, holograms and streaming video have been given a large boost by the pandemic.

In this case, the window has created the opportunity not for policy so much as for innovation. But innovation can help shape policy, for example relative to social injustice (through addressing social isolation, as we saw with the Romans at Home project in Chapter 4). As Grint (2022, 6) says, these advances in AI and big data 'should be able to generate sufficient computing power to address wicked problems that we previously had been unable to tame'. But it isn't that simple. It never is with wicked problems. As Grint (2022, 6) recognizes:

> Even if we had the supercomputers to handle all the variables, we are still left with choosing what to do with data results. For instance, were we to understand how to curb global hunger with the help of AI, we would still need to consider whether

we had the right to force farmers to change their practices, to displace existing market mechanisms with administrative controls, and to allocate power and rewards on some 'rational' basis.

This is something else that we need to get better at therefore: recognizing these policy windows when they occur and, even more, being able to anticipate them and the ethical and moral issues that they might present. Archaeology and heritage practice are often considered a low priority relative to more pressing social and economic needs (the housing crisis, homelessness, climate change, environmental pollution). The point of this book is that these issues are not separate but rather they are entangled, as we have seen, and that, within that context of entanglement, archaeology and heritage practice are well suited to addressing some of these problems. This means that, as archaeologists and heritage practitioners, we need to be both proactive and confident in promoting the wider benefits of our work, and alert to opportunities to undertake this promotion to the best effect, contributing meaningfully to these 'more pressing needs'. Returning to the head of this chapter, this was one of Chirikure's (2021) main points: that archaeologists have the potential to achieve influence on policy. I agree with that. I am less persuaded by his conclusion however that to achieve this requires 'disciplinary overhaul'. I think the discipline is in good shape and doing excellent work. The needs involve better communication and improved alignment with policy frameworks and with policymakers. To do that we need to learn to use a new language, which is also partly what this book is about. We also need to teach our students this language, giving them the confidence to use it, and this may also require us to re-evaluate how we think about leadership within the heritage sector. I will come to these two topics later in the chapter.

But let us return to the nature of the relationship between research and policy, a relationship that is vital to understanding impact. These types of relationships have been implicit if not clearly stated throughout this volume. And recall also that somewhere in the middle ground of each type of relationship there should be policy entrepreneurs, albeit acting in a slightly different way depending on the nature of the relationship. It is important to appreciate this complexity as often only one model is presented or considered. Figure 8.4 presents a simplified version of four types of relationship that can exist between research and policy (after Boswell and Smith 2017, 2). The first is an approach that focuses on what Boswell and Smith (2017, 2) refer to as the 'supply model', whereby knowledge and ideas shape policy. The second approach is focused on how political power shapes knowledge. The third approach takes this idea further by suggesting that 'knowledge and governance are co-produced through an ongoing process of mutual constitution' (2017, 2). The fourth and final approach suggests that there is no relationship between science and policy with policymakers selectively appropriating and giving meaning to the results of scientific research.

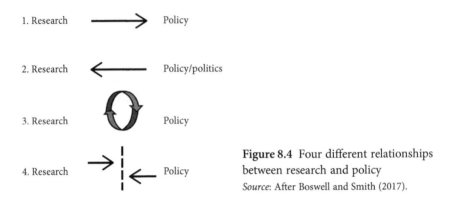

Figure 8.4 Four different relationships between research and policy
Source: After Boswell and Smith (2017).

As Boswell and Smith (2017, 2) state, this schema provides a helpful framework, for two reasons:

> First, it offers a classificatory tool for mapping, comparing and analysing a range of often disparate theoretical approaches in the emerging field of knowledge-policy relations-theories that emanate from a wide set of social science disciplines, and are informed by quite divergent assumptions about knowledge and governance. The second, more applied, use of the schema is to identify the plurality of ways of conceptualising knowledge-policy relations. In doing so, we demonstrate that prevalent models of impact are based on one particular set of assumptions about the role of research in policy, and not necessarily the most theoretically sophisticated at that.

The authors proceed to offer more detail on each of these four approaches. This detail is both interesting and relevant but perhaps not essential for this current discussion. Here it is more important to recognize the different types of approach, and the different roles that science (in this case archaeology and heritage practice) can play in shaping policy. Brian Head has discussed this in terms of what he refers to variously as 'evidence-based policy' (2010) and 'evidence-informed policymaking' (2015). In the first of these two papers, Head (2010) describes the long history of evidence-based policy, dating back to at least Early Modern Europe. He highlights the importance of this strategy, not least in medical research. He also helpfully identifies four crucial enabling factors which

> need to be promoted as a basis for constructing a more robust evidence-based (or at least evidence-informed) system of decision-making.

1. High-quality *information bases* on relevant topic areas;
2. cohorts of *professionals with skills* in data analysis and policy evaluation;
3. political and organisational *incentives* for utilising evidence-based analysis and advice; and
4. substantial *mutual understanding* between the roles of policy professionals, researchers and decision-makers. (Head 2010, 81–82; emphasis in original).

From the chapters in this book, and from the examples included within them, we can see instances of all of these factors but, crucially, never all in each case. To be successful in delivering research that has genuine social or environmental impact does require the full set of these enabling factors built around a solid information base. Over a decade ago, Head described evidence-based policy as being 'in transition' (2010, 88). This remains the case.

Let us briefly consider just one central aspect of this situation: relationships. Both in terms of policy entrepreneurs (whose role might be dependent on which of Boswell and Smith's (2017) four approaches are applicable) and in Head's (2010) four enabling factors, relationships are central and these play out across and throughout the three areas of: research, policy, and practice (e.g. Shonkoff 2000). Without good productive relationships along clear and trustworthy channels of communication, these linkages between science and policy simply cannot develop. This is therefore a priority, and eight areas have been identified where efforts could usefully be focused in building these relationships (after Mitton et al. 2007, 744, cited in Head 2015, 478–479):

1. Face-to-face exchange (consultation, regular meetings) between decision makers and researchers
2. Education sessions for decision makers
3. Networks and communities of practice
4. Facilitated meetings between decision makers and researchers
5. Interactive, multidisciplinary workshops
6. Capacity building
7. Web-based information, electronic communications
8. Steering committees (to integrate views of local experts into the design, conduct and interpretation of research).

As above, some of these strategies are already in place but some are not and one of the key gaps involves those crucial relationships involving scientists and policymakers. It is here that progress needs to be made. Recalling the Rainbow Model earlier in the chapter, I will continue this discussion in the next section, presenting first the role of leadership in managing wicked problems, and then the role of pedagogy: what should we be teaching our students in order to equip them

to be successful archaeologists who can build such relationships in the future, with their success measured in terms of impact, often if not typically relative to wicked problems.

So far in this chapter, I have looked at some ways to approach wicked problems through archaeology and heritage practice (using the context of missions-based and creative transdisciplinary perspectives, for example), and some frameworks for doing so (the Doughnut and the Rainbow, as ways of connecting science with policy) and through the need for good relationships between research, policy, and practice. In the language of Aristotle (after Gottweis 2006), we need more 'ethos' and definitely more 'pathos'. This all obviously touches on the question of impact, and it is a question both in terms of its definition and how it is measured, not to mention what we might recognize as success. This important topic is closely related to the subject of the previous sections on and the relationships that can exist between research and policy. Within the UK academic sector, and many other nations' academic sectors, these kinds of policy impacts are now a key measure of academic success. This has been discussed recently by Oancea (2019) and Chubb and Watermeyer (2017) for example. But rather than focus on that here (and not least because impact is implicit throughout this and the earlier chapters), I will instead finish this book by concentrating on two related issues that will directly shape archaeology's capacity to deal with wicked problems and their impact in the future. Those issues are leadership and pedagogy.

Some Final Thoughts on Leadership

In previous chapters, some important points were made about project management and its impacts, and about ways of successfully managing expectations. These points merit a degree of framing and some thoughts on leadership offer an appropriate context through which to provide this. To recap, in Chapter 2 I presented the view that archaeological data are not always (if often) presented by policy entrepreneurs in settings where they might catch the attention of policymakers and politicians. This raises the question: how can future research leaders help to better facilitate this provision of data to people who have the capacity to exert influence and create change? Another question concerns sustainability, and thinking beyond small wins that only have an immediate benefit, for example, to participants. This was discussed in Chapters 4 and 6 in relation to the various health and mental health benefits of heritage participation. Again, in these situations, how can leadership help to ensure further and sustained success? In Chapter 7, and specifically in the context of conflict resolution, Menkhaus (2010, 98) described a particular role for leaders, stating that they could:

Cajole, encourage, and shape [and] attempt to reshape the interests of political elites through the usual array of carrots and sticks; work around them by searching for 'clusters of competence' on which to build within the weak government; or, as has occurred in several places, work to replace incorrigible leaders in the hope that the replacement leadership will exhibit a greater commitment to state building.

So what do we need in order to make all of this happen, to give ourselves (in this instance as a community of professionals and practitioners involved with the related studies of archaeology and cultural heritage) a chance to successfully deliver meaningful impact relative to these wicked problems? We might say, for example, that we need to frame our conversations more around these problems and on how our work might align with them in a more effective and impactful way. But we may also need to address how meaningful and impact-led conversations might happen in the first place. Perhaps we spend too much time on debate and not enough on dialogue.[9] There may also be an issue around creativity and risk. Is there a tendency amongst funders to reduce risk for example and tend towards supporting projects that are more conservative or conventional, or just safer and more predictable? As within the business sector, we might suggest and promote the need to pursue bold ideas and explore options for the new design of business actions. We might highlight the aspiration to move creative ideas and creative thinking from the margins to the mainstream and encourage more and better 'thought leadership'.

Some of these same ideas and suggestions are promoted by Keith Grint, a public leadership scholar whose ideas I have discussed on occasion throughout this book. Most recently, for example, Grint (2022, 1529) discusses the different types of leadership required to help manage wicked problems such as the COVID-19 pandemic and climate change. His argument is that, in what he describes as unprecedented times, we either need to comply with commanders, 'whose unique skill set will guide us safely through the storm to the sunny uplands [beyond]', or gather behind more 'collaborative forms of leadership' (2022, 1529). Grint's conclusion is that neither of these approaches will help overcome or even mitigate wicked problems. Instead we need to recognize how the different types of leadership (or leadership models) relate to different aspects of the problem. With COVID-19 for example, there are three distinct problem areas, and they all require different approaches. To cite Grint on this (2022, 1528): 'we need commanders to coerce the recalcitrants to comply with the critical problem of lockdowns, we need managers to ensure the technology of track and trace systems

[9] In debate, generally the aim is to prove you are right and they are wrong; with dialogue, the starting position is that 'I *might* be right'. With debate we wait for the pause and then start shouting! Social media exacerbates this.

and vaccine programmes actually work, and we need leaders to engage the collective that supports the vulnerable wherever necessary.'

We can see very clearly how leadership and the progress of the pandemic in different countries are related. The degree of correlation versus coincidence probably still needs unpacking, but there are nonetheless interesting trends between those countries, relating to the extent and strict enforcement of quarantining, for example.

This example may not be very archaeological, but the same criteria and the same issues also relate to those wicked problems where archaeological interventions may have a more significant part to play. The examples in this book are all relevant here. And with those numerous and diverse examples in mind, let us be very clear on what Grint thinks about leadership in this context. In the past,

> critical problems (problems that are self evident yet still complex) required 'commanders', decisive individuals who could provide the answer to the problem and coerce others, where necessary, to ensure the collective good. Tame problems required 'managers' whose job was to provide or delegate the process that would resolve the problem, though this usually meant ensuring some skilled subordinate would take the responsibility and thus management was often regarded as relatively boring, by comparison with the allegedly more exciting world of leadership... that I confined to wicked problems. Such 'leaders' who, recognizing their own limits and the wicked nature of the problem, would engage the collective to address the problem. (Grint 2022, 1519)

This is one of the central points to the argument. In managing wicked problems from any angle and from the perspective of any particular discipline, commanding or managing will not usually be the best approach. As we saw in Chapter 1 and then throughout the thematic chapters, initiatives are generally more successful when they are inter- and ideally also transdisciplinary, involving academic researchers, industry, policymakers, and communities, for example. Good leadership involves drawing these various communities of interest together to deliver successful interventions and impact. Small wins can be managed (almost as tame problems) but always in the context of the wider wicked problems of which they form a part. As Grint also said, and recalling the terminology discussed by Dugmore et al. 2013 and others): in an age of uncertainty, we are looking for clumsy solutions, and it takes good leadership to successfully deliver on these.

This is therefore the main distinction between leadership and project management. Leadership involves drawing the various communities of interest together to deliver successful interventions and impact, and this applies to the broader wicked problems (and arguably at the level of missions, after Mazzucato 2018) where a diversity of interest groups, communities, and organizations are involved, often on an international scale. For the small wins, however, these often arise from

specific projects that are subject to simpler models of project management. One of the reasons that project management is more straightforward (beyond simply the scale of the operation and more attainable goals) is the relative absence of what Conklin (2006, 23) describes as 'social complexity' which is much more prevalent within leadership. Simply, the more diverse the parties involved in a project, the more social complexity will exist. This presents a dilemma for leadership. On the one hand it makes solutions harder to reach, because of the diversity of viewpoints and perspectives within the leadership (or the management) team. But it also makes it more likely that the creative solutions that these teams eventually reach will be more durable and robust.

If we return to Figure 1.5, Conklin's 'waterfall' model was presented alongside the 'seismograph'. In the waterfall, project management progresses seamlessly and often painlessly from stage to stage: learn > develop > analyse > implement. Many archaeology and heritage-based research projects follow this path. Many of the examples of small wins included in this book are examples of this approach. Funding bodies like this model. It is neat and the results are predictable and are usually therefore delivered on time. The seismograph is far more of a challenge. Some more experimental projects might follow this model, if a new method is being tested out, for example, or entirely new perspectives are being explored. In this approach, one only knows about the next step, the following one being dependent entirely upon its outcome. This is also how leadership works, at least as it applies to wicked problems. Thus, in terms of project management and funding models, the small wins approach is a better match for archaeology, albeit within the framework of the wicked problems those projects are seeking to address.

Finally in this section, I continue with Keith Grint's (e.g. 2010a) notion of leadership and make a few further observations by way of conclusion. In short, my aim here is to align these theories around leadership with the possibilities to review the expectations of leadership within the heritage sector, particularly if we are to align our work with wicked problems in the ways that I am suggesting. I will use one of Grint's (2010a) diagrams to illustrate these closing observations.

Grint (2010a, 21) presents as a graph what he refers to (helpfully and accurately) as a 'typology of problems, power and authority'. The graph (Figure 8.5) presents the nature of problems on one axis against notions of power on the other. The problems are: 'critical' (such as a radioactive leak, terrorist attack), tame, and wicked (as previously defined in Chapter 1). The notions of power are: coercive, calculative, and normative. Coercive power relates to the way control is physically maintained in institutions such as prisons and armed forces. Calculative power relates to what Grint refers to as rational institutions, such as companies. And normative power, which has a more emotional foundation, relates to institutions with shared values such as professional societies. Put more simply, and as Grint (2010a, 21) states: 'You cannot force people to follow you in addressing a wicked

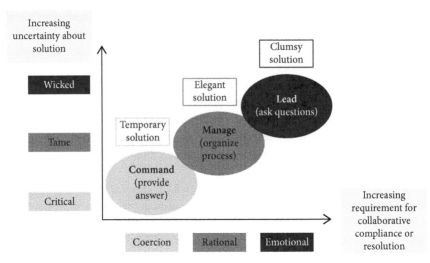

Figure 8.5 A typology of problems, power, and authority
Source: After Grint (2010a, 21).

problem because the nature of the problem demands that followers have to want to help.' These concepts then map onto the models of leadership defined previously, as shown in Figure 8.5.

Thus, small wins require rational management. The types of projects referred to in this book may be undertaken by universities or contracting companies. The problems they address at a local scale may be tame. However, the context will often be wicked, requiring overview and strategic direction, with those projects being undertaken within one disciplinary field integrated within both inter- and transdisciplinary contexts. Here social complexity will exist and a collaborative, normative approach will be required, often starting with the very head of the sector concerned. For this, leadership is needed and a leadership that aligns itself to a recognition of and commitment to resolving one or more wicked problems.

Grint also helpfully defines the characteristics that leaders need to adopt if they are to successfully lead their sectors into creating the kinds of 'clumsy' solutions required for resolving wicked problems (2010a, 26–31; Dugmore et al. 2013). He summarizes these characteristics, recognizing that every problem will be different and each will require a unique combination of these perspectives and approaches. As he says (2010a, 26): 'This is not a painting-by-numbers approach to guarantee a resolution but an experimental art form that may—or may not—work.'

First, there is likely to be a need for characteristics that align with what Grint refers to as hierarchists, who need to reverse their role from giving answers to asking questions; or, in other words, to change their role from one of expert to investigator. Second, they need to change dependence from structures to relationships. As Grint (2010a, 27) puts it: 'Power is a relationship, and change depends

on the relationships between leaders and followers.' This reminds us of Zimmerman et al.'s (2010) comments on a translational approach and being prepared to surrender authority to those communities one is working with and for (see also Wickens and Gupta 2022 on this subject relative to white supremacy culture in conservation). Finally, hierarchists have the capacity to authorize changes in practice, for example by facilitating and encouraging open debate and disagreement. Thus, for all these reasons, hierarchists are important.

As are individualists who must create the space for entrepreneurship and novel thinking. These are the people who often deviate from the norm, embrace ambiguity, or who are comfortable with uncertainty. Grint (2010a, 28–29) uses the poet John Keats's[10] notion of 'negative capability', the capacity to accept 'uncertainties, mysteries, doubts, without any irritable reaching after fact and reason', to characterize the, 'time and space to reflect upon the issue [and] not to have to react to somebody else's agenda or to be decisive'. Individualists also display constructive dissent and not destructive consent. They tend not to fall in line. As Grint (2010a, 30) puts it: 'destructive consent is the bedfellow of irresponsible followership and a wholly inadequate frame for addressing wicked problems.'

Finally, are the qualities of egalitarians, for whom, 'it isn't the rules that need altering and enforcing but [rather that] our communal attitude to the planet needs to change—we must develop more sustainable ways to live, not just obey the rules better' (Grint 2010a, 24). Success in business is more often due to social rather than individual action. Collective intelligence is therefore more important than individual genius. This is certainly true for wicked problems because they 'demand collective responses typical of systems not individuals' (2010a, 30). Grint gives the example of a community leader who mobilized her local community against a gang of youths engaged in antisocial behaviour. He describes how a fatalist community (all complaining but feeling unable to do anything to address the problem) transitioned into a community of fate, by confronting the gang as a community.

Empathy is another vital characteristic and, according to Grint (2010a, 31), a prerequisite for addressing wicked problems. Being able to step into another's shoes and see the problem from a different angle, or see the impact a problem is having, is essential to both understanding the impacts of the problem and thinking through workable solutions.

One can assume that human communities have always had leaders and followers. These relationships also exist across much of the non-human world, particularly where animals live in herds, packs, and prides. But different types of leadership have different impacts and the character of a group can take on or be shaped by a leadership style. This diversity of styles exists today, invariably given that everybody is different. Even people graduating from the same business or

[10] From a letter written in 1817.

leadership school or tradition will be different, given their unique combination of skills, life experiences, and characteristics. Some of these people will be good managers but not good leaders. Some will be exceptional leaders, for all of the reasons I have just described, but not necessarily good managers. Within the context of wicked problems, and the management of projects that align with them and which may constitute or aspire to produce small wins, it is important to match the people to the nature of the role. This is always important for business success, resilience, and longer-term viability. Within the context of climate change, archaeology has produced some exceptional data and arguments around long-term change from a deep-time perspective. Yet IPCC has barely considered them. Partly this comes down to a lack of policy entrepreneurship, but it may also come down to failures in leadership. Not management, but leadership. We could say something similar about social injustice and health and well-being, although in this latter field (and arguably also environmental pollution) there is some progress. The complexity of these problems will always present a significant challenge, and not least the entanglement of all of these various problems into what effectively constitutes a mess. But that is why strong, clear, and focused leadership is required. There is a need to focus on the present and do what we can do now. But there is also a need to look ahead to future leaders, and that is the subject I will discuss next.

Some Final Thoughts on Pedagogy

In the introduction to her *Doughnut Economics* book, Kate Raworth (2017a, 1–4) describes some of the ways that economics students have been challenging their professors over the past fifteen to twenty years, accusing them of delivering programmes that were 'absurdly narrow in their assumptions' (2017a, 1). This recognition has led to a more activist approach amongst some, leading Raworth to describe this as an 'extraordinary situation':

> No other academic discipline has managed to provoke its own students—the very people who have chosen to dedicate years of their life to studying its theories—into worldwide revolt. Their rebellion made one thing clear: the revolution in economics has indeed begun. Its success depends not only on debunking the old ideas but, more importantly, on bringing forth the new. As the ingenious twentieth-century inventor Buckminster Fuller once said, 'You never change things by fighting the existing reality. To change something, build a new model that makes the existing model obsolete.' (Raworth 2017a, 2)

On 23 June 1990, in a speech at Madison Park High School, Boston (United States), Nelson Mandela said: 'Education is the most powerful weapon which you can use to change the world.' I suspect most would agree with that statement, and

offer the complementary view that a significant role of universities is therefore to provide creative, diverse, and resilient future leaders. This is happening in economics through the building of new models to replace the old, as exemplified by Kate Raworth's work. But typically within universities we operate within silos, within departments, faculties, and schools, and in this siloed environment it can be challenging to create effective and efficient interdisciplinary collaborations, let alone transdisciplinary ones, through which strong future leaders with a relevant skill set can emerge. To meet the leadership challenges identified by Grint (2010a), academics need to be collaborative, passionate future leaders inspiring an even more collaborative and passionate next generation. These are qualities necessary for creating the possibility of long-term change. It is important, therefore, to teach students these skills and the significance of acquiring them, as well as teaching them to listen and to be resilient. And given some of the views discussed in the previous section (not least from Grint 2010a), we should also be looking to create (and teach students to prepare for) some entirely new business models: for example, new board structures that provide more opportunities for younger people. Often advisory boards and boards of trustees are composed of older people, with more experience. Younger idealists are often not welcome because they lack real-world experience. But for wicked problems we need to be creative and novel, bold in our approach. The old ways have not worked, so we need to try some new ones. I started the book by presenting an initiative of the Council for British Archaeology, a heritage advocacy organization, who created a 'letters to a young archaeologist' programme. I began this book with some extracts from one such letter. That same organization has now launched a Youth Advisory Board. As the advertisement for this initiative states:

> We are now looking to recruit 12 people, aged 18–25, to represent young people from different backgrounds across the UK. Whether you are a budding artist, a keen gardener, or a computer whizz, we recognise the value in everyone's experiences and the positive contribution you can make to the Youth Advisory Board. We are looking for young people who are passionate about making a change in society, eager to upskill, and use their voice to make a difference... in the archaeology and heritage sector, and beyond. As an organisation, there is so much we can learn from young people, and equally, we want to support their own personal development too.

In terms of governance, and how this filters through to what we deliver, we can align these kinds of initiatives more directly with society's biggest challenges—with those wicked problems covered in this book. As one example of this, my own university now exists, formally, 'for the public good'. In my own department, there is now a Leverhulme-funded centre which aligns archaeology and critical heritage studies with global challenges. And within our undergraduate programme, in 2023

we are introducing a new module for final year students, entitled 'Approaching Global Challenges: Archaeology and Heritage'. The module:

> introduces students to the ways in which archaeology and heritage interact with contemporary global challenges. We will consider how the unique transdisciplinary nature of archaeology and heritage provide imaginative solutions to complex global challenges. Thematic issues covered include climate crisis and climate mobilities, concepts of the anthropocene, environmental pollution, health and well-being, social injustice and inequality, crime and conflict, decolonisation, disaster cultures and dark heritage. These are all connected through the United Nations Sustainable Development Goals.

One aim of this module is to put some of the ideas discussed in this book into practice.

This wider framing for archaeology and heritage education within a wicked problems agenda feels important, therefore, both explicitly in the messages that it sends out, but also implicitly in the way we think, and how we prioritize and manage our programmes. Through the approach I am describing, we are well positioned to teach students, for an archaeology programme in this case, that their work as archaeologists has wider relevance than simply interpreting the past, helping them to develop some of the skills and language to extend its impact, for example, into the policy arena and into futures thinking. These are the kinds of archaeologists we need now—people with the traditional skill sets, and with open and enquiring minds, but with the addition of a very clear vision for the wider policy arena in which archaeology and heritage practice exist, and in which these related subjects can have real influence.

Put more specifically, Kawa et al. (2021) introduce the notion of 'wicked science' as a conceptual framework for training scientists to work within the context of wicked problems. As they state: 'If humanity hopes to effectively tackle the world's wicked problems, then it is time to train a generation of wicked scientists' (2021, 1). For this, they state, our future graduates must be able to:

1. Tackle wicked problems using a systems-thinking approach that considers the political roles, interests, and perspectives of stakeholders.
2. Collaborate effectively with stakeholders and team members with diverse backgrounds, life experiences, and ways of knowing.
3. Communicate scientific research and ideas to diverse audiences and through different modalities.
4. Meet ethical, collegial, and professional expectations and standards in collaborative research and other professional endeavours.
5. Articulate a sense of purpose and develop competencies, skills, and habits that prepare them for life-long learning about and engaging with wicked problems.

While in many ways, this 'wicked science' proposal does align closely with conventional transdisciplinary approaches that are covered in many if not most graduate programmes, it also takes a different course. It is, for example, specifically focused on:

> the dual scientific and political nature of the concept of wicked problems [which thus prepares] students to develop and refine skills that can lead to sustained and effective engagement with such grand challenges. This includes, for example, recognizing the different epistemological and ontological assumptions that stakeholders have about the problems at hand, and learning how to work across such differences in practical and equitable ways. Wicked science also encourages early career scientists to commit to problems that defy simple resolution but are nonetheless characterised by urgent mutual concern (i.e., shared concerns of researchers and other stakeholders). This means that wicked problems—and the strategies devised to address them—cannot be defined by scientific experts alone.
> (Kawa et al. 2021, 3)

Lehtonen et al. (2019) discuss some of these same ideas in considering climate change education, highlighting for example how: 'integrative, phenomena-based and collaborative learning builds systematic understanding of the world' (2019, 364). They present the need for new learning processes as an 'essential tool for confronting a changing world' (2019, 364). In making their pedagogical recommendations they helpfully emphasize the subject of this book's Chapter 6, on entanglement, and recalling Raworth's (2017a) Doughnut Model from earlier in the chapter, describing how earth, social, and economic systems are all deeply interrelated. They thus highlight that, 'a main principle of climate change education is that taking care of the well-being of future generations does not constitute a sacrifice. This is because an individual's interests and the common good can be aligned' (Lehtonen et al. (2019, 364). Thus, for all of these (and other) reasons, climate change education should be aimed towards:

> critical thinking about consumerism, human identity as a consumer, and prevailing ways of pursuing happiness pushed by globalisation, capitalism and advertising.... Climate change education [therefore also] applies systems thinking in order to understand how the world works... [and that] the understanding and response to climate change is socially constructed. Lehtonen et al. (2019, 365)

Finally and importantly, Lehtonen et al. (2019, 366) state that:

> It is essential that climate education be based on a scientific understanding of socio-ecological systems and the ethical dimensions of human behaviour. Connections between local and global, between individual behaviour and

communitarian practices and climate change need to be identified and illuminated through social experiences. Climate change education should be developed and enriched with contextual, subjective knowing in practice. The resulting dialogical learning situation offers open encounters where adults and young people can learn from each other and together construct pathways for a sustainable future.

This is one approach to education. Citizen science is another, with the clear implication (related to Kawa et al.'s third heading, above) that future graduates need to be well qualified to work with diverse audiences, for example, through citizen science. This is an opportunity recognized, for example, by Hodgkinson et al. (2022) who cite Brian Head's (2019, 192) call for 'governments to embrace stakeholder pluralism' in confronting wicked problems. The authors note that, by 'drawing on the enthusiasm, skills, passion, and knowledge of citizen volunteers across the world, citizen science research projects can provide a new channel to solution discovery' (Hodgkinson et al. 2022, 4).

To conclude this section, there is a need to think beyond our disciplines and into the world of policy and practice, if we are to successfully prepare future leaders for tackling wicked problems, whether as 'leaders' or as 'managers' of small wins projects that contribute to addressing those wicked problems (in Grint's 2010a terms). Some of the pedagogical priorities have been discussed briefly here. But within that framework is the need to also teach the language of wicked problems. That is one of the purposes of this book, to bring this language, the terms and the concepts, more to the attention of archaeologists and others operating within the cultural heritage sphere. These are big issues, but it is ultimately about the details: about what we teach, when, how, and to whom. But I will end on a wider point, and one articulated clearly and convincingly by Darin Payne (2022, 35). In discussing a larger curriculum paradigm within the humanities specifically, and in the context of wicked problems in a post-COVID world, Payne states that:

> Artists, storytellers, historians, and philosophers have contributions to make to the broad, collaborative efforts demanded by our ever-present wicked problems of gender discrimination, spiralling health care costs, and racial injustice, among others. The Humanities could become a powerful and visible site for developing the appropriate knowledges, pragmatic skill sets, and cognitive orientations for working on wicked problems with local and global stakeholders, across corporate contexts, government workplaces, legal and educational settings, and civic organisations.

> To develop such a curriculum broadly throughout the Humanities will not be easy, as it will necessitate greater collaborations across our own diverse disciplines and within an increasingly competitive academic marketplace, one in which we are structurally encouraged to compete amongst ourselves for majors and student semester hours. It will demand that we more directly discuss and debate

principles and practices of pedagogy, assessment, hiring, and programmatic requirements from our differing positions and perspectives.

This administrative pedagogic challenge is probably not a wicked problem so much as a 'complex tame' one, but it does need resolving if wicked problems are to feature on curricula, explicitly or implicitly, and if these programmes are to produce the future leaders (and project managers) that are required to help find resolution and begin to slowly turn the tide.

Some Final Thoughts on the Future of Archaeology

It is important to emphasize here that I am not proposing a single model for how archaeologists and heritage practitioners might employ their superpowers to address and help to resolve wicked problems. It should be obvious by now that wicked problems do not lend themselves to such a neat solution. Wicked problems are messy, and the solutions are likely to be clumsy. And hard to achieve. But archaeologists can use their superpowers to make a difference through the small wins framework that I have proposed and they can do that in many different ways. Arguably most archaeologists are doing this already, even though they may not recognize their work and its successes in these terms. What archaeologists then do with those small wins, alongside promoting examples of good practice as the foundation for new ways to both undertake their work, and how to frame it, has been the subject of this final chapter. And yet, once again, there is no panacea. What I have presented in this chapter are a selection of models and frameworks, perspectives and ideas that provide a menu of options that can be used to frame the types of archaeology and heritage projects described in the thematic chapters, and shape our thinking both in terms of (project) management and (subject) leadership. Almost all of these models and frameworks are best applied across disciplines and also through partnerships with business and industry and through involving policy entrepreneurs and policymakers. Archaeology should never stand alone. This might mean positioning archaeology and heritage practice within a broader framework that aligns, for example, with Mazzucato's (2018) missions-oriented approach, Dahlgren and Whitehead's (2021) Rainbow Model for mapping relationships between people and the environment within which they operate, Raworth's (2017a) Doughnut Economics framework, for reaching the sweet, safe, and just spot between the social foundation of human well-being and the ecological ceiling of planetary pressure or, as we have just seen, Grint's (2010a) distinctions between leadership and management and the characteristics associated with each. These are all points of reference, models, templates, ideas, or frameworks which we can use where appropriate to help frame our projects in ways that emphasize context and the importance of relationships, of all different kinds.

In terms of priorities, we might emphasize the need to be ambitious, going so far as to present this ambition as an essential requirement when our work falls within the context of wicked problems. Rather than focusing on projects that promote an economy that is carbon neutral for example, why not aim instead for carbon negative? And with that ambition confirmed, we might then think how this might look for archaeology, working collaboratively with other disciplines and areas of industry, looking for the small wins within this framework. And we need to be creative and novel. Within the business world it is sometimes said that: 'When disruptive innovation meets business as usual, something is transformed.' The same applies here. Let us try to introduce some disruptive innovation into our archaeological and heritage practice, and think what that might entail. For this we might adopt the 'Three Horizons Approach' to longer-term change[11] (Sharpe et al. 2016) in which the first of the three horizons reflects current policy initiatives and thinking, the second is where innovation starts to bite and new approaches appear more efficient than those used previously, while the third involves longer-term aspirational thinking. Clearly, we need to work with what we have, but we also need to think ahead. Put another way, the first step is to accept the problem; after that it is about momentum.

Some of these thoughts do help to explain why Chirikure (2021)[12] needed to ask why archaeology was failing to tackle global challenges. This book has been written with the intention not only of answering that question, but offering some ways to reverse the trend. One might even extend this to the viewpoint that, in spite of the obvious and inherent complexities of wicked problems, they do nonetheless provide opportunities for us. As Barnett (2021, 279) states in the context of urbanism and urban problems (with which I started this book):[13]

> While the disturbing force of the original formulation of the wicked problems idea lies in the proposition that wickedness might be irreducible, it remains the case that placing an issue under the description of wicked problems is not, and nor was it ever meant to be, a disabling move. It serves as a preliminary to claims about the potentials of selected professional fields of expertise to be able to better address those issues through the application of their specific form of expertise.

It is important to restate that much work is already underway in this field. The book contains many examples of good practice, describing projects that genuinely make a difference locally while demonstrating the success of methodologies to extend reach and influence. Some previous attempts have been made to synthesize impact specifically in relation to wicked problems. Davis (2022) for example has summarized the role of museums in this context, a topic I discussed in Chapter 4.

[11] As used by the International Futures Forum, for example: https://www.internationalfuturesforum.com/
[12] And Smith 2021. [13] *The Moon and the Ghetto*, if that is now a distant memory.

There is a need also for foresight and what Holtorf and Högberg (2022) refer to as 'futures literacy'. To quote from Steinbeck's (2001[1939]) *The Grapes of Wrath*, as the Joad family embarked on their journey west: 'Up ahead they's a thousan' lives we might live, but when it comes it'll on'y be one.' This sentiment is implicit in much of what I have said previously, not least in this chapter. Holtorf and Högberg (2022) describe how, 'futures literacy is the ability to think futures, by recognising existing assumptions about the future and by anticipating alternative futures—appreciating that the uses and values of cultural heritage in the future will not necessarily be the same as today.' This is something vital that we need to include within our thinking, our practice, and our teaching. We are very good at teaching archaeology students to learn about the past, and to create alternative pasts by interpreting human traces in different ways. But to make archaeology relevant, we also need to be teaching them how to use those same skills and perspectives to create and give evidence for alternative *futures*, and that is best achieved, I would argue, within the context of wicked problems.

Not everybody agrees with or even much likes the small wins framework as a meaningful contribution to wicked problems. Some might suggest we need to be more ambitious, and to fight the system of which the wicked problems are often symptomatic. As we saw in Chapter 1, activist and journalist George Monbiot (2021) places the blame squarely at the door of a capitalist system. Whether that is always the case or not, some people will argue quite rightly for an angrier and more activist approach to these problems. I am not in disagreement. But there is diversity in the ways we position ourselves relative to wicked problems, and we can and should incorporate these different perspectives and approaches into our teaching, giving future leaders the menu of options from which to choose and help them learn to choose which is best for them and which is most likely to succeed in the circumstances. Some people will be fighters and other thinkers. Some will use their superpowers to work actively within the small wins framework and others will not.

Frederick Douglass was a fighter. In 1852, he gave his famous Fifth of July Speech to commemorate the signing of the US Declaration of Independence, held at Rochester's Corinthian Hall. In it he said:

> O! had I the ability, and could I reach the nation's ear, I would, to-day, pour out a fiery stream of biting ridicule, blasting reproach, withering sarcasm, and stern rebuke. For it is not light that is needed, but fire; it is not the gentle shower, but thunder. We need the storm, the whirlwind, and the earthquake. The feeling of the nation must be quickened; the conscience of the nation must be roused; the propriety of the nation must be startled; the hypocrisy of the nation must be exposed; and its crimes against God and man must be proclaimed and denounced.

It was an angry speech that called for transformative change. Anger can be positive, provided it is channelled with creative energy and has a clear focus on finding solutions to the subject or cause of that anger. But because of its synergy

with the subject of this book, and its emphasis on solidarity, let us end instead where we began, in the dedication, with the Joad family in the American midwest of the 1930s. John Steinbeck's (2001[1939]) novel *The Grapes of Wrath* is another expression of the anger directed toward injustice and inequality. It is a tough read at the best of times, but especially now when it seems to be as relevant as ever. As Alan Yuhas (2014) summarizes it:

> *The Grapes of Wrath* tells a simple story: devastating weather and a bank's debt system force the Joad family off their farm; they go west, for work and good weather in California. They discover thousands of other migrants living in desperate poverty, exploited by the rich, abused by police, and abandoned by the government; they suffer, fight back and endure.

We have at least three wicked problems encapsulated in that one simple passage: climate change, financial insecurities, and social injustice. One can also add health and well-being into the mix. And, as we saw in Chapter 5, these problems are all deeply entangled, which merely increases the scale of the wickedness that these problems create for people and for society. The story opens with drought and dust; it ends with biblical floods that wash away the precious crops as well as homes and people. These are issues that are affecting people today, especially in those countries and regions that are less resilient, less well resourced, and therefore least able to manage severe climatic impacts. The other issues remain relevant too: the plight of migrant workers and their exploitation, being mistreated, demonized, and discriminated against, just as we saw in Chapter 7; and the impact on people's health and mental health of an economic system that sees people either thriving or struggling to survive. As Yuhas (2014) says, 'Seventy-five years later, *The Grapes of Wrath* is a mirror to a country splintered by inequality, controlled by a minority, and facing climate "catastrophe".' Further, and yet: 'Steinbeck didn't want us to lose hope—he wanted us to get angry at those who would strip hope from us.'

In Tom Joad's iconic speech, which constitutes a landmark moment in *The Grapes of Wrath* narrative, he restates Casey's (the preacher's) view that one only has a piece of a bigger soul. Within the speech's wider sentiment of strength, perseverance, and dignity, comes recognition of the need for solidarity for everyone, everywhere. The earlier entanglement chapter (Chapter 5) makes the point that everything is interconnected. Archaeology is only one very specific approach to tackling wicked problems, but it is an approach that offers some very particular opportunities. With its emphasis on people and the human experience, and a deep-time perspective, archaeology is ideally positioned to deliver on this message of solidarity and, by doing so, to use the small wins at its disposal to help make a difference, for everyone, everywhere. To restate what I said (twice) in Chapter 1: It is time. Archaeologists assemble!

Chapter Headlines

- There is a perception that archaeology and heritage practice have been slow to address what are variously referred to as global or grand challenges, or wicked problems.
- However, taking a small wins perspective, one might suggest that significant work has been undertaken and some progress made, at least relative to the thematic areas discussed in this book.
- To be more successful, and better able to demonstrate success (often described as having 'impact'), may require more effort to work across disciplines and more collaboratively with industry, policymakers, and other stakeholders. We need to make more use of our imagination and we must prioritize teaching students how to use it and channel it, and the need to do so.
- This learning will include closer awareness of concepts, models, and approaches from many other disciplines, including business management. Doughnut Economics, for example, and the Rainbow Model, as well as mission-oriented research. As archaeologists and heritage practitioners, we need to learn some new language.
- There needs to be a focus on ensuring that students[14] learn to use this language and develop critical and other skills necessary to have influence in the future. It is also important that they learn to recognize and adapt to different models of leadership and management, and the differences between them.
- It is important to understand how research and policy relate to one another, and the role of policy entrepreneurs in promoting data and stories to policymakers. Sometimes it is about timing, and knowing about (or being able to predict) windows of opportunity.
- Archaeologists and heritage practitioners can make a difference through their practice and the knowledge and insight that this generates. The deep-time perspectives on such things as climate change and inequality is one aspect of this, as are participation and the creation of environments within which people and communities can thrive.
- Through their particular skills and perspectives, archaeologists and heritage practitioners can help make the world a fairer, safer, and healthier place for everybody.

[14] All students, but here the focus is subjects closely aligned to archaeology and cultural heritage.

Chapter Nine: Ethics

...

Some Questions for Book-group Discussions, Essays, and Examinations

This short section provides some examples of the types of tasks and questions readers might wish to use, or adapt for use, in book-group settings, for essays, or in examinations. Some could also form the basis of group tasks at professional or corporate sectoral events and management (e.g. awayday) sessions.

Some Suggested Book-group, Essay, or Examination Questions

Why do you think the themes included in this book were selected while others (e.g. food insecurity and crime) were not? For those wicked problems that were not selected, can you see a role for archaeology and heritage practice in helping to resolve them? If so, what might those projects look like?

What do you think about small wins? Are they the best (or only) way to achieve success with wicked problems, or are they often just insignificant interventions in the greater scheme of things? Illustrate your answer with some examples from archaeology or heritage practice.

Is the author of *Wicked Problems for Archaeologists* correct in suggesting that archaeology and heritage practice have a significant part to play in helping to resolve wicked problems? Either way, how could these areas of practice become more successful in addressing these problems in the future? Is it about education, better integration with other disciplines, and better leadership, or are there other factors that need to be addressed?

Draw a Rainbow Model for any wicked problem, to incorporate cultural heritage stakeholders and/or interests. Remember that wicked problems are best resolved through inter- and transdisciplinary approaches, and this message should be clearly evident in the model that you produce.

Select three wicked problems and describe some of the ways in which these problems are interrelated (or 'entangled'). Follow this up with an example of a project that either has already or could in the future address all three of these problems, recognizing and taking full account of their entanglement. You could create an illustration as a part of your answer, to show both the extent and the nature of the relationships.

In what ways do you think Kate Raworth's (2017) *Doughnut Economics: Seven Ways to Think Like a 21st Twenty-first-century Economist* might be applied within a cultural heritage context?

Why do you think archaeology is sometimes dismissed as a worthless or old-fashioned degree subject, and how can archaeologists do more to persuade those doubters that it is central to helping understand and resolve many of the world's greatest challenges?

What do you think are the most important skills, abilities, and personal attributes that an archaeologist needs if they are to successfully help tackle some of the wicked problems described in this book?

In what ways do archaeologists hold superpowers? Are archaeologists really superheroes, or can they be?

What do you think should be the goals for archaeology and heritage practice in the next ten years? Why have you selected these goals and how will you know whether they have been achieved?

Fifty years into the future, reflecting back on archaeology's successes over the past half-century, what would you like the highlights to be? Or, put another way: in the fifty years since 2025, how would you like archaeologists and heritage practitioners to have changed the world?

Offer a definition of archaeology and, with examples, describe its importance to a sceptical audience.

Select a wicked problem and critically examine some examples of small wins that involve archaeology and/or heritage practice. How might these small wins be extended to ensure wider impact?

What does an activist archaeology look like? Use examples related to wicked problems to illustrate some good practice.

A wicked problem missing from this book is food insecurity, but there are others too such as crime. Create an outline for a new chapter that covers one of the wicked problems not currently included in the book. You can either structure this around those thematic chapters that are included or create a structure of your own. Remember to include some examples of small wins achieved or with potential through archaeology and/or heritage practice.

You are recruiting an archaeologist or heritage practitioner to a new management or leadership role. Beyond the day-to-day details of that role, what wider qualities are you looking for in the successful candidate? Write a profile of the kind of person you are looking for, in the hope that this person will promote the kind of agenda suggested in this book's Chapter 8. You can present this in terms of the essential attributes and the desirables.

'Students must learn how to discard old ideas, how and when to replace them...how to learn, unlearn and relearn', wrote the futurist Alvin Toffler in 1970. In what ways might this statement apply to students of archaeology and heritage studies? What is it that they need to learn, unlearn, and relearn?

Using examples, discuss the proposition that archaeology is not about the past, but about the present and the future.

...and a Task to Set Students

Create a short pitch for a project that uses some aspect of archaeology, heritage, or conservation practice to address a wicked problem. The pitch should comprise a five-slide Powerpoint presentation or a short film, which takes no more than three minutes for the examiner to view. In preparing the pitch you should include the following:

- A short executive summary or statement
- A brief presentation of aims and objectives
- A very short outline of the problem you are looking to address, citing some key literature and relevant policy
- An outline of the methodology (how will you use archaeology, heritage, or conservation approaches to address the problem). This should include reference to any ethical issues
- A comment on how you will measure success
- A very approximate outline of costs and timings
- A short but compelling closing statement. Remember that this is a pitch for support and/or funding!

This task could be extended into team projects and through the production of a larger, longer report which includes a more detailed project design.

Bibliography

Abell, N. 2014. Migration, mobility and craftspeople in the Aegean bronze age: a case study from Ayia Irini on the island of Kea. *World Archaeology* 46.4, 551–568.

Abraham, A., Sommerhalder, K., and Abel, T. 2010. Landscape and well-being: a scoping study on the health-promoting impact of outdoor environments. *International Journal of Public Health* 55.1, 59–69.

Ackoff, R. L. 1974. *Redesigning the Future: A Systems Approach to Societal Problems*. New York: Wiley.

Aked, J., Marks, N., Cordon, C., et al. 2008. *Five Ways to Wellbeing*. New Economics Foundation. https://neweconomics.org/2008/10/five-ways-to-wellbeing

Alford, J., and Head, B. W. 2017. Wicked and less wicked problems: a typology and a contingency framework. *Policy and Society* 26.3, 397–413.

Altman, I., and Low, S. 1992. *Human Behaviour and Environments: Advances in Theory and Research. Volume 12: Place Attachment*. New York: Plenum Press.

Altschul, J. H., Kintigh, K. W., Aldenderfer, M., et al. 2020. To understand how migrations affect human securities, look to the past, *PNAS* 117.34, 20342–20345.

Ammendolia, J., Saturno, J., Brooks, A. L., et al. J. 2021. An emerging source of plastic pollution: environmental presence of plastic personal protective equipment (PPE) debris related to COVID-19 in a metropolitan city. *Environmental Pollution* 269. https://doi.org/10.1016/j.envpol.2020.116160

Anderson, S., DeLeo, R. A., and Taylor, K. 2020. Policy entrepreneurs, legislators, and agenda setting: information and influence. *Policy Studies Journal* 48.3, 587–611.

Andre, C., and Velasquez, M. 1990. Justice and fairness. *Issues in Ethics* 3.2. https://www.scu.edu/mcae/publications/iie/v3n2.1.html

Angeli, F., Camporesi, S., and Dal Fabbro, G. 2021. The COVID-19 wicked problem in public health ethics: conflicting evidence, or incommensurable values? *Humanities and Social Sciences Communications* 8.161. https://doi.org/10.1057/s41599-021-00839-1

Angstrom, J. 2001. Towards a typology of internal armed conflict: synthesising a decade of conceptual turmoil. *Civil Wars* 4.3, 93–116. https://doi.org/10.1080/13698240108402480

Anon, 2023. Editorial: Will the world ever see another IPCC-style body? *Nature* 615, 7–8.

Ansell, C., Sørensen, E., and Torfing, J. 2021. The COVID Pandemic as a game changer for public administration and leadership? The need for robust governance responses to turbulent problems. *Public Management Review* 23.7, 949–960.

Arabena, K. 2010. All knowledge is indigenous. In V. E. Brown, J. Harris, and J. Russell (eds), *Tackling Wicked Problems through the Transdisciplinary Imagination*, 260–267. London: Routledge.

Armit, I. 2007. Hillforts at War: from Maiden Castle to Taniwaha Pā. *Proceedings of the Prehistoric Society* 73, 25–37.

Armstrong, N., and Pratt-Boyden, K. 2021. Silver linings: how mental health activists can help us navigate wicked problems. *British Journal of Psychology Bulletin* 45, 227–230. https://doi.org/10.1192/bjb.2021.25

Arthur, C., Baker, J. and Bamford, H. (eds), 2009. Proceedings of the international research workshop on the occurrence, effects, and fate of microplastic marine debris. NOAA marine

debris program. Technical memorandum NOS-OR&R-30. Available: https://marinedebris.noaa.gov/proceedings-second-research-workshop-microplastic-marine-debris.

Ashby, W. R. 1956. *An Introduction to Cybernetics*. London: Chapman & Hall.

Auld, G., Bernstein, S., Cashore, B., et al. 2021. Managing pandemics as super wicked problems: lessons from, and for, COVID-19 and the climate crisis. *Policy Sciences* 54, 707–728. https://doi.org/10.1007/s11077-021-09442-2

Avery, M. 1986. 'Stoning and fire' at hillfort entrances of southern Britain. *World Archaeology* 18, 216–230.

Bailey, G., Newland, C., Nilsson, A., et al. 2009. Transit, transition: excavating J641 VUJ. *Cambridge Archaeological Journal* 19.1, 1–27.

Baird, M. F. 2009. *The Politics of Place: Heritage, Identity, and the Epistemologies of Cultural Landscapes*. Unpublished PhD dissertation, Department of Anthropology, University of Oregon, Eugene.

Baird, M. F. 2014. Heritage, human rights, and social justice. *Heritage & Society* 7.2, 139–155.

Balsiger, P. 2004. Supradisciplinary research practices: history, objectives and rationale. *Futures* 36.4, 407–421.

Band, L., Barrie-Smith, C., Bettinson, G., et al. 2021. Climate change and coasts: lessons from history. *British Archaeology* 181, 16–23.

Barad, K. 2007. *Meeting the Universe Halfway: Quantum Physics and the Entanglement of Matter and Meaning*. Durham, NC: Duke University Press.

Barnett, C. 2021. The wicked city: genealogies of interdisciplinary hubris in urban thought. *Transactions of the Institute of British Geographers* 47, 271–284. https://doi.org/10.1111/tran.12483

Barrett, J. 2021. *Archaeology and its Discontents: Why Archaeology Matters*. London: Routledge.

Barthes, R. 1972 [1957]. Plastic. In *Mythologies*, trans. A. Lavers, 97–99. New York: Farrar, Straus and Giroux.

Bauman, W. A. 2015. Climate weirding and queering nature: getting beyond the Anthropocene. *Religions* 6, 742–754.

Bauman, W. A. 2017. The ethics of wicked problems: entanglement, multiple causality and rainbow time. *Worldviews* 21, 7–20. DOI:10.1163/15685357-02101002

Beaumont, N. J., Aaneson, M., Austen, M., et al. 2019. Global ecological, social and economic impacts of marine plastic. *Marine Pollution Bulletin* 142, 189–195.

Beck, C. M. 2002. The archaeology of scientific experiments at a nuclear testing ground. In J. Schofield, W. G. Johnson, and C. M. Beck (eds), *Matériel Culture: The Archaeology of Twentieth-Century Conflict*, 65–79. London: Routledge.

Beck, C. M., Drollinger, H., and Schofield, J. 2007. Archaeology of dissent: landscape and symbolism at the Nevada Peace Camp. In J. Schofield and W. Cocroft (eds), *A Fearsome Heritage: Diverse Legacies of the Cold War*, 297–320. Walnut Creek: Left Coast Press.

Beck, C. M., Falvey, L. W., and Drollinger, H. 2015. Inside the tunnels, inside the protests: the artistic legacy of anti-nuclear activists at a Nevada Peace Camp. In T. R. Lovata and E. Olton (eds), *Understanding Graffiti: Multidisciplinary Studies from Prehistory to the Present*, 177–191. New York: Routledge.

Bennett, G. R. 1960. Rubber bands in a Puffin's stomach. *British Birds* 53, 222.

van den Berg A. E., and Custers, M. H. G. 2010. Gardening promotes neuroendocrine and affective restoration from stress. *Journal of Health Psychology* 16.1, 3–11. doi:10.1177/1359105310365577

Bergmann, M., Mützel, S., Primpke, S., et al. 2019. White and wonderful? Microplastics prevail in snow from the Alps to the Arctic. *Science Advances* 5.8, eaax1157.

Besley, A., Vijver, M. G., Behrens, P., et al. 2017. A standardized method for sampling and extraction methods for quantifying microplastics in beach sand. *Marine Pollution Bulletin* 114.1, 77–83.

Besseling, E., Foekama, E. M., van Franeker, J. A., et al. 2015. Microplastic in a macro filter feeder: Humpback whale *Megaptera novaeangliae*. *Marine Pollution Bulletin* 95.1, 248–252.

Beyer, K. M., Kaltenbach, A., Szabo, A., et al. 2014. Exposure to neighborhood green space and mental health: evidence from the survey of the health of Wisconsin. *International Journal of Environmental Research and Public Health* 11, 3453–3472.

Bjerck, H. 2022. *Archaeology at Home: Notes on Things, Life and Time*. Sheffield and Bristol: Equinox.

Bjornlund, H., Nickum, J. E., and Stephan, R. M. 2018. The wicked problems of water quality governance. *Water International* 43.3, 323–326. doi:10.1080/02508060.2018.1452864

Bolin, A. 2012. On the side of light: performing morality at Rwanda's genocide memorials. *Journal of Conflict Archaeology* 7.3, 199–207. doi:10.1179/1574077312Z.00000000012

Bolin, A. nd. *Cultural Heritage and Armed Conflict: A Literature Review*. Social Science Research Council and Aarhus University.

Bonaiuto, M., Fornara, F., and Bonnes, M. 2006. Perceived residential environment quality in middle- and low-extension Italian cities. *Revue Européenne de Psychologie Appliquée* 56, 23–34.

Bondaroff, T. P., and Cooke, S. 2020. *Masks on the Beach: The Impact of COVID-19 on Marine Plastic Pollution*. Report for OceansAsia.

Boswell, C., and Smith, K. 2017. Rethinking policy 'impact': four models of research–policy relations. *Palgrave Communications* 3.44. https://doi.org/10.1057/s41599-017-0042-z

Boulton, E. 2016. Climate change as a 'hyperobject': a critical review of Timothy Morton's reframing narrative. *WIREs Climate Change* 7, 772–785.

Bourdieu, P. 1980. Le Capital social. Notes provisoires. *Actes Recherché Sciences Sociales* 31, 2–3.

Bours, S., Wanzenböck, I. and Frenken, K. 2022. Small wins for grand challenges. A bottom-up governance approach to regional innovation policy. *European Planning Studies* 30.11, 2245–2272. https://doi.org/10.1080/09654313.2021.1980502

Bowden, M., and McOmish, D. 1987. The required barrier. *Scottish Archaeological Review* 4, 76–84.

Bowlby, J. 1988. *A Secure Base: Clinical Applications of Attachment Theory*. London: Routledge.

Bradbury-Jones, C., and Isham, L. 2020. The pandemic paradox: the consequences of COVID-19 on domestic violence. *Journal of Clinical Nursing* 29.13–14, 2047–2049. https://doi.org/10.1111/jocn.15296

Brate, M., and Kiddey, R. 2015. Journeys in the city: homeless archaeologists or archaeologies of homelessness. *Journal of Contemporary Archaeology* 2.2, 235–245.

Braudel, F. 1958. Histoire et sciences sociales. La longue durée. *Annales ESC* 13.4, 725–753.

Bricout, J., and Baker, P. 2021. Exploring the smart future of participation: community, inclusivity, and people with disabilities. *International Journal of E-Planning Research* 10.2, 94–107. https://doi.org/10.4018/IJEPR.20210401.oa8

Brinkerhoff, D. W. 2014. State fragility and failure as wicked problems: beyond naming and taming. *Third World Quarterly* 35.2, 333–344. https://doi.org/10.1080/01436597.2014.878495

Brizi, A., Rabinovich, A., and Lewis, C. 2023. Psychological outcomes of local heritage engagement: participation in community archaeological excavations increases well-being, self-efficacy, and perceived community support. *Journal of Applied Social Psychology* 53, 850–861. https://doi.org/10.1111/jasp.12972

Brown, V. E., Deane, P. M., Harris, J., et al. 2010. Towards a just and sustainable future. In V. E. Brown, J. Harris, and J. Russell Russell (eds), *Tackling Wicked Problems through the Transdisciplinary Imagination*, 3–15. London: Routledge.

Brown, V. E., Harris, J., and Russell, J. 2010. *Tackling Wicked Problems through the Transdisciplinary Imagination*. London: Routledge.

Buchli, V., and Lucas, G. (eds) 2001. *Archaeologies of the Contemporary Past*. London: Routledge.

Budolfson, M., McPherson, T., and Plunkett, D. 2021. Philosophy and Climate Change. In M. Budolfson, T. McPherson, and D. Plunkett (eds), *Philosophy and Climate Change*. Oxford: Oxford University Press. https://doi.org/10.1093/oso/9780198796282.003.0001.

van Bueren, E. M., Klijn, E.-H., and Koppenjan, J. F. M. 2003. Dealing with wicked problems in networks: analysing an environmental debate from a network perspective. *Journal of Public Administration Research and Theory* 13.2, 193–212.

Buffa, D. C., Thompson, K., Reijerkerk, D. et al. 2023. Understanding constraints to adaptation using a community-centred toolkit. *Philosophical Transactions of the Royal Society B* 378. 20220391. https://doi.org/10.1098/rstb.2022.0391

Buheji, M. 2020. Easing post-Pandemic socio-economic 'wicked problems' through exploratory visits—taking 'generational poverty' as an example. *International Journal of Management* 11.12, 118–131.

Bulut, E. 2016. Pride and prejudice: the context of reception for Muslims in the United States. *Contemporary Social Science* 11.4, 3014–3314. https://doi.org/10.1080/21582041.2016.1176243

Burke, A., Peros, M. C., Wren, C. D., et al. 2021. The archaeology of climate change: the case for cultural diversity. *Proceedings of the National Academy of Sciences of the United States of America* 118.30, e2108537118

Burnell, K. 2010. Coping with traumatic memories: Second World War veterans' experiences of social support in relation to the narrative coherence of war memories. *Ageing and Society* 30, 57–78.

Burnell, K., Everill, P., Baxter, L., et al. 2021. *Guidelines for Involving People with Mental Health Issues in Heritage Projects*. MARCH Network Plus Fund Report. https://www.solent.ac.uk/research-innovation-enterprise/research-at-solent/projects-and-awards/documents/march-plus-guidelines-summary.pdf

Bushnik, T., et al. 2010. *Lead and Bisphenol A Concentrations in the Canadian Population*. Ottawa: Statistics Canada.

Büster, L. 2021. 'Problematic stuff': death, memory and the interpretation of cached objects. *Antiquity* 95.382, 973–985. https://doi.org/10.15184/aqy.2021.81

Büster, L., Croucher, K., Dayes, J., et al. 2018. From plastered skulls to palliative care: what the past can teach us about dealing with death. *AP: Online Journal in Public Archaeology* 3, 249–276.

Büster, L., Croucher, K., Green, L., et al. 2023. Mediating worlds: the role of nurses as ritual specialists in caring for the dead and dying. *Mortality*. https://DOI:10.1080/13576275.2023.2198694

Byrne, D. 2008. Heritage as social action. In G. Fairclough, R. Harrison, J. Jameson, Jnr., and J. Schofield (eds), *The Heritage Reader*, 209–218. London: Routledge.

Byrne, D. 2023. The migration heritage corridor: transnationalism, modernity and race. *International Journal of Heritage Studies* 4, 329–345. https://doi.org/10.1080/13527258.2023.2183884

Byrne, D., Brayshaw, H., and Ireland, T. 2003. *Social Significance: A Discussion Paper*. Second edition. Hurstville: New South Wales National Parks and Wildlife Service.

Caddick, N., Phoenix, C., and Smith, B. 2015. Collective stories and well-being: using a dialogical narrative approach to understand peer relationships among combat veterans experiencing PTSD. *Journal of Health Psychology* 20, 286–299.

Cairney, P. 2012. Complexity theory in political science and public policy. *Political Studies Review* 10, 346–358.

Camic, P. M., and Chatterjee, H. J. 2013. Museums and art galleries as partners for public health interventions. *Perspectives in Public Health* 133.1, 66–71.

Canosa, A., Paquette, M.-L., Cutter-Mackenzie-Knowles, A., et al. 2021. Young people's understandings and attitudes towards marine debris: a systematic scoping review. *Children's Geographies* 19.6, 659–676. https://doi.org/10.1080/14733285.2020.1862759

Capra, F. 1996. *The Web of Life: A New Synthesis of Mind and Matter.* New York: Harper Collins.

Carbery, M., O'Conner, W., and Thavamani, P. 2018. Trophic transfer of microplastics and mixed contaminants in the marine food web and implications for human health. *Environment International* 115, 400–409.

Carrington, B., and Young, P. 2009. *Aboriginal Heritage and Wellbeing.* Sydney: New South Wales Government.

Carson, L. 2011. Designing a public conversation using the World Café method. *Social Alternatives* 30.1, 10–14.

Cashore, B., and Bernstein, S. 2020. Why experts disagree on how to manage COVID-19: four problem conceptions, not one. *Global Policy.* https://www.globalpolicyjournal.com/blog/07/04/2020/why-experts-disagree-how-manage-covid-19-four-problem-conceptions-not-one

Cashore, B., Bernstein, S., Humphreys, D., et al. 2019. Designing stakeholder learning dialogues for effective global governance. *Policy and Society* 38.1, 118–147.

van Cauwenberghe, L., and Janseen, C. R. 2014. Microplastics in bivalves cultured for human consumption. *Environmental Pollution* 193, 65–70.

Chatterjee, H. J., Vreeland, S., and Noble, G. 2009. Museopathy: exploring the healing potential of handling museum objects. *Museums and Society* 7, 164–177.

Chiba, S., Saito, H., Fletcher, R., et al. 2018. Human footprint in the abyss: 30-year records of deep-sea plastic debris. *Marine Policy* 96, 204–212.

Chirikure, S. 2021. Making archaeology relevant to global challenges: a Global South perspective. *Antiquity* 95.382, 1073–1077.

Chubb, J., and Watermeyer, R. 2017. Artifice or integrity in the marketization of research impact? Investigating the moral economy of (pathways to) impact statements within research funding proposals in the UK and Australia. *Studies in Higher Education* 42.12, 2360–2372. https://doi.org/10.1080/03075079.2016.1144182

Churchman, C. W. 1967. Wicked problems. *Management Science* 14.4, B141–B142.

Churchman, C. W. 1968. *The Systems Approach.* New York: Delacorte Press.

Claxton, K. M. 2018. The Battle of Cheriton: the analysis of artefacts from an English Civil War Battlefield. *Journal of Conflict Archaeology* 13.2, 80–96. doi:10.1080/15740773.2018.1582912

Clements, F. 1916. *Plant Succession: An Analysis of the Development of Vegetation.* Washington: Carnegie Institution.

Cocroft, W., and Schofield, J. 2019. *Archaeology of the Teufelsberg: Exploring Western Electronic Intelligence Gathering in Cold War Berlin.* London: Routledge.

Coen, S., Meredith, J., and Condie, J. 2017. I dig therefore we are: community archaeology, place-based social identity, and intergroup relations within local communities. *Journal of Community & Applied Social Psychology* 27, 212–225.

Cohen, S. 1994. Identity, place and the 'Liverpool Sound'. In M. Stokes (ed.), *Ethnicity, Identity and Music: The Musical Construction of Place*, 117–134. Oxford: Berg.

Cohen, S., Schofield, J., and Lashua, B. 2009. Popular music, mapping, and the characterisation of Liverpool. *Popular Music History* 4.2, 126–144.

Conklin, J. 2006. *Dialogue Mapping: Building Shared Understanding of Wicked Problems*. Chichester: John Wiley.

Cornell, S., Costanza, R., Sörlin, S., et al. 2010. Developing a systematic science of the past to create our future. *Global Environmental Change* 20, 426–427.

da Costa, J. P., Mouneyrac, C., Costa, M., et al. 2020. The role of legislation, regulatory initiatives and guidelines on the control of plastic pollution. *Frontiers in Environmental Science*. 8:104. https://www.frontiersin.org/articles/10.3389/fenvs.2020.00104/full

Council of Europe 2005. *The Council of Europe Framework Convention on the Value of Cultural Heritage for Society (the 'Faro Convention')*. Strasbourg: Council of Europe.

Council of Europe 2009. *Heritage and Beyond*. Strasbourg: Council of Europe.

de Coverly, E., McDonagh, P., O'Malley, L., et al. 2008. Hidden mountain: the social avoidance of waste. *Journal of Macromarketing* 28.3, 289–303. doi:10.1177/0276146708320442

Crossland, Z. 2000. Buried lives: forensic archaeology and the Disappeared in Argentina. *Archaeological Dialogues* 7.2, 146–159.

Crossland, Z. 2002. Violent spaces: conflict over the reappearance of Argentina's Disappeared. In J. Schofield, W. G. Johnson, and C. M. Beck (eds), *Matériel Culture: The Archaeology of Twentieth-Century Conflict*, 115–131. London: Routledge.

Croucher, K., Büster, L., Dayes, J., et al. 2020. Archaeology and contemporary death: using the past to provoke, challenge and engage. *PLoS ONE*. https://doi.org/10.1371/journal.pone.0244058

Currie, E., Schofield, J., Ortega Perez, F., et al. 2018. Health beliefs, healing practices and medico-ritual frameworks in the Ecuadorian Andes: the continuity of an ancient tradition. *World Archaeology* 50.3, 461–479. doi:10.1080/00438243.2018.1474799

Currie, E. and Schofield, J. In Press. *Indigenous Concepts of Health and Healing in Andean Populations: Understanding the Relevance of Traditional Medicine in a Changing World*. London: Routledge.

Dadvand, P., de Nazelle, A., Figueras, F., et al. 2012. Green space, health inequality and pregnancy. *Environment International* 40, 110–115.

Dahlgren, G., and Whitehead, M. 1991. *Policies and Strategies to Promote Social Equity in Health*. Stockholm: Institute for Futures Studies.

Dahlgren, G., and Whitehead, M. 2021. The Dahlgren-Whitehead model of health determinants: 30 years on and still chasing rainbows. *Public Health* 199, 20–24. https://doi.org/10.1016/j.puhe.2021.08.009

Danken, T., Dribbisch, K., and Lange, A. 2016. Studying wicked problems forty years on: towards a synthesis of a fragmented debate. *Der Moderne Staat* 9.1, 15–33.

Darvill, T., Barrass, K., Drysdale, L., et al. (eds) 2019. *Historic Landscapes and Mental Well-being*. Oxford: Archaeopress.

Davies, T. 2019. Slow violence and toxic geographies: 'Out of sight' to whom? *Environment and Planning C: Politics and Space*. doi:10.1177/2399654419841063

Davis, J. 2022. Confronting wicked problems: perspectives in museum publications. *Museum Management and Curatorship* 37.1, 110–113, doi:10.1080/09647775.2021.2024680

Daviter, F. 2017. Coping, taming or solving: alternative approaches to the governance of wicked problems. *Policy Studies* 38.6, 571–588.

Debucquet, D. L., and Martin, W. 2018. Implications of the global growth slowdown for rural poverty. *Agricultural Economics* 49.3, 325–338.

Defries, R. S., and Nagendra, H. 2017. Ecosystem management as a wicked problem. *Science* 356, 265–270.

Delanda, M. 2016. *Assemblage Theory*. Edinburgh: Edinburgh University Press.

Deleuze, G., and Parnet, C. 2007. *Dialogues II*, translated by Hugh Tomlinson and Barbara Haberjam. New York: Columbia University Press.
De Pryck, K., and Hulme, M. 2023. *A Critical Assessment of the Intergovernmental Panel on Climate Change*. Cambridge: Cambridge University Press. Online at: https://doi.org/10.1017/9781009082099
De Salas, K., Scott, J. L., Schüz, B., et al. 2022. The super wicked problem of ocean health: a socio-ecological and behavioural perspective. *Philosophical Transactions of the Royal Society B* 377: 2021027120210271. http://doi.org/10.1098/rstb.2021.0271
DeSilvey, C. 2017. *Curated Decay: Heritage beyond Saving*. Minneapolis: University of Minnesota Press.
Desjardins, S. P. A., and Jordan, P. D. 2019. Arctic archaeology and climate change. *Annual Review of Anthropology* 48, 279–296.
Desjardins, S. P. A., Friesen, T. M., and Jordan, P. D. 2020. Looking back while moving forward: how past strategies to climate change can inform future adaptation and mitigation strategies in the Arctic. *Quaternary International* 549, 239–248.
De Veer, D., Drouin, A., Fischer, J., et al. 2022. How do schoolchildren perceive litter? Overlooked in urban but not in natural environments. *Journal of Environmental Psychology* 81, 101781. https://doi.org/10.1016/j.jenvp.2022.101781
Devine-Wright, P. 2009. Rethinking NIMBYism: the role of place attachment and place identity in explaining place-protective action. *Journal of Community and Applied Social Psychology* 19.6, 426–441.
Dezkhamkhooy, M. 2023. Wandering islands: towards an archaeology of garbage-based settlements. *World Archaeology* 54.4, 542–554. https://doi.org/10.1080/00438243.2023.2170910
Dietsch, P. 2020. Independent agencies, distribution, and legitimacy: the case of central banks. *American Political Science Review* 114.2, 591–595.
Dines, N., and Cattell, V. with Gesler, W., and Curtis, S. 2006. *Public Spaces, Social Relations and Well-being in East London*. London: Policy Press.
Dolan, P., Hallsworth, M., Halpern, D., et al. 2012. Influencing behaviour: the mindspace way. *Journal of Economic Psychology* 33, 264–277. http://doi.org/10.1016/j.joep.2011.10.009
Dolff-Bonekaemper, G. 2002. The Berlin Wall—an archaeological site in progress. In J. Schofield, W. G. Johnson, and C. M. Beck (eds), *Matériel Culture: The Archaeology of Twentieth-Century Conflict*, 236–248. London: Routledge.
Dorado, S., Antadze, N., Purdy, J., et al. 2022. Standing on the shoulders of giants: leveraging management research on grand challenges. *Business & Society* 61.5, 1242–1281. https://doi.org/10.1177/00076503221087701
Douglas, M. 2002 [1966]. *Purity and Danger: An Analysis of Concept of Pollution and Taboo*. London: Routledge.
Downs, A. 1957. *An Economic Theory of Democracy*. New York: Harper.
Drew, E. 2021. Romans at home: a collaborative outreach project with people living with dementia. https://wiki.york.ac.uk/display/YorkOpenResearch/Romans+at+Home%3A+a+collaborative+outreach+project+with+people+living+with+dementia
Dudley, S. 2011. Feeling at home: producing and consuming things in Karenni refugee camps on the Thai-Burma border. *Population, Space and Place* 17.6, 742–755.
Dugmore, A., McGovern, T., Street, R., et al. 2013. 'Clumsy solutions' and 'elegant failures': lessons on climate change adaptation from the settlement of the North Atlantic islands. In L. Sygna, K. O'Brien, and J. Wolf (eds), *A Changing Environment for Human Security: Transformative Approaches to Research, Policy and Action*, 435–451. London: Routledge.

Edensor, T. 2011. Entangled agencies, material networks and repair in a building assemblage: the mutable stone of St Anne's Church, Manchester. *Transactions of the Institute of British Geographers* 36, 238–252.

Edensor, T. 2020. *Stone: Stories of Urban Materiality*. London: Palgrave Macmillan.

Edgeworth, M., Haff, P. K., Ivar do Sul, J. A., et al. 2022. The Technofossil Record: Where Archaeology and Paleontology Meet. *Anthropocene Curriculum* (22 April 2022). https://www.anthropocene-curriculum.org/contribution/the-technofossil-record-where-archaeology-and-paleontology-meet

Eggert, L. K., Blood-Siegfried, J., Champagne, M., et al. 2015. Coalition building for health: a community garden pilot project with apartment-dwelling refugees. *Journal of Community Health Nursing* 32.3, 141–150. doi:10.1080/07370016.2015.1057072

Ehrlich, P. 2011. A personal view: environmental education—its content and delivery. *Journal of Environmental Studies and Sciences* 1, 6–13.

Einstein, A., and Infeld, L. 1938. *The Evolution of Physics*. London: Cambridge University Press.

Eppel. E. A., and Rhodes, M. L. 2018. Complexity theory and public management: a 'becoming' field. *Public Management Review* 20.7, 949–959. https://doi.org/10.1080/14719037.2017.1364414

Ergas, H. 1987. Does technology policy matter? In B. R. Guile and H. Brooks (eds), *Technology and Global Industry: Companies and Nations in the World Economy*, 191–245. Washington, DC: National Academies Press.

Escobar-Ballesta, M., García-Ramírez, M., and De Freitas, C. 2018. Taking stock of Roma health policies in Spain: lessons for health governance. *Health Policy* 122.4, 444–451. https://doi.org/10.1016/j.healthpol.2018.02.009

Eriksen, M., Cowger, W., Erdle, L. M., et al. 2023. A growing plastic smog, now estimated to be over 170 trillion plastic particles afloat in the world's oceans—urgent solutions required. *PLoS ONE* 18.3, e0281596. https://doi.org/10.1371/journal.pone.0281596

Everill, P., Bennet, R., and Burnell, K. 2020. Dig in: an evaluation of the role of archaeological fieldwork for the improved well-being of military veterans. *Antiquity* 94.373, 212–227.

Fairclough, G., and Herring, P. 2016. Lens, mirror, window: interactions between historic landscape characterisation and landscape character assessment. *Landscape Research* 41.2, 186–198. http://doi.org/10.1080/01426397.2015.1135318

Feltz, B. 2019. The philosophical and ethical issues of climate change. *The UNESCO Courier*, 7 August 2019. https://courier.unesco.org/en/articles/philosophical-and-ethical-issues-climate-change

Ferraro, E., and Barletti, J. P. S. 2016. Place wellbeing: anthropological perspectives on wellbeing and place. *Anthropology in Action* 23, 1–5. https://www.berghahnjournals.com/view/journals/aia/23/3/aia230301.xml

Ferreira, I. A. 2017. Measuring state fragility: a review of the theoretical groundings of existing approaches. *Third World Quarterly* 38.6, 1291–1309. https://doi.org/10.1080/01436597.2016.1257907

Fésüs, G., Piroska, Ö., McKee, M., et al. 2012. Policies to improve the health and well-being of Roma people: the European experience. *Health Policy* 105, 25–32. 10.1016/j.healthpol.2011.12.003

Finlay, N. 2022. An archaeology of dementia. *Antiquity* 96.386, 422–435. doi:10.15184/aqy.2021.186

Finnegan, A. 2016. The biopsychosocial benefits and shortfalls for armed forces veterans engaged in archaeological activities. *Nurse Education Today* 47, 15–22.

Flaws, J., Damdimopoulou, P., Patisaul, H. B., et al. 2020. *Plastics, EDCs & Health: A Guide for Public Interest Organizations and Policy-Makers on Endocrine Disrupting Chemicals and Plastic.* https://ipen.org/sites/default/files/documents/edc_guide_2020_v1_6ew-en.pdf

Flewellen, A., Dunnavant, J., Odewale, A., et al. 2021. 'The future of archaeology is antiracist': archaeology in the time of Black Lives Matter. *American Antiquity* 86.2, 224–243. doi:10.1017/aaq.2021.18

Fluck, H., and Dawson, M. 2021. Editorial: Climate change and the historic environment. *The Historic Environment: Policy & Practice* 12.3–4, 263–270.

Flyn, C. 2021. *Islands of Abandonment: Life in the Post-human Landscape.* London: William Collins.

Ford, H. V., Jones, N. H., Davies, A. J., et al. 2022. The fundamental links between climate change and marine plastic pollution. *Science of the Total Environment* 806, 150392. doi:10.1016/j.scitotenv.2021.150392

Forrest, A., Giacovazzi, L., Dunlop, S., et al. 2019. Eliminating plastic pollution: how a voluntary contribution from industry will drive the circular plastics economy. *Frontiers in Marine Science* 6.627. doi:10.3389/fmars.2019.00627

Fouché, C., and Light, G. 2011. An invitation to dialogue: 'The World Café' in social work research. *Qualitative Social Work* 10.1, 28–48. https://doi.org/10.1177/1473325010376016

Fredengren, C. 2021. Beyond entanglement. *Current Swedish Archaeology* 29, 11–33. https://doi.org/10.37718/CSA.2021.01

Fredheim, H., and Watson, S. 2023. *Understanding Public Benefit from Development-led Archaeology.* Report for UK Research and Innovation. London: Museum of London Archaeology.

Frias, J. and Nash, R. 2019. Microplastics: Finding a consensus on the definition. *Marine Pollution Bulletin* 138, 145–147. https://doi.org/10.1016/j.marpolbul.2018.11.022

Funtowicz, S., and Ravetz, J. 1993. Science for the post-normal age. *Futures* (September), 739–755.

Gabrys, J., Hawkins, G., and Michael, M. (eds) 2013. *Accumulation: The Material Politics of Plastic.* London and New York: Routledge.

Gaffney, V., Thomson, K., and Finch, S. (eds) 2007. *Mapping Doggerland: The Mesolithic Landscapes of the Southern North Sea.* Oxford: Archaeopress.

Gall, S. C., and Thompson, R. C. 2015. The impact of debris on marine life. *Marine Pollution Bulletin* 92.1, 170–179. doi:10.1016/j.marpolbul.2014.12.041

Galloway, S. 2006. Cultural participation and individual quality of life: a review of research findings. *Applied Research in Quality of Life* 1.3, 323–342. doi:10.1007/s11482-007-9024-4

Gamble, C. 1986. *The Palaeolithic Settlement of Europe.* Cambridge: Cambridge University Press.

Gard'ner, J. M. 2004. Heritage protection and social inclusion: a case study from the Bangladeshi community of East London. *International Journal of Heritage Studies* 10.1, 75–92. doi:10.1080/1352725032000194259

Gatersleben, B., Wyles, K., Myers, A., et al. 2020. Why are places so special? Uncovering how our brain reacts to meaningful places. *Landscape and Urban Planning* 197. https://doi.org/10.1016/j.landurbplan.2020.103758

Gau, J. M., and Pratt, T. C. 2010. Revisiting broken windows theory: examining the sources of the discriminant validity of perceived disorder and crime. *Journal of Criminal Justice* 38.4, 758–766. https://doi.org/10.1016/j.jcrimjus.2010.05.002

Gay-Antaki, M. 2021. Stories from the IPCC: an essay on climate science in fourteen questions. *Global Environmental Change* 71. https://doi.org/10.1016/j.gloenvcha.2021.102384

George, G., Howard-Grenville, J., Joshi, A., et al. 2016. Understanding and tackling societal grand challenges through management research. *Academy of Management Journal* 59, 1880–1895.

Geyer, R., Jambeck, J. R., and Law, K. L. 2017. Production, use, and fate of all plastics ever made. *Science Advances* 3.7, e1700782. https://advances.sciencemag.org/content/advances/3/7/e1700782.full.pdf.

Gibbons, M., Limoges, C., Nowotny, H., et al. 1994. *The New Production of Knowledge: The Dynamics of Science and Research in Contemporary Societies*. London: Sage Publications.

Giddens, A. 1991. *Modernity and Self-Identity: Self and Society in the Late Modern Age*. Cambridge: Polity Press.

Giddens, A. 2009. *The Politics of Climate Change*. Cambridge: Polity Press.

Gieryn, T. F. 1983. Boundary-work and the demarcation of science from non-science: strains and interests in professional ideologies of scientists. *American Sociology Review* 48.6, 781–795.

Godin, G. 2022. Monstrous things: horror, othering, and the Anthropocene. *Post-Medieval Archaeology* 56.2, 116–126. https://doi.org/10.1080/00794236.2022.2120709

Gonzalez-Ruibal, A. 2019. *An Archaeology of the Contemporary Era*. London: Routledge.

Gorman, A. 2019. *Dr Space Junk vs the Universe: Archaeology and the Future*. Sydney: New South Publishing.

Gottweis, H. 2006. Argumentative policy analysis. In B. G. Peters and J. Pierre (eds), *Handbook of Public Policy*, 461–480. London: Sage.

Graeber, D., and Wengrow, D. 2021. *The Dawn of Everything: A New History of Humanity*. London: Allen Lane.

Granovetter, M. S. 1973. The strength of weak ties. *American Journal of Sociology* 78, 1360–1380.

Graves-Brown, P. (ed.) 2000. *Matter, Materiality and Modern Culture*. London: Routledge.

Grenville, J. 2007. Conservation as Psychology: Ontological Security and the Built Environment. *International Journal of Heritage Studies* 13.6, 447–461. doi:10.1080/13527250701570614

Grewatsch, S., Kennedy, S., and Bansal, P. 2021. Tackling wicked problems in strategic management with systems thinking. *Strategic Organisation*. https://doi.org/10.1177/14761270211038635

Grint, K. 2008. Wicked problems and clumsy solutions: the role of leadership. *Clinical Leader* 1.2. http://leadershipforchange.org.uk/wp-content/uploads/Keith-Grint-Wicked-Problems-handout.pdf

Grint, K. 2010a. *Leadership: A Very Short Introduction*. Oxford: Oxford University Press.

Grint, K. 2010b. The cuckoo clock syndrome: addicted to command, allergic to leadership. *European Management Journal* 28.4, 306–313.

Grint, K. 2022. Critical essay: Wicked problems in the Age of Uncertainty. *Human Relations* 75.8, 1518–1532. https://doi.org/10.1177/00187267211070770

Groenewegen, P. P., van den Berg, A. E., de Vries, S., et al. 2006. Vitamin G: effects of green space on health, well-being, and social safety. *BMC Public Health* 6, 149

Grote, T. 2022. *Eindhovenseweg 56*. Netherlands: Idea Books.

Gwynne, K., and Cairnduff, A. 2017. Applying collective impact to wicked problems in Aboriginal health. *Metropolitan Universities* 28.4, 115–130.

Hagan, J. H. Jnr. 1954. The poor labyrinth: the theme of social injustice in Dickens's 'Great Expectations'. *Nineteenth-Century Fiction* 9.3, 169–178.

Hambrecht, G., and Rockman, M. 2017. International approaches to climate change and cultural heritage. *American Antiquity* 82.4, 627–641.

Hamilakis, Y. (ed) 2018. *The New Nomadic Age: Archaeologies of Forced and Undocumented Migration*. Bristol: Equinox.

Hannigan, B., and Coffey, M. 2011. Where the wicked problems are: the case of mental health. *Health Policy* 101.3, 220–227.

Haram, L. E., Carlton, J. T., Centurioni, L., et al. 2021. Emergence of a neopelagic community through the establishment of coastal species on the high seas. *Nature Communications* 12, 6885. https://doi.org/10.1038/s41467-021-27188-6

Haraway, D. 2008. *When Species Meet*. Minneapolis: University of Minnesota Press.

Harrison, R., and Maher, R. A. (eds) 2014. *Human Ecodynamics in the North Atlantic: A Collaborative Model of Humans and Nature through Space and Time*. London and New York: Lexington Books.

Harrison, R. 2011. Surface assemblages: towards an archaeology in and of the present. *Archaeological Dialogues* 18.2, 141–161.

Harrison, R. 2015. Beyond 'natural' and 'cultural' heritage: toward an ontological politics of heritage in the age of Anthropocene. *Heritage & Society* 8.1, 24–42. doi:10.1179/2159032X15Z.00000000036

Harrison, R., and Schofield, J. 2010. *After Modernity: Archaeological Approaches to the Contemporary Past*. Oxford: Oxford University Press.

Harrison, R., DeSilvey, C., Holtorf, C., et al. 2020. *Heritage Futures: Comparative Approaches to Natural and Cultural Heritage Practices*. London: UCL Press.

Harvey, D., and Perry, J. 2015. Heritage and climate change: the future is not the past. In D. Harvey and J. Perry (eds), *The Future of Heritage as Climates Change: Loss, Adaptation and Creativity*, 3–21. London and New York: Routledge.

Hawkins, G. 2018. Plastic and presentism: The time of disposability. *Journal of Contemporary Archaeology* 5.1, 91–102. https://doi.org/10.1558/jca.33291

Head, B. W. 2008. Wicked problems in public policy. *Public Policy* 3.2, 101–118.

Head, B. W. 2010. Reconsidering evidence-based policy: key issues and challenges. *Policy and Society* 29.2, 77–94. https://doi.org/10.1016/j.polsoc.2010.03.001

Head, B. W. 2015. Towards more 'evidence-informed' policy making? *Public Administration Review* 76.3, 472–484. https://doi.org/10.1111/puar.12475

Head, B. W. 2019. Forty years of wicked problems literature: forging closer links to policy studies. *Policy and Society* 38.2, 180–197. https://doi.org/10.1080/14494035.2018.1488797

Head, B. W. 2022. *Wicked Problems in Public Policy: Understanding and Responding to Complex Challenges*. London: Palgrave Macmillan.

Henderson, C., and Gronholm, P. C. 2018. Mental health related stigma as a 'wicked problem': the need to address stigma and consider the consequences. *International Journal of Environmental Research and Public Health* 15, 1158. doi: 10.3390/ijerph15061158

Heritage Alliance, 2020. *Heritage, Health and Wellbeing*. The Heritage Alliance. https://www.theheritagealliance.org.uk/wp-content/uploads/2020/10/Heritage-Alliance-AnnualReport_2020_Online.pdf

Heritage Lottery Fund, 2012. *Values and Benefits of Heritage: A Research Review*. London: Heritage Lottery Fund.

Hicks, D., and Mallet, S. 2019. *Lande: The Calais 'Jungle' and beyond*. Bristol: Bristol University Press.

Hiemstra, A., Rambonnet, L., Gravendeel, B., et al. 2021. The effects of COVID-19 litter on animal life. *Animal Biology* 71.2, 215–231. https://doi.org/10.1163/15707563-bja10052

Historic England 2012. *Battlefields Registration Selection Guide*. Swindon: Historic England. https://historicengland.org.uk/images-books/publications/dsg-battlefields/heag072-battlefields-rsg/

Historic England 2020a. *Historic England Statement on Climate Change and Sustainability.* (Accessed online. No longer available)

Historic England 2020b. *A Strategy for Inclusion, Diversity and Equality: November 2020 to March 2023.* Swindon: Historic England. https://historicengland.org.uk/content/docs/about/strategy-ide-nov20-mar23/

Historic England 2021. *A Wellbeing and Heritage Strategy for Historic England: Executive Summary.* A Strategy for Wellbeing and Heritage 2022-25 (historicengland.org.uk)

Hodder, I. 2011. Human-thing entanglement: towards an integrated archaeological perspective. *Journal of the Royal Anthropological Institute* 17, 154–177.

Hodder, I. 2012. *Entangled: An Archaeology of the Relationships between Humans and Things.* Malden, MA: Wiley-Blackwell.

Hodder, I. 2018. *Where Are We Heading? The Evolution of Humans and Things.* New Haven, CT: Yale University Press.

Hodder, I. 2020. The paradox of the long term: human evolution and entanglement. *Journal of the Royal Anthropological Institute* 26.2, 389–411.

Hodgkinson, I. R., Mousavi, S., and Hughes, P. 2022. New development: citizen science—discovering (new) solutions to wicked problems. *Public Money & Management* 42.2, 133–136. doi:10.1080/09540962.2021.1967630

Högberg, A., and Holtorf, C. 2021. Final reflections: the future of heritage. In C. Holtorf and A. Högberg (eds), *Cultural Heritage and the Future,* 264–269. London: Routledge.

Holgate, S., and Stokes-Lampard, H. 2017. Air pollution—a wicked problem. *British Medical Journal* 357. https://www.bmj.com/content/bmj/357/bmj.j2814.full.pdf

Holm, P., and Winiwarter, V. 2017. Climate change studies and human sciences. *Global and Planetary Change* 156, 115–122.

Holtorf, C. 2023. Towards a world heritage for the Anthropocene. In N. Shepherd (ed), *Rethinking Heritage in Precarious Times: Coloniality, Climate Change and COVID-19,* 111–126. London and New York: Routledge.

Holtorf, C., and Högberg, A. (eds) 2021a. *Cultural Heritage and the Future.* London: Routledge.

Holtorf, C., and Högberg, A. 2021b. What lies ahead? Nuclear waste as cultural heritage of the future. In C. Holtorf and A. Högberg (eds), *Cultural Heritage and the Future,* 144–158. London and New York: Routledge.

Holtorf, C., and Högberg, A. 2022. *Why Cultural Heritage Needs Foresight.* https://www.heritageresearch-hub.eu/app/uploads/2022/05/HOLTORF_Hogberg.pdf

Holtorf, C., Pantazatos, A., and Scarre, G. (eds), 2019. *Cultural Heritage, Ethics and Contemporary Migrations.* London: Routledge.

Horgan, J. 1993. Are scientists too messy for Antarctica? *Scientific American* 268, 22–23.

Hoshower-Leppo, L. 2002. Missing in action: searching for America's war dead. In J. Schofield, W. G. Johnson, and C. M. Beck (eds), *Matériel Culture: The Archaeology of Twentieth-Century Conflict,* 80–90. London: Routledge.

Hudson, M., Aoyama, M., Hoover, K., et al. 2012. Prospects and challenges for an archaeology of global climate change. *WIREs Climate Change* 3, 313–328.

Hughes, T. P., Huang, H., and Young, M. A. L. 2012. The wicked problem of China's disappearing coral reefs. *Conservation Biology* 27.2, 261–269.

Hyyppä, M. T. 2010. *Healthy Ties: Social Capital, Population Health, and Survival.* New York: Springer.

Hyyppä, M. T., Mäki, J., Impivaara, O., et al. 2005. Leisure participation predicts survival: a population-based study in Finland. *Health Promotion International* 21.1, 5–12.

Iakovlenko, K. 2022. Eyewitness: the Russian War in Ukraine: the matter of loss and arts. *Sociologica* 16.2, 227–238. https://doi.org/10.6092/ISSN.1971-8853/15272

Ingold, T. 2011. *Being Alive: Essays on Movement, Knowledge and Description*. London: Routledge.

IPCC 2000. *Special Report on Emissions Scenarios*. Cambridge: Cambridge University Press. https://www.ipcc.ch/site/assets/uploads/2018/03/emissions_scenarios-1.pdf

IPCC 2007a. *Climate Change 2007: Synthesis Report. Contribution of Working Groups I, II and III to the Fourth Assessment Report of the Intergovernmental Panel on Climate Change* (core writing team: Pachauri, R. K., and Reisinger, A. (eds.)). IPCC: Geneva, Switzerland.

IPCC 2007b. Climate Change 2007: Working Group 1: The Physical Science Basis. Available online at: https://archive.ipcc.ch/publications_and_data/ar4/wg1/en/spmsspm-projections-of.html

IPCC 2007c. Summary for policymakers. In S. Solomon, D. Qin, M. Manning, Z. Chen, M. Marquis, K. B. Avery, M. Tignor, and H. T. Miller (eds), *Climate Change 2007: The Physical Science Base. Contribution of Working Group 1 to the Fourth Assessment Report of the Intergovernmental Panel on Climate Change*, 1–18. Cambridge: Cambridge University Press.

Irvine, R. D. G. 2020. *An Anthropology of Deep Time: Geological Temporality and Social Life*. Cambridge: Cambridge University Press.

Izurieta, J. C. 2017. Behaviour and trends in tourism in Galápagos between 2007 and 2015. In *Galápagos Report 2015–16*, 83–89. Puerto Ayora, Galápagos, Ecuador: GNPD, GCREG, CDF, and GC.

Jabareen, Y. 2004. A knowledge map for describing variegated and conflict domains of sustainable development. *Journal of Environmental Planning and Management*, 47, 623–642.

Jacobs, J. 1992 [1961]. *The Death and Life of Great American Cities*. New York: Vintage Books.

Jambeck, J. R., Geyer, R., Wilcox, C., et al. 2015. Plastic waste inputs from land into the ocean *Science* 347, 768–771.

Jamieson, R. 2018. A bullet for Señor Cobos: anarchy in the Galápagos. *Journal of Contemporary Archaeology* 5.2, 268–275.

Jang, Y. C., Hong, S., Lee, J., et al. 2014. Estimation of lost tourism revenue in Geoje Island from the 2011 marine debris pollution event in South Korea. *Marine Pollution Bulletin* 81.1, 49–54.

Jarvis, H. 2002. Mapping Cambodia's 'killing fields'. In J. Schofield, W. G. Johnson, and C. M. Beck (eds), *Matériel Culture: The Archaeology of Twentieth-Century Conflict*, 91–102. London: Routledge.

Jenner, L. C., Rotchell, J. M., Bennet, R. T., et al. 2022. Detection of microplastics in human lung tissue using μFTIR Spectroscopy. *Science of the Total Environment* 831. http://dx.doi.org/10.1016/j.scitotenv.2022.154907

Johansson, S. E., Konlaan, B. B., and Bygren, L. O. 2001. Sustaining habits of attending cultural events and maintenance of health: a longitudinal study. *Health Promotion International* 16.3, 229–234.

Johnston, R., and Marwood, K. 2017. Action heritage: research, communities, social justice. *International Journal of Heritage Studies* 23.9, 816–831.

Jones, J., Porter, A., Muñoz-Pérez, J.-P., et al. 2021. Plastic contamination of a Galapagos Island (Ecuador) and the relative risks to native marine species. *Science of the Total Environment* 789, 147704. https://doi.org/10.1016/j.scitotenv.2021.147704

Jones, S. 2017. Wrestling with the social value of heritage: problems, dilemmas and opportunities. *Journal of Community Archaeology & Heritage* 4.1, 21–37. doi:10.1080/20518196.2016.1193996

Joyce, R. A., and Gillespie, S. D. (eds) 2015. *Things in Motion: Object Itineraries in Anthropological Practice.* Santa Fe: SAR Press.

Jungcurt, S. 2013. Taking boundary work seriously: towards a systemic approach to the analysis of interactions between knowledge production and decision-making on sustainable development. In L. Meuleman (ed.), *Transgovernance: Advancing Sustainability Governance*, 255–273. New York: Springer.

Kapoor, R. 2011. Is there a postnormal time? From the illusion of normality to the design for a new normality. *Futures* 43, 216–220.

Kawa, N. C., Arceño, M. A., Goeckner, R., et al. 2021. Training wicked scientists for a world of wicked problems. *Humanities & Social Sciences Communications* 8, 189. https://doi.org/10.1057/s41599-021-00871-1

Keeffe, G. 2010. Compost city: underground music, collapsoscapes and urban regeneration. *Popular Music History* 4.2, 145–159.

Kershaw, P. J., and Rochman, C. M. (eds) 2016. *Sources, fate and effects of microplastics in the marine environment: part two of a global assessment.* (IMO/FAO/UNESCO-IOC/UNIDO/WMO/IAEA/UN/UNEP/UNDP Joint Group of Experts on the Scientific Aspects of Marine Environmental Protection). GESAMP Reports and Studies 93.

Kiddey, R. 2017. *Homeless Heritage: Collaborative Social Archaeology as Therapeutic Practice.* Oxford: Oxford University Press.

Kiddey, R. 2020. Reluctant refuge: an activist archaeological approach to alternative refugee shelter in Athens (Greece). *Journal of Refugee Studies* 33.3, 599–621. https://doi.org/10.1093/jrs/fey061

Kiddey, R. 2023. We are displaced, but we are more than that: using anarchist principles to materialise capitalism's cracks at sites of contemporary forced displacement in Europe. *International Journal of Historical Archaeology.* https://doi.org/10.1007/s10761-023-00696-5

Kimberlee, R. 2015. What is social prescribing? *Advances in Social Sciences Research* 2.1, 102–111. https://doi.org/10.14738/assrj.21.808

Kingdon, J. 2013. *Agendas, Alternatives and Public Policies.* New International Edition. London: Pearson.

Kirschke, S., and Kosow, H. 2021. Designing policy mixes for emerging wicked problems: the case of pharmaceutical residues in freshwaters. *Journal of Environmental Policy & Planning* 24.5, 486–497. doi:10.1080/1523908X.2021.1960808

Kjellen, B. 2006. Foreword. In W. N. Adger, J. Paavola, S. Huq, and M. J. Mace (eds), *Fairness in Adaptation to Climate Change*, vii–x. Cambridge, MA: MIT Press.

Knez, I., Butler, A., Sang, Å. O., et al. 2018. Before and after a natural disaster: disruption in emotion component of place-identity and wellbeing. *Journal of Environmental Psychology* 55, 11–17.

Kokkinos, P. 2012. Physical activity, health benefits, and mortality risk. *International Scholarly Research Notices.* 718789. https://doi.org/10.5402/2012/718789

Korpela, K. M. 1992. Adolescents' favourite places and environmental self-regulation. *Journal of Environmental Psychology* 12.3, 249–258.

Korpela, K. M., and Ylén, M. P. 2009. Effectiveness of favourite-place prescriptions: a field experiment. *American Journal of Preventive Medicine* 36.5, 435–438.

Kramer, F. D. 2011. Irregular conflict and the wicked problem dilemma: strategies for imperfection. *Prism* 2.3, 75–100.

Kropotkin, P. 2009 [1902]. *Mutual Aid: A Factor of Evolution*. London: Freedom Press.
Kuletz, V. L. 1997. *The Tainted Desert: Environmental and Social Ruin in the American West*. New York: Routledge.
Kvan, T., and Karakiewicz, J. (eds) 2019. *Urban Galapagos: Transition to Sustainability in Complex Adaptive Systems*. New York: Springer.
Lachapelle, E., Montpetit, É., and Gauvin, J-P. 2014. Public perceptions of expert credibility on policy issues: the role of expert framing and political worldviews. *Policy Studies Journal* 42.4, 674–697.
Lachowycz, K., and Jones, A. P. 2011. Greenspace and obesity: a systematic review of the evidence. *Obesity Review* 12, e183–e189.
Lahr, M., Rivera, F., Power, R., et al. 2016. Inter-group violence among early Holocene hunter-gatherers of West Turkana, Kenya. *Nature* 529, 394–398. https://doi.org/10.1038/nature16477
Lamb, J. B., Willis, B. L., Fiorenza, E. A., et al. 2018. Plastic waste associated with disease on coral reefs. *Science* 359.6374, 460–462.
Landon-Lane, M. 2018. Corporate social responsibility in marine plastic debris governance. *Marine Pollution Bulletin* 127, 310–319. doi:https://doi.org/10.1016/j.marpolbul.2017.11.054
Lange, M., and van Sebille, E., 2017. Parcels v0.9: prototyping a Lagrangian ocean analysis framework for the petascale age. *Geoscientific Model Development* 10, 4175–4186. https://www.geosci-model-dev.net/10/4175/2017/gmd-10-4175-2017.html
Latour, B. 1993. *We Have Never Been Modern*. Cambridge, MA: Harvard University Press.
Latour, B. 2005. *Reassembling the Social: An Introduction to Actor-Network Theory*. Oxford: Oxford University Press.
Lavers, J. L., and Bond, A. L. 2017. Exceptional and rapid accumulation of anthropogenic debris on one of the world's most remote and pristine islands. *PNAS* 114.23, 6052–6055. doi:10.1073/pnas.1619818114.
Lavers, J. L., Bond, A. L., and Rolsky, C. 2022. Far from a distraction: plastic pollution and the planetary emergency. *Biological Conservation* 272, 109655. https://doi.org/10.1016/j.biocon.2022.109655
Lavers, J. L., Dicks, L., Dicks, M. R., et al. 2019. Significant plastic accumulation on the Cocos (Keeling) Islands, Australia. *Nature Scientific Reports* 9, 7102. https://doi.org/10.1038/s41598-019-43375-4
Law, J. 2004. *After Method: Mess in Social Science Research*. London and New York: Routledge.
Lawrence, R. J. 2010. Beyond disciplinary confinement to imaginative transdisciplinarity. In V. E. Brown, J. Harris, and J. Russell (eds), *Tackling Wicked Problems through the Transdisciplinary Imagination*, 16–30. London: Routledge.
Lazarus, R. J. 2009. Super-wicked problems and climate change: restraining the present to liberate the future. *Cornell Law Review* 94, 1153–1233.
Lebreton, L., Slat, B., Ferrari, F., et al. 2018. Evidence that the Great Pacific garbage patch is rapidly accumulating plastic. *Scientific Reports* 8, 4666. https://doi.org/10.1038/s41598-018-22939-w
Lee, J. C. 2018. The opioid crisis is a wicked problem. *The American Journal on Addictions* 27, 51.
Lefebvre, H. 1991. *The Production of Space*. Oxford: Blackwell.
Leggett, C., Scherer, N., Curry, M., et al. 2014. *Assessing the Economic Benefits of Reductions in Marine Debris: A Pilot Study of Beach Recreation in Orange County, California. Final report: June 15, 2014, from National Oceanic and Atmospheric Administration*. Cambridge, MA: National Oceanic and Atmospheric Administration.

Legnér, M., Ristic, M., and Bravaglieri, S. 2019. Contested heritage-making as an instrument of ethnic division. In M. Ristic and S. Frank (eds), *Urban Heritage in Divided Cities*, 35–52. London: Routledge.

Lehtonen, A., Salonen, A. O., and Cantell, H. 2019. Climate change education: a new approach for a world of wicked problems. In J. W. Cook (ed.), *Sustainability, Human Well-Being and the Future of Education*, 339–373. Cham: Palgrave Macmillan. https://doi.org/10.1007/978-3-319-78580-6_11

Levin, K., Cashore, B., Bernstein, S., et al. 2012. Overcoming the tragedy of super wicked problems: constraining our future selves to ameliorate global climate change. *Policy Sciences* 45, 121–152.

Lewis, C., van London, H., Marciniak, A., et al. 2022. Exploring the impact of participative place-based community archaeology in rural Europe. *Journal of Community Archaeology and Heritage* 9.4, 267–286.

Lewis, K., Gonzalez, M., and Kaufman, J. 2012. Social selection and peer influence in an online social network. *PNAS* 109.1, 68–72.

Liboiron, M. 2016. Redefining pollution and action: The matter of plastics. *Journal of Material Culture* 21.1, 87–110.

Liboiron, M. 2021. *Pollution Is Colonialism*. Durham, NC: Duke University Press.

Lijphart, A. 1990. The political consequences of electoral laws, 1945–85. *American Political Science Review* 84.2, 481–496.

Lin, N. 2001. *Social Capital: A Theory for Social Structure and Action*. Cambridge, MA: Cambridge University Press.

Linley, R., and Usherwood, B. 1998. New measures for the new library: a social audit of public libraries. *IFLA Journal* 25.2, 90–96.

Little, B. J., and Schackel, P. A. (eds) 2007. *Archaeology as a Tool of Civic Engagement*. Plymouth: Rowman Altamira.

Little, D. 2012. Assemblage Theory. Understanding Society blog post available at: https://understandingsociety.blogspot.com/2012/11/assemblage-theory.html

Liu, Y., Cleary, A., Fielding, K. S., et al. 2022. Nature connection, pro-environmental behaviours and wellbeing: understanding the mediating role of nature contact. *Landscape and Urban Planning* 228, 104550. https://doi.org/10.1016/j.landurbplan.2022.104550

Løkken, B. I., Merom, D., Sund, E. R., et al. 2020. Cultural participation and all-cause mortality, with possible gender differences: an 8-year follow-up in the HUNT Study, Norway. *Journal of Epidemiology and Community Health* 74.8, 624–630. doi:10.1136/jech-2019-213313.

Lønngren, J., and van Poeck, K. 2021. Wicked problems: a mapping review of the literature. *International Journal of Sustainable Development & World Ecology* 28.6, 481–502.

Lowenthal, D. 1985. *The Past is a Foreign Country*. Cambridge: Cambridge University Press.

Lowry, C. A., Hollis, J. H., de Vries, A., et al. 2007. Identification of an immune-responsive mesolimbocortical serotonergic system: potential role in regulation of emotional behavior. *Neuroscience* 146.2, 756–772.

Lucas, G. 2022. *Archaeological Situations: Archaeological Theory from the Inside Out*. London: Routledge.

Lyon, C., Saupe, E. E., Smith, C. J., et al. 2021. Climate change research and action must look beyond 2100. *Global Change Biology* 28.2, 349–361.

Lyons, M., and Jones, B. 2017. Does knowledge of local history increase prosocial behaviour and belongingness? In K. Niven, S. Lewis and C. Kagan (eds), *Making a Difference with*

Psychology, 42–48. University of Manchester: Richard Benjamin Trust. https://www.research.manchester.ac.uk/portal/files/60079984/Making_a_difference_with_psychology_PDF.pdf

Maas, J., Verheij, R. A., de Vries, S., et al. 2009. Morbidity is related to a green living environment. *Journal of Epidemiology and Community Health* 63, 967–973.

Macdonald, S. 2015. Is 'difficult heritage' still 'difficult'? Why public acknowledgment of past perpetration may no longer be so unsettling to collective identities. *Museum International* 67.1–4, 6–22.

Mack, J. 2003. *The Museum of the Mind: Art and Memory in World Cultures*. London: The British Museum Press.

Madden, O., Elena Charola, A., Cullen Cobb, K., et al. (eds) 2012. *The Age of Plastic: ingenuity and Responsibility: Proceedings of the 2012 MCI Symposium* (Smithsonian Institution to Museum Conservation 7). Washington, DC: Smithsonian Institution.

Mæland, C. E., and Staupe-Delgado, R. 2020. Can the global problem of marine litter be considered a crisis? *Risk, Hazards & Crisis in Public Policy* 11.1, 87–104.

Maes, M. J. A., Pirani, M., Booth, E. R., et al. 2021. Benefit of woodland and other natural environments for adolescents' cognition and mental health. *Nature Sustainability* 4, 851–858. https://doi.org/10.1038/s41893-021-00751-1

Magnani, M., Magnani, N., Venovcevs, A., et al. 2022. A contemporary archaeology of pandemic. *Journal of Social Archaeology* 22.1, 48–81.

Malin, A. 1994. Mother who won't disappear. *Human Rights Quarterly* 16.1, 187–213.

Marchant, R., and Lane, P. 2014. Past perspectives for the future: foundations for sustainable development in East Africa. *Journal of Archaeological Science* 51, 12–21.

Martin, S. C. 2023. Materiality in transit: an ethnographic-archaeological approach to objects carried, lost, and gained during contemporary migration journeys. *Journal of Social Archaeology* 23.1, 3–24. https://doi.org/10.1177/14696053221144754

Matarasso, F. 1998. *Beyond Book Issues: The Social Impact of Library Projects*. Stroud: Comedia.

Maxwell, C. R. 2016. 'The radium water worked fine until his jaw came off': the changing role of radioactivity in the twentieth century. In U. K. Frederick and A. Clarke (eds), *That Was Then, This is Now: Contemporary Archaeology and Material Cultures in Australia*, 84–100. Cambridge: Cambridge Scholars.

Mazzucato, M. 2018. *Mission-oriented Research and Innovation in the European Union: A Problem-solving Approach to Fuel Innovation-led Growth*. Luxembourg: Publications Office of the European Union. https://op.europa.eu/en/publication-detail/-/publication/5b2811d1-16be-11e8-9253-01aa75ed71a1/language-en

McCandless, E. 2013. Wicked problems in peacebuilding and statebuilding: making progress in measuring progress through the New Deal. *Global Governance* 19.2, 227–248.

McGrath, J. E. 1976. Stress and behavior in organizations. In M. D. Dunnette (ed.), *Handbook of Industrial and Organizational Psychology*, 1351–1395. Chicago: Rand McNally.

McGuire, R., and Paynter, R. 1991 (eds). *The Archaeology of Inequality*. Oxford: Blackwell.

McIntyre, O. 2020. Addressing marine plastic pollution as a 'wicked' problem of transnational environmental governance. *Environmental Liability: Law, Policy and Practice* 25/6, 282–295. https://ssrn.com/abstract=3637482

McLeish, T. 2022. *The Poetry and Music of Science: Comparing Creativity in Science and Art*. Revised Edition. Oxford: Oxford University Press.

McNeill, J. R. 2003. Observations on the nature and culture of environmental history. *History and Theory* 42.4, 5–43.

McNeill, J. R. 2010. Sustainable survival. In P. A. McAnany and N. Yoffee (eds), *Questioning Collapse: Human Resilience, Ecological Vulnerability and the Aftermath of Empire*, 355–366. Cambridge: Cambridge University Press.

Meirion Jones, A. 2021. Disentangling entanglement: archaeological encounters with the concept of entanglement. *Current Swedish Archaeology* 29, 38–42. https://doi.org/10.37718/CSA.2021.03

Memmott, P., and Bond, A. 2017. Aboriginal society and kinship in West End street life. *Parity* 30.2, 76–78.

Menkhaus, K. J. 2010. State fragility as a wicked problem. *Prism* 1.2, 85–100. https://www.jstor.org/stable/26469043

Meskimmon, M. 2011. *Contemporary Art and the Cosmopolitan Imagination*. New York: Routledge.

Mestanza, C., Botero, C. M., Anfuso, G., et al. 2019. Beach litter in Ecuador and the Galapagos Islands: a baseline to enhance environmental conservation and sustainable tourism. *Marine Pollution Bulletin* 140, 573–578.

Metz, S. 2005. Embracing the messiness of science. *The Science Teacher* 72, 8.

Meyer-Bisch, P. 2009. On the 'right to heritage'—The innovative approaches of Articles 1 and 2 of the Faro Convention. In Council of Europe 2009. *Heritage and Beyond*, 59–65. Strasbourg: Council of Europe.

Michalos, A., and Kahlke, P. P. 2008. Impact of arts-related activities on the perceived quality of life. *Social Indicators Research* 89.2, 193–258. https://psycnet.apa.org/doi/10.1007/s11205-007-9236-x

Mick, C. 2023. The fight for the past: contested heritage and the Russian invasion of Ukraine. *The Historic Environment: Policy and Practice* 14.2, 135–153. https://doi.org/10.1080/17567505.2023.2205703

Mikulincer, M., and Shaver, P. R. 2019. Attachment orientations and emotion regulation. *Current Opinion in Psychology* 25, 6–10.

Millar, G., Millar, J., and Verkoren, W. 2013. Peacebuilding plans and local configurations: frictions between imported processes and indigenous practices. *International Peacekeeping* 20.2, 137–143.

Milne, G., Newman, D., Hutchinson, O., et al. 2022. Citizen science in coastal archaeology: CITIZAN's community-based research in England, UK. In D. A. Scott-Ireton, J. E. Jones, and J. T. Raupp (eds), *Citizen Science in Maritime Archaeology: The Power of Public Engagement for Heritage Research, Monitoring, and Preservation*. Miami: University Press of Florida.

Mitton, C., Adair, C., McKenzie, E., et al. 2007. Knowledge transfer and exchange: review and synthesis of the literature. *Milbank Quarterly* 85.4, 729–768.

Monbiot, G. 2021. Capitalism is killing the planet—it's time to stop buying into our own destruction. *The Guardian*, 30 October 2021. https://www.theguardian.com/environment/2021/oct/30/capitalism-is-killing-the-planet-its-time-to-stop-buying-into-our-own-destruction

Monbiot, G. 2022. Do we really care more about Van Gogh's sunflowers than real ones? *The Guardian*, 19 October 2022. https://www.theguardian.com/commentisfree/2022/oct/19/van-gogh-sunflowers-just-stop-oil-tactics

Mondanaro, A., Melchionna, A., Di Febbraro, M., et al. 2020. A major change in rate of climate niche envelope evolution during hominid history. *iScience* 23.11, 101693. https://doi.org/10.1016/j.isci.2020.101693

Moraes, C., Blain-Moraes, S., Morell-Tomassoni, S., et al. 2021. The W-model: a pre-college design pedagogy for solving wicked problems. *International Journal of Technology and Design Education* 31, 139–164. https://doi.org/10.1007/s10798-019-09543-3

Morath, S. J. 2022. *Our Plastic Problem and How to Solve It*. Cambridge: Cambridge University Press.

Morel, H. 2018. Exploring heritage in IPCC documents. Available online at: https://heritage-research.org/app/uploads/2018/11/Exploring-Heritage-in-IPPC-Documents-2018.pdf

Morel, H., Megarry, W., Potts, A., et al. 2022. *Global Research and Action Agenda on Culture, Heritage and Climate Change*. ICOMOS and ICSM CHC: Charenton-le-Pont and Paris, France. https://openarchive.icomos.org/id/eprint/2716/

Morel, H., and oud Ammerveld, J. 2021. From climate crisis to climate action: exploring the entanglement of changing heritage in the Anthropocene. *The Historic Environment: Policy & Practice* 12.3–4, 271–291.

Morel, H., Band, L., Barrie-Smith, L., et al. 2023. Water heritage and the importance of local knowledge in climate action. *Historical Archaeology*. 57.2. 10.1007/s41636-023-00415-1

Morris, J. N., Heady, J. A., Raffle, P. A. B., et al. 1953. Coronary heart-disease and physical activity of work. *The Lancet* 262.6796, 1111–1120.

Morse, N. 2019. The social role of museums: from social inclusion to health and wellbeing. In M. O'Neill and G. Hooper (eds), *Connecting Museums*, 48–65. London: Routledge.

Morse, N. 2020. *The Museum as a Space of Social Care*. London: Routledge.

Morse, N., and Chatterjee, H. 2018. Museums, health and wellbeing research: co-developing a new observational method for people with dementia in hospital contexts. *Perspectives in Public Health* 138.3, 152–159.

Morton, T. 2013. *Hyperobjects: Philosophy, and Ecology after the End of the World*. Minneapolis: University of Minnesota Press.

Munawar, N. A., and Symonds, J. 2022. Post-conflict reconstruction, forced migration and community engagement: the case of Aleppo, Syria. *International Journal of Heritage Studies* 28.9, 1017–1035. https://doi.org/10.1080/13527258.2022.2117234

Muñoz-Pérez, J. P., Lewbart, G. A., Alarcón-Ruales, D., et al. 2023. Galápagos and the plastic problem. *Frontiers in Sustainability* 4.1091516. https://www.frontiersin.org/articles/10.3389/frsus.2023.1091516/full

Museums and Libraries Association (MLA) Renaissance North West, 2011. *Who Cares? Museums, Health and Wellbeing*. Renaissance North West. http://clok.uclan.ac.uk/3362/

Museums Association 2017. Valuing Diversity: The Case for Inclusive Museums. Available online at: https://media.museumsassociation.org/app/uploads/2020/06/11085809/27072016-diversity-report1.pdf

Myers, A. 2011. Contemporary archaeology in transit: the artefacts of a 1991 van. *International Journal of Historical Archaeology* 15, 138–161.

Napier, A. D., et al. 2014. Culture and health. *The Lancet* 384, 1607–1639.

National Lottery Heritage Fund, 2019. Public perceptions of heritage 2018. https://www.heritagefund.org.uk/about/insight/research/public-perceptions-heritage

National Trust, 2020. *Places That Make Us*. Research report. https://nt.global.ssl.fastly.net/binaries/content/assets/website/national/pdf/places-that-make-us.pdf

Nelson, D. E., Heinemeier, J., Lynnerup, N., et al. 2012. An isotopic analysis of the diet of the Greenland Norse. *Journal of the North Atlantic* 3, 93–118.

Nelson, R. R. 1977. *The Moon and the Ghetto: An Essay on Public Policy Analysis*. New York: W. W. Norton and Co. Inc.

Nelson, R. R. 2011. *The Moon and the Ghetto* Revisited. *Science and Public Policy* 38.9, 681–690.

Nettle, D. 2015. *Tyneside Neighbourhoods: Deprivation, Social Life and Social Behaviour in One British City*. Cambridge: Open Book Publishers. http://dx.doi.org/10.11647/OBP.0084

Nevell, M., and Brogan, L. 2021. Community archaeology, identity and the excavation of Manchester's Reno nightclub. In L. Maloney and J. Schofield (eds), *Music and Heritage: New Perspectives on Place-making and Sonic Identity*, 150–159. London: Routledge.

Newman, J., and Head, B. 2017. The national context of wicked problems: comparing policies on gun violence in the US, Canada, and Australia. *Journal of Comparative Policy Analysis: Research and Practice* 19.1, 40–53. doi:10.1080/13876988.2015.1029334

Nimenko, W., and Simpson, R. G. 2014. Rear operations group medicine: a pilot study of psychosocial decompression in a rear operations group during Operation HERRICK. *Journal of the Royal Army Medical Corps* 160, 295–297.

Niskanen, V-P., Rask, M., and Raisio, H. 2021. Wicked problems in Africa: a systematic literature review. *SAGE Open* 11.3. https://doi.org/10.1177/21582440211032163

Nolan, C. 2020. *Therapeutic Landscapes of Prehistory: Exploring the Role of Archaeology in the Promotion of Present-day Wellbeing*. PhD Thesis, University of Reading. https://centaur.reading.ac.uk/104551/

Nowotny, H. 2017. *An Orderly Mess*. Budapest: Central European University Press.

Oancea, A. 2019. Research governance and the future(s) of research assessment. *Palgrave Communications* 5.27. https://doi.org/10.1057/s41599-018-0213-6

Obbard, R. W., Sadri, S., Wong, Y. Q., et al. 2014. Global warming releases microplastic legacy frozen in Arctic sea ice. *Earth's Future* 1, 315–320. https://doi.org/10.1002/2014EF000240

Orr, S. A., Richards, J., and Fatorić, S. 2021. Climate change and cultural heritage: a systematic literature review (2016–2020). *The Historic Environment: Policy & Practice* 12.3–4, 434–477.

Orthel, B. D. 2022. Linking public health and heritage work. *International Journal of Heritage Studies* 281, 44–58. doi:10.1080/13527258.2021.1903969

Paddock, C. 2007. Soil bacteria work in similar way to antidepressants. *Medical News Today*. https://www.medicalnewstoday.com/articles/66840#1

Padgett, D. K., Henwood, B. F., and Tsemberis, S. J. 2016. *Housing First: Ending Homelessness, Transforming Systems, and Changing Lives*. New York: Oxford University Press.

Painter, G., and Culhane, D. 2021. Social investment in ending homeless. *European Journal of Homelessness* 15.3, 85–97.

Parekh, N., and Rose, T. 2011. Health inequalities of the Roma in Europe: a literature review. *Central European Journal of Public Health* 19, 139–142.

Parsell, C. 2012. Home is where the house is: the meaning of home for people sleeping rough. *Housing Studies* 27.2, 159–173.

Pavlyshyn, M. 2022. Destruction of historic sites and heritage during Russia's war on Ukraine. *Teaching History* 56.2, 4–12.

Payne, D. 2022. Remaking the humanities: neoliberal logics, wicked problems, and survival post-COVID. *Journal of Arts and Humanities* 11.1, 23–37. https://www.theartsjournal.org/index.php/site/article/view/2205

Paynter, R. 1989. The archaeology of equality and inequality. *Annual Review of Anthropology* 18, 369–399.

Peng, Y., Wu, P., Schartup, A. T., et al. 2021. Plastic waste release caused by COVID-19 and its fate in the global ocean. *PNAS* 118.47. https://doi.org/10.1073/pnas.2111530118

Pereira, P., Bašić, F., Bogunovic, I., et al. 2022. Russian-Ukrainian war impacts the total environment. *Science of the Total Environment* 837.155865. https://doi.org/10.1016/j.scitotenv.2022.155865

Peters, B. G. 2017. What is so wicked about wicked problems? A conceptual analysis and a research program. *Policy and Society* 36.3, 385–396.

Peters, T. J. 1979. *Designing and Executing 'Real' Tasks*. Unpublished ms, Stanford University, cited in Weick 1984.

Pétursdóttir, Þ. 2017. Climate change? Archaeology and Anthropocene. *Archaeological Dialogues* 24.2, 175–205.

Pétursdóttir, Þ, and Sørensen, T. 2023. Archaeological encounters: ethics and aesthetics under the mark of the Anthropocene. *Archaeological Dialogues* 30.1, 50–67. doi:10.1017/S1380203823000028

Phillips, T., Gilchrist, R., Skeates, R., et al. 2012. Inclusive, accessible archaeology: enabling persons with disabilities. In R. Skeates, C. McDavid, and J. Carman (eds), *The Oxford Handbook of Public Archaeology*, 673–693. Oxford: Oxford University Press.

Pickett, S., and Cadenasso, M. 2005. Vegetation succession. In M. van der Maarel (ed.), *Vegetation Ecology*, 172–198. Malden: Blackwell.

Pickett, S., and Grove, J. 2009. Urban ecosystems: what would Tansley do? *Urban Ecosystems* 12, 1–8.

PLoS Medicine Editors, 2013. Addressing the wicked problem of obesity through planning and policies. *PloS medicine* 10.6, e1001475. https://doi.org/10.1371/journal.pmed.1001475

Popper, K. 1976 [2002]. *Unended Quest: An Intellectual Autobiography*. London and New York: Routledge.

Povinelli, E. A. 2002. *The Cunning of Recognition: Indigenous Alterities and the Making of Australian Multiculturalism*. Durham, NC: Duke University Press.

Power, A., and Smyth, K. 2016. Heritage, health and place: the legacies of local community-based heritage conservation on social wellbeing. *Health & Place* 29, 160–167.

Praet, E., Baeza-Álvarez, J., De Veer, D., et al. 2023. Bottle with a message: the role of story writing as an engagement tool to explore children's perceptions of marine plastic litter. *Marine Pollution Bulletin* 186, 114457. https://doi.org/10.1016/j.marpolbul.2022.114457

Prewitt, V., 2011. Working in the café: lessons in group dialogue. *The Learning Organization* 18.3, 189–202. https://doi.org/10.1108/09696471111123252

Proshansky, H. M., Fabian, A. K., and Kaminoff, R. 1983. Place-identity: physical world socialisation of the self. *Journal of Environmental Psychology* 3.1, 57–83.

Putnam, R. D. 2000. *Bowling Alone: The Collapse and Revival of American Community*. New York: Simon & Schuster.

Quesada-Ganuza, L., Garmendia, L., Roji, E., et al. 2021. Do we know how urban heritage is being endangered by climate change? A systematic and critical review. *International Journal of Disaster Risk Reduction* 65. doi:https://www.sciencedirect.com/science/article/pii/S2212420921005124?via%3Dihub

Quiroga, D. 2009. Crafting nature: the Galápagos and the making and unmaking of a 'natural laboratory'. *Journal of Political Ecology: Case Studies in History and Society* 16, 123–140.

Rahm-Skågeby, J., and Rahm, L. 2022. Design and deep entanglements. *Interactions*, January–February, 73–76.

Rajic, M., and Howarth, D. 2021. Hollis Croft: a matter of time. *Internet Archaeology* 56. https://doi.org/10.11141/ia.56.4.comic

Randall, I. 2022. Epoch or event? Defining the Anthropocene. *Physics World*, December 2022. https://physicsworld.com/a/epoch-or-event-defining-the-anthropocene/

Rasch, D., and Bywater, K. 2014. Health promotion in Ecuador: a solution for a failing system. *Health* 6, 916–925. http://dx.doi.org/10.4236/health.2014.610115

Ratcliffe, E., and Korpela, K. M. 2018. Time- and self-related memories predict restorative perceptions of favourite places via place identity. *Environment and Behaviour* 50.6, 690–720.

Rathje, W., and Murphy, C. 1992. *Rubbish! The Archaeology of Garbage*. London: HarperCollins.

Raworth, K. 2017a. *Doughnut Economics: Seven Ways to Think Like a Twenty-first-century Economist*. London: Penguin Random House.

Raworth, K. 2017b. A doughnut for the Anthropocene: humanity's compass in the 21st century. *The Lancet Planetary Health* 1.2, e48–e49. https://www.thelancet.com/journals/lanplh/article/PIIS2542-5196(17)30028-1/fulltext

Read, P. 2011. *Returning to Nothing: The Meaning of Lost Places*. Cambridge: Cambridge University Press.

Reilly, S., Nolan, C., and Monckton, L. 2018. *Wellbeing and the Historic Environment: Threats, Issues and Opportunities for the Historic Environment*. Swindon: Historic England. https://historicengland.org.uk/images-books/publications/wellbeing-and-the-historic-environment/wellbeing-and-historic-environment/

Reno, J. 2015. Waste and waste management. *Annual Review of Anthropology* 44.1, 557–572.

Richardson, K., Hardesty, B. D., Vince, J., et al. 2022. Global estimates of fishing gear lost to the ocean each year. *Science Advances* 8.41. doi/10.1126/sciadv.abq0135

Richer, S., Stump, D., and Marchant, R. 2019. Archaeology has no relevance. *Internet Archaeology* 53. https://doi.org/10.11141/ia.53.2

Rick, T. C., and Sandweiss, D. H. 2020. Archaeology, climate, and global change in the Age of Humans. *Proceedings of the National Academy of Sciences of the United States of America* 117.15, 8250–8253.

Riesto, S., Egberts, L., Lund, A. A., et al. 2022. Plans for uncertain futures: heritage and climate imaginaries in coastal climate adaptation, *International Journal of Heritage Studies* 28.3, 358–375. 10.1080/13527258.2021.2009538

Riordan, A., and Schofield, J. 2015. Beyond biomedicine: traditional medicine as cultural heritage. *International Journal of Heritage Studies* 21.3, 280–299. 10.1080/13527258.2014.940368

Rittel, H. W. J. 1972. On the planning crisis: systems analysis of the first and second generations. *Bedriftsøkonomen* 8, 390–398.

Rittel, H. W. J., and Webber, M. M. 1973. Dilemmas in a general theory of planning. *Policy Sciences* 4.2, 155–169.

Robb, J. 2013. Material culture, landscapes of action, and emergent causation: a new model for the origins of the European Neolithic. *Current Anthropology* 54.6, 657–683.

Roberts, D. 2013. Hybrid politics and post-conflict policy. In D. Chandler and T. D. Sisk (eds), *The Routledge Handbook of International Statebuilding*, 94–106. London: Routledge.

Roberts, L., Waddell, H., and Birch, A. 2021. *Social Prescribing and the Potential of Historic England's Local Delivery*. Stockport: SQL. https://historicengland.org.uk/images-books/publications/social-prescribing-potential-historic-england-local-delivery/social-prescribing/

Roberts, N. 2000. Wicked problems and network approaches to resolution. *International Public Management Review* 1.1. https://ipmr.net/index.php/ipmr/article/view/175

Rockman, M., and Hritz, C. 2020. Expanding use of archaeology in climate change response by changing its social environment. *Proceedings of the National Academy of Sciences of the United States of America* 117.15, 8295–8302.

Roe, E. 2013. *Making the Most of Mess*. Durham, NC: Duke University Press.

Romanello, M., et al. 2022. The 2022 report of the Lancet Countdown on health and climate change: health at the mercy of fossil fuels. *The Lancet Public Health* 400.10363, P1619–1654. https://doi.org/10.1016/S0140-6736(22)01540-9

Ross, N. L. 2018. The 'Plasticene' Epoch? *Elements: An International Magazine of Mineralogy, Geochemistry and Petrology*, October 2018.

Rosenberg, N. 2021. Miner and doctor: a topography of injustice. *Perspectives in Biology and Medicine* 64.2, 189–199.

Rotchell, J. M., Mendrik, F., Chapman, E., et al. 2024. The contamination of in situ archaeological remains: A pilot analysis of microplastics in sediment samples using μFTIR. *Science of the Total Environment* 914, 169941. https://doi.org/10.1016/j.scitotenv.2024.169941

Rouhani, B. 2017. In search of lost values: is post-trauma cultural heritage reconstruction possible? In P. Schneider (ed.), *Catastrophe and Challenge: Cultural Heritage in Post-conflict Recovery*, 35–52. Cottbus: Brandenburg University of Technology.

Rowntree, B. S. 1902. *Poverty: A Study of Town Life*. London: Macmillan.

Royer, S.-J., Ferrón, S., Wilson, S. T., et al. 2018. Production of methane and ethylene from plastic in the environment. *PloS One* 13.8, e0200574.

Russell, J. Y. 2010. A philosophical framework for an open and critical transdisciplinary inquiry. In V. E. Brown, J. Harris, and J. Russell (eds), *Tackling Wicked Problems through the Transdisciplinary Imagination*, 31–60. London: Routledge.

Sahin, O., Salim, H., Suprun, E., et al. 2020. Developing a preliminary causal loop diagram for understanding the wicked complexity of the COVID-19 pandemic. *Systems* 8.20. https://doi.org/10.3390/systems8020020

Sánchez-García, N., and Sanz-Lazaro, C. 2023. Darwin's paradise contaminated by marine debris: understanding their sources and accumulation dynamics. *Environmental Pollution* 121310. https://doi.org/10.1016/j.envpol.2023.121310.

Sandweiss, D. H., and Kelley, A. R. 2012. Archaeological contributions to climate change research: the archaeological record as a paleoclimatic and paleoenvironmental archive. *Annual Review of Anthropology* 41, 371–391.

Sardar, Z. 2010. Welcome to postnormal times. *Futures* 42.5, 435–444.

Sardar, Z. 2013. *Future: All That Matters*. London: Hodder & Stoughton.

Sardar, Z. 2015. Postnormal times revisited. *Futures* 67, 26–39. https://doi.org/10.1016/j.futures.2015.02.003

Saunders, R. 2002. Tell the truth: the archaeology of human rights abuses in Guatemala and the former Yugoslavia. In J. Schofield, W. G. Johnson, and C. M. Beck (eds), *Matériel Culture: The Archaeology of Twentieth-Century Conflict*, 103–114. London: Routledge.

Sayer, F. 2015. Can digging make you happy? Archaeological excavations, happiness and heritage. *Arts & Health* 7.3, 247–260. http://dx.doi.org/10.1080/17533015.2015.1060615

Sayer, F. 2018. Understanding well-being: a mechanism for measuring the impact of heritage practice on well-being. In A. M. Labrador and N. A. Silberman (eds), *The Oxford Handbook of Public Heritage Theory and Practice*, 387–404. Oxford: Oxford University Press.

Scannell, L., and Gifford, R. 2017. The experienced psychological benefits of place attachment. *Journal of Environmental Psychology* 51, 256–269.

Schiefloe, P. M. 2021. The Corona crisis: a wicked problem. *Scandinavian Journal of Public Health* 49, 5–8.

Schickore, J. 2020. Mess in science and wicked problems. *Perspectives on Science* 28.4, 483–504. http://doi.org/10.1162/posc_a_00348

Schneider, P. (ed.) 2017. *Catastrophe and Challenge: Cultural Heritage in Post-conflict Recovery*. Cottbus: Brandenburg University of Technology.

Schofield, J. (ed.) 1991. *Interpreting Artefact Scatters: Contributions to Ploughzone Archaeology*. Oxford: Oxbow Books.

Schofield, J. 2006. Jessie's cats and other stories: presenting and interpreting recent troubles. In A. Hems and M. Blockley (eds), *Heritage Interpretation*, 141–162. London: Routledge and English Heritage.

Schofield, J. 2009. *Aftermath: Readings in the Archaeology of Recent Conflict*. New York: Springer.

Schofield, J. (ed.) 2014. *Who Needs Experts? Counter-mapping Cultural Heritage*. Farnham: Ashgate.

Schofield, J. 2017. People first? Reassessing heritage priorities in post-conflict recovery. In P. Schneider (ed.), *Catastrophe and Challenge: Cultural Heritage in Post-conflict Recovery*, 219–223. Cottbus: Brandenburg University of Technology.

Schofield, J., Aylmer, J., Donnelly, A., et al. 2021a. Contemporary archaeology as a framework for investigating the impact of disposable plastic bags on environmental pollution in Galápagos. *Journal of Contemporary Archaeology* 7.2, 276–306.

Schofield, J., and Morrissey, E., 2013. *Strait Street: Malta's 'Red-light District' Revealed*. Malta: Midsea Books.

Schofield, J., and Pocock, C. 2023. Plasticity and time: using the stress-strain curve as a framework for investigating the wicked problems of marine pollution and climate change. In E. Kryder-Reid and S. May (eds), *Toxic Heritage: Legacies, Futures, and Environmental Injustice*, 672–673. London and New York: Routledge.

Schofield, J., Johnson, W. G. and Beck, C. M. (eds) 2002. *Matériel Culture: The Archaeology of Twentieth-Century Conflict*. London: Routledge.

Schofield, J., Praet, E., Townsend, K., et al. 2021b. 'COVID waste' and social media as method: an archaeology of PPE and its contribution to policy. *Antiquity* 95.380, 435–449.

Schofield, J., Scott, C., Spikins, P., et al. 2020a. Autism spectrum condition and the built environment: new perspectives on place attachment and cultural heritage. *The Historic Environment: Policy & Practice* 11.2–3, 307–334. 10.1080/17567505.2020.1699638

Schofield, J., Wyles, K., Doherty, S., et al. 2020b. Object narratives as a methodology for mitigating marine plastic pollution: a new multidisciplinary approach, and a case study from Galápagos. *Antiquity* 94, 228–244.

Schuller, T., Preston, J., Hammond, C., et al. 2004. *The Benefits of Learning: The Impact of Education on Health, Family Life and Social Capital*. London: Routledge.

Schultz, P. W., Bator, R. J., Large, L. B., et al. 2013. Littering in context: personal and environmental predictors of littering behavior. *Environment and Behaviour* 45.1, 35–59. https://doi.org/10.1177/0013916511412179

Schuyler, Q. A., Wilcox, C., Townsend, K., et al. 2014. Mistaken identity? Visual similarities of marine debris to natural prey items of sea turtles. *BMC Ecology* 14.14. https://doi.org/10.1186/1472-6785-14-14

Schwartz, S. W. 2022. *An Archaeology of Temperature: Numerical Materials in the Capitalised Landscape*. London and New York: Routledge.

van Sebille, E., Delandmeter, P., Schofield, J., et al. 2019. Basin-scale sources and pathways of microplastic that end up in the Galápagos archipelago. *Ocean Science* 15, 1341–1349.

Selg, P., Klasche, B., and Nõgisto, J. 2022. Wicked problems and sociology: building a missing bridge through processual relationalism. *International Review of Sociology*. https://www.tandfonline.com/doi/full/10.1080/03906701.2022.2035909

Senga-Green, D., Boots, B., Blockley, D. J., et al. 2015. Impacts of discarded plastic bags on marine assemblages and ecosystem functioning. *Environmental Science & Technology* 49.9: 5380–5389. https://pubs.acs.org/doi/abs/10.1021/acs.est.5b00277

Serra, J. 2014. Postnormal governance. *East-West Affairs*. 5 October, 5–13.

Shah, K. U., Niles, K., Ali, S. H., et al. 2019. Plastics waste metabolism in a petro-island state: towards solving a 'wicked problem' in Trinidad and Tobago. *Sustainability* 11.23, 6580. https://doi.org/10.3390/su11236580

Shanks, M. 2007. Symmetrical archaeology. *World Archaeology* 39.4, 589–596. 10.1080/00438240701679676

Shapiro, M. 1988. Introduction: judicial selection and the design of clumsy institutions. *Southern California Law Review* 61, 1555–1563.

Sharpe, B., Hodgson, A., Leicester, G., et al. 2016. Three horizons: a pathways practice for transformation. *Ecology and Society* 21.2, 47. https://www.ecologyandsociety.org/vol21/iss2/art47/

Sharples, N. M. 1991. *Maiden Castle: Excavations and Field Survey 1985–86*. Archaeological Report 19. London: English Heritage.

Shennan, S. J. 1988. *Quantifying Archaeology*. Edinburgh: Edinburgh University Press.

Sherrington, C. 2016. *Plastics in the Marine Environment*. https://www.eunomia.co.uk/reports-tools/plastics-in-the-marine-environment/

Shonkoff, J. P. 2000. Science, policy and practice: three cultures in search of a shared mission. *Child Development* 71.1, 181–187.

Simon, H. 1956. Rational choice and the structure of the environment. *Psychological Review* 63.2, 129–138.

Simon, H. 1973. Applying information technology to organisational design. *Public Administration Review* 33, 268–278.

Singer, P. 1972. Famine, affluence and morality. *Philosophy and Public Affairs* 1.3, 229–243.

sintellyapp 2021. *7 Biggest Social Issues that could lead to Social Injustice*. https://sintelly.com/articles/biggest-social-issues-that-could-lead-to-social-injustice

Skaburskis, A. 2008. The origin of 'wicked problems'. *Planning Theory & Practice* 9.2, 277–280.

Skuse, A., Rodger, D., Wilmore, M., et al. 2021. Solving 'wicked problems' in the app co-design process. *Convergence* 27.2, 539–553. doi:10.1177/1354856520976450

Smith, G. H., and Smith, L. T. 2019. Doing indigenous work: decolonizing and transforming the academy. In E. A. McKinley and L. T. Smith (eds), *Handbook of Indigenous Education*, 1075–1101. Singapore: Springer.

Smith, L. 2006. *Uses of Heritage*. London and New York: Routledge.

Smith, M. 2021. Why archaeology's relevance to global challenges has not been recognised. *Antiquity* 95.382, 1061–1069. doi: 10.15184/aqy.2021.42

Sofaer, J., Davenport, B., Stig Sørensen, M.-L., et al. 2021. Heritage sites, value and well-being: learning from the COVID-19 pandemic in England. *International Journal of Heritage Studies* 27.11, 1117–1132. https://doi.org/10.1080/13527258.2021.1955729

Soga, M., Cox, D. T. C., Yamaura, Y., et al. 2017. Health benefits of urban allotment gardening: improved physical and psychological well-being and social integration. *International Journal of Environmental Research and Public Health* 14.1. https://doi.org/10.3390/ijerph14010071

Soga, M., Gaston, K. J., and Yamaura, Y. 2017. Gardening is beneficial for health: a meta-analysis. *Preventive Medicine Reports* 5, 92–99.

Sommerville, M., and Rapport, D. (eds) 2000. *Transdisciplinarity: Recreating Integrated Knowledge*. Oxford: EOLSS Publishers.

Stacy, H. 2009. *Human Rights for the 21st Century: Sovereignty, Civil Society, Culture*. Stanford: Stanford University Press.

Steidle, S. B. 2021. *Exploring the Role(s) of Community Colleges in Addressing Wicked Problems through Multi-stakeholder Collaboration: An Entrepreneurial Approach to Sustainability*. PhD thesis, Old Dominion University. Available online at:https://www.proquest.com/openview/70958a609bfce0863c056ea0436c8c82/1.pdf?pq-origsite=gscholar&cbl=18750&diss=y

Steinbeck, J. 2001 [1939]. *The Grapes of Wrath*. London: Penguin Books Ltd.

Stern, N. 2006. *The Economics of Climate Change: The Stern Review*. Cambridge: Cambridge University Press.

Stewart, H. E., Osterreicher, I., Gokee, C., et al. 2018. Surveilling surveillance: counter-mapping undocumented migration in the USA-Mexico borderlands. In Y. Hamilakis (ed.) 2018. *The New Nomadic Age: Archaeologies of Forced and Undocumented Migration*, 42-57. Bristol: Equinox.

Stewart, S. 1993. *On Longing: Narratives of the Miniature, the Gigantic, the Souvenir, the Collection*. Durham, NC: Duke University Press.

Stibbe, D. T., Reid, S., and Gilbert, J. 2019. *Maximising the Impact of Partnerships for the SDGs: The Partnering Initiative and UN DESA*. https://sustainabledevelopment.un.org/content/documents/2564Partnerships_for_the_SDGs_Maximising_Value_Guidebook_Final.pdf.

Stone, P. G. 2015. The challenge of protecting heritage in times of armed conflict. *Museum International* 67.1-4, 40-54. 10.1111/muse.12079

Stottman, M. J. (ed.) 2010. *Archaeologists as Activists: Can Archaeologists Change the World?* Alabama: Alabama University Press.

Sun, S., Folarin, A. A., Ranjan, Y., et al. 2020. Using smartphones and wearable devices to monitor behavioral changes during COVID-19. *Journal of Medical Internet Research* 22.9, e19992.

Taçon, P., and Baker, S. 2019. New and emerging challenges to heritage and well-being: a critical review. *Heritage* 2, 1300–1315. https://doi.org/10.3390/heritage2020084

Takano, T., Nakamura, K., and Watanabe, M. 2002. Urban residential environments and senior citizens longevity in megacity areas: the importance of walkable green spaces. *Journal of Epidemiology and Community Health* 56, 913–918.

Tansley, A. G. 1935. The use and abuse of vegetational concepts and terms. *Ecology* 16, 284–307.

Taylor, J. 2023. Choice architecture, nudging, and the historic environment: the subtle influences of heritage through the lens of behavioural science. *International Journal of Heritage Studies* 29.3, 199–219. https://doi.org/10.1080/13527258.2023.2179100

Tenzer, M. 2022. Tweets in the Peak: Twitter Analysis - the impact of Covid-19 on cultural landscapes. *Internet Archaeology* 59. https://doi.org/10.11141/ia.59.6

Termeer, C., and Dewulf, A. 2019. A small wins framework to overcome the evaluation paradox of governing wicked problems. *Policy and Society* 38.2, 298–314.

Termeer, C., Dewulf, A., and Biesbroek, R. 2019. A critical assessment of the wicked problem concept: relevance and usefulness for policy science and practice. *Policy and Society* 38.2, 167–179.

Thaler, R., and Sunstein, C. 2008. *Nudge: Improving Decisions about Health, Wealth and Happiness*. New Haven, CT: Yale University Press.

Thérond, D. 2009. Benefits and innovations of the Council of Europe Framework Convention on the Value of Cultural Heritage for Society. In Council of Europe, *Heritage and Beyond*, 9–11. Strasbourg: Council of Europe.

Thiel, M., de Veer, D., Espinoza-Fuenzalida, N. L., et al. 2021. COVID lessons from the global south—face masks invading tourist beaches and recommendations for the outdoor seasons. *Science of the Total Environment* 786. https://doi.org/10.1016/j.scitotenv.2021.147486

Thompson, R. C., Moore, C., vom Saal, F. S., et al. 2009a. Plastics, the environment and human health: current consensus and future trends. *Philosophical Transactions of the Royal Society B* 364.1526, 2153–2166.

Thompson, R. C., Swan, S. H., Moore, C. J., et al. 2009b. Our plastic age. *Philosophical Transactions of the Royal Society B: Biological Sciences* 364.1526, 1973–1976.

Thompson Klein, J. 2004. Prospects for transdisciplinarity. *Futures* 36.4, 515–526.

Thunberg, G. 2019. *No One Is Too Small to Make a Difference*. London: Penguin Books.

Toffler, A. 1970. *Future Shock*. London: Pan Books.

Tolia-Kelly, D. P., Waterton, E., and Watson, S. 2017. Introduction: heritage, affect and emotion. In D. P. Tolia-Kelly, E. Waterton, and S. Watson (eds), *Heritage, Affect and Emotion: Politics, Practices and Infrastructures*, 1–11. London: Routledge.

Townsend, K. A., Baduel, C., Hall, V., et al. 2019. The impact of marine pollutants and marine debris in Moreton Bay. *Moreton Bay Quandamooka & Catchment: Past, Present, and Future*, 227–244. Brisbane: The Moreton Bay Foundation, https://moretonbayfoundation.org/articles/marine-debris-and-pollutants-in-moreton-bay/

Trabert, S. 2020. Understanding the significance of migrants' material culture. *Journal of Social Archaeology* 20.1, 95–115.

Turk, A., Mahtani, K. R., Tierney, S., et al. 2020. *Can Gardens, Libraries and Museums Improve Well-being through Social Prescribing?* Nuffield Department of Primary Care Health Sciences Centre for Evidence-Based Medicine. https://www.cebm.ox.ac.uk/resources/reports/can-gardens-libraries-and-museums-improve-wellbeing-through-social-prescribing

Turnbull, C. M. 1972. *The Mountain People*. London: Jonathan Cape.

Turnbull, N., and Hoppe, R. 2019. Problematizing 'wickedness': a critique of the wicked problems concept, from philosophy to practice. *Policy and Society* 38.2, 315–337.

Turner, J. C., Oakes, P. J., Haslam, S. A., et al. 1994. Self and collective: cognition and social context. *Personality and Social Psychology Bulletin* 20.5, 454–463.

Tutton, R. 2017. Wicked futures: Meaning, matter and the sociology of the future. *The Sociological Review* 65.3, 478–492.

United Nations Assembly. 2015. *Transforming our World: The 2030 Agenda for Sustainable Development*. https://sdgs.un.org/publications/transforming-our-world-2030-agenda-sustainable-development-17981

United Nations Assembly. 2016. *The Sustainable Development Goals Report 2016*. https://unstats.un.org/sdgs/report/2016/the%20sustainable%20development%20goals%20report%202016.pdf

Valado, M. T. 2006. *Factors Influencing Homeless People's Perception and Use of Urban Space*. PhD dissertation, Department of Anthropology, University of Arizona. https://repository.arizona.edu/handle/10150/195017?show=full

Van de Noort, R. 2011. Conceptualising climate change archaeology. *Antiquity* 85, 1039–1048.

Van de Noort, R. 2013. *Climate Change Archaeology: Building Resilience from Research in the World's Coastal Wetlands*. Oxford: Oxford University Press.

Venture, T., DeSilvey, C., Onciul, B., et al. Articulating loss: a thematic framework for understanding coastal heritage transformations. *The Historic Environment: Policy & Practice* 12.3–4, 395–417.

Verbitsky, H. 1993. Identificación de una Mujer. *Página* 12, 8–9 (10 January).
Verveij, M., Douglas, M., Ellis, R. J., et al. 2006. Clumsy solutions for a complex world: the case of climate change. *Public Administration* 84, 817–843.
Vince, J., and Stoett, P. 2018. From problem to crisis to interdisciplinary solutions: plastic marine debris. *Marine Policy* 96, 200–203.
Vince, J., Praet, E., Schofield, J., et al. 2022. 'Windows of opportunity': exploring the relationship between social media and plastic policies during the COVID-19 pandemic. *Policy Sciences* 55, 737–753. https://doi.org/10.1007/s11077-022-09479-x
Vogt-Vincent, N., Burt, A. J., Kaplan, D. M., et al. 2023. Sources of marine debris for Seychelles and other remote islands in the western Indian Ocean. *Marine Pollution Bulletin* 187, 114497. https://doi.org/10.1016/j.marpolbul.2022.114497
Vos, T., et al. 2013. Global, regional, and national incidence, prevalence, and years lived with disability for 301 acute and chronic diseases and injuries in 188 countries, 1990–2013: a systematic analysis for the Global Burden of Disease Study. *The Lancet* 386. 9995, 743–800.
Wageraar, P., Rodenberg, J., and Rutgers, M. 2023. The crowding out of social values: on the reasons why social values so consistently lose out to other values in heritage management. *International Journal of Heritage Studies* 29.8, 759–772. https://doi.org/10.1080/13527258.2023.2220322
Wagner, M. 2022. Solutions to plastic pollution: a conceptual framework to tackle a wicked problem. In M. S. Bank (ed.), *Microplastic in the Environment: Pattern and Process*, 333–352. New York: Springer. https://link.springer.com/chapter/10.1007/978-3-030-78627-4_11
Walker, J. H. 2014. Reflections on archaeology, poverty and tourism in the Bolivian Amazon. *Worldwide Hospitality and Tourism Themes* 6.3, 215–228.
Waltner-Toews, D. 2017. Zoonoses, One Health and complexity: wicked problems and constructive conflict. *Philosophical Transactions of the Royal Society B* 372. 20160171. http://dx.doi.org/10.1098/rstb.2016.0171
Watson, S. 2021. Public benefit: the challenge for development-led archaeology in the UK. *Internet Archaeology* 57. https://doi.org/10.11141/ia.57.1
Weber, E. P., and Khademian, A. M. 2008. Wicked problems, knowledge challenges, and collaborative capacity builders in network settings. *Public Administration Review* 68.2, 334–349.
Weber, E. P., Lach, D., and Steel, B. S. 2017. Science and problem-solving for wicked problems: challenges and responses. In B. S. Steel, D. Lach, and E. P. Weber (eds), *New Strategies for Wicked Problems: Science and Solutions in the 21st Century*, 1–24. Corvallis: Oregon State University Press.
Weick, K. E. 1984. Small wins: redefining the scale of social problems. *American Psychologist* 39.1, 40–49.
Wheeler, R. E. M. 1954. *Archaeology from the Earth*. Oxford: Oxford University Press.
Wickens, J., and Gupta, A. 2022. Leadership: the act of making way for others. *Studies in Conservation* 67.1, 319–325. https://doi.org/10.1080/00393630.2022.2065956
Williams, T. 2022. *Adrift: The Curious Tale of the Lego Lost at Sea*. London: Unicorn.
Witmore, C. L. 2007. Symmetrical archaeology: excerpts of a manifesto. *World Archaeology* 39.4, 546–562. 10.1080/00438240701679411
Wood, C. 2007. *Museums of the Mind: Mental Health, Emotional Well-Being, and Museums*. Bude: Culture Unlimited.
Woodall, L. C., Sanchez-Vidal, A., Canals, M., et al. 2014. The deep sea is a major sink for microplastic debris. *Royal Society Open Science* 1.4. https://doi.org/10.1098/rsos.140317

Woodward, S. C., and Cooke, L. 2022. *World Heritage: Concepts, Management and Conservation*. London: Routledge.
Woolley, H., Rose, S., Carmona, M., et al. 2004. *The Value of Public Space: How High Quality Parks and Public Spaces Create Economic, Social and Environmental Value*. London: CABE Space.
World Health Organization 2001. *The World Health Report 2001: Mental Disorders Affect One in Four People*. https://www.who.int/news/item/28-09-2001-the-world-health-report-2001-mental-disorders-affect-one-in-four-people
World Health Organization 2021. *The Geneva Charter for Well-Being*. https://www.who.int/publications/m/item/the-geneva-charter-for-well-being
Wright, S. L., and Kelly, F. J. 2017. Plastic and human health: a micro issue? *Environmental Science & Technology* 51.12, 6634–6647.
Wyles, K. J., Pahl, S., Thomas, K., et al. 2016. Factors that can undermine the psychological benefits of coastal environments: exploring the effect of tidal state, presence, and type of litter. *Environment and Behaviour*, 48.9, 1095–1126.
Xiang, W-N. 2013. Working with wicked problems in socio-ecological systems: Awareness, acceptance, and adaptation. *Landscape and Urban Planning*, 110. https://doi.org/10.1016/j.landurbplan.2012.11.006
Yoffee, N. 2010. Collapse in Mesopotamia: what happened, what didn't? In P. A. McAnany and N. Yoffee (eds), *Questioning Collapse: Human Resilience, Ecological Vulnerability and the Aftermath of Empire*, 176–203. Cambridge: Cambridge University Press.
Yuhas, A. 2014. *The Grapes of Wrath* is 75 years old and more relevant than ever. *The Guardian*, 14 April 2014. https://www.theguardian.com/commentisfree/2014/apr/14/grapes-of-wrath-75-years-old-more-relevant-than-ever
Zalasiewicz, J., Waters, C. N., Ivar do Sul, J. A., et al. 2016. The geological cycle of plastics and their use as a stratigraphic indicator of the Anthropocene. *Anthropocene* 13, 4–17.
Zalasiewicz, J., Williams, M., Waters, C., et al. 2017. Scale and diversity of the physical technosphere: a geological perspective. *The Anthropocene Review* 4.1, 9–22. https://journals.sagepub.com/doi/10.1177/2053019616677743.
Zhang, R., Wang, J., and Brown, S. 2021. 'The Charm of a Thousand Years': exploring tourists' perspectives of the 'culture-nature value' of the Humble Administrator's Garden, Suzhou, China. *Landscape Research* 46.8, 1071–1088. 10.1080/01426397.2021.1940904
Zimmerman, L. J. 2014. Activism and archaeology. In C. Smith (ed.) *Encyclopedia of Global Archaeology*. Springer: New York. https://doi.org/10.1007/978-1-4419-0465-2_1076
Zimmerman, L. J., Singleton, C., and Welch, J. 2010. Activism and creating a translational archaeology of homelessness. *World Archaeology* 43.3, 443–454.
Žižek, S. 2011. *Living in the End Times*. London: Verso.
Zuanni, C. 2017. Unintended collaborations: interpreting archaeology on social media. *Internet Archaeology* 46. https://intarch.ac.uk/journal/issue46/2/1.html

Index

Note: Page numbers in *italics* refer to figures and tables.

Aboriginal people 155–6
Ackoff, Russell 171, 176
activism 38
Africa
 archaeology and 259–60
 climate change and 70–1
Aldabra Atoll 50, *51*
Aleppo 248
Alford, John 18, 22, 63
American Veterans Archaeological Recovery (AVAR) 144, 145
Ammendolia, Justine 115
Ammerveld, Janna oud 67–8, 81
Anderson, Sarah 39–40, 85
Angstrom, Jan 227–8
Ansell, Christopher 29
Anthropocene 44, 95, 274
antiquarianism 6
apartheid 240–1
Arabena, Kerry 271–2
archaeological sites, climate change threatening 49
archaeology
 activism and 38
 atomic test sites and 117–21, *121*
 beachcombing/surface beach collection 103, 106
 climate change and 49, 63–77, 88
 coastline erosion and 74–6, *75*, *76*
 collaboration and 267
 community benefits 140–1, 146–7
 conflict and 229, 233, 234–8, 246, 249, 256, 258
 COVID impact 113, 114
 COVID waste and 112–15
 death and bereavement and 150–1
 definition 4–5
 developer-led 9 n. 13
 education 291–5
 entanglement and 165–70
 excavations 143–8
 garbage and 90, 204
 global challenges and 292
 health/well-being and 10–14, 40, 133, 134–41, 145, 207, 215
 hidden objects and 91
 homelessness and 184, 205, 206–16, *209*, *210*, 220
 as interdisciplinary 66, 72, 212, 219, 261, 270–2
 investigating objects 148–51, *151*
 marine pollution and 103–12, *107*, *108*
 migrants and 250
 object biographies 107–11
 plastic as chronological indicator 95–6
 policy entrepreneurs and 38–40, 42, 83–5, 86, 278, 281, 299
 research, modes of 84
 sampling process 106–7
 social injustice and 203–16, 220
 social media and 113–14
 as study of people 6–7
 sustainable strategies and 48
 translational archaeology 185, 212, 218
 unborn/unseen and 65–6
 World Café methodology 107, 108
Archaeology on Prescription 133 n. 5
archives 148
 community archives 140
Arctic, climage change and 71–3
Argentina, disappeared people 245
Aristotle 186 n. 3, 278
Armit, Ian 235, 236–7
arts quarters 200
Ashby, W. Ross 29
assemblage theory 172–5, 181
Athens, migrants 252, *252*
atomic test sites 117–21, *118*
Auld, Graeme 129, 130, 131
Auschwitz Birkenau German Nazi Concentration and Extermination Camp 239–40
Australia, climate change and 62
Avellada cemetery 245
Avery, Michael 235

Baird, Melissa 182, 184, 216
Baker, Paul 280
Baker, Sarah 125, 161–2
Bamiyan temples 222

INDEX

Band, L. 74, 75
Barad, Karen 164, 165, 167, 168, 177, 181
Barnett, Clive 296
Barthes, Roland 89
Bauman, Whitney 44, 164, 168–9, 177, 180
beachcombing 103, 106
beanunfucker 3–4
Beirut 247
bereavement and mourning 150–1, 245–6
Berg, Agnes van den 140
Berlin 238
biofouling 109
Black Lives Matter 189
Blue Planet 105
Blue Shield International 253–4
Bohr, Neils 167
Boswell, Christina 281–2
Boulton, Elizabeth 58
boundary work 69, 77, 78, 81, 270, 275
Bourdieu, Pierre 126, 133, 134
Bowden, M. 235–6
Braidotti, Rosi 169
Brazell, Shadi 264
Breaking Ground Heritage 125, 144, 162
Bricout, John 280
Brinkerhoff, Derick 233–4
Bristol, homelessness 207, 208–11, *209*, *210*
Brizi, Ambra 147
Brookings Institution 232
Brown, Valerie 269
Budolfson, Mark 51–2
Bueren, Ellen van 29
Buffa, Danielle 76
Bulut, Elif 250
Burke, Ariane 64, 77
Byrne, Denis 186 n. 2, 218
Bywater, Krista 153

Cairnduff, Kylie 155
Camic, Paul 10, 11, 148–9
Camp de la Lande (the Jungle) 250
Cape Town *see* District Six (Cape Town)
carbon-neutral cities 266
Carrington, Berenice 156
Carver, Martin 146 n. 14
Central Identification Laboratory, Hawaii (CILH) 244
chaos 170
Chatterjee, Helen 10, 11, 148–9, 150
Chirikure, Shadreck 259–60, 266, 281, 296
Chubb, Jennifer 284
Churchman, West 16, 32, 83
CILH *see* Central Identification Laboratory, Hawaii

CITiZAN 74–5, *75*, 103
citizen science 294
Clean This Beach Up 113
Clements, Frederick 172
climate change 2, 43–88
 archaeological sites and 49
 archaeology and 63–77, 88
 archaeology of 54–7, *77*
 carbon-neutral cities and 266
 economics and 68
 education and 293–4
 future projections *60*
 heritage and 78–82, 88
 human adaption and 56
 modelling 64, *77*
 small wins 83–5, 86, 88
 social injustice and 187, 190
 as wicked problem 57–63, 88
 World Heritage Sites and 50
climate weirding *see* global weirding
coastline erosion, archaeology and 74–6, *75*, *76*
Coffey, Michael 132
collaboration 19, 64, 87, 122, 168, 212, 231, 266–7, 270, 291, 294; *see also* interdisciplinary working; transdisciplinary working
community archives *see under* archives
community benefits of archaeology *see under* archaeology
complexity theory 58, 176–7, 181
compost cities 200
computer modelling 64
conflict 221–58
 archaeology and 229, 233, 234–8, 246, 249, 256, 258
 audience response to 7–8, 224
 collaborative strategies and 231
 defining 225–9
 fragile states and 232–3
 heritage and 246, 253–5, 258
 post-conflict recovery and reconstruction 246–9
 repatriation of remains 244
 rule of state and 228, *228*
 small wins 227, 234, 237, 239, 240, 242, 243–55, 258
 small wins and 243–55
 World Heritage Sites and 238–43, *241*
 as wicked problem 229–34
Conklin, Jeffrey 18, 20, 25–6, 62, 87, 287
Cooke, Louise 50
COP26 (UN Conference for Climate Change, 2021) 59–60, 67
Cornell, Sarah 66

Council for British Archaeology 2, 103, 208 n. 28, 291
Council of Europe Framework Convention on the Value of Cultural Heritage for Society *see* Faro Convention (2005)
Coverly, Edd de 92
COVID-19 129–30, 131, 132, *171*, 279–80, 285–6
COVID waste 89, 104, 112–15, 280
Crossland, Zoe 244–6
Croucher, Karina 151
Culhane, Dennis 206
cultural participation 10–11, 134–41
culture 194
 compost cities and 200
 health and 125–6, 138–41
 nature and 52–3, 65, 74, 102, 166
 see also heritage
Currie, Elizabeth 152 n. 17, *153*, 154
Custers, Mariette 140

Dahlgren, Göran 275–6, 277, 295
Danken, Thomas 19, 58
Davies, Thom 92
Davis, Joy 296
Daviter, Falk 161
death 150–1; *see also* bereavement and mourning
Delanda, Manuel 174
De Leon, Jason 251
Deleuze, Gilles 174
dementia 150
Department for Digital, Culture, Media, and Sport (DCMS) 138
deprivation *see* poverty and deprivation
De Pryck, Kari 279
De Salas, Kristy 276, 277
Descartes, René 52
Desjardins, Sean 72, 85–6
Dewulf, Art 32–3
Dezhamkhooy, Maryam 190, 204
Dickens, Charles 183 n. 1
Dig Greater Manchester 146
Dines, Nicholas 140
District Six (Cape Town) 241, 257
diversity 135, 155, 184, 186, 191, 194, 195–7, 211, 219, 220
Doggerland 74, 75
Doherty, Sean 110 n. 12
Dolff-Bonekaemper, Gabi 242
Dorado, Silvia 23
Doughnut Economics Action Lab 275
Doughnut framework 272–5, *273*, 295, 299
Douglas, Mary 12, 90–1

Douglass, Frederick 297
Downes, Jane 67
Downs, Anthony 81

EAA *see* European Association of Archaeologists
East Chisenbury Midden 145
East London 140, 194
ecosystems 52, 71, 165, 172–5, 181
 plastics and 99, 100, 102
Ecuador, Indigenous peoples in 152–5
Edensor, Tim 166
education 290–5
Ehrlich, Paul 65
Einstein, Albert 267, 269
English Heritage *see* Historic England
entanglement 59, 65, 131, 164–81, *171*, 177, 180, 181, 270
environmental history 64
environmental pollution 89–124; *see also* garbage; marine pollution; plastic waste
Environmental Protection Agency (EPA) (US) 34
Eppel, Elizabeth Anne 176
equality and inequality 45, 88, 127, 182, 186, 188, 190, 193, 194, 195–7, 203, 204, 219, 220
 racial equality 189
 see also health and well-being; poverty and deprivation; social injustice
European Association of Archaeologists (EAA) 46, 47–9
Eustatic Sea Levels 45
excavations *see under* archaeology
Everill, Paul 145, 146

Failed States Index 230
Faro Convention (2005) 157, 186, 192–4, 197, 204, 219, 220, 234, 255
Fawkes, Guy 214
Feltz, Bernard 52
figurations 169
Finlay, Nyree 150
Finnegan, Alan 145
First World War 223
floods 82
Fluck, Hannah 2
Flyn, Cal 55, 56
food security 49, 187–8
Ford, Helen 179
Forestry Commission 139
Fourier Transformed Infrared Spectroscopy (Attenuated Total Reflectance) (FTIR-ATR) 109
fragile states 232–3
Fredengren, Christina 169–70

Friedman, Thomas 44
Fuller, Buckminster 290
Fund for Peace 230
Funtowicz, Silvio 27, 268

Galápagos Islands 104–12, *107*, *108*, 278, 279
Galloway, Susan 136
Gamble, Clive 54, 56, 63
garbage 90, 204; *see also* environmental pollution; marine pollution; plastic waste
gardening 11, 12, 133, 139–40, 159 n. 18, 200
Gard'ner, Jim 140, 194
Gaston, Kevin 11–12
Gatersleben, Birgitta 141
Gay-Antaki, Miriam 69 n. 21
Genbaku Dome *see* Hiroshima Peace Memorial
Geneva Charter for Well-Being 128
Geneva Convention (1949) 226
George, Gerard 23
Giddens, Anthony 43, 45, 63
Gieryn, Thomas 69, 77
Gifford, Robert 142
Glasgow, Climate Change Conference (2021) *see* COP26
globalization 168
global warming *see* climate change
global weirding 44, 55, 74, 88, 180
Godin, Geneviève 93
Gonzalez-Ruibal, Alfredo 1
Good Organisation 212–14, *213*
Gottweis, Herbert 278
graffiti 142
grand challenges 23, *24*
Granovetter, Mark 135
Great Pacific Garbage Patch (GPGP) 90, 92–3, 99, *99*
Greenham Common Airbase 238
Greenland, Norse colonisation of 72–3
Grewatsch, Sylvia 176, 179
Grint, Keith 20, 58, 280–1, 285–6, 287–9, 291, 295
Gronholm, Petra 132
Gwynne, Annette 155

Hambrecht, George 84–5
Hannigan, Ben 132
Haram, Linsey 99
Haraway, Donna 169–70
Harrison, Rodney 5, 173
Harvey, David 85
Hawkins, Gay 98
Head, Brian 18, 22, 62, 63, 161, 176–7, 199, 206–7, 262–3, 282–3, 294

health and well-being 11–13, 125–63
 archaeology, benefits of 10–14, 40, 133, 134–41, 145, 207, 215
 culture and 125–6, 138
 excavations and 143–8
 healthcare 187, 198
 heritage and 125, 157–61, *159*
 Indigenous peoples and 152–7, *153*, 163
 mental health 125, 127, 132, 139, 144, 146, 163
 museum objects, handling of 148–50
 nature and 139
 physical health 138–40
 place attachment and 141–3, 147, 246
 social prescribing and 133, 159
 as a wicked problem 126, 128–34, 161, 163
 see also equality and inequality
Henderson, Claire 132
heritage 4, 40, 50–1, 86, 127–8
 action heritage 218
 Authorized Heritage Discourse 128, 184, 194
 climate change and 78–82, 88
 conflict and 246, 253–5, 258
 culture and 125–6, 138–41
 education 291–5
 global challenges and 292
 health/well-being and 125, 157–61, *159*
 human rights and 192
 identity and 194
 inclusion, diversity, and equality and 195–7
 small wins 143–57, 161, 162, 163
 sustainability and 79–80
 see also culture; Faro Convention (2005)
heritage corridors 186 n. 2
Heritage Lottery Fund (HLF) 136, 137–8, 139, 140
Hicks, Dan 250–1
hillforts 235–6, *236*
Hiroshima Peace Memorial (Genbaku Dome) 239, 241–2, 248
Historic Battlefields Register 225, 234
Historic England 2, 79–80, 157–8, 195, 196–7, 219, 225, 242
Historic Landscape Characterisation (HLC) 173–4
Hockney, David 45 n. 3
Hodder, Ian 165, 166–7, 180
Hodgkinson, Ian 294
Högberg, Anders 121, 130, 297
Holm, Poul 64, 67, 68
Holocaust 240
Holtorf, Cornelius 50–1, 121, 130, 297
homelessness 184, 205, 206–16, *209*, *210*, 220; *see also* poverty and deprivation
Hoppe, Robert 24
Horgan, John 172 n. 7

Hritz, Carrie 68, 86
Huajuapán de León 114
Hudson, Mark 64, 65
Hulme 200
Hulme, Mike 279
human ecodynamics 64
human remains 8, 223, 234–5, 244–5
human rights 182, 183, 184, 186, 220; *see also* Universal Declaration of Human Rights (UDHR)
HUNT Study 134
Hyyppä, Markku 134, 136

ICOMOS 53
Impact Investing Institute 264
Imperial War Museum North 137
inclusivity 136, 149, *159*, 188, 191, 192, 195–7, 211, 219, 220
income gap 187
Index of State Weakness 232
Indianapolis 211
Indigenous peoples 6, 54, 56, 73, 117, 151–7, 163, 271–2
inequality *see* equality and inequality
Infeld, Leopold 267, 269
interdisciplinary working 270–2, 286; *see also* collaboration
International Panel for Climate Change (IPCC) 56, 67–9, 71, 88, 180, 250, 279, 290
International Union for Conservation of Nature (IUCN) 53, 100
In Touch programme 137
Inuit 73, 271
Invisible Cities 212, *213*
Iroquois 6
Irvine, Richard 178

Jacobs, Jane 182, 183, 197, 199
Johnston, Robert 218–19
Jones, Janis 113
Jones, Meirion 166, 167, 180
Jones, Siân 141
Jordan, Peter 72, 85–6
Julius Caesar 235
Jungcurt, Stefan 69, 77
Jungle, the *see* Camp de la Lande
Just Stop Oil 37, *37*

Kahlke, P. Maurine 136
Kapoor, Rakesh 28
Kawa, Nicholas 292, 293
Keats, John 289
Keeffe, Greg 200
Khademian, Anne 31

Kiddey, Rachael 207–11, *209*, 214–15, 252–3, *252*, 256
Kiel, EAA conference statement (2021) 46, 47–50
Kingdon, John 38–9
Kirschke, Sabrina 96
Klein, Thompson 271
Kneale, Nigel 43
Kosow, Hannah 96
Kramer, Franklin 230, 231
Kropotkin, Piotr 202
Kuletz, Valerie 119–20

Lahr, Mirazón 223
Landscape Character Assessment (LCA) 173–4
landscape preservation, climate change and 49
Lane, Paul 71
Latour, Bruno 166
Law, John 170, 171
Lawrence, Roderick 270–1
LCA *see* Landscape Character Assessment
leadership 284–90, *288*
Lee, Hoesung 2
Lefebvre, Henri 182, 183, 185
Lego Lost at Sea project 103
Lehtonen, Anna 293–4
LGBTQIA+ 188
Liboiron, Max 93–4, 101, 105
Lin, Nan 134
Linley, Rebecca 138
Little, Daniel 175
Liverpool 216
Løkken, Bente Irene 134–5
Lønngren, Johanna 20, 26, 29
Lovins, Hunter 44
Lowenthal, David 246
Lyon, Christopher 100

Macdonald, Sharon 221, 222, 257
McGrath, Joseph E. 35
McGuire, Randall 203
McLeish, Tom 267, 269
McOmish, D. 235–6
Maes, Mikaël 139
Magnani, Matthew 114
Maiden Castle 235, *236*
Malin, Andrea 245
Mallet, Sarah 250–1
Manchester 146, 200, 216
Manchester Museum 137, 149
Mandela, Nelson 240, 290
Manfil, Karina 245
Marchant, Rob 71

marine pollution 90, 95, 96, 98–100, 103–12, *107*, *108*, 115, 117, 278, 279
Marsh, George Perkins 68 n. 20
Martin, Stephanie 251
Marwood, Kimberley 218–19
Masaquiza Jimenez, Rubelio *153*
Matarasso, François 138
Maxwell, Charlotte Robert 121
Mazzucato, Mariana 264–6, 295
Menkhaus, Kenneth 229, 230, 232, 284–5
messiness 27, 29, 87, 165, 170–2, 176, 179, 181
Meyer-Bisch, Patrice 193, 194
Michalos, Alex C. 136
migration 186 n. 2, 249–52, *252*
Millennium Development Goals 21–2
MLA Renaissance North West 149–50
Monbiot, George 36–7, 58 n. 13, 297
moon-ghetto metaphor 1, 14–16, 20, 264
Moraes, Christopher 26
Morath, Sarah 96
Morel, Hana 67–8, 76, 81, 86–7
Morse, Nuala 150
Morton, Timothy 58
Mostar bridge *247*, 247–8
mourning *see* bereavement and mourning
multiple causality 177–80, 181
Munawar, Nour 248–9, 256
Munsell Soil Colour Chart 12
Murphy, Cullen 89, 90, 123
museum objects, handling of 148–50
Museums Association 195
Myers, Adrian 109

Nan Madol 50
Napier, A. David 125
Nataruk 8, 223, 234, 235
National Trust 142
nature and natureculture 12, 52–3, 65, 74, 102, 139, 166
Nelson, Richard 1, 14–15, 182, 264
neopelagic ecosystems 99, 102
Nettle, Daniel 201–3
networks 31, 166, 176, 266–7
Nevada Peace Camp and Test Site 117–21, *118*, 238
Newcastle-upon-Tyne 201
NIMBYism 143
Nimenko, W. 145
Noort, Robert van der 45–6, 63, 69
Nord-Trønderlag Health Study 134
Norse people 72–3
nuclear test sites *see* atomic test sites
nuclear waste 120–1

nudges *see* small wins
NVivo 116

Oancea, Alis 284
object biographies *see under* archaeology
ontological security 246; *see also* place attachment
Operation Nightingale 137, 144, *144*, 145
Orr, Scott Allan 82
Osgood, Richard 145 n. 13
Oxford University 275

Paddock, Catherine 13
Painter, Gary 206
palaeoenvironmental records 70, 72, 77, *77*
Palaeolithic Europe 54–6, 63
Parnet, Claire 174
Parsell, Cameron 207
participatory action research (PAR) 218
Payne, Darin 294–5
Paynter, Robert 203
Peck, Janine *144*
Peng, Yiming 115
Perry, Jim 85
Peters, B. Guy 17, 20, 22, 58
Pétursdóttir, Þóra 53–4
physical activity 11, 13
Pitt Rivers, Augustus 146 n. 14
place attachment 128, 140, 141–3, 147, 185, 200–1, 238, 246
plastic waste 89–90, 93–101, 124, 179
 attitudes towards 114
 biofouling 109
 as chronological indicator 95–6
 education regarding 115–17
 microplastics 90, 94, 95, 100, 105, 106
 plastic bags 100, 105
 small wins 95, 104, 112, 114, 119, 122, 123, 124
 technical examination of 109
 as wicked problem 95–103, *97*, 100, 124
 see also COVID waste; marine pollution
Plastic Age/Plasticene 93, 95
PNT *see* postnormal times
Poeck, Katrien van 20, 26, 29
policy entrepreneurs 38–40, 42, 83–5, 86, 278, 281, 299
policymaking 278
policy network theory 29–30
policy–research relations 281–4, *282*
policy windows 279–81
pollution *see* COVID waste; environmental pollution; marine pollution; plastic waste
polyester 110
polypropylene 110, 111

Popper, Karl 267
postnormal times (PNT) 27-8
poverty and deprivation 184-5, 199-206; see also equality and inequality; homelessness
PPE waste see COVID waste
Praet, Estelle 113 n. 16, 115-16
problem-solving 25, 25-6
Putnam, Robert 134

Quesada-Ganuza, Laura 82

racial equality see under equality and inequality
racism 189
Rahm, Lina 164, 178
Rahm-Skågeby, Jörgen 164, 178
Rainbow Model 275-8, 276, 295, 299
Rasch, Dana 153
Rathje, William 89, 90, 123
Ravetz, Jerome 27, 268
Raworth, Kate 259, 273-4, 290, 295
Read, Peter 222
Red de Científicos de la Basura (ReCiBa) 115-16, 122
Redfern, Neil 103
refugees 246, 248, 249-50
Reijerkerk, Dana 76
Reno, Joshua 89
research see policy-research relations
Rhodes, Mary Lee 176
Richer, Suzi 71, 72, 83-4
Rick, Torben 48, 86
Rittel, Horst 14, 16-18, 171, 172
Robb, John 166, 180
Robben Island prison 239, 240-1, 241
Roberts, Nancy 230-1
Rockman, Marcy 68, 84-5, 86
Roe, Emery 29, 170
Roma 127
Romans at Home project 150, 151
Rosenberg, Noah 197-8, 206
Rouhani, Bijan 246-7, 248
Rowntree, Seebohm 205, 208
Ruckelhaus, William 34
Rwanda genocide 232

St Paul (MN) 211
sampling process see under archaeology
Sandweiss, Daniel 48, 86
Sardar, Ziauddin 27-9, 269
Sassoon, Siegfried 223, 244, 256
Scannell, Leila 142
Sharples, Niall 236
Schickore, Jutta 170-1, 179
Schofield, John 114-15, 152 n. 17, 154, 237

Schuller, Tom 137
Schultz, P. Wesley 116
Science to Solutions 105-6, 108, 111
sea-level rises 45, 49, 61, 61
Sebille Erik van 105, 112
Second World War 223
Selg, Peeta 26
servicemen and veterans 144, 144-6, 160, 243, 244
Seven Generation Sustainability 6, 54
Shah, Kalim 96
Shamsi 221
Shanks, Michael 166
Shatan, Chaim 245
Sherrington, Chris 98
shoes 110
Shoshone, Western see Western Shoshone
Simon, Herbert 27
Simpson, R. G. 145
Singer, Peter 198 n. 15
Singleton, Courtney 211
slums 182, 197, 199
small wins 31-8, 42, 47, 180, 260-1, 263-4
 climate change 83-5, 86, 88
 conflict 227, 234, 237, 239, 240, 242, 243-55, 258
 health and well-being 143-57, 161, 162, 163
 plastic waste 95, 104, 112, 114, 119, 122, 123, 124
 social injustice 185, 187, 190, 198, 206, 212, 216, 220
Smith, Graham Hingangaroa 31
Smith, Katherine 281-2
Smith, Laurajane 119 n. 17, 128, 194, 196
Smith, Linda Tuhiwai 31
social capital
 connectivity 135
 cultural activity 138
 learning and personal development 137-8
 physical health and 138-40
 weak ties and 135
social injustice 65, 146, 182-220
 archaeology and 203-216
 small wins 185, 187, 190, 198, 206, 212, 216, 220
 as wicked problem 197-203
 see also equality and inequality
social justice 182-8, 216, 220
social media 113-14
social prescribing 133, 159, 163
social value 141
Sofaer, Joanna 160
Soga, Masashi 11-12, 139
soil 12-13
Sørensen, Tim 53-4
space junk 90, 123-4

Spurn Point 75, 83
state failure 232
Steinbeck, John 297, 298
Stern Report (2006) 69
Stonehenge 119 n. 17
storytelling 8–9, 81
South Africa, Apartheid regime 240–1
sustainability, heritage and 79–80
sustainable development 71, 77
Sustainable Development Goals 21, 21–2, 261–2, 263, 265, *265*, 274
Swanson, Jesse *144*
Symonds, James 248–9, 256
systems thinking 175–7, 181

Taçon, Paul 125, 161–2
Taliban 222
tame problems 20, *23*, 25
Tansley, Arthur George 52, 172–3
Taylor, Joel 32
Tebbitt, Norman 188 n. 6
Tehran 190, 204
Termeer, Catrien 32–3
Thames foreshore project 103
Thompson, Katharine 76
Three Horizons Approach 296
Thunberg, Greta 38, 43, 87
Toffler, Alvin 259
Tokio Express container spill 103
Toronto 115
tourism, impact of 105
transdisciplinary working 270–2, 286; *see also* collaboration
translational archaeology *see under* archaeology
Tromso 114
Turnbull, Nick 24, 202, 208
Tutton, Richard 5 n. 7, 131 n. 3
Twyford Down 238

Ukraine war 256–7
Ulrome *76*
UNESCO
 Universal Declaration on Cultural Diversity 194
 see also World Heritage Sites
United Nations
 Agenda for Sustainable Development 21
 The Climate Crisis—A Race We Can Win 59–60
 conflict, definitions of 226–7
 plastic pollution, strategies for 96
United Nations Conference for Climate Change (2021) *see* COP26
United Nations Environment Programme (UNEP) 67

Universal Declaration of Human Rights (UDHR) 183, 184, 186, 189, 190–7, 204, 219; *see also* human rights
Universidad Católica del Norte, Coquimbo 115
universities 291
University of Central Lancashire, Psychosocial Research Unit 149
University of Essex 139
University of York 150
US Army, repatriation of remains 244
Usherwood, Bob 138

Valado, Martha Trenna 212
Valletta, Strait Street 216–18, *217*, 238
veterans *see* servicemen and veterans
Veterans Reunited Programme 137
Vezo 76
Vince, Joanna 280
volunteering 75, 135, 136, 138, 140, *159*, 159 n. 18, 294
voting rights 189–90

Wagner, Martin 97–8, 122
Walshe, Diarmaid 145 n. 13
waste *see* COVID waste; environmental pollution; plastic waste
Waterfall Model 25, 25–61, 287
Waterloo Uncovered 144
Watermeyer, Richard 284
Webber, Mel 14, 16–18, 171, 172
Weber, Edward 31, 268–9
Weick, Karl 32, 33–6
Welch, Jessica 211
Western Shoshone 117
Wheeler, Mortimer 7, 146 n. 14, 235
Whitehead, Alfred North 167
Whitehead, Margaret 275–6, 277, 295
wicked problems 4, 5, 14–15, *15*, 97, 169, 261–3, *265*
 as complex 29, 31, 35, 42, 58
 climate change as 57–63, 88
 conflict as 229–34
 creativity and knowledge 267–70
 definition 16–19
 divide and conquer/partial solutions 32
 entanglement and 59, 131, 270
 grand challenges and 23–4, *24*
 health as 126, 128–34, 161, 163
 leadership and 284–90 *288*
 management of 24–7, 42
 networks and 31
 plastic waste as 95–103, *97*, 100, 124
 small wins and 31–8, 42, 263
 social injustice as 197–203

types of problems 22–3, *23*
super wicked problems 22, 57
Williams, Tracy 103
Winiwarter, Verena 64, 67, 68
Witmore, Christopher 166
Wood, C. 149
Woodward, Simon 50
World Health Organization (WHO) 113, 125, 126, 128, 129, 132, 136
World Heritage Sites 50, 103, 238–43, *241*

Yamaura, Yuichi 11–12
York 204–5, 212, *213*
York Archaeological Trust 205
York Archaeology 133 n. 5, 150
Young, Pamela 156
Yuhas, Alan 298

Zimmerman, Larry 38, 211–12
Zinc Debate 30–1
Žižek, Slavoj 58